THE WOMEN
ARE MARCHING

112814

THE WOMEN ARE MARCHING

The Second Sex
and the
Palestinian Revolution

Philippa Strum

LAWRENCE HILL BOOKS

Library of Congress Cataloging-in-Publication Data

Strum, Philippa.
 The women are marching : the second sex and the Palestinian
revolution / Philippa Strum. — 1st ed.
 p. cm.
 ISBN 1-55652-122-7 (cloth) : $29.00. — ISBN 1-55652-123-5 (paper)
 : $16.95
 1. Women, Palestinian Arab—West Bank—Political activity.
 2. Women, Palestinian Arab—Gaza Strip—Political activity.
 3. Intifada, 1987—Participation, Female. I. Title.
 HQ1728.5.Z8W4775 1992
 305.42'5695'3—dc20 91-42410
 CIP

Front cover photo: Judy Janda, Impact Visuals

Printed in the United States of America
First Edition
Published by Lawrence Hill Books, Brooklyn, New York
An imprint of Chicago Review Press, Incorporated
814 North Franklin Street
Chicago, Illinois 60610

To David

and for the women of Palestine

Contents

Acknowledgments

So many people contributed to this book that I hope they will forgive me if I do not thank all of them individually. Three women, however, were so important that each must be mentioned.

Zahira Kamal gave me the idea for the project, took time from an impossibly hectic schedule to make herself available for repeated interviews, and arranged for me to see one women's project after another. Mona Rishmawi provided practical advice and moral support from the beginning of the project, adopted me into her family, and provided me with information and comments throughout. Randa Siniora was generous with her time and knowledge and helped me reach the network of women who are creating the "revolution within the revolution."

Jill Norgren wrote the most careful and helpful critique of a manuscript that I can imagine. Penny Johnson read through parts of three successive drafts and commented with the kind of constructive criticism all authors seek but rarely find. Raja Shehadeh, Joost Hiltermann, and Suha Sabbagh read various drafts, providing information where needed and eliminating my more egregious errors.

That is not to suggest that my readers were in agreement. It appeared at times that no two people who read any of the manuscript wanted the same things from it. Some of the Palestinian women asked in bewilderment, "But why are you writing about the occupation? We know about it! Why aren't you analyzing our movement in a way that will help us?" Others, who had lived in the United States, urged me to include more descriptions of the occupation. American women who have written about women's movements asked for more comparative material; other Americans wondered why I was using terms drawn from the discipline of women's studies; still others kept urging me to put more of myself

into the book. While some people advised me to take Israeli sources out of the Notes and use more by Palestinians, just as many suggested I omit all Palestinian sources to avoid the appearance of bias and concentrate on those by Israelis; a third group counseled using only publications written by neither Palestinians nor Israelis. In the end, I made my own decisions. Those who read my drafts, which differed from the final version, are of course in no way responsible for my interpretations or opinions or for any mistakes I have made.

My thanks go also to all the following, some of whom permitted me to subject them to endless hours of questions: Salwa al-Najab, Haifa As'ad, Hanan Ashrawi, Terry Boulatta, Rita Giacaman, Suha Hindiyeh, Izzat Abdul Hadi, Nancy Ibrihim, Mariam Ismail, Ghada Izghayar, Islah Jad, Samihah Khalil, Amal Khreisheh, Eileen Kuttab, Maha Mustaqlem, Rana Nashashibi, Nahla Qourah, Mervat Rishmawi, Charles Shamas, Lisa Taraki, Nada T'weil, and Amal Wahdan, as well as many women in the committees, the villages, and the refugee camps and my guide/translators. Security reasons prevent me from naming many of them and there are others whose full names I don't even know. That does not lessen my debt to them.

The research facilities of al-Haq were invaluable, and I am grateful to its staff for their help and their wonderful friendliness. Particular thanks are due to Nina 'Attalah, Omar 'Attalah, and Fateh Azzam.

For reasons they will know, Maha Jarad, Najla Khoury, Georgette Shamshoum, Kemal Shamshoum, and Widad Shehadeh have my great gratitude. So do Israeli friends, including Dana Arieli, Haim Cohn, Yael and Yigal Elam, the late Dan Horowitz, Neri and Tamar Horowitz, Hagit Shlonsky, Michal Smoira-Cohn, and Ruchama Marton, who stilled whatever qualms they may have had and provided moral sustenance, sounding boards, and beds and meals.

Abdallah and Clemence Rishmawi deserve words beyond those I can find for calmly and warmly fitting an extra and, I suspect, occasionally difficult "daughter" into their open hearts and home. They are very special people.

Carol Bernstein Ferry, W. H. Ferry, and Arthur Kobacker generously presented me with the greatest gift of all—time in which to

undertake this project—although none had the slightest idea of how it would turn out.

Esther Cohen set aside her own writing to edit the manuscript. She managed the difficult feat of becoming an even closer friend while offering both encouragement and sound editorial judgment, for which she has my great admiration as well as my gratitude and affection. Shirley Cloyes has been the most patient, forgiving, insightful, and supportive publisher imaginable. And Barbara Flanagan's copyediting taught me what her profession is all about.

The usual thanks go to the family members and friends who patiently (I think) lived through the researching and writing of yet another manuscript. I regret that my trips to the West Bank were so frightening to some of the people I love most. Among them are my parents and my son. David is still puzzled by a mother who prefers writing to hanging out, but he is becoming more tolerant with age. I hope that tolerance extends to my dedication of this volume to him along with the courageous women of Palestine.

A Note on Transliteration

There are many ways to transliterate Arabic terms into English. Birzeit University, for example, is also referred to as Bir Zeit and Beir Zeit. In most cases, I have followed the spelling used by al-Haq, which tries to replicate the sounds made in Arabic as closely as possible, and am grateful to Nina 'Attalah for her help.

THE WEST BANK

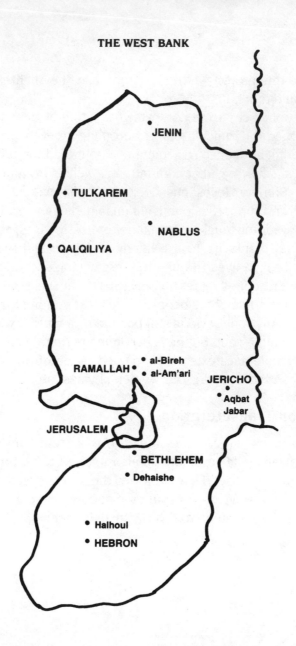

JENIN

TULKAREM

NABLUS

QALQILIYA

RAMALLAH • • al-Bireh
• al-Am'ari
JERICHO
•
• Aqbat
Jabar

JERUSALEM

• BETHLEHEM
• Dehaishe

• Halhoul
• HEBRON

THE REGION OF ISRAEL AND PALESTINE

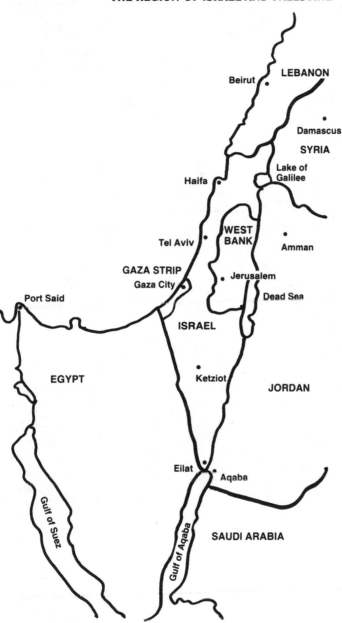

Introduction

"The women of Palestine will not be like the women of Algeria!"

When the Palestinian popular movement known as the intifada began in December 1987, the Israeli-Palestinian conflict claimed the international spotlight, as it has done periodically since the creation of the state of Israel in 1948. For a while, pictures of stone-throwing young Palestinian men defying young Israeli soldiers dominated the screens and news pages of the world. Once the confrontation inside the occupied territories was no longer a novelty, however, the media turned their attention elsewhere, although they continued to recite the number of Palestinians killed each day, each week, each month. Eventually the repetitive nature of the news resulted in an informal moratorium on the coverage of the occupation and the intifada, lifted only for such dramas as the mass murder of Palestinian workers in Rishon Lezion, assassinations of Israeli civilians by individual Palestinians, and the massacre of Moslem Palestinian worshipers by Israeli police on Jerusalem's al-Haram al-Sharif, or the Temple Mount.

Virtually all of the media coverage as well as the scholarly literature on the intifada has ignored one of its most important aspects: the centrality of women and of a feminist movement. Beginning in 1978, the movement has emerged since 1987 as a key organizing force, a threat to many traditional Palestinian customs and values as well as to Israeli hegemony over the West Bank and

Gaza, and a significant component of the effort to restructure the Palestinian economy, which is an essential goal of the intifada.

This book is an account both of the women before and during the intifada and of my own life in their society, where I spent July 1989, January and July 1990, and May 1991 based in the city of Ramallah, a twenty-minute drive north of Jerusalem. I have interspersed accounts of my research with some of my diary entries from Ramallah to help readers understand the changing status of West Bank women and the world in which they live. Both have been altered by the creation of the Israeli state in 1948 and Great Britain's agreement to Jordan's hegemony over the West Bank; by the Arab nations' lack of interest in the Palestinians who emerged from the 1947–1948 war as refugees; by Israel's occupation of the West Bank in 1967; by the development of a Palestinian women's movement in the late 1970s; and, finally, by the daily experiences of all Palestinians since the onset of the intifada.

One obvious question is how a Jewish-American came to write this book. I am a political scientist specializing in American constitutional law, women and politics in comparative perspective, and human rights. My intensive relationship with Israelis and Palestinians began in November 1980, when the United States Information Service (USIS), which had earlier sent me to Turkey as an "expert lecturer," added Israel to the itinerary for my next lecture tour. I spoke at the U.S. embassy, the American consulate in West Jerusalem, and various Israeli universities about American politics, the American women's movement, and civil liberties. I was scheduled to speak at Birzeit University, the West Bank's largest, but the repeated closings of the university by the Israelis seemed always to coincide with my prospective lectures there. I was nonetheless able to meet Palestinian as well as Israeli political leaders. When I was sent to Israel again in 1982 by the USIS and the Fulbright Commission, some of my lectures were cosponsored by groups such as the Tel Aviv University Law School, the Association for Civil Rights in Israel, and Hebrew University's Program on Sex Differences in Society. I gave lectures in 1984 and 1986 under the auspices of the Tel Aviv University Faculty of Political Science and Hebrew University's Law School and Truman Institute.

The Israeli civil libertarians whom I met in 1980, concerned about what they considered the undue influence provided to antilibertarian forces by American public and private money, asked if I would help them create a support group in the United States. Using as initial contacts several fellow directors of the American Civil Liberties Union and working with an Israeli woman who had moved to the United States, I did so, helping to organize and serving for seven years as the first president of the American-Israeli Civil Liberties Coalition. The coalition aided Israelis in producing written and videotaped civil liberties materials for use in Israeli high schools and in initiating cases in the Israeli courts on issues such as religious liberty and gender equality. In addition, it gradually became a major source of information in the United States about the state of civil liberties in Israel and, after 1987, about the intifada.

Lecturing in Israel and working for civil liberties had stimulated my curiosity about the reasons for Israel's failure to adopt a constitution and the impact on Israeli civil liberties of the lack of such a document. I learned enough through my experiences and my reading to start teaching an undergraduate course in the politics of Israel and to begin what has in effect become an extensive additional career lecturing in the United States about Israel and, more recently, about Palestine. My new knowledge and curiosity led to a visiting fellowship at Hebrew University's Truman Institute, which gave me access to surviving founders of the state, academicians, lawyers, judges, politicians, and civil libertarians in groups such as the newly formed Israel Women's Network, Soldiers Against Silence, and Yesh G'vul (the latter two being protest groups of soldiers who had served in the 1982 invasion of Lebanon, the second still in existence as an organization of selective conscientious objectors). I also came to know Raja Shehadeh and Jonathan Kuttab, the human rights attorneys who organized al-Haq (roughly translated as "rights" or "justice"), the Palestinian affiliate of the International Commission of Jurists, and began working informally with them. In 1986, al-Haq sponsored a lecture I gave at Ibrahimiya College in East Jerusalem on democracy and human rights—the first such public lecture, al-Haq believed, to be offered to Palestinians. So I found myself with wide-ranging contacts in both Israel and

Palestine, and I became one of the Jewish-Americans encouraging meetings between Israelis and Palestinians and between Americans and Palestinians as a step on the road to peace.

In March 1989, I met Zahira Kamal, the head of the largest and oldest Palestinian women's committee with a feminist agenda. The occasion was a conference at Columbia University sponsored by the Israeli English-language magazine *New Outlook* and the English edition of the Palestinian weekly newspaper *al-Fajr*. I had been asked to moderate a panel of Israeli and Palestinian women at the conference and another in a postconference presentation at a local synagogue. Zahira was a member of each panel, and as we chatted beforehand she tried to explain to me the new kind of Palestinian women's committees that had begun developing in 1978. She believes that "the women of Palestine will not be like the women of Algeria;" that is, they will not regress into denigrated homebodies. The combination of women's role in the intifada and the organizational activities of the women's committees would make a permanent change in the status of Palestinian women, Zahira and other West Bank women insisted. I was skeptical, aware that the participation of women in national liberation movements never has been translated into gender equality once the revolution has succeeded. "Why don't you come see for yourself?" Zahira responded. The idea was enthusiastically seconded by attorney Mona Rishmawi, who was in New York for a year getting a master's degree in human rights law at Columbia University before returning to the West Bank as al-Haq's executive director. She had lived with me and my family briefly; we had shared a number of platforms, speaking about Israeli and Palestinian women; and she had piqued my interest in the Palestinian women's movement. I had visited and gotten to know both Mona's and Raja's families during the months I was doing research in West Jerusalem, so the idea of going to the West Bank was not strange.

Zahira's casual invitation made me wonder whether I could learn anything meaningful without speaking Arabic and whether I would have difficulty meeting women. She assured me that the leaders of the committees all speak English and that the guides they would provide for visits with non-English-speaking women would be able

to translate. Paradoxically, my inability to speak Arabic and my consequent need for guides became an advantage: because I was brought by women from the local committees, other women accepted me without suspicion and, as far as I could tell, talked quite freely. Their frankness led me to take such elementary precautions as changing most names when I wrote (that applies to everyone referred to only by a first name) and limiting my use of full names to women in the public eye who would be readily identifiable anyway.

The women's committees are national, which means that they are active in the Gaza Strip as well as in the West Bank. But their headquarters are in the West Bank, where all their key leaders live, and most of their activities are centered in Jerusalem or Ramallah. Gaza is separated from the West Bank and is quite different in history, belief patterns, institutions, and many factors affecting the status of women: fundamentalists exert greater influence in Gaza, a larger proportion of the population lives in refugee camps and is under age twenty-five, and poverty is more pervasive. Although more than half of the people in the territories are refugees and about 50 percent of them still live in camps, refugees constitute only 10 percent of the West Bank population. (The Jabalya camp in Gaza, where the intifada began, is the largest in the occupied territories, with 55,488 people; the biggest West Bank camp, Balata, houses 13,094. Of the approximately 450 Palestinian villages, 435 are in the West Bank and are home to 64 percent of West Bankers, whereas only 11 percent of Gazans live in villages; 46 percent of Gazans but only 26 percent of West Bankers reside in cities.) For all these reasons, along with my limited time and al-Haq's agreement to let me use its research library, I decided to base myself in Ramallah and confine my research to West Bank women. Many of the phenomena described in the book, such as women's participation in the intifada and the emphasis of the committees on grassroots organization, are common to the West Bank and Gaza. But because of the differences in the two societies, I want to emphasize that the "Palestinian women" discussed here are from the West Bank.

Friends in Ramallah found me a place to stay. I neither expected nor experienced difficulties that might have troubled some other

foreigners. My work in Israel, my reading, and my visits to Ramallah had made me sufficiently familiar with the Israeli occupation to have been able to lecture about it in the United States, so I had some idea of what I was walking into. I still had to learn the lesson surely shared by many other people that there's absolutely no adequate preparation for living in a war zone. I had a network of friends and professional acquaintances who would both keep me from being socially isolated and direct me to the people crucial for my work. My past visits to Ramallah, where I was forever getting lost and having to ask my way, had shown me that a lot of people living there could speak at least basic English (many members of the professional classes, of course, are fluent in it) and had convinced me that the Palestinians constituted no threat to my safety: there was no animosity toward a foreigner willing to visit, and by the time I arrived, the sense of community engendered by the intifada had virtually eliminated petty crime (a phenomenon that was to change later in 1989 as the economic situation worsened). I knew that while one can never be sure of avoiding spontaneous marches or demonstrations by stone-throwing Palestinians and the shooting with which the Israel Defense Force (IDF) reacts, one quickly becomes sufficiently street smart to know at what time of day demonstrations are likely to occur in what areas of what municipalities and to feel the tension in the streets that precedes most demonstrations by enough minutes so that one can move out of harm's way. As I kept trying to convince my dubious family, I really was safer in the West Bank than I was living in my apartment on the Upper West Side of Manhattan.

I knew before I went that the women in the committees believe in the desirability of a two-state solution, as do the four political parties (Fateh, the Democratic Front for the Liberation of Palestine, the Popular Front for the Liberation of Palestine, and the Communist party) and the PLO; if I met anyone in the West Bank, male or female, who feels otherwise, I was unaware of it. (The fundamentalists reject the two-state solution, but I was investigating members of the women's committees, women who participate actively in the intifada, and women concerned with gender equality. None of these characteristics apply to fundamentalist women, so I had no reason

to talk with them, nor am I sure that they would have been willing to speak with me.) The idea is accepted, with varying degrees of enthusiasm, not because most Palestinians want an Israeli state but because they regard it as a fact of life and their recognition of it as necessary to the attainment of their own state. The Likud party's platform of permanent local autonomy under Israeli sovereignty and the outdated notion of turning the West Bank over to Jordan— the "Jordanian solution," rejected even by Jordan from 1988 to 1991—are considered too unacceptable for serious discussion.

I didn't expect my Jewishness to be a problem, and it wasn't. I'd been so accepted by the politically conscious Palestinians I'd met, however, that I gave too little thought to what the reaction of other Palestinians could have been. I discovered the need to deal with that reaction on my first day in Ramallah. Much to my surprise, Marie, the woman in whose house I was to live, hadn't been told I was Jewish. She didn't realize that I wasn't Greek Orthodox, as she is, until, as she was giving me instructions about locking up, I asked whether a small wall light in the hall was meant to be left on. She smilingly explained that it was an eternal light under the image of the Virgin Mary and then asked curiously if I was Catholic. I unthinkingly replied that I was Jewish. She showed no particular reaction but later advised me not to mention that fact to others— some people, she explained, were "unenlightened." I realized I'd have to develop a strategy and, within a day, was fortunate to meet another Jewish-American woman, who was married to a Palestinian and living in Ramallah. Her advice was to do whatever felt comfortable in a particular situation, which I gradually discovered meant telling people I was Jewish if the question arose and not mentioning it if it didn't. I found that most people simply assumed I was some form of Christian and didn't inquire, but if they did, it was invariably after we had established some kind of conversational relationship; while some people were momentarily startled, no one appeared to be disturbed. Since I was distributing copies of the coalition newsletter, it's possible that more people were aware of my Jewishness than I realized. It just wasn't relevant. In what is both the very warm and the highly politically charged atmosphere in the West Bank, the important thing has become one's presence: a

foreigner living in Ramallah for a month can be presumed to believe in the right of Palestinians, as of all people, to govern themselves and so is welcomed.

A number of people who read early drafts of this book wanted me to include more of my own reactions. How, they asked, did I, a Jew, react to living among non-Jews who were resentful at the Israeli occupation, who regarded Israel as their enemy, and who were regarded as enemies by most Israelis? What was my reaction to all my experiences, and how was I changed by them?

The first question is easily answered. I have never felt responsible for the acts of Israelis or the Israeli government. I have never been an Israeli citizen; Israel has never asked me to vote in its elections; I do not feel that the Israeli government represents me, whether I agree with its policies or not; and, in fact, I frequently resent its claiming to speak in the name of world Jewry. I have angered Israeli friends who refer to ''the Jewish homeland'' by pointing out that I have a very nice homeland in the United States and that I have far more civil liberties there—the right to marry a non-Jew if I so choose, the right to apply to a domestic law court that is not run by clergy, the right to start a newspaper without first securing a government license, the right not to have religious holidays imposed on me through limitations on public transportation or on the foods that can be sold—than I would if I lived in Israel. I doubt that I feel more accountability for the Israeli government than Norwegian-Americans do for its Norwegian counterpart. I was constantly shocked by what I consider the perversions of Judaism that I heard being used to justify inhuman acts, but my knowledge of history has acquainted me with similar perversions of Christianity and Islam. I love some Israelis and like many more. I regret that the Israeli state came into existence by displacing Palestinians as I regret that the United States was based on violation of the rights of Native Americans, but I realize that the origins of many of the world's countries were not dissimilar and I accept both countries as a fact of life. My feelings about the Israeli treatment of Palestinians are similar to my feelings about the way the United States treated Vietnamese during its involvement in the war in Vietnam, which I vociferously opposed.

As to the impact of living under occupation: it was traumatic. Anyone raised in the twentieth century, in the shadow of the Holocaust, the Turkish slaughter of Armenians, the murder by the Soviet government of its own people whether through slow deaths in Siberia or faster deaths elsewhere, knows how brutal groups of human beings can be to each other. But intellectual knowledge and gut feelings are two different things. When I am in Israel, I live and laugh with people who are or have been members of what is a true citizens' army. When I am in the West Bank, where it is clear that the Israeli soldiers with their guns always at the ready cannot distinguish me from the Palestinians around me, the Israeli army is my enemy.

Some of my experiences put me in a sustained state of shock: seeing soldiers riding in jeeps with their submachine guns pointed out the sides; shopping or walking down the street while being watched by armed soldiers posted on rooftops; being stopped at checkpoints by soldiers who demanded my papers in voices filled with contempt; having sexual taunts shouted at me in the streets. I was also shocked to realize not only that the people whose homes I visited were in worse and more constant danger than I—after all, I had my American passport and eventually I'd go home—but that many of them had been beaten, or had their homes broken into and vandalized, or were imprisoned without a trial and in some cases tortured or shot, or were forced to watch the physical mistreatment of friends and relatives, or had been present at too many of their friends' and relatives' funerals, or were living with permanent injuries, or were simply made to bear repeated petty humiliations whenever they applied for papers or were stopped by soldiers for whatever reason. What was even worse was the knowledge that there was no recourse. Life and well-being are so tenuous in the West Bank that I made every effort to keep hidden the identity of the people with whom I lived so they would not be subjected to the kind of harassment frequently meted out to Palestinians who have hosted foreigners or Israelis; there is no way that I or my well-intentioned and concerned Israeli friends can protect them. I learned that in the West Bank, as under any military occupation, there is no law—not if law means established and publicized rules of behavior whose violation will lead to judicial procedures.

Palestinians have no one to whom they can complain about human rights abuses. There is an ongoing debate among both Israelis and Palestinians about whether some of the worst brutalities have been ordered or inflicted by soldiers in violation of their orders. Frankly, when one is living under occupation, it doesn't much matter. At the offices of the military government, complaints are usually met with incredulity and are ignored altogether. Raja Shehadeh and Jonathan Kuttab once tried to complain to the military authorities about soldiers they saw beating an elderly man in the stairwell of al-Haq. They were laughed at—and they are internationally known and well-connected attorneys. The constant violations of what are supposedly standing military orders have been well documented not only by al-Haq but by B'Tselem, the Israel Information Center for Human Rights in the Occupied Territories. While the accounts of both are noted by the international community, most Israelis and their government either do not know about them or shrug them off.

Occasionally, as I mention in my diary and the endnotes, a charge against a soldier is officially accepted and either a disciplinary hearing or a court-martial takes place. The number of such occurrences, according to both B'Tselem and Middle East Watch, is extremely low; only when a soldier does something so egregious that his colleagues, rather than Palestinians, lodge a protest is there any chance of his being held accountable. The sole exception to that informal rule occurs when the international media has indisputable evidence of a violation, as in ABC's videotape of a soldier shooting a Palestinian in the back or the photographs of soldiers exposing themselves on a rooftop lookout post that a member of Knesset gave to the international press.

In an odd way, I found the absence of law and redress the most shocking part of the occupation. I was violently upset by visits with the mothers of children killed during the intifada as well as by the sight of wounded occupation victims in the hospital. But it was my first visit to a military court that sent me home so white-faced that one of the neighbors admonished me, "You've got to try and be strong, like us." I was relieved a year later to talk about that experience with a Jewish-American woman working in East Jerusa-

lem who probably has seen and heard of far more horrors than I and to discover that her reaction had been similar. Apparently the sense of a secure existence that most Americans feel (at least white or economically comfortable Americans) is based, more than we recognize, on the rule of law and our belief that we have access to a system of justice. My professional life has been devoted in large part to making that system respond when rights are violated, and I have come to take it for granted that when rights are abused, recourse usually is available. To me, phrases like "due process" and "equal protection" are grounds for redress as well as abstract principles, and I found the absence of law in the occupied territories not only outrageous but terrifying. It is clear that a society that governs itself may not be just, but living under occupation reinforced my conviction that there will be little justice in a society that does not govern itself, and so my experiences reaffirmed my belief that self-determination is the bottom line of civil liberties.

There were times when I was frightened. In fact, looking back, I now realize that during my first month in Ramallah fear was a constant presence, a bit like a gnawing ache that one can ignore for hours but that is always there, ready to flare occasionally into undeniable pain. I was frightened when I was shot at, when I was teargassed, whenever a jeep brimming with hostile-looking soldiers and guns rolled past me on the street. I learned to look straight ahead and to appear as nonchalant as possible when soldiers were about, ignoring the thumps of my heart. Initially, if I saw a soldier walking in my direction, gun at the ready, I crossed the street. By my third month in Ramallah I was sleeping like a baby and brushing contemptuously past soldiers in my way. During my fourth month there, I was awakened at 2:00 A.M. by the repeated sound of gunshots, not usually heard in Ramallah at that hour. I reacted much as I do in Manhattan when, awakened by the sound of a fire engine, I assume that if my building is on fire there will be enough noise to reawaken me, and I go back to sleep. In Ramallah, I sleepily reasoned that if the IDF was going to shoot at my house I'd know about it soon enough, and I didn't awaken again until morning. Human beings adapt.

One of the most frightening experiences I had was the fault of no

one. It was the first time I left Ramallah in the morning and returned by myself in the afternoon, during strike hours, when all work had stopped. The morning streets were swirling with colors, merchants, shoppers, spices, noises. By the afternoon it was as if they had been transformed by a malevolent magician. The streets were empty. The stores were shuttered; all the people were gone. The car that had just dropped me off had disappeared. Nothing moved. The streets looked so different that I didn't know where I was or how to get home, and there was no one to ask. It was eerily quiet.

Suddenly, a few blocks away, an army vehicle zoomed down a cross street, its bullet-proof glass sides rattling, the crackle of its radio shockingly loud. For a moment I was paralyzed by fright at the surrealistic juxtaposition, in that otherwise deserted place, of the mellowed Mediterranean buildings and the space age military. The soldiers roared into the distance and I began to understand their fear. During strike hours, the Palestinians show the Israelis who really controls the streets. The people who buy and sell in the morning and disappear in the afternoon are committed to a goal for which they know they will suffer. Every time one of their number is wounded, humiliated, imprisoned, deported, or killed they all suffer, but they are like iron in their determination. I saw myself as pampered, effete, naive, untested by comparison. And yet when I finally found my way to the house where I was staying and, still trembling slightly, turned the key in the door, I felt that I was home, and it was as a member of the family that I was greeted. Palestinian society is intensely family-centered in ways that can be wonderful or stifling or anything in between, and I understood that to be accepted was to be made part of a family and I was quite grateful for the acceptance. But when I got home that day I said nothing about being afraid. I had been shown the bullets that landed in our bathroom months before when soldiers apparently had decided to use it for target practice. The holes they made in the window were still there. I had just visited a mother whose only son was permanently paralyzed by the soldiers who had beaten him before her eyes and a father who would never again be certain of his manhood because he had not been able to stop the beating. I had no right to complain of my fear.

In addition to experiencing occupation, which I certainly had not expected to be pleasant even if I had not appreciated its full horror, I discovered two unanticipated problems. The first was the reaction to my being an American. All the Palestinians I met knew the amount of aid given to Israel by the United States and were certain that without it the occupation would not be possible. Some Palestinians understand the workings of the American political system. Many others do not, and I was constantly being asked why we Americans were permitting the use of our money for occupation and why I didn't talk to President Bush about it. I had to keep reminding myself that today's Palestinians have never enjoyed self-government: they were ruled first by the Turks, then the British, then the Jordanians (or the Egyptians in Gaza), and now the Israelis. Although they very much want democracy, they know it in theory rather than practice. But I began to feel under siege when I returned in July 1990. The massacre of eight Palestinian workers by an allegedly crazed Israeli had occurred little more than a month earlier, and so had the subsequent United States veto of a UN Security Council resolution that would have sent to the territories a three-person mission to investigate violations of Palestinian human rights. The reaction of the Palestinian leadership had been to call for a boycott of American products as well as of all meetings with American officials, along with a tightening of the Arab boycott of international companies doing business with Israel. Anti-Americanism increased dramatically, as it did again in 1991, after the Gulf war and the refusal of the U.S. government to treat the Israeli occupation of the territories as it had the Iraqi invasion of Kuwait. I was so angrily harangued by sophisticated Palestinians as well as others that, to complete some of the interviews I needed, I had to keep reminding myself that I was an outlet for legitimate and generalized feelings rather than a personal object of hatred. Every once in a while either the person speaking became so excited or I became so exasperated that I would interject, "Will you please try to remember that I'm not the one doing this to you?" Occasionally I just wondered why I'd left home.

The second problem had to do with the nature of what was for me a new kind of scholarship, involving interaction with the people

being studied. I was in the West Bank as an observer: a scholar, a researcher. But I was invited precisely because I am a human rights activist especially interested in women's rights. I understood that that role was bound to color my observations. My sympathy for the Palestinian independence movement as such would preclude my attempting to do scholarly work about it because, while I reject the notion that social science can ever be entirely value-free, I recognize that scholarship is impossible unless one attempts a degree of objectivity that I doubt I would be able to attain on the subject. But my concern for the equality of women didn't strike me as an impediment to what I was trying to do: study the women's committees, document the role of women in the intifada, and assess the impact on the status of women that both the committees and the women in the intifada have had and are likely to have in the future.

At the same time, I understood that the dividing line between researcher and participant is so thin as to be nonexistent. One alters an event by being present to record it—a phenomenon that Elizabeth and Robert Fernea, who have done extensive research in the Arab world, call "participant observation." My forays into the villages and camps were a signal to the committees arranging my visits, my guides, and the women whom I interviewed that a foreign scholar considered their status as women to be an important concern and that she believed other foreigners would be equally interested. The method of interviewing I found myself adopting was to devote the first, and longest, part of each interview to extracting a maximum amount of information with a minimum of questions. Then I asked for elaboration or details I thought I might have missed. Finally, I found myself pushing on some issues, as when I spent the final moments of group interviews asking women why they considered it appropriate for their husbands to do no household chores, or a minimum of them, when they themselves expected and hoped to fill one job at home and another in the paid economy. A number inquired about how things are organized in my home, once they shed the idea that it is packed with servants. The act of listening to my description of my own life and of the manner in which I've sought to apportion roles in the home without regard to gender altered them from women without such information to

women with it, even if my account in no way changed their opinion. Wherever I went I raised the issue of what I think of as the "two-job trap": the entry of women into the paid work force, with all its demands on time and energy (as well as the income and possible personal satisfaction), coupled with a lack of redefinition of gender roles that would free women from sole responsibility for the full-time work at home as child care worker, maid, cook, laundress, nurse, and so on. Now the Palestinian women with whom I spoke can identify and articulate the problem in a way that they were perhaps unable to do before.

If I didn't care about improving the status of women, I wouldn't have been doing research about it, which alone implied that I could not play a neutral role. I wrestled with that awareness as well as with the knowledge that I wanted the status of Palestinian women to change, meaning that I consider one kind of status good and another bad. I thought that a general belief in the dignity of all individuals and their right to exercise the maximum control possible over their lives would be sufficient to overcome my cultural predispositions, but I could scarcely be certain. (Randa Siniora, the head of the women's project at al-Haq, unwittingly tested me by talking about polygamy in Tunisia. Its abolition, she pointed out, could have initially negative as well as positive effects on the status of women: if a husband attracted to another woman could not marry her without divorcing his first wife, especially in a society that war and other phenomena had left with an uneven number of potential husbands and wives, the wife might well find herself divorced and impoverished. Western-style monogamy might be viewed as too intense by some women, who might welcome the combination of economic security provided by marriage and the absence of a need for them to fulfill all roles for their husband. My solution would be the availability of independent economic resources for women—but might that solution be rejected by some women, especially as it entails the assumption of economic responsibility and the juggling of paid work and family in a world that is frequently inhospitable both to the combination and to workers generally?) Eventually I reached the conclusions already arrived at by so many anthropologists: that the mere act of doing research

alters the entity being researched; that the unattainability of objectivity has to be recognized; and that one can come as close as possible to responsible scholarship by both accepting and articulating one's values and unavoidable involvement in the research project.

Not only could I not alter or overcome my being both a scholar and an activist; in fact, the dual role made the research all the more interesting. Al-Haq asked me to give a lecture on women in other national liberation movements and what had happened to them once their country's independence was attained. The lecture was attended by leaders of the four Palestinian women's committees and many women called "independent," not allied with committees or political parties. Although I declined to speak about Palestine during the lecture, anyone familiar with the subject knows that the only tale I had to tell was of women fighting for independence and later being denied equality by the political system for which they had fought. Obviously, people were drawing their own conclusions about the implications for Palestinian women. On the last day of my first stay in Ramallah, I had a smaller meeting with leaders of all four women's committees. This was generated by Randa's desire to let the women hear my reactions to what I'd found "out in the field." I told her I'd be glad to give them my observations but that, while I might possess the interestingly different view of the outsider, they knew more about what was happening in the West Bank than I did. So the session became one of brainstorming about where the women's movement ought to go next. It was only when I returned the following January that I was told by one leader that the session was the first that the four committees had ever had in which they talked freely together about the direction of the movement. They had been so divided by their varied political proclivities, their differences about the wisdom of introducing a potentially divisive women's agenda into a national liberation movement, and, perhaps, their sense of turf that it was, I think, only the fear that the others would influence me in some way that brought all of them together. Some of the possible techniques we discussed for introducing elements of the women's agenda had indeed been put into

place a year later. Would that have happened anyway? There's no way to tell.

The Intifada

It is impossible to understand the changing roles and status of Palestinian women without an understanding of the social and political phenomenon that has determined the course of everyday life for the past four years. The popular movement known as the intifada began in Gaza on December 9, 1987. The many reasons for its inception are covered so adequately elsewhere that I can quickly summarize them here. Among the immediate causes were the early December 1987 Reagan-Gorbachev summit meeting, which ignored the Palestinian question, and the November 1987 meeting of heads of Arab states, which similarly bypassed the conflict to focus on the war between Iran and Iraq. The absence of concern by the superpowers and the Arab nations about the Palestinians living in an increasingly difficult situation in the occupied territories led many of them to believe they could rely only on themselves for a remedy. Other contributing factors included the heightening tension as the Israel Defense Force under Defense Minister Yitzhak Rabin maintained the Iron Fist policy that had been introduced in 1985 and violent incidents became more frequent; the success of a hang-glider pilot in infiltrating Israeli defenses from Lebanon and attacking a military base in the north; the murder of a Tel Aviv salesman in the main square of Gaza and, a day later, the collision between a swerving Israeli army truck and Palestinian cars waiting at the checkpoint between Israel and Gaza, the latter resulting in four deaths and the belief by Palestinians that the truck driver's action was taken in retaliation for the murder; and the decision of the IDF to increase the number of daily patrols by the Border Police (the most feared and hated of the occupation forces) in the Balata refugee camp, which was seen by residents as the beginning of a crackdown. The intifada spread to the West Bank within days, both because the underlying problems caused by the occupation are similar in the two areas and because the West Bankers became

outraged at the violence inflicted on the Gazans as the IDF reacted
to the first days of the uprising.

Intifada actually does not mean "uprising" in Arabic but rather a
"shaking off," and this is what the intifada is about. It is a shaking
off of all things Israeli: political control, ideas, economic domi-
nance. The Palestinians insist that, while the presence and the
actions of the occupiers may alter the rhythm of their lives, it is the
intifada and not the occupation that will define the way Palestini-
ans live. Palestinians will work when they choose to, close their
shops when they choose to, enjoy their families and the normal
interactions of life when they choose to, and tenaciously refuse to
permit the occupation to establish their mood.

One of the first elements of the intifada apparent to an outsider
is strikes—strike days and strike hours. During the early months of
the intifada, as a tug-of-war for control of daily life took place
between the Israelis and the Palestinians, spontaneous commer-
cial protest strikes erupted. The Israeli government ordered its
troops to keep the stores open, forcing the locks with crowbars and
threatening to close permanently any stores that would not open as
demanded. The occupied territories' hastily organized Unified Na-
tional Leadership of the Uprising (UNLU) decreed specific limited
hours (9:00 A.M. to noon in most places, including Jerusalem and
Ramallah) to demonstrate the control by Palestinians of their
community. The government finally gave up. Movie houses and
restaurants also came under the self-imposed limitations, so all
theaters and restaurants with the exception of a few coffee shops
were closed. Shopping is now telescoped into a few morning
hours—the hours in Ramallah had de facto been extended to 8:00
to noon in July 1989 and had formally been set at 9:00 to 1:00 by the
time of my third stay in July 1990—except on full strike days, when
only pharmacies and bakeries open, there is no public transporta-
tion except for emergencies, private travel is forbidden, and any car
ignoring the ban is at risk of being stoned. Spontaneous local
strikes still occur in reaction to political events such as deporta-
tions, mass arrests, or deaths caused by the IDF or Jewish settlers.

The rhythm of life reflects strikes. Streets in the shopping dis-
tricts are crowded during the morning hours and eerily empty in the

afternoon, the doors to stores and offices locked. There is at least one strike day a week and frequently as many as three, so one must plan food shopping, appointments, and visits to family and friends in other locations with those days in mind. Most strike days are announced in the *bayanat* (leaflets) written by the UNLU and clandestinely left, usually at night, on windshields, under shop doors, or wherever else people are likely to find them easily. The French-owned Monte Carlo radio that broadcasts from Egypt announces strike days as soon as it receives word of them, and the Arabic newspapers list them. Some strikes are hastily called, however, as may happen after a particularly brutal IDF raid on a village, and between such strike days and IDF-imposed curfews one can never be certain whether a day's activities will go as planned.

The first stage of the intifada, roughly from December 1987 to February 1988, consisted primarily of mass demonstrations—direct confrontations with the occupiers, mainly rock throwing at the IDF, tire burning, and creation of barricades—followed by an armed response by the IDF. The negative worldwide reaction to the shooting of people armed only with rocks led Israeli Defense Minister Yitzhak Rabin to call for a policy of "beatings, might, force" that he hoped would minimize the number of deaths but that would frighten the population and put the rock throwers out of commission for some time. Around March 1988 a second stage began in which mass demonstrations continued, with greater concentration on consolidation and extension of the popular committees and a boycott of Israeli goods. Demonstrations and the boycott continued during the third stage, that of diplomatic initiatives, which began in November 1988 with the formal recognition of Israel by the Palestine National Council and its adoption of a Declaration of Independence. As this is written, a fourth stage, its ultimate configurations as yet unknown, has begun. It is the result of the invasion of Kuwait by Iraq in August 1990 and the war that followed in January and February 1991; the PLO's support for Iraq; the devastation of the Palestinian economy during and following the war; the shift in world attention away from that part of the Middle East once the war ended; the postwar reexamination and condemnation by Palestinian leaders of some of the aspects of the intifada, such as

killings by masked youths of alleged collaborators with Israel; and
the onset of U.S.-engendered peace talks among Israel, the Arab
nations, and the Palestinians.

The Israeli reaction to the phenomena introduced during the first
two stages also is discussed extensively elsewhere. At the end of
May 1991, the Palestine Human Rights Information Center counted
956 Palestinians killed during the intifada and an estimated
113,468 injured. The figures issued by B'Tselem for that period,
which included the last month I spent in the West Bank, were 768
IDF-caused deaths. Among them were those of 163 children as well
as of 86 additional people, including 30 infants, probably killed by
exposure to teargas and 35 apparently killed by Israeli civilians. The
IDF's judge-advocate general stated in February 1991 that 75,000
had been arrested, with 14,000 of those arrested having been put
under administrative detention. The latter is a procedure that
involves no formal charges, no trial, and incarceration for an infi-
nitely renewable sentence of up to twelve months (extended from a
maximum of six months in August 1989), usually in a tent prison
created for the purpose in Israel's Negev desert. This is a violation
of the Fourth Geneva Convention, which permits administrative
detention "only if the security of the Detaining Power makes it
absolutely necessary" and forbids transfers of people under occu-
pation from their territory to that of the occupying country. Condi-
tions at the prison, referred to as Ketziot or Ansar 3, have been
strongly criticized by groups such as the Association for Civil Rights
in Israel, the New York–based Lawyers Committee for Human
Rights, and al-Haq: poor food, insufficient water, overcrowding, lack
of medical care, no access by detainees to their relatives, and only
sporadic access to a lawyer. Administrative detention had begun to
be used systematically by Israel in 1985, with 164 people (147 of
them from the West Bank) jailed in 1987. They were primarily trade
unionists, university student activists, mobile health workers, and
other volunteer activists. During the intifada, administrative deten-
tion has been used not only against leaders but against members of
popular committees and others whose suspected involvement goes
beyond mere participation in demonstrations. The Israeli High
Court has upheld the government's authority both to detain people

administratively and to deport the 66 people who have been summarily exiled since December 1987. People arrested and not put under administrative detention have been held for a few days, usually interrogated, and either let go or tried in military court.

Other techniques used by Israel in addition to force have been curfews (9,867 full days of curfew as of May 1, 1991, counting each curfew day per municipality, but not including the 45-day blanket curfew imposed during the Gulf war); cutting off of a community's water supplies; collection of highly inflated tax assessments; limitations on bringing money into the territories; a one-year elimination of all international telephone links; demolition and sealing of the homes of families of those suspected of participation in the intifada (1,891 demolitions and sealings, displacing 10,500 people); outlawing of popular organizations; uprooting of olive and fruit trees (105,123) and prevention of harvesting and sale of agricultural goods; issuance of new identity cards to prevent certain categories of Palestinians from leaving their immediate area of residence or traveling into Israel; and imposition of a variety of licensing requirements.

The intifada inevitably affected the movement begun by the women's committees in 1978, for it has altered the activities and lives of women as much as those of Palestinian men and children. A cross section of the population has been involved from the start, albeit with differing levels of commitment: people of all ages, from toddlers to the elderly; Christians and Moslems; residents of cities, villages, and refugee camps; professionals, well-to-do merchants, shopkeepers, members of the working class; students and housewives; adherents to all the political parties and factions. In that sense, the intifada has created one community where previously there were many. The key question, of course, and the major one addressed by this book, is the extent to which these changes will outlive the intifada and result in a lasting transformation of the status of Palestinian women. To understand the impact of the committees and appreciate the distance Palestinian women have come during the last two decades and the alterations in their lives that have been made by the movement and the intifada, it is necessary to understand something of their highly protected role

and inferior status in traditional society, which is the subject of Chapter 1.

I must make two caveats before beginning that chapter. One is that my research focused on the reactions of women and so I include very little, except tangentially, about Palestinian men. What they think about the status and roles of women is of course of great importance. On the same theory that led me to believe that, at least in the area of gender relations, a woman would be better able to elicit information from women, I felt myself unlikely to be able to get direct answers from most men. And, indeed, given the Palestinian culture, I do not know to what extent I would have been able to engage in real discussions on the subject with non-elite and perhaps even more sophisticated elite men.

The second is that while I made a point of speaking with as many village and refugee camp women as possible, circumstances dictated that most of my conversations were with elite women and were concentrated in the central Ramallah-Jerusalem-Bethlehem region. Among the contributing factors was my lack of Arabic and consequent need of an English-speaking (usually an elite) woman to accompany me—a role that the women were generously willing but frequently unable to fill, given the demands on their time. As businesses and stores are open only during the mornings, for example, even women who are not currently studying at a university or working and who are free to act as guides must use those hours for shopping. School closures meant that many women had to be at home taking care of their children. The enormous amount of time spent in bureaucratic offices to secure vital papers meant that women's afternoons were also busy (the Israeli bureaucracy of course does not observe strike hours).

Then I faced the problem of transportation. Public transportation to villages and refugee camps and within cities is less than good. I had no car, most West Bank women do not drive, and in any event most family cars were being used by the family wage earner. Even had I been able to borrow or rent a car and take another woman with me, the committees insisted that IDF patrols made it unsafe for two women to drive without a man accompanying them, at least outside the cities. My guides and I were thus dependent on unsatis-

factory public transportation or the availability of men willing to act as chauffeurs. Although I did visit and write about camps and villages as well as the Nablus and Hebron areas, most of the camps and villages mentioned here are along the Jerusalem-Ramallah-Bethlehem axis and most of my conversations were with the more accessible urban elite women rather than their rural counterparts.

1

West Bank Women

"My woman never left our home until the day she was carried out."

Palestinians are Arabs; a majority of them are also Moslems. All are affected by the restricted view of the role of women that prevails in the Middle East and—as Palestinian women are quick to point out—throughout much of the Mediterranean region. For generations, Islamic and Arabic tradition adhered to an ideal of woman as a completely private creature, secluded in her home, hidden behind a veil—or, in the twentieth century, behind a scarf covering her head and forehead. The walls and the long loose clothing that concealed her body "protected" the Arabic woman—and the Arabic man—from her sexuality, for Islam, like other major world religions, traditionally has viewed women's sexuality as highly problematic. How, then, with the private and secondary status of women constituting a critical Palestinian value, was the society altered sufficiently to produce a nucleus of women active in the public sphere?

Some of the answers can be found in the side effects of the 1947–1948 war during which the state of Israel was proclaimed and a generation of Palestinians became refugees. Other major factors, such as the decline of agriculture, the increase in college-educated women, and the greater involvement of women in the national liberation movement, followed the Israeli takeover of the West Bank in 1967. All are links in a causal chain that resulted in 1978 in the emergence of a women's nationalist movement, and, more recently, a feminist movement. The changes have been evolutionary, but the result is revolutionary. It was nonetheless a long road to

the emergence of the women's committees that are at the heart of the current women's movement.

Islam considers women's sexuality a problem but does not condemn the sexuality of men. Instead, it approves male satisfaction so that sexual desire will not disrupt the harmonious functioning of society. This is one reason a man is permitted to have four wives. Women's sexuality, however, is regarded as voracious, never-ending, insatiable, and potentially socially disruptive. The Arabic word *fitna* is used to refer to a beautiful woman; it also means "social chaos," suggesting that women's potent seductiveness can easily lead men astray. Women are assumed to be incapable of self-discipline, and thus the proper functioning of society is dependent on their being confined to spaces controllable by the men of their families. The Egyptian feminist Nawal El-Saadawi quotes what she reports to be a saying common among Palestinians until the mid-twentieth century: "My woman never left our home until the day she was carried out." The genders did not normally mix outside the home. In many villages until fairly recently, men, accompanied by their male children, did much of the purchasing of goods for the home, including food. Women in larger towns may have shopped, but only when accompanied by other female relatives. It was men who went into the paid work force, men who mingled in cafés and played backgammon after work, men who socialized outside the home.

There is a divergence in every society between the ideal and reality. The ideal of the perfect woman tends to be generated and implemented in most societies within the upper or upper middle class. It is accepted as an ideal by other classes but such forces as economic necessity may prevent it from being practiced. The Arab and Moslem ideals of female seclusion and female economic powerlessness have followed this pattern. Rural women, for example, frequently had to work in the fields, particularly during October and November, when entire families harvest the olive crop. While some jobs were gender-specific, with women fetching water and men herding flocks, others, such as picking olives, were done by men and women together. There is evidence that women in the Nablus area bought and sold small quantities of agricultural prod-

ucts but that larger amounts were the province of men. Some poor women may even have worked for other families as paid harvesters. Field work does not lend itself to the wearing of a veil. In many instances, the adoption of a veil was a middle-class symbol: a signal that a man had amassed sufficient wealth for his wife no longer to have to work in the fields. One study indicates that the only time peasant women wore face veils early in the twentieth century was when they were buried. Far more common than female seclusion and segregation, attained primarily by the wealthier members of society, were noneconomic segregation—the separation of women from men socially—and the sexual division of labor. Women frequently participated in "men's work"; Palestinian men, like those everywhere else, normally played no role in the "women's work" of childrearing, cooking, and housekeeping. Men controlled money no matter who earned it and were viewed as the primary breadwinners.

Palestinian women of all classes have been expected to be chaste, and men's honor has depended on their being kept that way. An unchaste married woman dishonors her parents' family even more than she does her husband's, for it is assumed that she has been improperly raised. Her original family's continued responsibility for her behavior is emphasized by her keeping its name even after she marries. Leila Mahmoud Jazar, wife of Mustafa Fahmi Hanani, is the daughter of Abdallah Khaled Jazar. A family seeking a wife for one of its sons will look closely at a woman's mother: if the mother's reputation is not respectable, her daughter will be rejected.

Palestinian society is almost overwhelmingly family-oriented. One leading scholar has noted, "If the Koran is the soul of Islam, then perhaps the institution of the Muslim family might be described as its body." Another describes the Arab family as "the socioeconomic unit of production at the center of Arab social organization and socioeconomic activities." Each marriage involves uniting two extended families as well as two people. Even in today's urban areas, where the pattern of a multigenerational family living together and functioning as the basic work unit is breaking down, it is common for most leisure time to be spent in visits with family members, and it is still the extended family to

whom a person turns in any emergency. These practices make it logical for families to arrange marriages, as they have done for centuries. The most desirable match is between a woman and the son of her father's brother, for it reinforces family ties, keeps land in the family, assures minimal friction between in-laws, and usually entails a lower bride-price (*mahr*) than a nonrelative would receive. Marriage formally transfers the responsibility of protection of a woman from her father to her husband. In a traditional marriage, the couple have not met in advance. The bride is irrelevant to the marriage contract, which is signed without her presence or participation. The *mahr* is more than compensation to her family for the loss of her labor. Should she be divorced, the *mahr* becomes her only means of support, although a divorced woman usually returns in disgrace to the home of her father.

In spite of these attitudes and practices toward women and their roles, nationalism enabled a few to be involved in the public world of politics at least as early as the beginning of the twentieth century. Some are reported to have demonstrated alongside men against the first Jewish settlement near 'Afulah in 1884 and in opposition to the 1917 Balfour Declaration. By 1903, small groups organized by women were doing charitable work, holding their meetings in homes, schoolrooms, and churches. In 1921, the Palestinian Women's Union was organized in Jerusalem as a mechanism for female participation in the demonstrations supporting the Palestinian national movement. But even though its goal was nationalistic, its organization of women for a public role was seen as too radical, and social and political pressures caused it to disintegrate within two years. In 1929, following an anti-Zionist uprising that had been suppressed by the British, the first Arab Women's Congress of Palestine was organized to protest the force used in putting down the uprising and the continuing British support for a Jewish homeland in Palestine first expressed in the 1917 Balfour Declaration. The leaders of the Women's Congress included Moslems Zlikha a-Shahabi and Hind al-Husseini and Christian Milia Sakakini. About two to three hundred women attended, traveling to Jerusalem and chanting anti-British slogans in the streets. A fourteen-member delegation presented a protest to

the British high commissioner. These were extraordinary acts for Arab women, and they were undertaken primarily by the wives and relatives of political leaders or by wealthy women, who were more able than other women to flout tradition. The congress nonetheless had to be confined to women, for it would have been unthinkable for even elite women to participate in an activity with men. The event is noteworthy as an indication that at least some women wanted to play a political role and that they presumably were able to receive permission from their male relatives to do so.

The early organizations had no specific women's or feminist agenda. The Palestinian women's movement always has been inextricably intertwined with the Palestinian liberation movement, which until recently determined the women's agenda, simultaneously nurturing and hindering the drive for gender equality. The work of the Arab Women's Congress in the 1920s and 1930s appears to have been coordinated with if not dictated by the larger male-dominated movement, with its charter specifically stating that its purpose was to help the men in the movement. Women's groups from the late 1920s through 1947 concentrated on playing a backup role for male revolutionaries, providing them with first aid, sending protest telegrams to the British mandate authorities, distributing leaflets, demonstrating, raising money for health care and blankets for families of detainees, helping pay fines of people convicted of "crimes" in support of the nationalist cause, and aiding in replanting land stripped by the British. These displays of charity were seen not as individual acts but as patriotic statements, so the women engaged in them brought honor to their families. They took their cues from men, and yet they had found a way of performing respectable, noteworthy deeds other than remaining virtuous in the seclusion of their homes. The women's groups identified promising female students in villages that had girls' schools and paid to complete their education. Higher education for young women, however, was not meant for personal advancement but rather for enhancing the family environment they would create after marriage.

Women in rural areas played an important role in the 1936 uprising, primarily by smuggling food to the men fighting the

British. One woman recalled that she had hidden fighters in her house, cared for the horses they stole from the British, and taken provisions to her guerrilla husband, who hid for days at a time in caves. She described women in her town, however, as sounding the traditional ululation (trill) to encourage their men when the British attacked, implying that the women were bystanders. A few Palestinian women were in the final fight against the establishment of the state of Israel, a fight that began in 1947 and intensified in 1948, when the British withdrew from Palestine and the Israelis declared the creation of a state. One woman picked up her son's weapons after he and her husband were killed and continued fighting until she too was slain. Another, a schoolteacher, died while giving first aid to victims of the massacre in the village of Deir Yassin, when residents were attacked by the extremist Jewish terrorist organizations Irgun Zvaí Leumi and Lehi. But these were isolated acts in a culture that defined women's place as the home. One writer even views the flood of refugees during the 1947–1948 period as prompted in part by a fear that Israeli soldiers would dishonor Arab families by molesting their women.

Whether the Palestinians were forced from their homes, left voluntarily during the fighting in the expectation that they would return, or simply fled in fear is still a matter of contention among historians. Whatever the reasons, the result was a massive dislocation of the Palestinian Arab population and the transformation of many into refugees living in hastily constructed camps in the Jordanian-controlled West Bank and the Egyptian-ruled Gaza Strip. The overwhelming majority had few material resources. West Bank women responded by creating charitable organizations. Six societies were started within the camps by refugees; most, however, were organized by West Bank residents outside the camps. The societies sponsored training centers for women nurses, establishing nursing as an acceptable profession for women; set up first aid stations, literacy programs, and committees for the preservation of culture and heritage; amassed and distributed clothing that they had washed and mended; ran soup kitchens; and collected money and whatever commodities they could.

Once the refugees realized that they would be in the camps

longer than they had expected, they focused on earning a living. Large numbers of the men sought work wherever it could be found, particularly in the Gulf states, leaving behind a population made up largely of women and children. Although the absence of men reinforced the importance of women in the home, there was no change in the traditional values of female chastity, male honor, respect for one's elders, and sacrificing one's comfort for that of others. Refugee families tended to arrange marriages for their children with other refugee children because of their shared experiences, the reluctance of nonrefugees to marry their daughters to landless refugees, and the tendency to marry within the extended family. Contact between refugee women and members of the urban middle-class women's relief committees had no perceptible impact on values or gender stereotypes. One phenomenon did change, however. Money from men working far away from home was never certain. As a result, educating girls became a high priority, for without education refugee women could get jobs only as domestics, serving and sewing.

The women in the camps did what little they could to keep their families alive, particularly if their men were unable to find any or sufficient employment or sought work far away. In addition to lack of income, refugee women suffered from limited access to health care, including prenatal information; illiteracy; large numbers of children; and lack of both marketable skills and any knowledge about the few legal rights they possessed. They might receive temporary aid from the women's groups, but those groups treated them as objects rather than subjects and did not attempt to address the underlying causes of their plight. Women in rural areas, whose families had more land but not necessarily more income than the refugees, were, like the refugee women, too concerned with the mechanics of survival to worry about abstract concepts of culture and heritage.

The United Nations Relief and Works Administration (UNRWA), a major source of health and educational services and basic food rations today, came into existence in 1950, eliminating much of the gaping vacuum that had been partly filled by the women's organizations during the 1947–1950 period. In 1951, Jordan established the

Ministry for Social Affairs, which, with voluntary relief agencies, began to provide basic social services. The women's charitable societies then turned their entire attention to relief programs, feeding children, distributing food and money to the poor, and caring for the sick.

Thirty-eight societies were listed in the register of the Jordanian General Union of Charitable Societies in 1980, among them Ri'ayat al-Tifl Society (Society for the Care of Children), established in Ramallah in 1945; the Jordanian Red Crescent Society in Tulkarem (1947); Rawdat al-Zuhur Society (Kindergarten of Flowers) in Jerusalem (1952); the Arab Women's Union of Tulkarem (1953); the Society for the Care of Children and the Guidance of Mothers (Nablus, 1954). The names of some of the societies (such as Hamilat-al-Tib, the Greek Orthodox Society for the Relief of the Miserable Sick) reflect the involvement of Christians as well as Moslems.

Most registered societies were founded in cities or towns in the central area of the West Bank (Jerusalem, Ramallah, Bethlehem) and were dominated by women from the urban upper middle class, many connected by kinship or marriage to male political leaders. They had very little in common with most West Bank women. Seventy percent of the population was rural and most was not upper middle class. The large majority of women, unlike the leadership of the women's groups, had neither time nor freedom to appear in public or participate in organizations.

The elite women's groups, emphasizing the charitable functions that are extensions of the traditional female functions in the home, played the unthreatening role of ladies bountiful bringing benefits to unfamiliar lives. No one seems to have realized that, by drawing both elite and refugee women out of their homes, the societies were quietly and unwittingly challenging the reality of women as entirely private, economically dependent creatures. In addition, many of the wealthier, urban families, particularly among Christians but including some Moslems, educated their daughters.

Two organizations put unusual emphasis on self-empowerment. One was the Arab Women's Union of Bethlehem. Almost as soon as the 1967 war ended, the union understood the need for change and

the potential role of the existing organizations as a unifying force. It therefore called a meeting of all the charitable societies in Bethlehem to urge an alteration of their mission from charity to *samed* (steadfastness): maintaining a Palestinian identity and opposing the Israeli occupation by peaceful means. A small silver factory that trained and employed local workers resulted. The business carefully avoided conflict with Israelis by producing noncompetitive products and by contracting to sell them in local souvenir shops rather than within Israel. Its small profits were distributed to young men and women as long-term educational loans. The union remained upper class, however, limiting its expensive membership and offering such elite features as a family club with access to a swimming pool. The second organization, In'ash al-Usra, is described in Chapter 2.

Many of the traditional values were codified in law. At the same time that Israel claimed sovereignty over much of Palestine in 1948, Jordan annexed the West Bank, which became subject to Jordanian law. The Jordanian Law of Personal Status still governs formal personal relationships in the West Bank. It permits a woman to specify in her marriage contract that she has a right to work, that her husband cannot force her to leave her village, that he cannot take another wife, and that she as well as he can initiate divorce proceedings. But most West Bank marriage contracts have not included such clauses because of male reluctance. The husband is charged with the traditional Islamic obligation to support his wife and she is charged with the duty of *ta'a*, or obedience, toward him. Thus the husband has no responsibility toward a wife who works without his consent, and he retains his absolute right to divorce.

Some Palestinian families have accepted more gender equality, many of them, not surprisingly, in cities like Ramallah, where the urban, disproportionately Christian, educated, and relatively affluent elite permitted its daughters to meet suitors with the option of rejecting them. Some families allowed their daughters to learn and practice professions, particularly teaching. But this was not the norm.

The national liberation struggle continued to involve some West Bank women. In 1964, the newly founded Palestinian Women's

Association sent delegates to the first Palestinian National Congress (PNC) in East Jerusalem, which in turn organized the Palestine Liberation Organization (PLO). The use of women's groups as a mobilizing force was again apparent in 1965, when the General Union of Palestinian Women was set up as the women's branch of the PLO outside Palestine. During the same year the first Palestinian Women's Association conference was held in the West Bank.

No change from traditional roles was immediately apparent. Men decided which women and how many would attend the Palestinian National Congress, choosing few and confining them to unimportant roles. It was not until 1989 that a woman was elected to the ten-member central committee of Fateh, the major constituent group of the PLO, and even then the appointment was the result of her status as the widow of Abu Jihad, a Fateh leader who had been assassinated by Israel, rather than her considerable abilities.

In 1967, Israel shocked most Palestinians by capturing the West Bank, including East Jerusalem, and the Gaza Strip. Israeli policies confiscating Palestinian land, restricting the Palestinians' access to water, and minimizing agricultural competition by limiting the kinds of foods Palestinians were permitted to grow gradually resulted in the abandonment of large-scale cultivation, the decline of farming, and women's entry into the work force. While most West Bankers were farmers, a disproportionate amount of the land had been owned by large families friendly to the Hashemite regime in Jordan. By the mid-1960s, these families, believing that a Palestinian state with a developed economy might be in their interest, began to move from agriculture into trade and small-scale manufacturing. Israeli land policies after 1967 encouraged less-wealthy rural Palestinians to give up farming as well. Instead, they became workers in Israel. Israelis were unwilling to employ Palestinians in white-collar positions; the jobs available to the Palestinians were ill paid or socially undesirable by Israeli standards, but they were still more profitable than most available in the territories. So Palestinians became unskilled agricultural and construction workers, waiters, dishwashers, and handymen. Between 1967 and 1987 only about 20 percent of West Bank high school and university graduates could find jobs in their fields. Others either became

blue-collar workers or emigrated. The result was a shortage of agricultural workers in the occupied territories. Loss of family farms through state confiscation led to further migration of men and to the increased need for women to enter the paid work force. A 1984 United Nations report estimated the percentage of West Bank women in the paid work force as 8.4 percent in 1968 and 24.8 percent in 1980. The percentage undoubtedly is higher now.

Most revolutionary leaders have been well educated, but few West Bank women have had access to higher education. University education abroad was an option during the 1948–1967 period for Palestinian men whose families could afford it, as well as for some elite women. Family ties brought most men home after receiving their degrees, although returning was not always economically feasible. After 1967, Israel required residents of the territories to obtain permission to leave and to return and set minimum and maximum time limitations. These policies made it difficult for young men to pursue university education abroad or to do so with any assurance of being able to return home when they graduated. Relatively junior institutions of higher education, such as teachers' colleges, consequently were transformed by Palestinians during the mid- and late 1970s into nine full-fledged community colleges, senior colleges, and universities. The result was that young women whose parents would not have considered sending them abroad could now receive a college education close to home. Women began entering universities in substantial numbers, growing to constitute an estimated 35–55 percent of the students at the Palestinian institutions in the early 1980s. They moved into student organizations and women's groups, creating such new entities as the Birzeit University Young Women's Youth Organization. Most of the universities enabled students to earn money by doing jobs on campus, a revolutionary experience for many of the women. Among available jobs were some in the women's dormitories, which the women organized and ran themselves.

Birzeit, the oldest and best university in the occupied territories, had been attended primarily by children of the wealthy. In the 1980s it became much less elitist, accepting students with high grades from all over the occupied territories, including Gaza, and making

their attendance possible by keeping fees low. Its student body grew intensely political, frequently challenging the IDF. Students became used to sleeping on campus after demonstrations, while the university administration or the Red Cross tried to negotiate so that the IDF would not arrest the demonstrators.

Male students saw women participating equally in demonstrations and doing well in courses. Initially the men teased them about getting high grades from male professors, but the teasing ended as men realized that female students were earning equally good grades in courses taught by women professors. Some activist women students recall sociology classes particularly vividly because gender roles frequently would be discussed, although no activist I interviewed could remember reading feminist works at the university.

Men nonetheless remained dominant on the campuses. Only once, for example, was there more than one woman on the nine-person Birzeit student council. But before the intifada about 50 percent of women university students were involved with women's committees as well as other student groups. The key impact of their classroom experiences and their participation in student organizations is emphasized by most women who are political, intellectual, and professional leaders between twenty and fifty years old today.

Not all Palestinian girls were sent to school. Palestinians recognized, however, that education is important to both economic mobility and political self-determination. This attitude, coupled with the Israeli example of universal education for girls as well as boys, led to more girls being schooled for longer periods of time. A study of education in 1982 found that the female rate of education was half that of men, but it was increasing rapidly. UNRWA figures show that the ratio of the percentages of male to female students in its schools during the 1950–51 academic year was 74:26; in 1988–89 it was 51:49. Thus the option of education, including higher education, became more available to women than it had been decades earlier.

Palestinian women were also affected by close contact with Israelis, whose customs were such a great contrast to Palestinian traditions that many women reacted with shock. Palestinian women told me of being confused, even traumatized, by the dress

and behavior of the Israeli women they began to see for the first time in 1967—not because the women were Israeli but because they were living examples of an otherwise remote image of the modern, Western woman. Israeli women in the military wore short skirts, carried weapons, and chatted familiarly with their male colleagues. The women civilians who shopped in West Bank stores frequently were bare-armed as well as bare-legged and made casual physical contact with men. The shock of occupation induced political paralysis among most Palestinians, and the uninhibited behavior of the women occupiers added to the bewilderment of Palestinian women. A few women nevertheless were so outraged by the occupation that they demonstrated in Jerusalem in February 1968 against land confiscation and deportation, and a handful joined new, largely male armed groups. Women were generally aware of the armed participation by a very few women such as Leila Khaled in the small post-1967 Palestinian resistance movement.

Palestinians living in East Jerusalem, which was incorporated into Israel and subject to Israeli law, encountered additional unfamiliar phenomena. Children in public schools were exposed to an Israeli-influenced curriculum, with glimpses of the Westernized Israeli culture. Inevitably, this contact led some to begin questioning family constraints and the authority of elders. It was shocking to Palestinians rooted in traditional values to witness an Israeli court punish a Palestinian father for beating his daughter. East Jerusalem women, subject to Israeli law, discovered that they had more rights than did their sisters in the rest of the West Bank, who remained subject to Jordanian law.

Although family law in Israel is under the jurisdiction of ecclesiastical courts, and Israeli domestic law is the domain of Orthodox rabbinical courts that render judgments quite restrictive of women's rights, Israeli women have great freedom by comparison with Palestinian women: they can choose their husbands; leave their houses to work or socialize without the permission of men; participate in if not control decision making about the number of children they have; and raise their children if their marriage ends while the children are young. Becoming aware of these disparities at the same time as they were attaining higher levels of education

and were entering the paid work force caused some Palestinian women to regard Islamic law and Islam in general with a new coolness. The Islamic religious hierarchy realized that it was beginning to lose control of large parts of the population and encouraged the emergence of a movement to reactivate earlier values by emphasizing, among other things, traditional women's dress. West Bank women were subjected to the opposing forces of modernization and Islamic tradition. With the exception of East Jerusalem women, however, they were not as exposed to alien values as were their men, a large percentage of whom were working in Israel or for Israelis in the West Bank.

A new factor was added to the equation in 1976, when Israel granted West Bank women the right to vote and held municipal elections. The elections produced a leadership loyal to the PLO. The newly elected municipal leaders encouraged and expanded the voluntary work committees that young middle-class people, particularly from the universities, had begun in 1971, donating labor wherever it was needed. Volunteers spent their days working with their hands and their evenings discussing everything they could think of, particularly the effects of Israeli occupation on society and their society's attempts to deal with the occupation. Many Palestinians came to view Israeli policies as deliberate attempts to destroy Palestinian culture: replacing agriculture as a means of Palestinian livelihood with low-paying, menial jobs in Israel or in Israeli businesses in the territories; building Jewish settlements in the territories; prohibiting importation of certain books and journals and censoring newspapers and magazines; frequently closing universities for short periods; limiting the number of people permitted to meet together; imprisoning community leaders either after pro forma trials in military courts or under administrative detention requiring no charges or trials; and deporting community leaders.

Women in the work committees also discussed the tension between the role many of them wished to play in the national liberation struggle and the traditional status of women. By the mid-1970s the shock of Israeli occupation was wearing off, and the work camps became training grounds for many of the women interviewed for this book: Amal Wahdan, a leader of the trade union

movement and of one of the women's committees; Maha Mus-
taqlem, leader of another committee; Mona Rishmawi, one of
about fifteen women attorneys (of approximately two hundred) on
the West Bank; and Zahira Kamal. What began as an ad hoc attempt
by the young elite to broaden their knowledge of and participation
in their society was soon recognized as crucial to mobilizing and
educating other women. Birzeit University still requires every stu-
dent to complete 120 hours of community work such as helping
farmers. Perhaps emulating the Communist party, the PLO encour-
aged the emergence of grassroots organizations, including the
Social Youth Movement, or Shabiebeh (which means "young
men").

Many factors converged in the mid- to late 1970s. The depend-
ence of Palestinians on the Israeli economy pushed many Palestin-
ian women into the work force. Palestinian women were confronted
with the relatively liberated model of Israeli women. Growing
numbers of Palestinian women were graduating from colleges and
universities with degrees in liberal arts, medicine, law, journalism,
engineering, and pharmacy. Student unions, youth movements,
professional organizations, and a professionally staffed health
movement supported by grassroots participation developed in the
mid- and late 1970s, reflecting a growing determination to reclaim
and rebuild Palestinian society. Increased resistance inside the
territories was encouraged by the development of the PLO, which
incorporated the General Union of Palestinian Women and other
women in the PLO's schools, economic entities, and literacy pro-
grams in Lebanon's refugee camps. The organizations that emerged
in the West Bank in the late 1970s and early 1980s had a new kind of
leadership: frequently Christians, professionals, grassroots orga-
nizers, and sometimes the well-educated children of poorer fami-
lies rather than the former wealthy Moslem families. Members of
the traditionally dominant families were now recognized as influen-
tial only if they shared the new leaders' educational background,
activities, and ideas. Trade unions, which had existed before 1967
and had become somewhat quiescent during the postwar shock,
began to revive in the early 1970s and finally became active in 1976
following the local elections and the concomitant reinforcement of

the desire for autonomy. Many women assumed total control over homes without men, who had left in search of work. Women's societies brought women out of their homes and into public and economic life.

Finally, the 1977 Israeli national elections changed both Israeli and Palestinian society. The right-wing Likud party won a plurality of the vote and, assuming leadership of the Israeli government for the first time, instituted increasingly repressive measures. At least 682 women had been imprisoned between 1967 and 1977, many not as a result of their own alleged activities but as an attempt by the IDF to get information about their male relatives. Fifty-six women were arrested in 1977. According to one scholar, by 1981 three thousand Palestinian women had been imprisoned. Intensified repression included limitations on the activities of the women's charitable organizations, which were rendered vulnerable by their highly centralized structures, and a consequent rise in importance of the university-based groups.

It was in this context that the new women's movement emerged.

2

Ramallah

"The women are marching!"

June 30, 1989: No wall bisects it, but Jerusalem is a very divided city. My Jewish Tel Aviv taxi driver delivers me to Jerusalem's Notre Dame Hotel, at the edge of East Jerusalem. It has become a transfer point between what is in effect Arab and Jewish territory. Jewish drivers feel unsafe among East Jerusalem's Arabs; Palestinian drivers are equally uncomfortable in the Jewish neighborhoods of West Jerusalem. So it's at the Notre Dame that my Palestinian friends from Ramallah meet me. A month later, I will return there to be picked up by Israeli friends, feeling rather like the subject of an exchange in an outmoded cold war movie.

My friends and I leave quickly for Ramallah. The Israeli government has just deported a number of Palestinian leaders to Lebanon after waiting almost a year because of American pressure. Shopkeepers are pulling down their shutters in reaction. My friends are in a hurry to return to Ramallah, for it is almost noon, and even if there is no protest strike during shopping hours there might well be one afterward, making private travel less safe. When spontaneous strikes occur, cars usually are not in danger, for it is understood that people who left their homes before the strike began must return. But it is wiser not to travel to avoid the possibility of overenthusiastic stone throwers.

Although I've visited Ramallah in the past, I've never lived here, and as we drive I get advice about behavior under occupation, including a stern injunction against walking alone at night for fear of army patrols. I will live in the center of Ramallah. On the outskirts

41

or in the villages I would have to be wary of nighttime incursions by
Jewish settlers.

Ramallah is a lovely city of about twenty-five thousand people.
Most of the houses as well as the stores are one story high, made
out of the famous Jerusalem-area white stone tinged with orange-
brown. The buildings look rose-colored or golden when the light of
the setting sun hits them at just the right angle. Most of the stones
are cut into perfect bricklike rectangles, and some are left roughly
rounded or angled on the outside for a richer texture. The multi-
dwelling buildings that dot the city are never more than four stories
high, with the exception of a few in the shopping district that have
five floors over one level of stores. Many windows are graced with
iron grilles and flanked by painted wooden shutters. Most residen-
tial areas are lined with trees, covered at this time of year with
blossoms of every imaginable shade of pink and red and purple and
orange, or with plums or cherries or apricots or barely discernible
oranges that are not yet in season and are still the color of the
leaves that surround them. Much of Ramallah is on hills and
sometimes, particularly when the sun is hot, it seems as if one is
constantly walking uphill. Part of the shopping area is filled with
modern stores selling groceries, household goods, clothing, furni-
ture, or shoes. There are also travel agencies, pharmacies, doctors'
and lawyers' offices, computer supply firms, and taxicab agencies.
Other streets constitute the market area. They overflow with big
crates of tomatoes, onions, cauliflower, eggplant, plums of red and
purple and yellow, green grapes, round watermelons, and miniature
varieties of zucchini, cucumbers, pears, and okra. Boys maneuver
pushcarts filled with round pita bread or long oval loops of sesame-
covered bread that are sold with small amounts of zatar, a spice like
thyme that is grown locally and is mixed with sesame seeds.
Pungent smoke rises from the charcoal braziers of stalls selling pita
stuffed with small skewers of meat kababs. Other stands carry flat
round pita filled with felafal (deep-fried chickpea balls) and what-
ever mixture one chooses of hummus (chickpea paste), shredded
lettuce, chopped cucumbers and tomatoes and pickles, and spicy
red sauce called harisa. Or one can opt for slivers of lamb, sliced
from a constantly turning hot joint and stuffed into the ubiquitous

pita, and perhaps a can of soda or freshly made orange or grapefruit or carrot juice.

My home in Ramallah is a big bedroom in a house owned by Marie, a widow whose adult children are dispersed in the United States, Switzerland, and Kuwait. Today's Palestinians speak of their diaspora. Almost every family I meet in cities, villages, and refugee camps has immediate relatives living abroad. Either they are making a living or they have not been permitted back because of Israeli policies: residency is restricted only to those registered by the government as physically present in the West Bank or the Gaza Strip on a particular day shortly after the moment of occupation in 1967.

Marie is Christian, as are about 5 percent of West Bank Palestinians. The percentage had begun decreasing before the intifada but has dropped dramatically recently. Palestinian Christians tend to be highly educated and upper middle class; here as elsewhere, those characteristics imply a relatively low birthrate and have also led to a high migration rate because of the limited professional opportunities in the West Bank.

Marie is clearly uncomfortable about some of the Palestinian women's movement publications I bring into her house. The IDF has been known to enter homes and search for "subversive" literature. Pamphlets about the women's movement, with their emphasis on nation building and the role of women, are considered subversive by the IDF. They might be confiscated, the house might be vandalized, and Marie might be arrested. I tell her I'll keep all my subversive reading in my suitcase. If it's found she can disclaim any knowledge of it.

The clothing I unpack brings a little familiarity to the room, because it's clothing I wear in New York. The dress of Palestinian women varies. They may wear the traditional long, embroidered black dress and snowy white head covering tied under the chin, or a modern dress or blouse and skirt along with a head covering (*hijab*, plural *ahjiba*), or the same without a head covering. Some younger women wear slacks or jeans and a shirt. The only clothing I bought especially for the trip was a skirt that ended a few inches above my ankles that I plan to wear when visiting refugee camps or the more

remote villages. My usual below-the-knee skirts, coupled with long-sleeved shirts (the sleeves frequently rolled up because of the heat), are fine. Earlier trips to Ramallah had taught me that when I visited friends slacks would be appropriate, and while I'd packed sandals and a pair of low-heeled pumps, I also brought the sneakers I knew I'd want for long relaxed walks in the rolling hills. Elite women, urban women, and Christian women (a woman can be all three) tend to dress as any middle-class woman would in the United States, although their arms are usually at least partially covered. Many women in the central Ramallah-Jerusalem-Bethlehem area stopped wearing head scarves early in the twentieth century, and their example spread among middle-class women of the region by the time of the British mandate in the 1920s. Some of their daughters and granddaughters will surprise me—and other Palestinian women—by dressing in jeans and short-sleeved T-shirts to take me into the refugee camps. In fact, women's clothing constitutes a political statement in the West Bank, as elsewhere. The al-Haq women staffers customarily wear jeans or skirts, depending on their mood. A more religious staffer is always dressed in a skirt and head covering.

Women shopping on the streets of Ramallah present a pastiche of embroidered gowns, short skirts, and jeans. Older women dressed in skirts and blouses frequently wear all black or a dark skirt with a print blouse. The shoe stores in Ramallah carry smart pumps with the kind of really high heels I'd finally given up some years ago when I decided comfort was more important than fashion. It is not uncommon to see spiked heels peeping out below the hem of a traditional gown, although it is just as usual to see such gowns accompanied by sandals or, in the winter, by boots. Some women adopted face veils when the seventeenth-century Ottomans brought them to Palestine. Today they're a rarity and are not to be seen in Ramallah or most other parts of the West Bank; an occasional exception can be found in Nablus or Hebron. Fundamentalist women frequently can be identified by the recently invented *jilbaab*, ankle-length dresses that look like straight gray overcoats. Many nonfundamentalist women of varying degrees of religiosity wear snow white *ahjiba*: tied under the chin, crossed

under the chin with the ends tossed over the shoulders, pinned under the chin and falling gracefully onto their gowns or blouses, or draped over their heads untied.

July 1: The reading I've done so far has raised the question of whether the still evolving changes in political, economic, and social life will result in greater long-term equality and power for women. It's that question I'm here to try to answer. I'll do so primarily by interviewing women and visiting their projects, but there's still more reading to be done, so I head for the third-floor office of al-Haq. Since the early months of the intifada demonstrated the impact of televised news on world opinion, the Israeli government has limited media access to the territories. Journalists and governments have therefore turned to al-Haq as one of the few reliable sources of information about the occupation. Its extensive library is routinely used by Palestinians, foreign researchers, medical teams, and many others. Randa Siniora, the al-Haq staffer in charge of the women's project, has agreed to help my research by getting me appointments with the leaders of the four party-affiliated women's committees and with other, independent (non-party-affiliated) women. It's not easy: al-Haq, which began as a handful of people brought together by two young human rights attorneys almost a decade ago, now employs more than forty people. But the office has only one telephone line. Repeated requests for more lines have been turned down.

As I begin my reading in the library, I hear the cry "The women are marching!" I join in the rush to the balcony, where we see about fifty women in the middle of the street a block away. They're walking toward the heart of the business district, recognizable from afar by Ramallah's tallest building. The IDF has put a command post on its roof. Soldiers are always stationed there during business hours, holding their submachine guns pointed down at the crowds. The marching women in the front line are dressed in the traditional long dresses and white head scarves. They walk for two blocks before the soldiers fire teargas, scattering them. We never do find out why they are marching. The people around me explain that such marches occur spontaneously for a variety of reasons: the arrest of someone's son, a miscarriage attributed to the use of teargas, a deporta-

tion. It's my first direct encounter with occupation, and I'm open-mouthed and distressed at the sight of totally unarmed women being teargassed by Israelis. "They were lucky to have gotten as far as they did," someone comments bitterly. All demonstrations are illegal. They're also common and treated as such: most of the people visible on the street simply resume their business as soon as the cloud of teargas lifts.

The march is over; the staff resumes work, occasional laughter mingled with their intense concentration. I wonder at their ability to move with such seeming smoothness from moments of crisis back to their routine. But of course such immediate transitions are necessary if they are to maintain any semblance of normal life. The transitions are also a matter of pride. The intifada, after all, is about control.

A non-Palestinian al-Haq staffer who arrives right after the march and who is quite knowledgeable about the women's movement, says enviously that he's not yet seen one of the women's spontaneous marches. This one was brief but impressive: seemingly ordinary, traditional Palestinian women not only taking part in public life but doing it on their own initiative and in a way that put them in physical jeopardy. They were defying the Israelis and, by doing so, were also challenging hundreds of years of their own traditions. This would of course have been impossible as recently ago as two decades, perhaps even two years, ago.

July 2: Someone takes me to the center of the shopping district to buy *The Jerusalem Post*, the Israeli English-language daily, in the one store in Ramallah that still carries it. I look up to see three soldiers at their post on the highest roof. Americans have been very fortunate in never experiencing occupation. Buying a newspaper under observation by armed soldiers is a relatively benign aspect of it but a thoroughly uncomfortable one. I find myself glancing up every few seconds.

Then I take a cab to al-Bireh, Ramallah's sister city, a largely Moslem entity of about 25,000 people. I'm to interview Mrs. Samihah Khalil (usually referred to as Umm Khalil, meaning "mother of Khalil"), founder and president of In'ash al-Usra (Family Rehabilitation Society), the second unusual older organization I'd learned

about. Her society is in many ways the forerunner of today's women's committees, although she dismisses them with a casual "They do the same things we do, but less" and they in turn denigrate what they see as her lack of feminist consciousness.

Umm Khalil is large, aristocratic, and forceful. Her black hair pulled back in a severe bun, her dress modern but with modest long sleeves and high neck, she juggles telephone calls and gives orders to secretaries while we talk. She is the first but far from the last person who tells me that the real villain in the Palestinian situation is the United States because Israel could not carry out its current policies without American money. On the subject of peace she says, "We're offering [the Israelis] our land, keeping only thirty percent, and the worst part. We want to live as we did before '48, without hatred. What more do they want?" She's concerned about what she calls "the generation of hatred," the young Israelis and Palestinians who have been shaped by occupation and the intifada.

But most of our conversation is about In'ash al-Usra. Umm Khalil's wealthy conservative family had taken her out of high school at age seventeen to marry. Her husband was the headmaster of a school in the Ashkelon area, and the family lived in a substantial, well-furnished home. When they fled to Gaza during the fighting in 1948, they assumed they would soon return and took only Umm Khalil's jewelry with them. She sold her last gold bracelet so that her husband could rent a car and drive to Ashkelon to retrieve some of their belongings. He rented the car but then discovered that the Israeli authorities would neither permit him to go to Ashkelon nor recognize any property right in what the family had left behind.

The Khalils remained in Gaza until 1951. They saw nothing of the rest of their family, living, as did other refugees, in poverty and without such basic means of communication as a radio, newspapers, or post office. Their luck changed when UNRWA asked Mr. Khalil to aid its West Bank education effort. They could not travel overland to the West Bank, however, as Israel would not permit Gazans into Israel, so they managed to rent a rowboat to take them from Gaza to Port Said. The boat was ill equipped for what proved to be a frightening journey that lasted for a week because they

frequently had to pull close to shore to avoid dangerous Mediterra-
nean currents. They had brought enough food for a shorter trip.
After finally reaching Port Said, they traveled overland to Jordan
and the West Bank.

When they arrived in al-Bireh, Umm Khalil was dismayed to find
poorly housed refugees standing in endless lines waiting for
UNRWA's handouts of basic foodstuffs and other provisions. Deter-
mined to prove that Palestinians could help themselves, she orga-
nized the Arab Union Women's Society. She persuaded the mayor
of al-Bireh to give the society a loan of 100 Jordanian dinars, and
other funds were raised through door-to-door solicitations. The
society quickly became a source of economic or bureaucratic help
for the refugees, and until the early 1970s it concentrated primarily
on relief activities. It proved unable to deal with the large number of
supplicants, however, and began to experiment with projects to
enable people to earn income. The first of these, housed in a
garage, was a sewing project that started with one secondhand
sewing machine and eight girls chosen from among the poorest
refugee families in the vicinity.

The clothing the girls were trained to sew was sold locally. The
project grew, and food preservation and packaging projects were
added. Both of the latter, however, were ultimately unsuccessful
because their products were seen as competitive with Israeli goods
and because of marketing problems. An experiment in chicken
farming (the Palestinians were totally dependent on Israeli farmers
for chickens) failed for similar reasons. Finally, a decision was made
to produce goods that would not compete with Israeli commodi-
ties: clothing embroidered in the traditional style, pottery, and
woven straw items. These also were sold locally, particularly to
stores whose food the society would buy in exchange.

It was while running the society in 1964 that Umm Khalil took and
passed the secondary school examination, along with one of her
sons. She then studied Arabic literature through a Beirut University
correspondence course but was unable to complete a degree because
Israeli authorities denied her permission to travel to Beirut for the
required examinations, which had to be taken in person.

In 1965, the society was reconstituted as In'ash al-Usra. By 1988 it

had become a major enterprise. Its projects included the manufacture of ready-made clothing, hand knitting done in homes and machine knitting done at the society's headquarters, a network of almost five thousand village women making traditional embroidered dresses and wall hangings in their homes, a bakery producing biscuits and cakes sold in local markets, the preparation and preservation of food products, and a beauty care project run by society-trained beauticians. The society housed, trained, and awarded certificates to approximately 350 women each year in sewing, machine dressmaking, hairdressing and beauty services, machine embroidery, and business and secretarial skills. It placed 85 percent of its graduates in jobs. Two hundred full-time employees worked in its offices, running training programs, an orphanage housing 136 girls, a nursery for children beginning at age one month, a kindergarten, a library, a museum, and a quarterly magazine of Palestinian folk art. A medical and a dental clinic were housed at the society's headquarters. If both the doctor and Umm Khalil certified that specialized care was needed, impoverished patients were treated without cost by cooperating doctors. Umm Khalil persuaded many doctors to accept about ten gratis cases a year each. Hospitals did not charge patients referred by her. Rotating six-month arrangements were made with five pharmacies to sell the society 40 percent of the medicines it needed at cost. The remaining 60 percent was provided through contributions.

The profits varied. The hand-embroidered work, for example, was much in demand, especially in the Gulf states, so the society's profits were 65 percent after the women were paid. Baked goods and herbs made only an 8 percent profit. Profits not designated to maintain and expand existing projects were used to aid victims of war and needy families and to provide scholarships and educational loans. The society also ran a family-sponsored program for thirteen hundred children whose parents either were killed in war or were serving lengthy prison terms. It and the Higher Committee for Adult Education established a literacy campaign.

Umm Khalil's guiding mottoes are that it is better to light a candle every day than to sit weeping in the darkness, that nothing is impossible, and that the people must be called on whenever help is

needed. Her goal is to create an infrastructure that minimizes reliance on Israel. But her project was succeeding, and the government reacted. Between 1972 and 1986, Israeli licensing and censorship prevented the society from publishing more than nineteen issues of what was designed as a quarterly magazine. The Israelis interfered frequently with the society's attempts to bring in funds raised abroad. In 1970, the government cited "security reasons" in closing the four village centers the society had set up to facilitate its knitting and embroidery projects. In 1986, the society, planning to establish twenty-three such centers, opened the first two in Beit Sira and al-Nabi Saleh, but the Israelis closed them.

Umm Khalil herself is the object of government attention. She was detained six times and was put under town arrest for two and a half years. Since 1982, she has been forbidden to leave Israel and the territories, in spite of having been invited to participate in dozens of international conferences. Her children, all outside the country, are prohibited from entering it; her husband has died. Twice she petitioned unsuccessfully to be permitted to leave the country, the first time when one son was injured in an automobile accident and again when a grandchild became severely ill and died.

In 1988, the government apparently decided that the growing economic infrastructure, by this time a priority both of the new women's committees and of the Unified National Leadership, constituted too much of a threat to be permitted to continue. On June 8, 1988, soldiers raided the offices of In'ash al-Usra, confiscating files, letters, a register of addresses, and videocassettes. Twelve days later, charging that the society was a center of subversive activities and propaganda and was aiding terrorist organizations and helping to organize riots, the IDF closed the larger of the society's two buildings for two years. The structure had housed the society's training centers, museum, library, school, and offices. Only the orphanage building remained open. Although the building was quickly rearranged to hold offices and some of the projects, the society's functions other than running the orphanage and nursery were effectively ended or so severely cut back that they were virtually nonexistent. Umm Khalil was charged with a number of offenses against the rules promulgated by the military, including

being anti-Semitic, inciting others against Israeli-appointed local officials, and possessing a Palestinian flag. The society appealed to the Israeli High Court of Justice, until April 1989 the only court to which Palestinians could appeal decisions of the military, and on October 11, 1989, the court reduced the closure order to one year.

July 3: This morning I decide to buy myself a newspaper. I can get to the middle of the few streets that constitute the shopping district, guiding myself by the soldiers on the roof of the high building, but once there I discover that all the streets still look alike to me: bright masses of people, all busily marketing. Enough people speak English for me to ask my way. I realize only the next day that the entrance to the newspaper store is so tiny that it's easily missed. I probably pass it five times as I go back and forth, constantly asking directions of bemused people who don't under-stand my inability to find something that's just a few doors away. I'd feel ridiculously conspicuous if everyone weren't too busy shopping to take much notice.

Suddenly I feel eyes, and I look up to see one of the soldiers pointing me out to a companion. The submachine gun he holds in his other hand makes me uneasy, especially as I realize that all my back and forths and my truncated conversations probably appear from above as if I'm organizing or spreading the word of a strike day. The possible price for finding *The Jerusalem Post* strikes me as too high and I start walking toward al-Haq.

There's a burst of gunfire. Quite certain that I'm about to be shot, I whirl around and see four soldiers running about a block away, just turning a corner. I quickly and gratefully go in the other direction. Later, surprised people ask why I went the way I did, as their response would have been to follow the soldiers and find out what happened. Within a few days I'll be doing the same. Had I been Palestinian, I would have been expected to follow the soldiers, not only to learn what the problem was but to see if I could prevent the arrest of any young men the IDF might have been attempting to take into custody. Now, as I leave, I see another group of soldiers walk by, clutching their ever-ready submachine guns, apparently unconcerned with whatever is happening around the corner. I'm distressed to find their eyes so hard and unyielding, but the

consistency with which all the soldiers maintain that expression suggests that it's the result of a policy of intimidation or a widely used mechanism for hiding fear or a method of removing oneself as much as one can from an impossible situation. Israelis say it's all three.

Gradually I'll learn more about eyes and facial expressions in the intifada. One mustn't look directly into the eyes of soldiers when one is walking down the street. It draws undesirable attention. The soldiers may become violent with a man: they've been ordered to do whatever is necessary to remind the local population of its subservient position, and looking the occupier in the eye doesn't convey the required respect. With women, the soldiers usually limit themselves to calling out sexual invitations in Arabic or Hebrew. But one is to look directly at the soldiers when a confrontation is already in progress, to demonstrate the fearlessness of the community. The day after I leave Ramallah I'll be in an Israeli friend's car in West Jerusalem when a uniformed soldier in a jeep cuts recklessly into the lane alongside us. Like my friend, I glare at him, realizing as I do that it is the first time in a month that I've not guarded my expression in the presence of a soldier. But by that time I also will have seen the bewilderment and unhappiness in the faces of some of the young soldiers who stop cars at checkpoints, under orders to display who is in charge.

I meet Yussrah, a leader of one of the women's committees, and we take the *service* (communal taxi cab; pronounced "seyr-*vees*," in the French manner) to the East Jerusalem offices of the Palestinian Federation of Women's Action Committees (PFWAC), one of the four new women's committees.

Among the reactions to the Iron Fist policy that included raids on offices was the physical move of national women's committees. The Union of Palestinian Working Women's Committees (UPWWC) used to be based in Ramallah but moved its offices to East Jerusalem because Israel considers all of Jerusalem to be part of Israel and therefore under Israeli law. The territories are not under civilian law but rather the administration of the military, which draws on Emergency Defense Regulations that empower it to do virtually as it pleases. Israeli forces in East Jerusalem usually

respect some due process constraints, so offices there are considered somewhat safer. Consequently the PFWAC offices that I am visiting today are in the Jerusalem suburb of Beit Hanina. The safety is far from absolute, however: when I return to the West Bank in January 1990 I'll hear that about a month and a half after my visit to Beit Hanina, the IDF, unable to find the young men responsible for a barricade of several burning tires on the nearby highway at about 2:30 A.M., raided the committee's nursery, smashing windows and uprooting the tires that were stuck in the earth for children's games.

The building currently houses an exhibit of traditional embroidered cloth, embroidery framed in hammered copper, dresses, artwork in enamel on brass, and cookies, all made by the committee's production groups. Each of the four committees has its own groups in which women learn to make food products, clothing, and handicrafts that are marketed by the committees. All the committees have sewing and embroidery projects; some sponsor agricultural cooperatives as well as projects or cooperatives that produce such foods as cheeses, bottled grape leaves, syrup, and tomato juice. The committees' projects differ somewhat. Only the PFWAC, for example, does cloisonné artwork; grape syrup is a specialty of the Union of Palestinian Women's Committees in the West Bank and Gaza (UPWC); the UPWWC makes huge round straw trays for serving food; the Union of Women's Committees for Social Work (UWCSW) concentrates on embroidery. Nonetheless, many of the four committees' projects are similar, and as soon as one begins marketing a new product, the three others quickly emulate it. The PFWAC also makes a high-protein baby food, which is marketed at low cost by the committee and by church groups and is prescribed by doctors. The production projects are part of the move to boycott Israeli consumer goods as much as possible.

Some days later I'll visit the workshop in 'Eisawiyya, a Jerusalem-area village, where the enamelware and metal frames for embroidery are made. The PFWAC created the workshop at the request of the young women who staff it and who spent a year training in the techniques. I'll meet five of the women who work there, most in their early twenties and unmarried, all from large working-class families. All dropped out of school, all have fathers who were

injured working in the Israeli construction business (Israeli statistics indicate that about 80 percent of its construction workers are Palestinians), all had fights with their families about going out to work, especially at the arduous job of hammering stenciled patterns into metal. Their families are proud of them now, less because of the money they earn—which some of the women have become independent enough to keep for themselves—than because of the beauty of the work they produce. They share their families' pride: when asked about their vision of the state-to-be, they speak of a society of workshops like their own. They expect to continue working even after marrying and having children.

Their opportunity to do so will depend in part on the expansion of the kind of child care facilities run by all the women's committees and currently existing in most cities and refugee camps as well as some villages. Child care centers are not the norm in the Arab world. At the women's committee headquarters this morning, I see what may be the biggest and best-equipped center. It is located in a relatively affluent area and charges between 8 and 18 Jordanian dinars per month per child, depending on the child's age and whether he or she is still in diapers. (The dinar, or JD, which fluctuates in value, can be exchanged for about 2.5 Israeli shekels now; the U.S. dollar, for 2 shekels.) The children get a hot midday meal, and parents have the option of sending food from home to be warmed up or paying an additional 4 JD ($5) a month for food provided by the school. Parents in many of the villages and refugee camps cannot afford the lower fees charged there and pay partial fees or nothing at all; such subsidized care is one reason the committees are constantly seeking donations, more outlets for their products, and ideas for new products that will bring a profit. The child care day runs from 7:00 A.M. to 2:00 P.M., with an extension to 5:00 P.M. for those parents who need it. There are two teachers in the morning and one in the afternoon for the fifteen three-month-old to three-year-old children; one each for the groups of children from age two to three and a half and from three and a half to five. The amount of equipment and number of toys in the child care centers vary, depending on the area and the sponsoring committee, but all are spotless and even the lesser-equipped ones are bright with

posters and pictures made by the teachers. All try to prepare children for kindergarten by teaching concepts such as color, numbers, and texture.

The nurseries have created employment opportunities, but they are poorly paid ones. Salaries average about 70 dinars ($87.50) a month. Those in hiring positions are apologetic about the salaries, explaining that the centers have been affected by the limited amount of money available in the territories during the intifada. The teachers admit that low salaries hurt but shrug off the difficulties with a smile: "It's until we have our own state." Many mothers of children in the nurseries are members of the committees, but committee membership is not a prerequisite for enrollment. All the children I'll see in the nurseries I visit look well nourished and healthy. They arrive absolutely spotless in the morning and the teachers make sure they're not much dirtier when they leave. Palestinian culture places a very high value on cleanliness, and a visitor quickly notices that every home, no matter how poor, always looks newly cleaned.

Child care was among the first responsibilities assumed by the women's committees, and the number of facilities has grown since the intifada. The PFWAC has thirty-two nurseries or kindergartens (the words tend to be used interchangeably, both meaning preschool centers); the UPWWC, seventeen; the UWCSW, seventeen; the UPWC, which emphasizes creating them wherever the committee has projects so that mothers of young children can be free to join them, thirty-six. A few days later I'll visit the UPWWC Ramallah nursery, which houses ten children from age two and a half to four as well as ten who are younger. The nursery is open from 7:30 to 3:30, with teachers working seven-hour shifts. The cost is 20 dinars ($25) a month plus an additional 8 dinars ($10) for children who don't bring their own food, with a reduction for working-class mothers. Here the stock of toys is less than that in Beit Hanina and the teachers have made colorful pictures to cover the otherwise drab walls. The women picking up their children aren't necessarily committee members and are dressed in everything from jeans to long skirts.

In the past, it was unusual for students to eat at school. The

traditional West Bank school day begins around 7:00 A.M. and ends at 1:00. This schedule allows children to return home for the main meal of the day, which the mother or another female relative serves. The exceptions are private schools run by religious denominations, which represent about 12 percent of all West Bank schools and are attended primarily by children from wealthier families, and, since 1950, the approximately 10 percent of West Bank schools run in refugee camps by UNRWA, which provide a meager free meal. So it has been only the upper and lower strata, in perhaps 22 percent of the territories' schools, that have become accustomed to having their children fed outside the family circle. In many minds a meal at school has been associated with the meatless lunches provided by UNRWA and a somewhat embarrassing need to accept its charity.

The first non-church-affiliated school and non-UNRWA child care center to feed children was organized at Birzeit University by women students and faculty in 1983 or 1984. Initially, mothers were asked to prepare enough of one dish for all the children about every two weeks. The center later hired a cook responsible for preparing food with a high nutritional value and for supervising the meal hour. Personnel at the Beit Hanina center, which originally followed the custom of asking children to bring their own food, tell me that they became concerned about the work entailed in heating up as many different meals as there were children. Knowing that parents would be reluctant to have a nonrelative cook for their children, the center called a meeting to explain the problem and to suggest that the center provide the meal at a nominal fee. Parents were given the option of continuing to send individual meals or paying 4 dinars ($5) a month for center-provided meals. The Beit Hanina area is quite cosmopolitan. Most parents agreed to the second option; within a short period, all the children were being fed that way. Similarly, the UPWWC nursery in Ramallah provides a meal for 8 dinars ($10) a month but also permits the children to bring their own food.

The impact on women's roles of having day care centers providing the main meal of the day is intriguing. Having children fed by child care personnel is a radical departure from tradition, all the more so because the children are very young. On the one hand, the

extended family concept in Palestinian society, which can easily stretch beyond blood ties in the small villages of the West Bank, can be viewed as simply expanding to include another kind of home, particularly as its personnel live in or near the community. On the other hand, having children fed by non–family members is not the traditional practice. It may be that the tradition of mothers providing the midday meal at home was simply the function of the early school hours and the gathering of the entire rural family in the afternoon for the main meal, or it may be a holdover from the traditional heavier emphasis on the schooling of boys. In a Moslem society, an all-male institution could not be expected to engage in the female function of making and serving meals. But now both boys and girls are being nurtured by child care professionals. The implications are potentially important for the view of women as being entirely responsible for feeding their families, especially if a future Palestinian state provides child care for entire days.

When we're finished viewing the handicrafts exhibit in Beit Hanina, its doors are carefully locked. We later leave the young head of the child care center alone in her office behind similarly locked doors. During the five hours we're there we notice IDF jeeps circling the building twice. Like most jeeps throughout the territories, they contain four men. Those not driving hold submachine guns pointed out both sides and the back of the jeep.

3

The Women's Committees

"The struggle for our rights as workers and as women should start now. . . . It all has to go side by side."

The new Palestinian women's movement began formally with the Women's Work Committee (WWC), established in Ramallah in 1978 by young middle-class university-trained women activists. They wanted to create a national political entity with a specific women's agenda that would be tied to the larger national liberation movement, rather than geographically and functionally discrete societies.

This first organizational step in the women's movement reflected the general reaction in the occupied territories to the increased repression of the late 1970s as well as the growing understanding by Palestinian leaders that self-determination could not be achieved without organization of the masses. The leaders of the WWC began by creating cadres within existing organizations and raising the consciousness of both male and female members about the needs of women. They cooperated with the women's charitable societies, joining their boards and requesting permission to use the societies' licenses as an umbrella for their own work. When the WWC attempted to persuade women workers to enroll in the trade unions, traditionalism intervened. Those who joined the unions tended to be single; membership of married women still depended on the attitudes of their husbands, who usually did not want them

involved in gender-integrated groups even when the husbands themselves were union members. Confronted by the equally vehement objections of families to having their unmarried daughters join male organizations, the WWC leaders set up union centers in their own houses where only women unionists met. Perhaps 5 percent of the roughly thirty-three thousand Palestinian women workers became unionized (about 17 percent of male workers are unionized). The leaders also encouraged women's membership in the WWC regardless of political party affiliation—another unity measure.

The women of the WWC knew they wanted to do something beyond the charitable work of the old societies, but the question was where they might best put their efforts. To find out, they undertook two surveys, one of women workers in Ramallah and al-Bireh and one of housewives in the same area.

A large number of the Palestinian women who moved into the paid work force after 1967 got jobs in West Bank garment factories. Many Israeli companies began providing Palestinian subcontractors with partially finished products or raw materials that were then returned as finished products to the Israeli companies that sold them. Clothing became a major subcontracting industry, with women about 95 percent of its work force. Women Palestinian workers, like those in other Third World countries, have become a reserve army of labor mobilized according to the needs of the employers. Employers justify the low pay and lack of job security or fringe benefits by viewing women as providers of additional income rather than as family breadwinners. The factories provide highly routinized jobs that require not only patience but self-discipline and unquestioning obedience; employers find women from the patriarchal Palestinian society ideal workers.

Because making clothing is an extension of a traditional female task, it does not violate the notion of women's role. The primary initial objection to women's working outside the home was their exposure to different values and possible loss of chastity, particularly for young unmarried women. Most women in the workshops are between age eighteen and twenty-nine, unmarried, working for two or three years and stopping when they are about to be married.

The problem of morality was solved by turning the workplace into a pseudo extension of the home, with the employer adopting the role of an older male relative. Women's families, rather than women themselves, were contacted directly by potential employers, who assumed responsibility for transporting the women to the factories, segregating them from male workers, and returning them home. The employers emphasized their paternal role by discussing directly with the families any difficulties the women were experiencing or causing.

Replacing women about to be married with other young unmarried women and reporting on their behavior to their families guarantees the employers a low-paid, unorganized, docile work force. Other women garment workers suffered—and continue to suffer—worse exploitation. These are the women, particularly in refugee camps and villages, who cannot work in the factories because of traditional values, family obligations, or distance. Palestinian subcontractors take work directly to them. The women may work for ten to twelve hours a day and are so desperately in need and so unaware of their rights, or afraid to assert them, that they frequently work without knowing how much they will be paid or how much the subcontractor is receiving for the work they do. Women were also forced by economic necessity to work on land owned by others, as domestics in the Jewish settlements that began to flourish in the West Bank in the 1970s and in homes within the Green Line (the pre-1967 borders) and for Israeli hospitals, citrus fruit growers, and companies such as Elite, a chocolate manufacturer.

The WWC surveys were the first to document the needs of the workers, particularly in the textile factories, and the problems faced by the larger number of urban women working at unpaid jobs in the home. One result was a successful drive by the WWC to include unionized women in health care plans.

The WWC did not know how to achieve its next goal: mobilizing the masses of women outside urban areas like Ramallah and al-Bireh in the national struggle. One idea came from a small group of organizers led by activist Zahira Kamal, a teacher of education who emerged as the head of the WWC. She was concerned because

both the WWC and the older women's societies consisted almost entirely of wealthy women. Her knowledge of politics led to her recognition of the need for mass mobilization; her knowledge of education, to the lesson that the best educator is the one who is responsive to students. She persuaded the other leaders to break up into small groups and go listen to the women outside the cities, reassemble to discuss and digest what they had learned, and then write material for the women that would be relevant to their problems. So the thousand members of the WWC fanned out, knocking on every door in the West Bank, whether in refugee camps, villages, or towns. Some, like Kamal, traveled by themselves, climbing the rudimentary streets of refugee camps and journeying to isolated villages. They were astonished to discover a population totally outside their experience. A large proportion of nonurban women were illiterate, overworked, poor, economically dependent on men, unaware of their legal rights, and focused entirely on the private domain of home, cooking, cleaning, and children. Their burden was too great to permit immediate mobilization for political activities.

The WWC was helped by the fact that numerous organizers had come to the same realization individually and that some women who had paid jobs or who had managed to obtain a few years' education had put together more informal women's committees, some in remote areas. This discovery gave rural women and their problems increased visibility and provided the WWC with individuals and small groups among rural women for its initial efforts.

The efforts included writing material for literacy projects and informing women about health care, their rights, and national liberation. Nursery schools were established to take care of children while their mothers learned to read and attended newly organized vocational training classes. Basic health care services were provided. Projects aimed at giving women independent sources of income were developed. Many of these efforts were successful. There were virtually no nurseries or kindergartens in the rural areas in 1980; by 1988, there were at least eighty.

The grassroots information-gathering process proved to be a crucial step in the emergence of a consciousness that is both

feminist and political-national. It became a journey in which Palestinian elite women discovered their own country. It was also a major development for the male-dominated national liberation movement, for the only grassroots organizations that existed before the intifada were the trade union movement and the women's movement (a medical relief committee movement, begun by medical personnel who encouraged grassroots participation, is discussed in chapter 13), and the trade unions were as concentrated in the central cities as were the earlier women's societies. Middle-class, educated Palestinian women first joined forces with peasant and working-class women in the local women's committees. As Birzeit Professor of Public Health Rita Giacaman has commented, "The popular movement is extremely important, not only because it raised the consciousness of villages, but equally because it helped people like me—nice middle-class academics on the fringe of their society—to get acquainted and link up with real people, the rural majority, 70 percent of the people." In addition, the elite women's new awareness of problems faced by other women led to the adoption of a platform demanding improvement in women's political, economic, social, and cultural status as part of the process of liberation from all forms of exploitation. The deprivation of rural women was viewed not only as a reason to fight for national liberation but as a means of focusing attention on the specific problems of women in Palestinian society. For at least some women, the concepts of national liberation and women's liberation became inextricably intertwined.

The politics of the two became equally intermingled, and the factionalism that divides Palestinians inevitably came to affect the women leaders. What had been one committee was transformed into four, mirroring what had happened to the trade unions. On March 8, 1980, International Women's Day, some members of the WWC broke away to establish the Working Women's Committee, now the Union of Palestinian Working Women's Committees (Itihad Lijan al-Mara'a al Amella), or UPWWC, which has reflected the program of the Palestinian Communist party since the latter's inception in 1982. The following year the Palestine Women's Committee, now the Union of Palestinian Women's Committees in the

West Bank and Gaza (Itihad Lijan al-Mara'a al-Filistinia), or UPWC, was set up in ideological sympathy with the Popular Front for the Liberation of Palestine. Finally, in 1983 came the Itihad Lijan al-Mara'a Lil 'Amal al-Ijtima'i, the Women's Social Work Committee (currently known as the Union of Women's Committees for Social Work, or UWCSW), associated with the philosophy of Fateh. The original Women's Work Committee, which altered its name first to the Palestine Union of Women's Work Committee and later to the Palestinian Federation of Women's Action Committees (Lijan al-'Amal an-Nisa'i al-Falistini), or PFWAC, came to mirror the thinking of the Democratic Front for the Liberation of Palestine. The PFWAC, UPWWC, and UPWC are avowedly socialist. They have adopted the cooperative system and a democratic grassroots structure, approaches compatible with both socialism and the policies of the three parties whose ideas they reflect, such as avoiding Fateh-type investment in capitalist ventures abroad and using their relatively low budgets to create institutions within the territories. The three parties tend to emphasize the class struggle. The effect of Marxism-Leninism on the women's committees, however, seems to be limited to the occasional mention of "dialectics" or "class" and an emphasis on the cooperative as the key form of production unit; the nature of basic production units and ownership of property in a future Palestinian state have not been addressed by the committees. The proliferation of committees has led to some strains among them but has also had the effect of increasing the numbers of women involved by creating a committee for every political opinion. In addition, a number of professional upper-middle-class women work closely with the committees but remain independent of them because of a desire to avoid partisan politics. This group includes, for example, Professor Giacaman; Islah Jad, of Birzeit's Cultural Affairs Department; Mona Rishmawi; al-Haq's Randa Siniora; and Professor Hanan Mikhail-Ashrawi, former dean of arts at Birzeit.

One reason for the relatively low membership in the committees before the intifada was their identification with the ideas of specific political factions. This made them unattractive to the majority of women, whose families considered it unacceptable for women to

become engaged in party politics. If women were to come into the movement without first affiliating themselves with a political faction, there was little in the women's committees' activities to differentiate them from one another.

Women were brought into the committees largely through personal visits by committee members and through the provision of services to them. Unlike the trade unions, the committees were able to organize women, even in highly traditional, remote areas, for the committees were all female and therefore challenged no ideas about the mingling of the sexes. This is not to say that they encountered no resistance, for they did, especially in the villages and the refugee camps, where they found that, like women everywhere, women had internalized the restrictions placed on them by society.

The committees' structure reflected both the highly sophisticated organizational skills the leaders had honed in universities and trade unions and their commitment to grassroots democracy. With the exception of the Women's Committee for Social Work, they created a decentralized and hierarchical structure that relied heavily on the local level and enabled the work to continue when leaders were immobilized by the IDF. The specifics varied from one committee to another, but their general framework consisted of local committees, election by them of district or area committees, and their selection in turn of representatives to a national body. The most highly structured organization, the PFWAC, had base committees with mandatory monthly meetings, a branch committee for every two base committees, representation of base and branch committees on eight district committees, and an elected executive committee that established subcommittees to control the federation's work in education, health, agriculture, and food storage and to oversee finances. The PFWAC's highest legislative body, the general assembly, to which representations were sent from all base units and branches, held annual meetings. The UPWWC, with an estimated five thousand members, had a similar if smaller-scale structure with sixty-three branches before the intifada; the UPWC, relatively limited grassroots representation because of its limited size; the UWCSW, control from the top.

The committees were financed by a one-time admission fee and an annual membership fee. The fees, in addition to donations and periodical sales of the projects' work at what are called bazaars, made up the whole of the committees' financing. As the committees became better known abroad, foreign donor organizations sponsored individual projects. That source of income, however, was severely impeded by the promulgation of a 1982 military order that required a permit from the military authorities before an organization could accept outside funds. Money therefore was and remains a major limitation on the committees' work. In addition, the committees have faced the same treatment as that meted out to other Palestinian institutions by the IDF: arrest and interrogation of members; refusal to issue the permits required to conduct meetings, cultural activities, bazaars, collection of donations, and new building construction; arrest of committee leaders and denial of permission to leave the country; and raids on committee headquarters and seizure of their products as well as their files.

It is difficult to know exactly how many women belonged to the committees just before the intifada. Repeated IDF raids led some local committees to stop keeping membership records in 1985, when Israel initiated the Iron Fist policy that included an increased number of military orders on the West Bank and the arrest of leaders of volunteer organizations. Those that continued to maintain membership files stopped doing so shortly after the beginning of the intifada and the heightened danger of retaliatory raids. According to Palestinian scholars, perhaps 2–3 percent of West Bank women were committee members at the end of 1987, an estimated 10 percent used some of their services, and a total of 15–20 percent were involved with them in some way.

The major difference between the new women's committees and the earlier societies was what one scholar called the "level of political consciousness" of committee leaders. This resulted in empowering members and raising their political consciousness through voting for officers and deciding on agendas. Most activities of the two types of groups—embroidery, sewing, food production, child care, literacy—were similar, but decisions in the older groups were made by the leaders for the members they sought to help.

Even In'ash al-Usra, which empowered women by training them in marketable skills, did not permit them to help design the programs. The committees' pre-intifada goal was the sense of personal independence that would enable women to contribute to the struggle for national liberation, and involvement in the committees was the equivalent of involvement in the national liberation movement. Although the committees' conceptual framework included the subjugation of women, their practice was based on a two-stage process of national liberation now and women's liberation later. This prevented them from challenging either the control of men over political, economic, and social life or the continuing gender-based division of labor at home. So they addressed specific "women's issues"—child care, female illiteracy, women's legal rights—rather than more basic problems of women's role and the economic relations between men and women.

A few women leaders understood that this was not enough if women were to achieve anything like equality. Amal Wahdan, who moved from student organizations at Birzeit University to the trade union movement and to the women's committees, kept maintaining that "the struggle for our rights as workers and as women should start now or we'll end up with another bourgeois state and another kind of regime that will oppress women and the working class. It all has to go side by side." Rita Giacaman observed, "The danger in the present strategy for women's liberation is that an exclusive emphasis on the national question now might make it impossible to adequately address other contradictions later." But the women's committees faced an uphill job in overcoming centuries of adherence to gender roles. Acceptance by society required them to build most of their activities around women's traditional functions. Making it possible for women to engage in them outside their homes was an exhausting task as well as an extraordinary cultural change. The committees therefore concentrated for the most part on visible gains rather than an attempt to alter ideas about gender roles.

Their pre-intifada successes lay primarily in urban areas. They were seemingly unaware of the enormous but still dormant strength of the mass of nonurban women, viewing them as unlikely

recruits for a women's movement that by its very nature repre-
sented a radical break with tradition. The committees achieved
extraordinary success in freeing some women from a life of confine-
ment within their homes and in persuading their families to accept
their new freedom; articulating—but not necessarily achieving—
the demand that employers provide equal pay for equal work, sick
leave, and maternity leave; creating child care centers; training a
small number of women for economic independence; involving
women in the national struggle; and, through the grassroots struc-
ture, empowering poor women rather than making them the ob-
jects of middle-class programs.

The fact that only 2 to 3 percent of West Bank women are involved
in committee work masks the magnitude of the change involved.
These were the daughters and granddaughters of Palestinian
women who had left their homes only in the company of female
relatives, who were in a different room when men came to the
house to talk politics or simply to socialize, whom no one saw any
point in educating. An Arab woman writing in the 1980s described
the life of others as one "of renunciation, of captivity, during which
[they] will have to atone for [their] sin of having been born [women]
in a hyper-male society where the ever-present feminine remains
synonymous with shame and threat." The women's committees
had torn that definition from their shoulders in their march toward
equality and had left it piled with the veils and head coverings they
would no longer wear.

4

Scenes of Life Under Occupation

"If they want us to be active in the national struggle, expect us to be different at home."

July 4, 1989: Marie has returned quickly from food shopping in the city center because the *shabab* were about to set fire to tires, block the street, and lure soldiers to a place where they'll be stoned. Her decision to get away from the demonstration is interesting. I've heard no one express opposition to the intifada and its goal of a Palestinian state, but there are big differences in how people participate. Elderly upper-middle-class urban women like Marie support the intifada through sponsorship of handicraft projects for poor women. Her church society supplies them with materials for embroidery and pays them after marketing their products. The society also visits the families of the wounded and dead. The enormous changes the intifada has brought about in the lives of women is more obvious outside neighborhoods like ours. Women of Marie's age in the villages and refugee camps participate in the kind of demonstrations she avoids. So do poorer urban women. Villages and camps are cohesive communities, leading most residents to feel more involved, and women in camps and villages, their men working elsewhere, are used to assuming previously male roles.

The little shopping Marie had done before the demonstration left her appalled at the prices. Her pension, like that of many West Bank residents, comes from Jordan in dinars. Israel will permit each

individual to receive no more than 200 JD ($250) a month, and the exchange rate of dinars to Israeli shekels, the basic commercial currency, has dropped by a third during the last year. One of the causes of Palestinian discontent has been Israeli inflation. Israeli policies had encouraged the territories' economic dependence, and prices here zoomed when Israeli inflation was high. Israelis were not severely hurt because their salaries are "linked" to the cost of living index and were raised accordingly. The Palestinians have no such linkage, so the Israeli goods are expensive for Palestinian incomes even now that inflation has been brought under control. With the addition of the limit on bringing in money and the falling value of the JD, Palestinians are hurting economically—even if they've got decent Jordanian pensions or money in bank accounts outside the country. It's not the basic reason for the intifada but it is a contributing factor. The creation of an alternative economic infrastructure, with Palestinians building factories and organizing cooperatives to produce more consumer goods, is in part an attempt to end economic reliance on Israel.

July 6: Ramallah is tense today. Yesterday the Likud party's central committee met and Prime Minister Yitzhak Shamir enunciated his "four no's" about the proposed local elections in the territories: no participation by East Jerusalem Arabs (Jerusalem Mayor Teddy Kollek has found no problem with such participation), no negotiations until the intifada stops, no Palestinian state, no cessation of Jewish settlements. The conditions make an election impossible, particularly as Shamir probably would not have made even the limited offer had it not been for the intifada. There are more soldiers than usual in the streets and people are constantly checking their watches as if they're expecting demonstrations.

I walk from the center of town to the Birzeit board of trustees building and meet Islah Jad, of the Department of Cultural Studies, who has written about the status of Palestinian women. She's on her way to class and I'd like to call later to discuss her work but can't: her family, like others, has been unable to get a telephone. It's not unusual to visit a home here filled with the products of modern technology—refrigerator, dishwasher, food processor, color television, stereo cassette player—but without a telephone. The Israeli

company that installs telephones acts as an arm of government policy in the territories. It's ended a decades-long practice of taking years to install telephones and Israelis can now get them within a few months, but Palestinians still wait for as long as a decade.

On the subject of telephones: while I was in Tel Aviv I called a friend who's a prominent member of the Israeli establishment, and promised to call him again from Ramallah. He said he assumed I knew that all the telephone lines in the territories were tapped and monitored by a computer bank but that it didn't bother him to be called from there. I can hear the regular click of the tap whenever I use my telephone to call the outside world, whether as near as West Jerusalem or as far away as the United States. The Israelis certainly can tap telephones without the telltale click, so presumably the taps are there less to obtain information than to remind Palestinians of who's in control.

I'm going to the PFWAC offices with Penny Johnson, who works in the Birzeit public relations department. We're given a lift by an Englishman who's one of her colleagues. Cars are identified here by the color of their license plates. Those of Israelis and East Jerusalemites are yellow; those of the territories, blue; local cabs, green. The Englishman's car has British black-on-white license plates that can easily be mistaken at a distance or at night for Israeli black-on-yellow plates and put the driver in jeopardy of being stoned. That's why he's placed a *kuffiyeh*, the traditional black and white or red and white head covering worn by men, on the dashboard to signal his loyalties. The cars of Palestinians from East Jerusalem have yellow license plates. When they drive to Ramallah, a *kuffiyeh* goes on the dashboard as soon as they leave the outskirts of Jerusalem and is quickly stuck under their seat on the return journey when they reach Jerusalem. An American who frequently comes to the West Bank in the cars of Israeli peace camp members tells me that she carries a kerchief to pop on her head whenever they reach a checkpoint so the soldiers will think she's an Orthodox settler and let the car through. As soon as the checkpoint's behind, she takes off the kerchief and a *kuffiyeh* appears on the dashboard.

July 7: I manage to locate the newspaper store without too much difficulty and then walk to al-Haq, where I find the staff upset:

one field worker and his brother were arrested last night. Five of al-Haq's field workers, who gather information about human rights violations under the occupation, have been arrested at one time or another and taken to Ketziot, the tent camp that Israel erected in the Negev for Palestinians under administrative detention. It has been strongly criticized by Israeli and international human rights organizations for its poor food, insufficient water and medical care, overcrowding, lack of access to relatives, and only sporadic access to a lawyer. Apparently whenever one of al-Haq's field workers is released, another is imprisoned. The news makes it difficult to sit down and read—harder, of course, for the people around me, who know the man—but I'm beginning to understand that if work stopped whenever a friend or colleague or relative was jailed or beaten, no work would ever be done.

I take the *service* to East Jerusalem, where Islah Jad is to give a lecture about Palestinian women at the UPWWC offices. They now house part of a collection of children's drawings depicting the intifada. The drawings had been on display at a theater in East Jerusalem, but the IDF had gone into the theater (without written authorization, not legal in Jerusalem) and had threatened to destroy the drawings. The owner rushed to get Jonathan Kuttab, one of al-Haq's cofounders, whose law office is in East Jerusalem, and Jonathan had managed to prevent the destruction. But the drawings were safer elsewhere. They show bombs or flowers falling from helicopters, *shabab* running, the Israeli and Palestinian flags together. The occupation leaves no hiding place, and even very young kids are clearly affected.

The lecture is attended by about thirty-five women, wearing everything from traditional dress to jeans. Most of the subsequent discussion is devoted to a dialogue engendered by a traditionally dressed member of the audience who expresses her vehement objection to young women visiting the wounded in hospitals while wearing shorts, T-shirts, and lipstick. She's offended by their immodesty. She refers to one incident in which the women were pelted with eggs and says that while she wasn't among the throwers, she was glad the women were treated that way.

She's touched a particularly sore point. An explosive discussion

ensues. Many modern Palestinian women interpret the pressure to wear "modest clothing" as part of an illegitimate attempt by fundamentalists to reject modernity and women's redefinition of their roles. The women at the meeting retort that they all wear dresses with sleeves and high necklines. I remember shopping in New York with Mona when she was thinking of her imminent return to Ramallah and was avoiding any blouses that were sleeveless or low cut. The woman who raised the subject has implicitly referred to an important dilemma that's not being discussed. While women who choose to dress in modern style deplore those who don't, they can accept the right of others to dress differently because they're not offended by long gowns or *ahjiba* on others. But modern dress, when it is particularly revealing, does trouble some traditional women. There's tacit realization of this by some modern young women I've seen visiting the wounded in hospitals and mourning families. Respecting the sensibilities of those who may be more traditional, they often tuck a long-sleeved shirt into their jeans. Aware of the traditional women's disapproval of their clothing, the modern-dressed women at the meeting focus their remarks on methods of resolving communal conflicts that respect all Palestinians engaged in the struggle. I wonder quietly how they will confront the problem of fundamentalist sensibilities without offending them.

I've noticed that many women, particularly outside the cities but including working- and lower-middle class urbanites, have given up makeup and jewelry other than earrings for the duration of the intifada because it's not considered appropriate to concentrate on self-beautification while a national liberation struggle is going on. I lean over and whisper a question to a neighbor: Why, if the traditional woman is insistent on modesty and low-keyed apparel during the intifada, does she wear earrings? I've seen her at quite a few demonstrations and visits to mourners, and she does wear different earrings. The reply, verified by others, is that earrings are so ubiquitous that they're considered a part of clothing. Girls here have their ears pierced no later than their early teens and everyone takes small earrings, unlike bigger jewelry or cosmetics, for granted.

July 8: I'm going to visit a cooperative, one of the increased number of production teams organized by the women's commit-

tees during the intifada. Lubna, my jeans-clad guide from the
UPWC, was studying for a degree in economics at Birzeit and
working with the committee part-time before the universities were
closed. She's currently doing committee work full-time, often ac-
companying the frequent visitors who have come from abroad on
fact-finding missions while waiting for the chance to complete her
education.

We take a cab to Beitello, about 36 kilometers northwest of
Ramallah and impossible to get to by public transportation other
than private cab. It's a lovely little village of about two thousand
residents, surrounded by the vine-covered, terraced rocky hills
typical of the terrain. It's also the home of Production Is Our Pride,
a cooperative founded through the joint efforts of the UPWC, Birzeit
University professors, and some of the Beitello women.

In 1986, Elizabeth Roed, representing the Norwegian Save the
Children organization, arrived in the West Bank and offered to stay
for some months to help with whatever project the women's com-
mittees suggested. Factional politics kept the committees from
working together to identify a project and eventually Elizabeth and
her organization accepted the UPWC's idea to establish a women's
cooperative. The UPWC knew that its Beitello committee was active
and was eager to be more so. It therefore planned a food co-op,
drawing on the skills of committee members and other women in
the town. This was not long before the beginning of the intifada,
and the desire to avoid reliance on Israeli products already existed.
The women thought of bottling pickles, which were usually im-
ported from Israel, as well as carrots and beets. A marketing study
undertaken by the committee showed no demand for prepared
carrots and beets, so the co-op decided to concentrate on pickles,
although it has since added stuffed eggplant and apple and plum
jam to its product line and is now considering producing tomato
paste as well.

The Beitello committee announced formation of the co-op and
asked all interested women, without regard to membership in the
committee or any political faction, to join. Twenty-one, most of
them not affiliated with any committee, responded. Roed organized
a training session that met one day a week for nine months and

covered accounting, nutrition, marketing, co-op management, and hygiene. The lessons were taught by members of the Birzeit University faculty. The co-op opened for a three-month trial. Of the nineteen women who finished the course, six were obligated by their families or by family responsibilities to drop out, but the co-op still consists of the thirteen women who remained and had the project in place by September 1987.

During the three-month trial two of the faculty, who were from Ramallah and were familiar with many of the shopkeepers there, began the marketing process, taking the women of the co-op with them. The trial period was indeed a trial. The co-op had no equipment and the women had to do all the pickling and bottling in each other's homes. The women are between age sixteen and sixty. Most are married mothers in their twenties who understood that they were on trial not only in the eyes of the UPWC but more important in those of their families and village: if they failed to perform their usual homemaker functions, they would be prevented from working in the co-op. So they rose before dawn each morning, prepared food, cleaned their homes, and then arrived at 7:00 A.M. "to work"— in their words, an implicit suggestion that their earlier activities were in a different category. Because the village has no child care facilities, they had to bring their children with them (the UPWC is now trying to raise money for a nursery). They frequently worked until 4:00 P.M. and then returned home to finish cooking and serve dinner, clean up afterward, and collapse into bed. They estimate that they each put one hundred hours a month into the co-op, nagged by feelings of guilt about neglecting their children, exhausted, and angry at having to make major sacrifices to have a business of their own. But they describe themselves as absolutely determined.

Life became a bit easier when the Norwegian organization bought two machines, one for sealing bottles and the other for vacuum packing, found an empty apartment in the village and turned it into a factory, and said it would pay for the early expenses of rent, electricity, and raw materials. The running expenses have now been picked up by the UPWC, which sometimes can't give the co-op enough money for raw materials. It expects the co-op to be

able to cover its overhead within a few months. The co-op's physical plant is still rudimentary. The three-room factory has cement floors. One room has a wall of shelves with products, two big tables, a number of folding chairs, the two prized machines, a fan, and an electric wall clock. Meetings are held here by the co-op and its elected executive committee. A smaller room is used as a warehouse. The third contains sinks, shelves, pickling vats, and a large work table.

The products are packaged in elegant silver paper packages that are labeled in English as well as Arabic because of the many foreigners who visit the Ramallah-Jerusalem area where the food is sold and because delegations of foreign women frequently come to the factory. The co-op members decided to expand into stuffed eggplant when they realized that some of the nearby urban women working at paid jobs would be more amenable than village women to the radical idea of buying prepared foods. To maximize their marketing possibilities they make certain that they prepare the eggplant exactly as they would in their homes, by a laborious, time-consuming process.

The lack of public transportation made marketing a problem. Earlier, the women hitched rides into Ramallah with their products when they could. Now they have the use of a mini-bus twice a week. When times are good, they get their products to market eight times a month, selling about 260 kilos (roughly 570 pounds) of pickles each month, somewhat less of stuffed eggplant, and less still of their jams, earning a total of 1,000 shekels ($500). Their prices are low: the plum jam, for example, costs 3 Israeli shekels ($1.50) for a 1-kilo (2.2-pound) jar. Thirty percent of the gross price goes to the women, depending on the numbers of hours they work. The remainder is used for costs. When I interview Maha Mustaqlem, the head of the UPWC, she tells me that this, like all the committee's co-ops, produces an average wage for its workers at least equal to any they could receive in Israel. The unpredictability of their hours has made them willing to think about starting a new training program for the many women who have inquired about membership. They won't permit anyone to join who has not been trained as they were. I think that with their training and experience they are capable of teaching

women to run additional co-ops, but they're far too busy to consider that idea.

Good times are those in which the co-op is not subject to army harassment such as confiscation of its goods for nonpayment of taxes (the Unified Leadership has called on the population not to pay Israeli-imposed taxes), curfews, or a high number of either planned or spontaneous strikes. When I visit in January, I'll learn that the IDF recently stopped the mini-bus at a checkpoint. There were no products in the bus, which is owned by a woman not affiliated with the group, but there were papers with the names of co-op members. The bus was seized while an investigation was undertaken, and the IDF discovered that the co-op, registered with the government as a company, had not paid taxes. The members were threatened with arrest, and one member has had to accompany a newly hired accountant on daily visits to military headquarters to negotiate about the amount of taxes owed. Eventually, the women will realize that the amount of taxes negotiated would pay for a new bus and that even if the taxes currently assessed are paid, it is likely that the bus will be seized again in the future. They will therefore decline to reclaim the bus and find informal means of getting their goods to market. At the moment, however, most production and all sales have had to be stopped temporarily, although cucumbers are still pickling in colorful vats. Another reason that the co-op's financial independence is running behind schedule is that part of its income is derived from bottling and selling olives. The olive harvest in 1990 was poor, as it is every second year.

The co-op is run along completely democratic lines. Decision making rests with the general membership; each member has one vote. The co-op's constitution can be altered only by two-thirds of the membership, which elects an executive committee each year: a chairperson, secretary, treasurer, and coordinators for production, marketing, and sales. Executive committee members are quick to point out that they undertake their duties for no additional compensation. Once the co-op is financially independent, it will decide what proportion of its gross proceeds to allocate to wages and social welfare insurance: an annual medical examination, medical

insurance, maternity and annual leave, and use of the planned nursery. A similar UPWC co-op in the village of Sa'ir, near Hebron, which began marketing in April 1988, specializes in dried fruits and vegetables and grape-based molasses, a Palestinian specialty. Both co-ops hope they'll eventually be able to set up shops in refugee camps and villages.

I ask the women if their husbands, who they say now appreciate their work, have demonstrated their appreciation by taking on additional responsibilities in the home. They've obviously talked about this because they immediately smile at one another and answer that their husbands are too selfish for that. Pressed further about why they have undertaken such a major and demanding project, they answer that they want to enable women to contribute to their families economically and to engage in nontraditional roles while freeing Palestinians from their reliance on Israeli products. They feel that by making foods traditional to Palestinian cuisine, even in a nontraditional setting, they are performing a nationalist as well as an economic function.

Like their counterparts in the 'Eisawiyya enamelware workshop, these women have little education. Most wear ankle-length dresses; those who do not still wear head coverings. But what they're doing is far from traditional, and they are very proud.

5

Intifada: The First Years

"He is my son!"

"It's my struggle too; it's for my country."

The physical involvement of women in the intifada, particularly during its first year, meant a major change in activities considered permissible for women and shook the old ideas of women's dependence and isolation from the public eye. There was no question before 1987 that the role of women was in the private domain. The intifada brought them out of their homes.

Although a main element of the early intifada was the demonstrations by the *shabab* and their consequent emergence as street leaders, the spontaneous nature of many demonstrations, such as those following funerals attended by massive numbers of people, meant that a cross section of the population was involved from the start. And more women may have been involved than men, especially in the refugee camps and villages, where the women not working outside their homes were available at all hours. They quickly became a backbone of the demonstrations both as participants and as protectors of their men when the IDF attempted to arrest them. The bulk of the violent casualties of the uprising—deaths, beatings, and teargassings—came from refugee camps, villages, and poorer city neighborhoods, precisely the areas populated by families whose men work abroad or in Israel, as well as the places that had seen a disproportionate share of pre-intifada IDF

violence. Some urban women claim that they too took to the streets before men did.

Women from all areas rushed out to play a public political function. Women who had been kept from visual as well as physical contact with men began throwing themselves between soldiers and the young men they were trying to seize. One day in the Old City of Ramallah, a poor village within a small city, women wielding pots and pans attacked a patrol of soldiers to force them to release a youth being arrested. Another day, following Friday prayers at an al-Bireh mosque, the modern-looking mother of a young man being arrested and kicked by soldiers was herself beaten when she tried to free him. A traditionally dressed elderly peasant woman promptly threw herself across the boy, crying "He is my son!" The mocking soldiers demanded to know how such an old woman could be the mother of such a young son. She snapped, "They are all our sons, not like you without mothers!" Women picked up the motto "He's my son!" and extended their traditional function of protecting their families to protecting all men at demonstrations.

On another occasion a man in his early twenties was being beaten by soldiers in Ramallah. A woman rushed up with her baby in her arms and began shouting at the man, "I told you not to leave the house today, that the situation is too dangerous. But you didn't listen. You never listen to me!" She turned in disgust to the soldiers and, telling them to beat the man, cried, "I am sick of you and your baby. Take him and leave me alone." Then she pushed the baby into the young man's arms and ran away. The confused soldiers soon left the scene. In a few minutes the woman reappeared, retrieved her child, and wished the young man safety and a quick recovery. They were total strangers. The degree of women's success in protecting men from the IDF is indicated by one scholar's comment that "it has become dangerous for men to participate in demonstrations or marches in the absence of women."

The women not only protected the men around them but also engaged in spontaneous demonstrations of their own, expressing their outrage at violence by soldiers or Jewish settlers, at arrests or killings, at the deaths and wounding of women and children, and at the miscarriages attributed to exposure to teargas, especially when

canisters were thrown into homes or hospitals. The misuse of teargas in confined spaces has been particularly devastating for pregnant women and their young children. A report issued on May 5, 1988, by the chief physician of the IDF stated that thirty women who miscarried at Shifa Hospital in Gaza had been exposed to teargas within four hours prior to their miscarriages. In Beit Fajjar, near Bethlehem, soldiers forced a resident into his home and shot a teargas canister inside. The eleven-day-old infant in the room immediately began having breathing difficulties. The family took him to a local doctor but couldn't get to a hospital because the army had placed a curfew on the town. The infant died. On January 16, 1988, a number of canisters fell into the front yard of a house in Qalqiliya; gas wafted into the home. The two-month-old twins inside almost immediately developed fevers and continuous coughs. Their mother rushed them to a health center near the house, where one child was pronounced dead. She took the other to Tulkarem Governmental Hospital, where he was given first aid and hospitalized for thirteen days. The doctor who signed the first baby's death certificate told the mother the child had died from exposure to teargas. By March 1988, three months after the intifada began, reactions of women in the territories to these incidents had resulted in a weekly average of 115 women's marches. Sixteen women died in them. An eight-by-four-inch sticker distributed jointly by the women's committees on March 8, 1989, International Women's Day, had drawings of fifty-seven roses torn up by their roots. Under each was the name of a woman killed during the intifada.

Teargas has also been sprayed directly at women. A fifty-year-old mother attempted to interfere with the five soldiers holding and kicking her fifteen-year-old son. A soldier pushed her to the ground. "When I got up I begged the soldiers and said: 'May God keep you, please release my son.' The soldier who had pushed me took a tube from his pocket and sprayed gas in my face and eyes. I had difficulty breathing. My face started to burn and tears came pouring out of my eyes. I was sprayed with gas for about ten seconds. I then lost consciousness and woke up to find myself in Ramallah Hospital with oxygen in my nose and a glucose injection [intravenous tube] in my hand."

Women were beaten and shot even when they were not partici-

pating in demonstrations. Al-Haq has noted that most women subjected to violence during the intifada have been in their homes, frequently attempting to protect male relatives from physical assault or arrest. On January 19, 1988, for example, soldiers broke into a home in the Jenin district, continuing to beat the male householder after they had taken him outside and tied him, hands behind his back, to an electricity pole. A group of women attempted to rescue him. One woman had begun to untie the thin metal cord binding his hands "when one of the soldiers came up to me and kicked me to the ground. . . . But I gathered my strength, with some difficulty, and went back and untied the cord completely; but I discovered that he was also bound with plastic handcuffs that I couldn't take off." The soldiers began firing and the women retreated, stopping about thirty feet away. One of the soldiers then "pelted me with a rock weighing about one kilogram and hit me in my abdomen under my rib cage; I still suffer from the effects." A woman in the Balata refugee camp found one of a group of soldiers in her home pointing a gun at her brother-in-law, who had been forced to kneel. "I stood between them. The soldier told me: 'Move or I will shoot.' I refused and told him that he could do so if he wished. He warned me again but I refused, so he directly fired at me and hit me with two bullets in both . . . my legs." Ten minutes later, when the soldiers were taking the man from the house, his sixty-year-old mother attempted to interfere and was shot in the leg. Al-Haq has concluded that "it is absolutely clear that soldiers resorted to lethal force when they were not in a life-endangering situation." In January 1988 a mother of eight children in the same refugee camp was beaten to death while attempting to rescue a young man.

The protective function of women has continued. A mother who returned to her home in the Jenin refugee camp when told that soldiers were raiding her house found a soldier beating her children, who were three, five, eight, nine, thirteen, and sixteen years old. She herself was beaten when she tried to push him away. The fifty-two-year-old mother of a wanted man in Beit Furik, near Nablus, was shot trying to protect him in February 1990 when soldiers entered the village disguised as women and arrested him

and another man at a local clinic. A few days later five Nablus women, attempting to stop soldiers who were beating ten boys, were themselves beaten.

Some of the women who have died during the intifada were passersby killed by chance, like the forty-five-year-old Bethlehem housewife in the market who was shot in the eye during a demonstration, the fifteen-year-old killed while visiting relatives in the village of Rafidiya (near Nablus), the eleven-year-old shot while leaning against the door of her Nablus home watching a demonstration, and the seventeen-year-old on her way home from school shot in the chest when soldiers opened fire on a main street after their vehicle had been stoned. Two hundred Nablus schoolgirls marched to commemorate the dead seventeen-year-old. A five-month-old girl died of suffocation in Kafr al-Deek, in the Nablus area, when teargas canisters were thrown into her parents' home during a raid in the village. In June 1990, a number of *shabab* carrying rocks in the Tulkarem refugee camp were chased by soldiers. One youth turned to throw a rock, which struck the commander of the patrol, and then raced into an alley. The commander followed and, reportedly seeing no one but the youths, aimed at the one he had identified as their leader. The plastic-covered bullet hit and killed a nine-year-old girl who had just emerged from her adjacent house. A curfew was immediately placed on the camp, but residents defied it and began demonstrating. While breaking up the protest, soldiers killed a twenty-five-year-old woman who was passing the area on her way home and was hit in the head by a stray bullet.

Other women were deliberately chosen as targets. Soldiers who saw burning tires near the home of a Nablus businessman raided the house and beat family members aged nine to fifty, including his sister Shifta, a doctor, who along with three others had to be hospitalized. A sixteen-year-old studying on the roof of her house in the Shati refugee camp and using the water tank as a writing board was killed by a plastic-covered bullet. In the course of an investigation by the Association for Civil Rights in Israel, a Member of Knesset asked Defense Minister Rabin a parliamentary question concerning the death of another young woman, a fifteen-year-old in the village of Jeba', near Jenin, who was shot when the IDF arrived to look for her

twenty-two-year-old brother. The IDF shot through windows into the room where the family barricaded itself after the soldiers arrived, although both *The Jerusalem Post* and an attorney for the Association of Civil Rights in Israel later visited the house and discovered that the windows of the room were covered with metal grilles that would have made it impossible for the wanted man or anyone else to escape. The IDF reportedly continued shooting even after family members shouted that there were casualties—among them the man, who had been wounded, and another sister, eighteen-year-old Asmahan, who was wounded when she rushed to help him.

The only explanation the IDF offered for the shootings was that one officer broke a window of the house and put his hand inside to remove the curtain. He was stabbed by an unknown person inside. He reported that this "forced" him "to open fire from his pistol," killing the fifteen-year-old, and that Asmahan and her brother, still inside the house, "threw various articles at him such as kitchen knives, vases and sickles," causing him to shoot at Asmahan and wound her. Asmahan was taken to jail. She reportedly was beaten, cursed, and threatened with rape when she tried to cover the breast of her dead sister in the military vehicle that took both the live and the dead sister as well as the wanted man from their home. Her attorney could still see the bruises when he was permitted to visit her. She was kept in solitary confinement and was not permitted to wash the blood from her body for six days. It was December, but she had no shoes or stockings. The bandages on her wounded leg were rarely changed. A month and a half later, M. K. Shulamit Aloni asked Rabin another question about the continued detention of Asmahan, who was denied bail although no charges had been brought against her and no court hearings had been held. Asmahan then was taken to court, her leg still exuding pus and blood, and was charged with throwing objects at the officer who had said earlier he couldn't tell who had thrown them. This was the sole charge against her, on the basis of which she had been kept in solitary confinement and denied adequate medical treatment.

The women continued to march, and the IDF continued to respond violently. In November 1989, women held a pre–independence day march in the al-Am'ari camp. Women marching in downtown

Ramallah the following month were dispersed by soldiers, who used gravel cannon against stone-throwing *shabab* protesting the soldiers' actions. There were numerous marches and sit-ins by women on March 8, International Women's Day. In Nablus, about a hundred and fifty marched behind Palestinian flags, carrying posters calling for the end of Soviet immigration. Close to two hundred Beit Sahur women were joined by about a dozen Israeli women peace activists when they took the authorities by surprise by holding their Women's Day march three days early, carrying Palestinian flags, singing and chanting slogans. The march was dispersed by teargas. A twelve-year-old girl was struck in the head by a rubber-coated bullet and eighteen other women were injured by teargas when police broke up another Women's Day demonstration in Jerusalem's Old City. Troops beat three girls, one of whom was hospitalized, when four hundred women carried flags and anti-immigration posters through the Nablus casbah. Ten women were treated at the Ramallah Hospital after rubber-coated bullets were fired at about a hundred women marching near the old quarter. In Jenin, a seventeen-year-old was injured in the head by a rubber-coated bullet in one of four processions of women and girls. Similar marches, also broken up by rubber bullets and teargas, were held in Tulkarem, Bethlehem, Hebron, Halhul, and elsewhere.

By the end of 1989, sixty-seven women had been killed in the territories, and al-Haq had evidence proving that forty-six of them had been killed by the IDF. Of the forty-six, thirty-three of whom were from the West Bank, twenty-eight were killed by live ammunition, eleven by teargas, two by rubber-coated bullets, one by a plastic-coated bullet, and four by other means. More women and girls were killed in 1990 and 1991, including a ten-year-old who died two days after being hit in the head with rubber bullets during clashes in Qabatiya, near Jenin. Some women began assuming more active roles in mixed-gender demonstrations, even as the nature of demonstrations changed. There are fewer and smaller spontaneous demonstrations as the intifada continues. In their place are well-organized marches by young people, including women, who are no longer willing to subject themselves to jail and who therefore mask their faces with *kuffiyehs*, the head coverings

used by men. On the 1989 anniversary of the founding of the Popular Front for the Liberation of Palestine, for example, it was young women as well as men who masked their faces with *kuffiyehs* or hoods bearing the colors of the Palestinian flag and marched in Birzeit. A twenty-two-year-old woman and a twenty-six-year-old man were killed in a demonstration in Bani Naim on the second anniversary of the intifada. Some of those in the women's demonstration that took place in the Nablus casbah and in which twenty-five people were shot and wounded were wearing *kuffiyeh* masks. On January 23, 1990, during my second stay in Ramallah, we would hear that the IDF had shot and killed a man in Nablus the night before. Two days later two young women masked by *kuffiyehs* led a march of about one hundred people in his honor and read a eulogy on behalf of the PFLP. A sixteen-year-old girl was shot in the leg and hit in the eye by a rubber bullet during mixed-gender demonstrations in Qalqiliya on the anniversary of the founding of the Democratic Front for the Liberation of Palestine.

In a war situation women are always confronted with the threat of sexual violence and men are always tempted to use such violence as a threatened or actual method of punishment and control. Traditional mores made it unthinkable that Palestinian women hearing men even mention sexual acts would do more than cover their ears or shriek with horror. The intifada changed that. Al-Haq has documented numerous cases of soldiers using obscene language. It was something I would experience frequently while walking with other women, although as the soldiers have learned how to curse in Arabic I was dependent on the others for the sketchy translations they were willing to give me. There have also been cases of soldiers exposing themselves to women. The IDF jailed one such soldier for twenty-eight days and reprimanded two others when a brave neighbor took photographs that were published by the media. (The self-exposure phenomenon seemed to be catching. A few days after it was reported, I began hearing tales of other, undocumented incidents. In an attempt to verify the reports, I was taken to the town of Beit Sahur and saw four soldiers walking naked on a rooftop. My camera was not good enough to photograph their faces and I probably wouldn't have used it in any case: soldiers may

shoot when they see photographs being taken and, at the least, seize them and beat the photographers.)

Women probably have shocked soldiers as much as themselves not only by resisting physical assaults but by returning the soldiers' sexual taunts and using explicitly sexual language to question their manhood. The reliance on women for protection may have begun as an extension of a traditional role but the forms it took, at least during the first year of the intifada, suggest a new and different sensibility. A number of anecdotes have become part of the folklore. One involves a young man who fled after participating in a demonstration and dashed into a village home for protection. The elderly woman he found there immediately ordered him to undress and put on her son's pajamas. The soldiers who soon arrived knew that the man they were seeking was not this woman's immediate relative and left, certain she would not be in the pajama-clad presence of anyone else. The story is told of another fugitive who was quickly hidden in the bed of an older woman's unmarried daughter.

The stories were told to me by village women; urban women, hearing them, were skeptical about such things having happened. Whether or not such stories are true is less important than the fact that they could be recounted, with laughter, and implicitly accepted by an insistently protective patriarchal society as appropriate behavior in a time of emergency.

Palestinian women face sexual threats and sometimes overt sexual abuse by soldiers. Before the intifada, a woman "contaminated" by such treatment, whether at the hands of soldiers or of men of her own society, would have been ostracized if not killed. Women who were prisoners during the first year or so of the intifada report being treated as heroines by men as well as women. This change in attitude toward women led Birzeit Professor Eileen Kuttab to suggest that "the honor of the women has a more political and nationalist context now.... The women feel that their honor is really in protecting people, not their own bodies.... Many women have survived interrogation and remained politically active. They don't give confessions; they feel this is their honor, a way to prove themselves, that they can be equal to and as strong as men." Her colleague Hanan Mikhail-Ashrawi added, "The whole system of

taboos and the definitions of honor and shame have changed. Now it is the national issue which determines what is shameful and what is not, not the social issue."

A new kind of committee, the "neighborhood" or "popular" committee, drawn from local men and women, came into existence in the early days of the intifada. It was only in the second stage, however, beginning in March and April 1988 after the euphoria and confusion of the first stage had ended and the need for long-term planning became clear, that consolidation and extension of the fledgling committee network was undertaken. After International Women's Day on March 8, 1988, women institutionalized their protective function by forming teams designed to prevent arrests. An entire infrastructure of highly specialized popular committees was organized. Some provided emergency medical treatment, blood-typed entire neighborhoods, or taught first aid. Education committees came into existence, primarily to replace the schools as the authorities began to close them on the grounds that they were indoctrinating and rallying the protestors, but also in part to provide an education different from that offered by government-run schools. Some committees stockpiled food and other necessaries that were distributed when curfews, sometimes lasting for weeks, were imposed. Others collected money for families that lost their incomes from the imprisonment, deportation, death, or wounding of the wage-earning men. (As the intifada continued, additional families became needy as the men were laid off by their Israeli employers or were unable to work full-time because of curfews or the self-imposed strike hours and strike days. Other families suffered from the Israeli limitations on importation of money, including Jordanian old-age pensions.) There were committees to aid in planting home gardens, to clean the roads, to ensure proper disposal of garbage, to provide information to the media—in short, to maintain an entire societal infrastructure.

Although these were mixed-gender committees, it was women who were most active in almost all of them. Women in some towns and villages even claim to have been in charge of some popular committees. Women's committee activists were among their first members, marching, building barricades, smuggling food and other

necessities to communities under curfew, and supplying rocks to the *shabab* as soon as the intifada began. The women's committees were a model for the popular committees, with which they cooperated and in some cases overlapped. They also provided a mechanism for women wanting to increase their involvement in the intifada. Hanan Mikhail-Ashrawi has noted that "the grass-root women's committees were formed in the late 1970s, not 1980s, and it was this long process of politicization, socialization, and social work activities that gave women in the intifada their strength."

There was also a dramatic rise in the variety of agricultural and food production projects and the number of women involved in them. Such projects are a key element of the intifada's drive for self-sufficiency and creation of an economic infrastructure. They also contribute to the empowerment of women. One typical example is the women's agricultural committee that was formed in a refugee camp near Jericho. Moyassar, the twenty-eight-year-old mother of four children, was married at fifteen. Her husband refused to let her work until the combination of the intifada and his imprisonment changed his mind. One of the women's committees, organizing the agricultural committee, helped her plant a small herb garden in a plot behind her house. She picks, washes, and chops the herbs, which a committee member collects for marketing. A twenty-one-year-old rural woman helps another women's committee harvest eggplants specially ordered from her husband's farm for the committee's pickling project. "As rural women, we have been working on the land all our lives," she said, "but we did not take a role in the decision making and we never dared to ask to be paid. . . . Now we can . . . [participate] in the decision making." Another rural woman in an agricultural cooperative added, referring to International Women's Day, "The eighth of March means something to me now. Not long ago I thought that this date didn't concern me or Palestinian women in general."

The reaction of both men and women to working together in the neighborhood committees is instructive. A committee newsletter quoted one young woman who, asked whether her activism in a neighborhood committee had led to problems, said, "Not at all, although my community is conservative. I think that in the uprising,

many people have put their conservatism aside. I am respected by my neighbors. . . . In the beginning, I felt a certain timidity from the young men who . . . believe women should take a more active role but who also hold traditional social values. But I think this interaction between men and women will become more natural." A women's committee member is quoted in *Voice of Women*, a publication of another committee: "Really, the shebab's respect for us increased because of our awareness and our role in the streets and in the neighbourhood committees. Our initiatives gain us the respect of all the people, not just the young men." She added, however, "But this is not everything. We have to give more, make a stronger effort, not to lose their respect and to transfer it to their daily behaviour, to reflect the change in the position of women in the future." Another woman commented: "When we went to demonstrations or participated in clashes in the beginning of the Intifada, we met groups of young men. We didn't speak to them, because of the social customs we were raised with, and also to prove to people that we were there to confront the soldiers and not to meet boys. But later on, we would talk to them every day. We would make plans, build barricades for the streets, burn tyres, and would provide the boys with stones as well as throwing stones ourselves. So the trust between us increased and we feel now that they respect us." She, too, perceived a continuing problem: "But they still believe that we are weaker than them and sometimes we hear things like, 'You have long fingernails—give me those stones, and I will throw them for you.' But we have discussed these ridiculous comments with them," and many of the men have stopped trying to coddle the women.

The alteration of the relationship between the sexes was closely connected to a wider transformation of the authority patterns in Palestinian society, particularly the lessening of the father's domination. In the early months of the intifada, many young women stopped automatically accepting family limitations on their participation in it. A young committee member reported, "My mother tried to prevent me from participating in the clashes, but after I was arrested, it became an accepted thing." Women, especially in the rural areas, initially lied to their parents about their participation in

popular committees or demonstrations, but some stopped doing so. I watched two parents plead in 1989 with their fifteen-year-old daughter not to visit the home of a young man who had been killed the day before during a demonstration. The couple was concerned that she might be caught up in IDF reprisals. The daughter is usually quick to respect her parents' wishes. But now she was insistent: "It's my struggle too; it's for my country," she said as she left. Some young women are involved in distributing the Unified Leadership's *bayanat*, which set strike days and hours and establish basic rules of behavior. Teenage women have been described as particularly adept at smuggling food to needy families during curfews. They have joined young men in checking to see that shops close as soon as strike hours begin and in organizing demonstrations.

Meeson Sabri, a Qalqiliya girls' high school principal, commented ruefully, "The authority of the father and mother in the family has been damaged. The youth set the tone today." Members of the working class have gained positions in popular committees that enable them to tell the economically better-off what to do. It is all part of the changed social structure brought about by the intifada.

Membership in the women's committees also changed. The danger of keeping records and the general turmoil of the intifada make it impossible to know exactly how many women are committee members, but the various subcommittees and production teams can be counted, and the number makes clear that the intifada initially raised the committees' membership. The UPWC, for example, had three thousand members in 1985 and 60 branches immediately before the intifada. In 1989 it had 106 branches, only 12 of them urban, with the remainder in camps and villages. It also sponsored forty-three cooperatives in addition to four run jointly with other committees and participated in mixed-gender agricultural cooperatives. One scholar reports that one national committee had 20 subgroups before the intifada and 100 in 1990.

The very definition of "belonging" to a committee has been altered in fact if not in form. While formal membership still exists and many women report having "joined" a committee since the outbreak of the intifada, many others participate in some or most of

a committee's activities without considering themselves members. This may be due to a continuing distaste for associating themselves with a politically allied entity or to remaining societal restrictions and their internalization. It is less "radical" to participate spontaneously in intifada-related activities than to become part of the structure of a women's committee. In addition, nonmembers are now welcome in virtually all the committees' activities, such as the agricultural cooperatives, the child care services, alternative education, food stockpiling, first aid, visiting hospitalized victims and families, and the regular meetings that were one of the hallmarks of the formal hierarchical structure but that have decreased dramatically because of the military pressure.

Certainly the intifada has taught far more women (and men) about the committees and their activities, and the consciousness-raising implicit in this knowledge may eventually increase membership. A substantial number of women interviewed on the grassroots level declared that, while they had not been "political" before the intifada, a desire to involve themselves led to participation in committee activities. In some cases their participation resulted in eventual formal membership; in a few, women taken by friends to meetings of committees outside their neighborhoods or refugee camps went even further and organized their own local groups. Political affiliation seems to have little to do with a woman's formal or informal choice of a committee; rather, membership appears to depend on which friend happens to proffer an invitation or which committee is active locally. Some committees have gained members as young as fifteen and sixteen who, working in popular committees, realized that women were the nucleus of many and sought an organizational framework in which to continue their intifada activities while exploring the nature and possible alteration of gender roles. The UPWWC has held highly successful open discussions for teenage women in urban areas and has aided young women in organizing their own sports and cultural clubs.

The intifada and the IDF's response have caused the committees to move from a geographically based hierarchical structure to a more centralized one based on function. At the same time, women's groups in universities have in effect disbanded because

the military administration closed the universities early in the intifada and have kept them closed. University women have been dispersed to committees near their homes, which makes the committees more diverse, as university women interact with nonuniversity women, and at the same time more homogeneous, for all the women share a subcultural background. University women are thus making what may prove to be important connections with others.

Women's committees apparently are not among the popular committees made illegal by the military in August 1988. The order is so unclear that one cannot tell precisely what groups were outlawed. Where leaders of women's committees have been indicted by the military government, however, their membership in women's committees alone is not cited; it is mentioned in conjunction with alleged use of the committees by other political groups. The charge sheet submitted against Ni'meh al-Hilu of the Jabalya refugee camp in Gaza, the first woman to be accused of membership in the UNLU, for example, cites her alleged responsibility "for the operating of the women's organization which worked on behalf of the Democratic Front Organization" and of leading the DFLP in Gaza, although she reported that she has been interrogated only about activities within the framework of women's organizations. Zahira Kamal and Maha Mustaqlem, leaders of two of the women's committees, have been interrogated about their committees' alleged involvement, respectively, with the Democratic Front for the Liberation of Palestine and the Popular Front for the Liberation of Palestine. But whether or not women's committees are considered a security threat by the military government, the time available for their meetings has been severely limited by the difficulties of life under the intifada. So they meet less and act more.

6

Scenes from the Intifada

"We are not going to waste the achievements of the intifada and we will be equal with men!"

July 9, 1989: A strike day. There's always one on the ninth of the month, to commemorate December 9, 1987, when the intifada began. Moving vehicles are rare. The comparison wouldn't be appreciated by either side, but Palestinian strike days remind me of the Sabbath in West Jerusalem, where the law mandates the closing of all but a few shops and restaurants as well as the cessation of public transportation. Strike days are even quieter because in Jerusalem the non-Orthodox majority drive their cars on the Sabbath, but here only emergency vehicles are permitted to move.

Mona Rishmawi arrives to say hello and chat a bit. She's home from her year of studies in New York, having returned two days before via the Allenby bridge from Amman. Everyone entering Israel that way is thoroughly searched, their luggage emptied, their papers examined. Shoes are dumped into a big communal bin from which they can be retrieved when the search is over. Stories are told of people deciding they liked someone else's shoes better and walking off with them! The heat, the interminable lines, and the noisy confusion had hit Mona so badly that she forgot to retrieve her shoes and reached Ramallah with only the ones on her feet.

She goes home and I go out to the vine-covered grape arbor behind our house for lunch. Marie has made stuffed grape leaves, the leaves picked from the vine that forms our canopy. The garden

95

in front still has flowers; the one behind has been converted into a vegetable garden—another widespread intifada measure. Marie and I are joined by neighbors, Rema and Adnan, both teachers, and their teenage children. It's a leisurely, delicious meal, and we continue sitting and chatting long after it's ended. The conversation is of course about the intifada. Whatever else people speak about in addition, that topic is inevitable. The thrust is always the same, although the wording sometimes differs: we're exhausted; the occupation has gone on too long; we've no reason to be optimistic; we'll continue the intifada, no matter what the cost, until occupation ends.

July 10: To al-Haq for some more reading. There's the sound of a demonstration and we race to the windows. We can see stones being thrown and soldiers shooting. A jeep with an ambulance-sounding siren tears up the street below us and we hear others heading for the city center. A few minutes later everyone is back at work: after all, there are demonstrations every day. About an hour later, wanting a break, I go out on the balcony and quickly call to the people inside when I see a jeep draw up to a nearby shop, brakes squealing. Two soldiers jump out, run into the shop, and return dragging a young man, whom they handcuff and throw into the jeep. The staff people watching with me say they're used to such scenes. One of them tells me she first realized how much Israelis hate Palestinians about a year before, when she was in the old market of Ramallah and a demonstration started. She tells of seeing a young man who had not been involved in the demonstration running away when he saw soldiers coming—a usual reaction because after a demonstration the soldiers tend to grab every young man in sight. The soldiers chased him and when he was finally cornered, one of the soldiers put a gun to his forehead and fired. She said she could see his brains splattered on the wall behind him; he died instantly. Nonetheless, the soldier who had shot him pulled the pin of a teargas canister and threw it on his body.

I haven't been here too long but I've learned how to react when I'm told a story as shocking as this one. It's acceptable to let my horror show, as long as I keep it within informally but carefully calculated limits. People want to tell their stories but they don't

want the kind of expressions of sympathy that will jolt them out of their rigorously maintained composure. The Israelis have the guns, they say, but it is the Palestinians who are strong. My displaying too much shock would be a sign of weakness, of not being able to take it. Women can wail when someone dies, but that's about it. I wonder where all the built-up pressure will go and if someday it will just explode.

The staffer telling me this particularly gruesome story meets with Israeli peace activists and civil libertarians and knows that all Israelis don't hate Palestinians. This isn't the time to mention it, though, because her exaggeration of their hatred is so clearly a reaction to the scene outside and her frustration at being unable to do anything about it. Sometimes when I hear outrageous statements I object and sometimes not. It depends on what is most likely to keep people talking and do the least damage to their already battered psyches, without requiring me to ignore anything really unacceptable. When I hear people talking about what "the Jews" are doing, for example, I invariably correct them. It's not the Jews, I admonish, it's the Israelis, and far from all of them. Remember the peace camp. It's this Israeli administration; it's the Likud party. That goes down well at al-Haq, where many of the staff have Israeli friends, but it doesn't go very far in refugee camps and villages, many of which have never seen an Israeli who's not a soldier and where I'm reminded that it was under a Labor party administration that the Jewish settlements in the territories were begun.

Actually, I can't much blame the Palestinians for saying "the Jews" when I remember who taught them to do so. Israel insists that only Jews have the "right" to "return" to Israel, wherever they were born, and this exclusively Jewish right of return also applies to the territories that Israel controls. Many Palestinians who were born here are kept out because they're not Jewish. Jews who live in the territories are subject to Israeli law; non-Jews come under military regulations. I still cringe when I hear "the Jews." But I'm struck almost dumb when I hear stories, like this one, about what "the Jews" or "the Israelis" have done to people simply because they're Palestinians; so many of these incidents are well documented that their collective weight becomes close to unbearable.

Later in the day, I meet Baheeja, a jeans-clad young woman from the UPWC. We go through one of her committee's nurseries and then join a group of women with whom we'll travel by hired bus to the village of Qarawat Bani Zeid to visit a bereaved family. Early in the intifada women assumed the function of going in groups to the funerals of martyrs (Islamic law gives no role to women in funerals), to the bedsides of the wounded, to the homes of the families of those killed, and to villages that had been attacked by the army to show their solidarity. This kind of activity can be dangerous. Sixty-three-year-old Husna Shihab Muhammad 'Ali Hasanein from the Jenin refugee camp, for example, started out with a woman neighbor for the funeral march of a camp resident on April 16, 1988. Shooting began and the neighbor fell, blood flowing from many places on her face, including a suddenly empty eye socket. Husna Hasanein was shot twice in the right leg while trying to aid her neighbor, who died.

The reason for today's visit is that it's almost a year since a young man from Qarawat Bani Zeid was killed by settlers who had entered the village at night to vandalize it and shoot at residents. Some settlers deputize themselves to keep the Palestinians "in their place" and to make night forays into villages and camps. Top IDF officers have repeatedly expressed their distress at the settlers' raids, but internal Israeli politics prevents their being stopped or punished in almost all cases, even when the violence can be attributed to specific individuals. The government is dependent on the votes of the far right, which consists of both the religious fanatics, who "know" that God "gave" this land to "the Jews," and those who want the land for purely secular reasons—for its space, its water, its produce. Both consider the Palestinians to be trespassers and applaud acts designed to harass, hurt, or frighten them away.

The apparel and ages of today's group of fourteen women are indicative of the way the intifada crosses lines. One older Moslem woman wearing a skirt, blouse, glasses, and head covering tries to talk to me: she can't speak English, and the only Arabic I've picked up consists of things like "Please" and "Hello" and, for the *service*, "Stop here." Not daunted, she announces (someone translates) that she'll teach me Arabic and takes my arm to escort me to the

bus. But I end up sitting next to a Christian teacher from Ramallah who is on the executive committee of the teachers' union. She's in her late fifties and teaches some of the illegal classes that are held all over the West Bank. She also works in the teachers' union as well as the women's committee and other committees and cares for her home and her youngest child.

Our conversation is interrupted when the bus comes to an army checkpoint. All the cars ahead of us are carefully searched. Don't tell the soldiers where we're going or why, I'm warned; say you're visiting a friend. If they hear we're going to see a martyr's mother, they'll turn us back. The mothers of people killed in the intifada are always referred to as martyrs' mothers. I wonder if the Palestinians know the Israelis also use the word *martyr* for those fighting for *their* state. In any event, the soldiers wave the bus on without checking our papers. There's a lively discussion when I ask the women why we got through so uneventfully. Some say it's because Israeli men consider all women so unimportant that they don't realize how involved Palestinian women are in the intifada. Others argue that, to the contrary, the soldiers are now more afraid of Palestinian women than they are of men because of the women's place in the front lines of demonstrations, their defense of young men about to be arrested, and their harassing the soldiers who retaliate by asking whether they also beat their own mothers.

The bus wends its way through the West Bank hills. As we approach the village, the driver repeatedly honks the horn to let the *shabab* know we're friends. They're posted in nearby hills, watching for the IDF and settlers. They're also around every corner as we drive through the village. The house next door to the one we're headed for is flying a Palestinian flag—strictly forbidden by the IDF, which spends a good deal of time pulling down flags and destroying anything depicting them or made in their colors of red, black, green, and white. Reaching our destination, we go into the living room, which in the Arab fashion has couches and matching upholstered chairs on all four sides. The young man's mother and grandmother move methodically around the room shaking everyone's hand. The mother looks as if she's in her seventies; I would have taken her for his grandmother. The faded green lines tattooed onto the grandmother's face are remnants of an old custom that I'll see on no one

else. As the family has no telephone, we're not expected, but it has always been appropriate for friends and neighbors to pay their respects to families in mourning. Now that the intifada has reinforced the idea of community, it has become customary for strangers simply to drop in at the homes of martyrs' families. Two family members go around the room offering water and Arab coffee. Three young women from the village subcommittee join us (I'm told this committee has about 150 subcommittees in the West Bank and Gaza). The teacher with whom I'd been speaking makes a short speech saying that these are members of the committee (in fact, a number are not members of any women's committee) who have come to show that all Palestinians are one people. "Your grief is our grief," she says. The mother replies that she's grateful and that the visit makes her feel that her son was the son of everyone present. She then asks about me, an obvious outsider. Although Baheeja was unaware of it, my ten-year-old son and thirteen-year-old daughter were killed some years ago in an airplane accident, and I ask her to tell the mother that I know what it is to lose a child and that my heart goes out to her. There's a bit more conversation and then we get up to leave, explaining that we want to make another such call in a different town. We file out, each in turn shaking the mother's hand. When it's my turn, she and I look at each other and impulsively hug and then kiss each other's cheeks. There couldn't be two more different women: different in language, religion, customs, age, education, style of life. But as we embrace we're simply two mothers, mourning.

The bus heads back toward Ramallah. There's excitement when we drive through one town that has Palestinian flags hanging from the electrical wires above the road. We also see a flag flying from the very high minaret of a mosque, which has sported a flag since the beginning of the intifada. Whenever the IDF takes one down, another is put up. Upon my return to the town in January 1990, I'll be greeted by the sight of a life-size effigy standing in the divider of the main road: a *shabab* masked by a *kuffiyeh*, a stone in one hand and the Palestinian flag in the other. The people with me don't know how long it's been up, but its presence implies that the IDF hasn't seen it.

The women want to go on to the village of Beitunia. Yaser

Abu-Ghosh, a seventeen-year-old from there who was wanted by the military authorities, had been pointed out that morning in Ramallah by a collaborator. As al-Haq later ascertains from sworn depositions, he was in a place where he could have been captured with little difficulty. Instead, he was shot repeatedly by one of three Israeli men in civilian clothes who had used a car with local license plates to track him. Two army jeeps arrived within seconds. When bystanders began moving to help Abu-Ghosh, who was still alive, one soldier told them that anyone doing so would be killed. Nor would the soldiers permit the approach of a hastily summoned doctor. Abu-Ghosh was thrown into a jeep, part of his body dangling outside, and taken not to the hospital but to the military administration, where he bled to death. Again many Israeli newspapers and public figures would protest, expressing their disbelief of the IDF's claim that Abu-Ghosh was shot while resisting arrest. The media would later report that the Shin Bet admitted killing him. (The Shin Bet is Israel's internal security force, a kind of combination of FBI and secret service, usually referred to in English as the General Security Service. It is responsible only to the Israeli prime minister.) Abu-Ghosh's best friend, distraught, said that he didn't want to go on living and went to Beitunia to lead a protest demonstration. He was shot and killed.

Before the trip ends we each chip in 8 shekels ($4) for the cost of the bus. Sometimes the drivers will undertake such trips free of charge. This time the arrangement was for twenty women to pay 6 shekels each, but as there are fewer of us, the price per person is higher. Although I'm told that as their guest I don't have to pay, I insist on doing so—8 shekels each constitutes enough of a sacrifice for many of these women.

July 11: The morning's first news is that a strike has been called to protest yesterday's two deaths.

Two days earlier I had been reading at al-Haq when Raja Shehadeh and Penny Johnson walked in. Raja, one of al-Haq's two founders, is also the author of *Samed*, a personal account of life under occupation, and of *Occupier's Law*, the definitive volume on current law in the territories. Penny, an American who has worked in the public relations department of Birzeit University for some years, writes a regular report on educational institutions in the *Journal of*

Palestine Studies and is a contributing editor of *Middle East Reports*. It's hard to work at Birzeit now, however: the Israeli authorities have kept it and the other universities—as well as the elementary, middle, and high schools—closed on and off for a year and a half on the grounds that riots are fomented there. Nursery schools are the only ones permitted to function. Rumors circulate that international and Israeli pressure may lead the authorities to permit the schools to reopen, but it's not expected that the universities will be included. I'll meet a number of Birzeit students—some of whom attended only one week of their freshman year, two years ago, before the university was shut down—who are now spending their time working for a Palestinian state. As with many occupation measures, this one seems to be counterproductive. The university's administration continues to function in a Ramallah building that used to house its board of trustees, and some classes are held there. The authorities would have to be blind not to notice the activity in the building, and in fact it has been raided by the IDF a number of times. Presumably it's not shut down because the military administration that rules the territories (and is called the civil administration, although the people working in it wear military uniforms) realizes that it would only reappear elsewhere.

Raja and Penny arrived in the afternoon, after shopping hours, when the university's temporary quarters were closed. The three of us took a short stroll on the road near their home in the lovely Ramallah hills, discussing whether one can ever trust a government with the power to ban speech, even if the result of a government's not having that power places racist or pornographic speech beyond the reach of the law. Whenever we heard a car approaching, Penny and Raja automatically looked to see whether it was an IDF jeep, a settler's car, or a friendly vehicle. Apparently so many cars are using what once was a relatively untraveled road because the IDF patrols it less than other, more central roads, and local residents are attempting to avoid the humiliation that ensues whenever soldiers in a jeep conduct a routine stop-and-search operation.

Now, the day after Abu-Ghosh's death, I speak with Raja, who is extremely disturbed after taking a deposition from someone who witnessed the murder in Ramallah. The occupation is twenty-two years old and Raja is thirty-eight, but he's still sufficiently shocked

to exclaim in outrage, "It was a summary execution!" The al-Haq press release issued on July 22, after all the affidavits have been secured, will be captioned "Summary Execution in Ramallah." For once, I haven't had to keep to myself my own shock at the substitution of cold-blooded murder for any form of due process. The Palestinians around me are used to terrible things, but this is almost unbelievable.

I return home and receive a telephone call from an Israeli friend in Jerusalem who is concerned about me because of the news that there's been trouble in Ramallah. Marie answers the telephone and can tell from the accent that the caller is Israeli; Yael, calling me here, knows that Marie is Palestinian. That doesn't stop them from exchanging a few pleasant words, because each knows the other's my friend. It's embarrassingly naive for a trained political scientist to sit in the midst of all this brutality and wonder why people can't just be human to each other, but that's the effect their conversation has on me.

July 12: It's the day before 'Id al-Adha, the Feast of the Sacrifice, which occurs at the time of year when devout Moslems travel to the holy city of Mecca—something all Moslems are supposed to do at least once in their lives. The feast commemorates Ibrahim's near sacrifice of his son Isma'il, similar to the Jewish tale of Abraham's willingness to sacrifice his son Isaac. In the Moslem version, Allah sent as an intervener the angel Jibril, who gave Ibrahim a sheep to slaughter instead. That's why sheep are usually slaughtered at the time of the feast. There are huge meals, and much food is given to the poor. During intifada the feast, along with birthday and wedding celebrations, is much quieter out of deference to the victims of the occupation and the absence of independence. It is nonetheless a welcome occasion in a life that now holds little entertainment and enormous tension. The stores are to be open all day so that people can make their purchases for the feast. The streets are thronged with shoppers and others who are simply enjoying the unusual activity.

It seems a good day to visit some merchant friends and do some shopping in Jerusalem's Old City. The seventeen-year-old eldest son of one merchant I've known for years is in prison, accused of throwing stones and a Molotov cocktail. He's told his family that he

threw stones but nothing else. As is frequently the case, however, he's signed a confession—in Hebrew, which he can't read—to end his interrogation. No one was hurt in the incident, so the lawyer his father hired has hopes of getting the six-year sentence requested by the military prosecutor reduced to two. This is all happening at the same time that four members of the IDF's Givati Brigade have been found guilty of grievous bodily harm; they beat a Palestinian man who died while in custody. The military court that tried them said it could not find them guilty of murder because so many groups of soldiers had beaten the man after he'd been apprehended that it was impossible to say which blows had killed him and because their culpability was lessened by their commander's illegal order to them to beat the man. The court sentenced the soldiers to a few months each. The IDF decided not to try the officer who gave the order but to dismiss him from the army. The roar of outrage from the Israeli press and many Israeli public figures evoked by the leniency indicated how divided the country is about anything having to do with the occupation. It did not, however, alter the sentences.

July 13: The first day of 'Id al-Adha. Stores and offices are closed, although it's not a strike day. In the morning, I'm taken to the village of Birzeit so I can see what is, at least temporarily, a "liberated zone": one under community rather than IDF control. It's a charming, Mediterranean-looking place, with walled white stone houses, narrow winding streets, olive trees, and donkeys, and notable for the plethora of Palestinian flags—flying over churches, mosques, and homes, strung from wires, painted on buildings— and the posters, plastered onto the walls, of Arafat, Abu Jihad, and two of the young men killed in the intifada. Nationalist slogans are scrawled on the walls in the flag's colors. The IDF hasn't been here in about a month. Everyone knows that eventually they'll return and make the inhabitants take down all the flags, rip off the posters, and whitewash the walls.

I return to Ramallah and lunch at the home of Abdallah and Clemence Rishmawi, Mona's parents. Abdallah is a retired school principal. He and other educators and Birzeit University faculty, women included, are putting together a curriculum designed for the Palestinian state to replace the Jordanian-prescribed books and

approach still used in West Bank schools and the Egyptian ones in Gaza. The Rishmawis have had to go to Gaza because, as they lived there in 1967 and so were registered as Gaza residents, they must seek permission from the Gazan rather than the West Bank branch of the military administration for their California-based son to visit them. New rules make it technically illegal for the Rishmawis to live in the West Bank, but Abdallah has a letter from the military governor permitting them to do so.

The license plates on their car are still from Gaza, however. In a week that will cause trouble. Three soldiers will come up the flagstone path to their house, demanding to know why a car from Gaza is parked outside and to see the identification papers of its owner. Abdallah will get the papers as well as the military governor's letter. The soldier who barks out the demand in Hebrew will look at them and then turn away without a word. As soon as the soldiers appear, the three-year-old child of a neighbor will jump into Clemence's arms, screaming that the soldiers are coming to kill them all. Another of the soldiers will tell the child in Arabic that they're not coming to shoot anyone and, after looking at Abdallah's papers, say "Thank you." The personalities of the particular soldiers in a patrol can make the difference between a relatively peaceful and a violent encounter. The first soldier apparently was restrained by the presence of the less aggressive one. Had the personalities been different, Abdallah might have been beaten.

The Rishmawis' trip resulted in permission, but the official papers have to be picked up in a few days. When Clemence goes to get them, she will discover that they're not there because the application has been lost and the process must be repeated. That's not an unusual occurrence and would be only a minor nuisance if their lives weren't governed by the need to secure papers. They've been told in Gaza that the two stickers on their car are not enough; they must get a third. Acquisition of any official paper—car registration, a *laissez-passer* allowing one to leave the country and travel abroad (Palestinians are technically stateless and have no passports: Israel will not give them one, nor during the intifada would they be likely to accept it), a permit for a relative to visit, permission to plant fruit-bearing trees or dig a well or add a room to one's house, a declaration that one has paid one's taxes so that one may apply for

any of the foregoing—means payment of a fee, sometimes as high as 100 JD ($125). When I return in January I'll discover that at the checkpoints, which by that time have increased in number, soldiers occasionally take the driver's license or the identity card of one of the people in the car, apparently at random. An identity card is a permit to remain in the territories; without it, a person is there illegally. A driver's license or car registration is necessary to drive anywhere, including to work. A person whose document is thus confiscated is told to go to the "civil" administration in two or three days to retrieve the precious paper, all the while knowing the high probability that the paper or the official who has it will be unavailable and that a number of additional trips will be required before the paper is returned. Some drivers, in an attempt to prevent their papers from being seized, tape them to the windshield so they can be checked without the windows being opened, lessening soldiers' temptation to confiscate them.

Today, much of the talk is about curfews, for a month-long one has recently ended in Gaza. Curfews keep everyone at home and enable the IDF to enter homes, find "wanted" people, and, in Gaza, undertake confiscations: in this case of the old ID cards the IDF currently is replacing, for those whose taxes have been paid and who are not "wanted" for any other reason, with magnetized ones without which workers cannot cross into Israel. Beit Sahur, a town on the other side of Jerusalem, is now under curfew. Week-long curfews (longer in Gaza) are not uncommon, so families must attempt to keep enough food on hand for a month. That is virtually impossible for poorer, large families without large refrigerators and freezers. Food storage committees have been organized in both the West Bank and Gaza to cache food and attempt to distribute it to poor families during "normal" times and to all families needing it during periods of curfew. A few days earlier, the Beit Sahur pharmacy owned by Abdallah's nephew Elias Rishmawi was raided by the IDF. Most of the stock was confiscated and put in large metal containers outside in the sun, where the medicines were certain to spoil. The damage was estimated at $100,000 to $150,000. The reason for the raid was that Beit Sahur has been more steadfast than most towns in passive resistance, including following the

Unified Leadership's policy of nonpayment of taxes to a government in which the Palestinians are not represented and that does not return most of the taxes to the Palestinians in services. The town will become famous for adopting the American Revolution's slogan of "No taxation without representation," for its refusal to pay taxes and for the illogically large amounts of furniture, appliances, products, foodstuffs, and so on that the IDF will take in the resultant raids. As a letter from three Israelis published in a subsequent *Jerusalem Post* will note, it is inconceivable that the taxes owed by the pharmacist are as high as the value of the medicine destroyed. The current curfew means that no one can leave the town, the Rishmawis or anyone else can't get into it to find out if their relatives are all right, and the telephone lines have been cut.

Back home, I telephone my friend Haim Cohn, a retired justice of Israel's Supreme Court and its current honorary president. Insisting that there is no such thing as a benign occupation, he is deeply depressed at what he views as the moral decay of Israel demonstrated by the continuation of the occupation. I have to hold on to thoughts of him and other Israeli friends while I'm here, because the view of Israel from the underside of the occupation is not pretty. Haim's right: occupation is inherently inhumane.

In the early evening Rema and I put on sneakers and take a brisk hour's hike around Ramallah. One of the nice things about the Ramallah-Jerusalem area is that however hot the day may be, the evening brings cool breezes. The sun has become a spectacular red ball hanging over the main part of Ramallah, which we can see as we walk high up on the hills near prosperous villas. As dark falls we walk down to the old market area where we hear shooting. There are usually demonstrations in the Old City at night, when the *shabab* can take advantage of the narrow, twisting streets to get away from the soldiers. We're used to hearing shots coming from that direction when it gets dark; earlier each day, the shots seem to be in the marketing district or the main arteries leading from Ramallah to other major cities.

July 14: As I go to the newspaper store I see a group of *shabab* at the nearby corner, putting up a street barrier of tires and preparing a pile of stones. Most people on the street obviously are aware of

what's going on but continue with their shopping. Only a few have darted to the safety of the stores, peering out. I try to look unconcerned but leave the market area as soon as I can.

In the evening Dalal, a young jeans-wearing member of a women's committee that for some unknown reason has been reticent about setting up meetings for me with people I want to meet, drops in to find out who I am, where I work, and why I'm here. She describes some of the horrors of occupation that she and other women have seen, indicating that she views everything in the struggle as black or white. She demonstrates no awareness of the tumultuous schism among Israelis, almost equally divided between the hard-liners determined to beat down the intifada and the peace camp, which demands an exchange of land for peace. Each side accuses the other of destroying the country, and with only a small percentage of uncommitted Israelis remaining in the middle, the verbal and political battles between the two are fierce.

Dalal's seeming lack of knowledge about Israeli differences is unusual among Palestinians, particularly the better-educated and better-informed ones. They're familiar with the names of Ran Cohen and Dedi Zucker, two Knesset members who have persistently investigated and asked public questions about human rights violations in the territories (for which they've been physically attacked, as has Zucker's home); they've seen and met with delegations from Peace Now; they know about the conference at Columbia University sponsored by New Outlook and al-Fajr, where a few Israeli Knesset members appeared with members of the Palestine National Council. They're appreciative of the peace camp's efforts but despairing about its seeming inability to alter either government policy or public opinion. I've heard some people lamenting the resignation of IDF commander Amram Mitzna and his replacement by Yitzhak Mordechai, considered far more hard-line. Dalal may know nothing of this but at least she appears to think I've passed whatever test has been set, for she announces that she'll arrange a schedule for me and in subsequent days proves as good as her word.

7

"The Intifada Smile"

"You've got to try and be strong, like us."

July 15, 1989: I putter away at the computer and then, forgetting it's the hour when demonstrations are most likely, go into town at about 10:30. As I walk up one street near the center I hear shots and suddenly two young men with *kuffiyeh*-covered faces race by. My mind divides into three parts. One is concentrating on the action, watching avidly as a scene that I've known only from television and photographs springs into life. A second is aware that if the soldiers are shooting at the *shabab* and I'm standing in their path it might be wiser to move elsewhere. A third is standing by noting the first two reactions. Is this the curse of the intellectual? My more cautious self takes over and I move into the safety of a nearby building, lined with shops on two sides of a big empty covered mall. An army jeep comes zooming the wrong way up the one-way street and without warning I find myself surrounded by *shabab* who must have sprung from the walls, rocks in their hands. Their movement toward the street taking me along with it, they sound the cry "*Shabab!*" and throw rocks in a high arc toward the jeeps full of soldiers that are now chasing the masked men. Again I have a schizophrenic reaction, this time part outrage that my place of safety has been invaded, part wonder at the distance the stones travel—the stone throwers have had a good deal of practice—and part recognition of the desirability of moving elsewhere before I am inadvertently fired upon. A car parked nearby provides the "elsewhere." The *shabab* are gone as quickly as they appeared through what turns out to be the building's back entrance. The firing is now directed toward another block, and I can hear the reopening of metal store shutters that

began to clang shut at the first sound of shots. I walk the block remaining to a corner in the center of town from which I can look down the two streets spreading into a wide V. One is the street I've just been on; the other, which is part of a main route to Jerusalem, has been barricaded some blocks away with burning tires. Apparently the masked *shabab* were trying to lure the soldiers toward the barricade to be stoned. Shots are still being fired from the rooftop and I can hear others from beyond the barricade. Soldiers have either gone around it or been told by radio to come from another direction and are chasing the *shabab*. Each civilian car coming from Jerusalem reaches the place where the driver can see the barricade and immediately swings without pause into a U-turn, the repeated phenomenon making it seem like a scene from an old comic movie. I'm all of a block and a half away from the barricade, the smoke, and the running soldiers, but most of the people around me have resumed their shopping and merely glance down the street occasionally between purchases, too used to demonstrations and too intent on buying what they need to pause any longer. They're more aware than I am of what's happening, however: when the soldiers on the roof resume shooting, a number of hands pull me into a store and out of the line of fire. Within a couple of minutes the city center is back to normal. The soldiers near the barricade can be seen pushing any male passerby into the street to dismantle it. Trying to keep my shaking imperceptible, I get into the *service* leaving for Jerusalem. I hadn't planned to go there, but right now I have an overwhelming need to sit down and a strong desire to be anywhere else.

In the evening Mona comes to talk after a day spent visiting schools in various villages. The government has announced that the schools can reopen in stages, beginning with grades one through six and the last year of high school. If things go peacefully, the other grades will follow. Mona and other al-Haq staff were shocked to find that every school they saw, all utilized as temporary army encampments, had also been used as toilets by the soldiers before they left: it was impossible to walk into them. The windows, desks, and chairs had been smashed. The equally horrified women of the villages were already cleaning the schools, and the men were making what repairs they could.

Living in the West Bank has transformed my abstract belief in self-determination into partisanship, and the scene described by Mona demonstrates why. Every day I'm exposed to something that leaves me wondering how people can permit themselves to be turned into animals. I suppose I don't fully comprehend the soldiers' fears and frustrations. I'm not sure I care. When I'm in West Jerusalem for a day before I return to New York, I'll be on the receiving end of a tirade from a young woman who's just completed her army service. She'd been driving through the West Bank when a stone smashed through the windshield of her jeep. Stones are weapons, she rages; she could have been killed. It's to her credit that she remains a member of the peace camp. The answer I don't articulate is that she shouldn't have been there at all. Conscientious objection is illegal in Israel, but I can't imagine that sitting in jail would be worse than allowing a government to send me into a situation where I'd brutalize others and, in the process, be brutalized myself. I'm aware that Israel has no bill of rights or tradition of teaching about civil liberties and that most Israelis define democracy only as majority rule, without reference to individual rights. I know that Jewish children in Israel are socialized into equating citizenship with army service (Arabs other than Bedouins and Druze are not permitted to serve), that people refusing to serve become pariahs, that army service is a prerequisite for many government benefits, and that all those things taken together are responsible for otherwise decent people agreeing to serve in the territories. I'm nonetheless convinced that, once having seen what serving as occupiers means both for the Palestinians and for themselves, Israeli soldiers should refuse to come back—and if enough of them did so, the occupation would have to end.

Yet I have to keep wondering about my conclusion. I know so many decent Israelis who are sufficiently opposed to the occupation to spend a good part of their lives working on behalf of peace, accepting the price of societal condemnation and in some cases physical danger from the right wing, and who nevertheless still consider refusal to serve unthinkable. They argue that the very fabric of Israeli society would be endangered without the citizens' army unifying a population that is extremely heterogeneous in

national origin, subcultures, political beliefs, class, education, and religious beliefs. One can only respect and admire the hundred or so young men who have chosen repeated jail terms and social opprobrium for their principled refusal to serve in the territories. The paucity of their numbers, however, leads to the question of whether an outsider can fully appreciate the depth of Israelis' socialization and whether it is too facile to condemn individual Israelis for repeated service. Perhaps what should be condemned is the societal failure to create a system that could combine a citizens' army with greater respect for individual choice, particularly when that choice reflects a principled decision made in the face of imprisonment.

July 16: Mona takes me to the Ramallah military court, cautioning me on the way not to say anything so that the soldiers won't know I'm American and alter their behavior. The court is in a compound that also houses military administration offices and a Shin Bet prison. There's a closed metal gate and a line of people waiting along a wall leading to it. These are the families of prisoners. Mona takes out her attorney's pass, issued by the military administration, and attempts to show it to the soldier guarding the gate. Without looking at it he waves us back to the outside of the gate. We watch vehicles going in and out for five minutes until Mona, murmuring that this is a usual part of the humiliation inflicted on Palestinians but that she's had enough, starts marching through the gate. The soldier orders us outside again. She begins to protest in Arabic; the incident is ended when another soldier who knows her tells the guard to let us in. Mona identifies me simply as someone she needs for a case. Our handbags are checked. We enter the building housing the court and go into the larger of its two small courtrooms. There are perhaps fifty people facing the high bench. Along one wall is a row of seats for prisoners; along the opposite wall, with the spectators in between, sit three soldiers with submachine guns. A fourth soldier with a teargas launcher is near the prisoners. I wonder if he thinks it likely that he'll use teargas in the enclosed space that's filled partly by his fellow soldiers and the judge. Most of the spectators, families of the accused, are in traditional dress. It's the families of the young men

not yet in the room who must wait outside. The other young men awaiting trial today are crowded into a tiny room next door, the one window of which is covered with metal sheeting. Mona describes it as crowded, airless, and smelly. The blond, blue-eyed judge is empowered to hand down sentences of up to five years; longer sentences can be imposed only by a three-person court.

Mona takes me to sit at the lawyers' long desk near the bench, greeting her colleagues, all of whom are men. My eyes focus more on the three submachine guns than on the judge. A soldier, ignoring what's happening in the front of the room, decides that two mothers have been breaking the rules by talking and pushes them out of the courtroom. One lawyer is attempting to speak. The judge cuts him off: the attorney is improperly dressed because he's not robed. A colleague promptly takes off a robe and hands it to him. Mona was once reprimanded by a military court judge for showing disrespect by wearing street clothes while representing a client in this courtroom. She replied that she considered it disrespectful to be surrounded by guns in a courtroom. She asks a colleague to show me a charge sheet. It's a preprinted form that says the defendant, whose name is to be filled in, is charged with threatening the security of the state at a place to be filled in, on a date to be filled in. That's all: no mention of exactly where in the city or town the act is purported to have occurred, who saw it or was responsible for the arrest, or what time it happened.

There's a lot of talk but very little being accomplished, something that seems to be typical of Israeli courtrooms: a parade of cases, each being postponed because one of the defendants or a witness or a file is missing. The defendants who thought their cases were to be heard today will return to jail. Bail has been granted to very few defendants during the intifada. Mona has obtained it only once, in a case she handled on a day when an American judge happened to be present in the courtroom. The soldier who pushed out the two mothers has been eyeing us. Now he walks over, rather nastily asks Mona if she speaks English, and then demands to know who we are. When Mona shows him her attorney's card, which bears her picture, he sneers and asks if she's sure she's a lawyer. The judge finally takes note of the noise and wants to know what's going on. Mona

stands up and says rather firmly that she finds the soldier's behavior incomprehensible; she's a lawyer and showed him her ID when he asked for it. The soldier complains that no one has identified me. Mona says I'm her guest. The judge's eyebrows go up in disbelief: a guest in his courtroom? She adds, "A professor from the United States." His eyebrows go down and he tells the soldier to forget it. But now they know I'm an American, so after a few minutes we move into the smaller courtroom. There another lawyer is attempting to argue a case that's been scheduled for the day. The judge doesn't have the proper file and angrily demands its whereabouts from the attorney! A colleague tells us that the judge is an inept lawyer from Jaffa who's been given a one-year contract from the military to sit in this court. The case is postponed and a new one is called and actually begins being heard. Soon, however, the judge announces a lunch break, which means not that the case will be continued that afternoon but that it will be held over for a different day, while the defendant remains in jail. The defendant immediately asks his lawyer to strike a deal with the prosecutor. No one has ever been found not guilty by the military courts. The only thing an attorney can do for his or her client is to plea-bargain to get a lesser sentence. It's something the lawyers particularly dislike doing in those rare instances when their clients have held out and refused to "confess" during interrogation.

The deal is struck and the judge leaves. Two of the young men in the room awaiting trial were arrested in April and have not seen their families until today. Their mothers rush over and begin kissing and hugging them frantically. Two soldiers yank the mothers away from their sons and push them outside. Touching is forbidden. Mona asks if I've had enough; I feel sick. All of this has happened in the presence of guards armed with submachine guns.

Outside, Mona introduces me to another leading attorney, a relatively young man who's been representing defendants in the military courts for years and yet has somehow retained his sense of humor. The soldiers ask him constantly why he laughs. He replies that in the military court one has only two civil liberties, the right to laugh and the right to cry, and he prefers to laugh. He suggests, straight-faced, that the government should provide a psychiatrist for every lawyer

practicing before the military courts. Then he speaks seriously about the plight of the attorneys, who are caught between the court and the defendants' families. The families can't understand why the lawyers can't get their sons out on bail or take them the food and medicines that their relatives have brought. He says that the search of our handbags was done less out of fear of weapons than to make certain we were bringing in no food. He and the other Palestinian military court attorneys are going on strike in two days, for a month. They've been on strike before and were promised improvements that have not materialized. They consider themselves no more than actors playing parts written by someone else. The judge invariably will find the defendants guilty and ask the prosecutor what their sentences should be. The most the defendants' lawyers can do is get them a shorter sentence. He suggests that the American Bar Association send a fact-finding delegation to see the military courts of what he refers to bitterly as the "only democracy in the Middle East."

As we walk home Mona describes one of her cases, in which a young man was charged with participating in a demonstration. She questioned the arresting officer closely in the courtroom, showing that the map he drew of the area in Ramallah where the demonstration and arrest supposedly took place was entirely wrong, inquiring how he happened to be so certain of the offender's name but did not know whether he was in the middle of the street or on the sidewalk when the soldier allegedly saw him throwing stones, and so on. She then called four witnesses, including a priest, who testified that at the time of the demonstration the defendant was in church. The prosecution's only witness was the arresting soldier. When all the testimony had been presented, the judge announced that the defendant obviously was guilty as charged. Mona demanded to know if he believed that all her witnesses had lied. "Yes," he replied. "Including the priest?" "Yes." When he asked if there was anything she wanted to add, a signal that the ritualistic moment had come to plead for a sentence lighter than that requested by the prosecution, she said only that she saw no point in wasting his time and hers in speaking further. Looking somewhat abashed, he sentenced the defendant to the time he'd already served in prison. It was as close to a victory as she'd ever gotten.

Few Palestinians know that at least one Israeli newspaper, outraged at the flagrant abuse of power by a military court system that most Israelis still believe dispenses justice, had headlined that story. Palestinians do, however, know the names of Lea Tsemel and Felicia Langer and the few other Israeli attorneys who defy the contempt of their own society to represent Palestinian clients in these courts.

July 17: A strike day, called by the Unified Leadership. I'm picked up on foot by Ghada, a women's committee member who had been arrested during the marches organized by all the committees on International Women's Day in March. She's kept the rigid plastic tape with which she was handcuffed. The women were put into the seatless back of an army bus with big plastic bullet-proof windows, very eerie-looking, and told to sit on the floor. She refused to do so and when a soldier brought over the woman commander in charge of female prisoners Ghada pointed out that the floor was covered with broken glass. The commander was exasperated but told the soldier to get something to clean it up. When he returned she told Ghada to get busy; Ghada asked how she was supposed to clean anything with her hands tied behind her. More exasperation, but the soldier cleaned the floor. Now Ghada has received a summons from the military government. Again it's a preprinted form that simply tells someone to show up on a certain day—no reason given. She would ignore the summons even if the Leadership hadn't urged people to do so.

We walk to al-Am'ari refugee camp and the home of twenty-year-old Samia, a two-year-college graduate who began working with one of the women's committees two years ago and then put together a women's committee in the camp. Her committee has since organized classes for camp children in grades one through six. Because all schooling other than kindergarten has been illegal in the West Bank, the classes have had to be held in different homes every day, at different hours. The committee also established an embroidery cooperative, with each member putting in a little money for supplies and sharing in the profits, and took two bus loads of children from the camp to Jerusalem to hear political leader Zahira Kamal speak. I ask how she organized the committee

in the camp. She says she began by talking with friends and persuading them to join. She then asked them to speak with their friends and, as word of the committee got around, many women from the camp came and asked to be included. It's the way many such committees have been organized.

We sit in the living room with her mother, who was two years old when her family left the al-Lid area in 1948. Al-Lid is now called Lod, and what was her village is Ben-Gurion airport. Her oldest son, twenty-five, has been deported to Lebanon. (Like administrative detention, deportation is widely considered a violation of international law and is specifically prohibited by the Fourth Geneva Convention. Israel's deportation of forty people during the intifada—the number will be sixty-six by the end of my last stay in Ramallah—has been condemned by both the United States and the United Nations.) Her next two sons are in Ketziot prison, one of them with an unattended bleeding ulcer. Her fourth son was shot in a demonstration in April, at the age of seventeen, and died in the hospital a few hours later. His friends immediately took his body from the hospital. The IDF goes into hospitals in the territories to arrest the wounded and to take the bodies of those who have died so that they can be returned to the family for a nighttime burial attended by a minimum of relatives. The point is to forestall the demonstrations that frequently follow burials. Not long after she was informed by friends that her son was dead, IDF soldiers came to the house looking for his body, which, unbeknownst to them, was being moved from house to house in the camp. They demanded that she give them the body. She feared that if she indicated any knowledge about it they might threaten or beat one of her other six children to make her tell them where it was. So she laughed and said that her son wasn't dead—he was out throwing stones—why didn't they go look for him? I asked where she had gotten the strength to go through such a charade at such a time. Her reply was "From Allah; from Palestine. They can kill the rest of my children, they can kill me, they can kill my husband; even if there is only one of us left alive, he will fight for the state." The soldiers told her that they'd watch the family when it attempted to bury their son and that they'd be permitted to do so only if the burial was at night with

no more than four people present. Word was spread throughout the camp and nearly its entire population—hundreds and hundreds of people—defied the order and came together that night for the burial. Samia's mother is extraordinarily proud of that son. He had always wanted to be the first one to demonstrate, as a result of which he had been jailed when he was fifteen and again at sixteen. She's doubly proud that he died what she considers a meaningful death.

She goes on to tell us that his twelve-year-old brother later got into trouble, probably for throwing stones. It is now Israeli policy that parents of young children are punished, usually by a heavy fine, for the children's misbehavior. Soldiers came looking for the boy and, they claimed, for Palestinian flags. They broke up the furniture and arrested his fifty-five-year-old father, the only adult then at home. When his wife arrived while the soldiers were putting him into a jeep and asked him why he was being arrested, he laughed and shrugged and said he had no idea. The soldiers demanded to know why he was laughing. He gave his own version of the lawyer's answer: he could either laugh or cry. Their response was that in that case they'd make him cry, and they broke the bones of his hand and arm. Samia shows me the marks of a dumdum-type bullet that hit her leg on another occasion. She was fortunate that it hit the ground and ricocheted rather than hitting her directly, for then it might have broken bones.

The refugee camps in the West Bank are no longer a collection of tents or even of the appalling hovels one sees in Gaza, although the intifada has brought something new: the IDF has blocked most of the entrances to the camps with big metal barrels of cement to prevent demonstrators from fleeing into or out of them easily. A week later I'll visit the Deheisha refugee camp, which, surrounded by barbed wire and with dust everywhere, feels more like Gaza or the West Bank camps of some years ago. It has no flat dirt streets but is built on rocks that are still outside all the houses. The houses can be reached only by climbing on and around the rocks and the ruts that have been carved by rain and feet wherever there are no rocks. In most West Bank camps the refugees, unable to move back to their original homes and unwilling to leave Palestine, have put

much of the money they've earned into building decent housing. The home of this woman and many others are fairly good-size permanent buildings. She's traditionally but very simply dressed; Samia wears a denim skirt and a blouse. Pictures of the four oldest sons hang on the living room walls, all in red and green and black frames. There's also a framed poster in English, captioned "Deportation Is Transfer" and containing pictures of those deported, including the oldest son. It is propped on a table behind a vase of fabric flowers. I'll see the poster in homes of other deported men.

Throughout the visit Samia's mother has worn what I have come to think of as the "intifada smile." In villages and refugee camps, among the parents of dead or wounded children and on the faces of children whose fathers have been imprisoned or deported, it's an insistently cheerful grin that looks natural until one realizes that it's maintained even while its wearer is recounting the most horrible experiences. It disappears only when the storytelling leads to brief tears, quickly brushed away as the smile is replaced. Palestinian culture puts a very low premium on display of negative emotions, and the intifada has reinforced an absolute determination not to be or appear beaten down. Samia's mother stops smiling for no more than a moment as she speaks about her dead son, but she wipes her eyes with her hand and immediately and resolutely restores her smile.

Our little group is a study in contrasts as Samia guides us along the dirt streets of the camp. Ghada and her pretty cousin from Chicago who is here for a visit are in jeans and T-shirts. Samia and I are wearing skirts and blouses, but she added a *hijab* as we left her house. The woman we're going to see is dressed, like Samia's mother and most other women we see as we walk through the camp, in traditional gown and *hijab*.

The woman's house is very small. The front door opens directly into a windowless box of a living room. The smell from the open sewer outside fills the house. The floor is cement: no carpet or rug. The walls have at one time been covered with pink paint and at another with yellow. Both colors show; it's impossible to tell which color is on top. But as usual, the room is immaculately clean. Al-Am'ari houses 5,306 people. If it reflects the overall statistical

picture for West Bank camps, its unemployment rate is about 20 percent, 77 percent of its workers are employed as day laborers, 96 percent of its residents do not own their own house (UNRWA owns most of them), and 86 percent have no bathroom. This house seems all too typical.

It's the home of an enormous woman with a reputation for throwing herself between the soldiers and any young man from the camp whom they're attempting to arrest. She shows us the marks and sores that cover her arms and legs. I can't tell which are from beatings and which from rubber-covered bullets. After serving us orange soda from a tray (even the poorest Palestinians present drinks on a tray), she begins a harangue about United States policy. Ghada is embarrassed and doesn't want to translate everything. The woman says she can't understand how it is that nice Americans have been visiting her ever since the intifada began but the United States hasn't changed its policies. I reply that the government isn't the same thing as the people; that there are good and bad people everywhere; and that some of us are trying to change our government's policies. Her retort is that people are responsible for what their government does. Of course she's right, but I find myself thinking that self-determination is needed here for more than one reason. These people have never known what it is to rule themselves; self-government will teach them the sad lesson that democratically elected governments are not a panacea. She's really a massive woman. When she says that if the soldiers came without guns she'd tear them limb from limb, I believe it. Her voice is raised, her nose is about two inches away from mine, and it's clear that in spite of my encouragement Ghada still isn't translating everything she's saying about Americans. I begin to wonder if I'm going to leave here in one piece. She compares Palestinians to Vietnamese: they won't disappear; they won't stop fighting. I tell her anecdotes from the antiwar movement, and the tension level drops. Eventually, as we leave, she shakes my hand enthusiastically and invites me to return "when we have our state."

Our next visit is to the home of a very pretty traditionally dressed women in her early thirties, who is washing clothes with an uncovered head when we arrive and immediately rolls down her sleeves

and gets a scarf. Her twelve-year-old daughter had offered some months ago to take bread dough her mother made to the bakery oven, her real reason being to go to a demonstration she knew was planned. The child left with the dough and was shot in the head at the demonstration. Four young men tried to help her as she lay on the ground. Each one was shot and wounded. Someone got her to the hospital. She was there for a week, unconscious, before she died and her family rapidly took her body away. I'm reliving the horror of my own children's deaths, but at least no one took aim at them. This woman has four other children, including an eleven-year-old boy who was born blind and who was beaten recently by soldiers he couldn't see. Her father-in-law died from the effects of teargas. Her husband has been beaten many times. She too is absolutely determined about statehood; she too wears the intifada smile. She'll have more children, she says, but she wants her husband to take an additional wife so they can produce more Palestinians. Her husband, who has just made coffee for all of us, smiles at what he knows is just rhetoric. I wonder what the women's committee will do about consciousness-raising here! This woman strikes me as too intelligent to be permitted to go through life seeing herself as nothing but a baby machine. At the same time, her desire for more children is life-affirming and probably a very good defense against the impact of almost unimaginable experiences.

We go on to the nearby Qaddoura refugee camp. Our first stop there is a one-room home, dark, without windows. Bedclothes are in two big piles along the walls. Eight people live in that one room. The father has been dead for some years. The oldest son, who was having difficulty finding work, is in prison. The next son could get a job in Israel but refuses to work for people who send their troops to beat him. Their house is on a corner of a street at the edge of the camp, so that soldiers coming through the camp regularly attack the family. The littlest girl has the mark of a rubber bullet on her forehead; the youngest boy has one right near his eye. Their mother cleans houses but can earn only 200 JD ($250) a month. Nonetheless, the oldest daughter, a teenager, insists on serving us apples, soda, coffee, and gum. The family is helped a little by a system that has been developed by the committees since the start of the

intifada: pairing a family in need with one or more wealthier families, either in the territories or abroad. Sometimes, however, the wealthier people stop sending money. Local merchants occasionally contribute flour, rice, or other staples to the committees for distribution, but there's never enough for everyone.

Our last visit in the camp is to a nearby house that consists of a small living room–bedroom, a bedroom, a kitchen, and a bathroom. It's the home of a widow with three daughters and one son. The oldest child is in the sixth grade. The mother, who has a heart condition and is partially blind, is too ill to work. They have no source of income whatsoever. The young woman escorting us says that if people give them enough money each month, they eat; if not, they don't. Everything in their home has been donated, some of it by neighbors who have little themselves. Neighbors also worked to run water and electricity lines into the house. In spite of her illness, the mother regularly joins women from the committee to visit homes of martyrs and wounded. The committees deliberately involve poor women in such visits so that by their participation they can feel that they're not just the recipients of charity. We're taken up to the roof for a view of the camp to see how easy it is for the soldiers to break into homes from the roofs and how simple it is for demonstrators to hide by moving from one house to another.

We leave the camp and walk to Ramallah Hospital, with our guide recounting familiar stories about wounded people being beaten outside the hospital gates and soldiers going into the hospital to beat and arrest still others, to search the maternity wards and operating rooms, and to use teargas in the enclosed spaces.

Sitting outside the hospital is a young committee member and her emaciated mother. The mother is constantly ill, her husband is in the hospital following a heart attack the family attributes to beatings, their son is in jail and the family is almost penniless. A sense of discomfort at my own relatively good fortune is rapidly becoming a constant companion. Inside, we meet a young woman from Nablus whose respiratory system has been damaged by teargas. She has to come to the hospital repeatedly to have fluid drained from her lungs and is walking around carrying the large plastic container that's hooked up to her body. She can't return to

Nablus, where use of teargas is frequent, so whenever she leaves the hospital she must move to the home of one relative after another. Along with almost all the other patients, she wears the insistent intifada smile while telling us about her situation. A sixteen-year-old man—sixteen-year-olds are not children here—is sitting in the hall. He had been in jail for two days. After he was released he got as far as the street leading to his home when soldiers called to him. Fearing a return to jail, he ignored the calls and kept walking; he was shot in the head. He's lucky: he's been operated on and his head is swathed in bandages, but he'll recover. The woman escorting us comments in an aside that he'll probably be arrested again as soon as he's well enough to go home. A slightly older man in a room nearby has a lung damaged by a bullet and is awaiting an operation.

Visiting another patient proves more harrowing than anything we expected. We're taken into the room of a young man who had been shot in the head and beaten. In the process, some of his teeth were broken and his tongue was torn so badly that he can't speak and may never be able to. His head was shaved some weeks ago for the operation that saved his life and only a dark fuzz covers it now. He's extremely thin; his face is covered with wounds that presumably are healing but look awful. He's lying in bed, his head turned away, his liquid brown eyes staring at the wall without blinking. It's an almost unbearable sight made infinitely worse when he suddenly sits up, looking like a charred fire victim rising from the ground. We all start and then force ourselves to make conversation as a young man sitting nearby, probably a relative, jumps to help him. After a couple of minutes we permit ourselves to go into the hall, where Ghada's cousin promptly faints. She quickly recovers but is mortified at having displayed weakness when the badly wounded people around her are being so brave. I'm glad to be busy shoving her into a chair and pushing her head between her knees because, as I tell her, it's only the activity that's keeping me from fainting as well. We end our visit, and I'm astonished to find when we get outside—hot, sweaty, covered with dust, upset—that I'm only a few blocks from home and the garden and the vine-covered arbor: I've been in a different world.

Returning from a food production project in a village near Nablus some days later, I learn that a friend has injured himself and been taken to Maqasad Islamic Hospital, considered the best Palestinian hospital. The family is shocked at its condition. The intifada has strained its facilities close to the breaking point. New restrictions on the amount of money charitable organizations can bring into the country have limited its access to the funds it has raised abroad and the hardworking staff is inadequate for the workload. I'm told that at least three applications for permission to build an additional hospital in the West Bank are pending. The money is in hand, the doctors and nurses are ready, but no permission is forthcoming from the military administration. Patients are not covered by health insurance. Money supposedly designated as premiums for health coverage is deducted from the wages of all Palestinians who work inside Israel, as it is from the wages of Israelis, but Palestinians are not entitled to payment for hospitalization other than the expenses of childbirth and, even then, only if the birth occurs in an Israeli hospital. On July 9, 1988, the government raised the cost of treatment in government hospitals for Palestinians wounded in clashes with troops, said that a lien would be put on the property of any patients who were unable to pay the newly imposed daily fee of 248 shekels (about $125) three days in advance, and decreed that all medicines prescribed in government hospitals could be dispensed only at the health offices of the civil administration and that outpatients waiting to see hospital specialists had to be referred to them by its health department. The Israeli press reports that government hospital fees on the West Bank are leading Palestinians to avoid those institutions in favor of private hospitals like Maqasad that, even under strained financial circumstances, are sufficiently sympathetic to the Palestinians' limited incomes to treat intifada victims for nothing and charge others only nominal fees. The disparity in cost obviously increases the number of patients in and the pressure on the Palestinian hospitals. The Israeli administration says that it has limited the funds that can be brought in because the money might be used to support terrorist activities. It has offered no justification for withholding the permits for new hospitals.

8

From the Committees to the Prisons

"In prison, you are not allowed to sing."

July 18, 1989: I'm taken to the village of al-Khader and the home of Mariam Ismail, the first of thirteen women put under administrative detention since the beginning of the intifada (a year later the total will be nineteen). A short, slender, attractive twenty-eight-year-old kindergarten teacher, she smiles a great deal and her eyes show curiosity, but one sign of her enormous control is that she doesn't speak the English I'm convinced she understands. She was arrested one night in February 1988 and questioned about distributing *bayanat* and raising Palestinian flags. She describes her thirty-three-day interrogation, during which she was kept in solitary confinement in a closed, unlighted room, was made to stand for long periods with her hands tied behind her back and a sack covering her head, was frequently denied food and water and permission to use the bathroom, was doused with icy water and then pushed into the kind of frigid air-conditioned room called a "refrigerator" by Palestinian prisoners, was threatened with rape, and was beaten. She spent most of the thirty-three days alone in that room when she wasn't being questioned, but for one week she was put into the kind of cell known as a "coffin" or "cupboard," one too small to allow any position but standing or sitting with knees pulled up to the chest. She nonetheless refused to sign a "confession," and no charges were ever brought against her, but an order placing her under administrative detention was issued in March 1988.

She was then taken to a cell that she estimated to be about six feet square and that already held four other women. It also contained very primitive bathroom facilities, but at least it had water. The five women were always confined to their cell; if the prison had recreational facilities, she says, the women never saw them. No books or newspapers were permitted. Red Cross representatives brought reading material but it was confiscated as soon as they left. The only news she had during her six-month incarceration was from the front page of a newspaper she managed to read surreptitiously while the Red Cross was still present. Family visits by up to three people were allowed once a week for what seemed to her to be a quarter of an hour. She and other women political prisoners continued the pre-intifada practice of refusing to be housed or to eat with criminal prisoners. (Until August 1988 and the completion of the Hasharon prison for women political prisoners, they were kept in prisons that also held Israeli women jailed for criminal offenses. Initially recreation hours were the same for all, and the Israeli women sometimes used the opportunity to attack the Palestinians. Palestinian women prisoners struck in protest in May 1988.)

The stomach and kidney problems Ismail had before being imprisoned worsened, and while in solitary confinement she developed back pains and sensitivity to light. Because she was the first woman to be placed under administrative detention, her case was reported by the Israeli press. It has been documented by the Tel Aviv–based Women's Organization for Political Prisoners and by al-Haq and received renewed attention after her twenty-five-year-old brother was shot and killed in May. When I ask her about her vision of the future state, she immediately replies that it will have no prisons. She denies having been involved in political work before she was arrested but makes no secret of her intensive participation now. There isn't time to discuss the definition of *political*, which is unfortunate, because she was an active member of a Bethlehem area women's committee before her arrest.

Later I interview another former prisoner. A cab takes me from Jerusalem's National Palace Hotel to the home of Amal Wahdan in Abu Dis, a village of about ten thousand people. There's a fantastic view of Jerusalem as we descend, and the mostly white sky displays

a hazy line of pale red light—not pink, but pale red, as if it's being seen through a theatrical scrim. There's an equally spectacular view of Abu Dis. When we reach the village the driver props the *kuffiyeh* a bit higher on the dashboard—his Jerusalem car has Israeli license plates—turns on the interior light, and stops to ask directions. As is usual, the house is not known by any street name but is described as "Beit Labadi—near the UNRWA school" (Labadi is the last name of Amal's husband). A number of young men walk alongside the cab as it twists through narrow streets, one of them opening the cab door for me and ringing the doorbell—a combination of courtesy and security. Amal's mother-in-law leads me into the large living room that seems packed with humanity. There are five young women, one in the final stages of pregnancy, two older women, and a mass of children aged one to five running about barefoot. Little shoes are lying everywhere. The women's dress varies from traditional to modern. The walls and table hold posters protesting deportation and pictures of Amal's husband and brother-in-law. We sip coffee, and eventually the women, who have dropped in to chat, gather their offspring and depart. Amal, who left the house at 7:30 this morning, returns at about 9:30: clear-eyed, smiling, energetic, scooping up her three-year-old son, Khalid, who refuses to go to bed until he's sure she's home.

She and I sit talking until 2:00 A.M. A political activist since her student days at Birzeit, she's a labor leader, a leader of one of the women's committees, and the head of the organization of families of deported men. She met her husband, Mohammed, through the labor movement. They've known each other for eleven years and have been married for seven. She estimates that during those seven years they've managed to spend a total of three years together, in bits and pieces. Mohammed was in prison throughout most of both her pregnancies. Amal was put under town arrest when she was five months pregnant with her first child, Liana, now five, and could not travel to her doctor's office or to the Gaza prison where Mohammed was being held. Each of the three times that Lea Tsemel, her Israeli lawyer, filed an appeal notice in the High Court, Amal's arrest order was lifted immediately before her case was scheduled to be heard but was then renewed. A campaign by Israeli women and others

abroad finally led to cancellation of the order after two and a half months.

Mohammed was imprisoned again but released before Khalid was born and, in a most unconventional act, stayed with Amal in the delivery room. They were both put under town arrest for the year and a half following, losing the jobs to which they could no longer commute. As a result, Mohammed assumed much of the responsibility for the little boy's care. Khalid was under two in 1988 when a warrant was issued for the arrest of both his parents and their sister-in-law Fadua. They went into hiding but Amal and Mohammed emerged to see the children when they could. Khalid would become hysterical each time his father left. On one occasion he became so upset that Amal told her husband to go and she'd join him after she'd calmed down the child. She tried to sing Khalid to sleep and couldn't understand his increasing unhappiness until she realized that the song she was singing contained the word *Daddy* and that he cried louder each time he heard it.

It was not long afterward that Amal, Mohammed, and Fadua were found and arrested separately. None knew that the others had been taken, and Amal was grateful that at least, as she thought, her children still had one of their parents. Two days later her interrogator came as close to destroying her morale as was possible by telling her about Mohammed's arrest.

The children are unlikely to see their father soon, nor is Amal. He and his brother, also a labor leader, were deported to Lebanon in June. No charges had been brought against them. The only reason given for the deportation: "security." Amal has not been allowed to leave the country for eleven years. The reason: "security." She had finally been given permission some weeks before to travel abroad and was told to come back today to pick up her *laissez-passer*. When she arrived at the office she found that a decision had been made not to issue it. The reason: "security." She now sits in the living room, smiling sadly and saying quietly, "This means a new campaign. I'll have to start making the rounds of the embassies again. I won't stop fighting. I can't stop fighting. They're my rights."

She believes that her interrogation had been an attempt to get

evidence that would convict Mohammed. The IDF colonel who interrogated her, whom she says is widely known, told her he didn't want to keep her husband in prison because Mohammed was too successful at organizing prisoners, and the colonel would make every effort to get him deported. She was usually interrogated between 11:00 P.M. and 4:00 or 5:00 A.M. She saw the sessions as a challenge, accepted it, and insisted on lecturing the colonel about politics. She talked about the inevitability of a Palestinian state next to Israel and said Israel was mistaken in putting political opponents in prison, which only served them as a school; he agreed, adding matter-of-factly that it was more than a school—it was their university. On the fifth day of interrogation she decided she'd said everything she wanted and resolved not to speak. The colonel filled the silence by talking for three hours, during which Amal thought she could see him becoming more nervous. Finally he asked her to collaborate. She burst into hysterical laughter. He said he'd just been joking; he'd wanted to see her laugh; the interrogation was over (it was nonetheless resumed two weeks later). It wasn't until that point that he even detailed the "security" charges against her.

During her five-day interrogation she was kept in a "cupboard." There was no fresh air, no electricity, no food, no water. Sounds became important: the heavy metal doors being shut, the clinking of the guards' keys, even other voices screaming. She learned to sleep standing up. Her sleep was light and whenever she heard the guards coming she'd smile so that that would be the expression they'd see as they looked through the cell's little window. She had to fight to get access to a toilet. She yelled and banged on the door. She was finally allowed to use the toilet (most unusual for a prisoner in a "cupboard") in a larger unoccupied cell nearby. Once there she'd rush to the toilet and then lie on the cell's mattress—a major luxury. The guard would urge her to hurry up; she'd remain out of sight and shout back that she wasn't finished just to prolong the joy of the mattress. As soon as she obtained toilet privileges she began demanding food, which she didn't want but demanded because she thought she'd become less of a person if she stopped

insisting on her rights. She'd knock on the "cupboard" next door to communicate. She'd sing loudly. She recalls that none of this was permitted: "In prison, you are not allowed to sing."

Eventually she found herself in a women's prison ward and realized with joy that she could hear Fadua singing down the hall. Prisoners in jails controlled by the Israeli Prisons Bureau supposedly have a right to books, but Amal says you don't get them if you don't fight for them. Fadua had obtained newspapers and books that she persuaded a guard to take to Amal. One of the books, by a Russian author, was more than four hundred pages long. Amal read it five times. She made a chessboard from a piece of her blanket and playing pieces out of fragments of orange peel. So did the prisoners next door, and they were able to play checkers by giving each piece a number and communicating their moves through knocks on the wall. They made necklaces out of olive pits; they kept time by letting water drip into a glass and calculating how long it took to fill; they used the punched-out "holes" of paper, grabbed from the floor in interrogation rooms when interrogators weren't watching, to write out an alphabet with which they could play word games.

Her cell was filled with flies and the smell of the toilet. A few weeks after she was arrested she was taken to court. There she was allowed to see her children, but only at a distance. Khalid ignored the guards and ran to her with Liana following. Liana recoiled: Amal had been in the same clothes and without soap for twenty-one days, and her daughter was repelled by her odor.

Amal stole a tiny piece of soap from the courtroom bathroom and had the enormous morale boost of being able to wash her underwear. Later she got sympathetic guards to bring her soap and sanitary napkins and toilet paper and to act as a courier between her and Fadua. Many of them told her openly that they considered both the occupation and the imprisonment of Palestinians a hopeless cause. They expressed surprise at finding Palestinian prisoners who treated them, the guards, as human beings. As soon as new guards came on shift Amal would try to establish a relationship with them. For a while she was the cellmate of Roni Ben-Efrat, one of the Israeli women editors of *Derech Hanitzotz*, an Israeli-

Palestinian newspaper whose staff was accused of working for a terrorist organization.

She speaks persuasively about the need to organize a women's agenda while the national liberation struggle is going on rather than, as some women insist, waiting until after independence. Hers is not the intifada smile. Its source is unclear, but she has a real one.

July 19:　　Amal has asked me to get her up early. But we went to bed late, and when I go to her bedroom at the agreed-upon hour I see through the open door that her son has climbed into her bed and they're both so soundly asleep that I can't bring myself to awaken her. Her mother-in-law has already arrived and is cleaning the kitchen, feeding the various children, preparing coffee. Eventually Amal drops me off in Jerusalem before driving to wherever it is she's going. I comment as we drive that Abu Dis is a beautiful town. She says it used to be; now, however, the beauty is ruined by an IDF encampment in its midst, located in a confiscated house high up on a hill.

I'll learn in September that Amal has been to Kibbutz Harel to address the first national meeting of Israeli Women in Black, a group of Jewish Israelis that began in Jerusalem and now has branches throughout Israel. Its members wear black when they stand each Friday in highly visible, usually government-related areas silently protesting the current loss of Palestinian lives and what they view as the inevitable loss of Israeli lives if the territories are not ceded and a Palestinian state is not permitted to come into existence. It may be their pressure as well as that of other Israeli women and foreign officials that resulted in the permission given to Amal to leave the country, when she was finally reunited with Mohammed in Egypt. When I visit again in January she is still in Egypt, considering asking for permission for her children and their grandmother to leave the country but herself planning to return to the West Bank to continue the struggle. I'll see her the following July at one of the women's committees' offices and tell her I'm asking the women whom I'm mentioning by name to review the draft of my book to see if inclusion of their names might endanger

them. She smiles ironically and says she can't imagine being more endangered than she is already.

In July 1990 I'll be reminded of the suffering of Amal's children when I meet Amal Aruri, supervisor of a women's committee kindergarten program in the Ramallah area and the wife of deported physicist Taysir Aruri. An international campaign by physicists and other scientists as well as nonscientists to prevent his deportation was ignored by the authorities. When Amal Aruri and her three children, aged three, five, and eight, went to the Jerusalem airport to say good-bye to Taysir, who was taken there directly from prison, she and the children were removed from their car by the authorities and held in a room for six hours. Her requests for an explanation, an attorney, and food and milk for the children were all denied. Taysir was put into the airplane without Amal or the children being able to see him, and they were released only after the plane had left. Almost a year later I'll find the children vibrant with youthful energy but angry and confused. Nadia, now four, will still insist on drinking milk from a bottle, and because she refuses almost all food Amal will permit it—the child has enough to contend with.

Today, at the Ramallah home of Maha Mustaqlem, a high school physics teacher who leads the UPWC, there is more talk of women in prison. I arrive at her house to be told by her husband, Hani Nasser, that she's called to say she's caught up in an unexpected curfew in Beit Hanina, a town that's considered part of East Jerusalem, but expects to be home soon. He speaks about his life in and out of prison, where he was first sent in 1967 in connection with *bayanat* calling for a boycott of Israeli goods. He shows me the picture of a friend who, according to prison officials, committed suicide in the bathroom while they were incarcerated together. In fact, the two of them and a number of other men were housed in a cell that had only a bucket, no bathroom. I realize that the picture is one I've seen in posters on walls and in other homes. The dead man was a much-admired leader who no one believes killed himself; nor do the Palestinians find credible the stories of the deaths of the other political prisoners who are said to have committed suicide.

Hani recounts the story of one of his own brothers. The brother

and his wife and three children had come from Sweden to live with his family in Ramallah, although none of them was on the official Israeli register and thus had no legal right to live there. Their fourth child was born in Ramallah but Israeli officials refused to register the child as a citizen. The brother ignored an order to leave the city in which his family had lived for decades and was therefore imprisoned. His wife died of cancer after he was released. The family was forcibly deported to Sweden. They can't come here nor can their relatives go to see them: they've all been denied *laissez-passers*. Hani speaks bitterly of Soviet Jewish émigrés who want to go to the United States but are being pressured to move to Israel when non-Jews born in the territories are not allowed to live here. He wistfully wishes he could take his four- and five-year-old children to parks, museums, or on trips out of the country and talks sadly about watching the little kids in the streets playing "intifada." Later I wonder how the children decide who will play the soldiers.

Maha and the children arrive. A Palestinian flag had been put high up on a wire in Beit Hanina, and a contingent of soldiers had arrived to take it down. They tried climbing on top of a jeep and using a long pole, but it didn't reach. Another attempt was made from the roof of a police car, which was bigger, but that also failed. Meanwhile a group of little children was dancing around near the soldiers, chanting the intifada's "PLO! Israel no!" The soldiers became so frustrated and tense that they slapped a curfew on the town. Eventually a truck with a built-in ladder arrived, the flag was removed, and the curfew was lifted.

Maha laughs while she recounts the story, but most of her tales of life under occupation are less amusing. She reports having made a point of going to every demonstration when the intifada started. A few months later she miscarried and was told it was probably from the effects of teargas, after which she reluctantly stopped going to the demonstrations. She was nonetheless jailed for ten days, while her husband was also in prison; she assumes it was an attempt by the Israelis to get incriminating evidence about him. She, too, was put into a "cupboard." One day her menstrual period began. Without sanitary napkins or tampons, there was nothing she could do about the blood running down the backs of her legs. She became

so angry when the interrogator chose that day to lecture her about the modern and humane nature of Israeli prisons that she turned around (she was kept standing throughout all interrogations) to show him the blood. He immediately got her tampons and clean clothing. When she was returned to her cell, another soldier took the tampons away.

She mentions, as do others, that there's a decided difference among guards. Many Palestinians believe that the Ashkenazim (of Western origin) are more humane and the Sephardim (whose families came from Middle Eastern or North African countries governed by Arabs) more brutal. An Israeli psychologist emphasizes factors other than background. Itamar Luria, who has done research on soldiers and the intifada, cites as major factors the example set by the soldier's unit (something that appears to be borne out by the repeated appearance of such groups as the Givati Brigade in allegations of violence) and the example set by the commanding officer. Whatever the causes of the differences in soldiers' actions, the Palestinians are well aware of their effects.

I will learn during the fall that Maha was back in prison, having been arrested and taken to the Russian compound in Jerusalem and accused (but not formally charged) once again with membership in the Popular Front for the Liberation of Palestine. As they had in the past, her interrogators would demand information about the PFLP, which she kept insisting she knew nothing about. On the fourth day of her incarceration, with constant interrogation and no food or sleep and with a sack over her head and her hands secured behind her back, she fainted. She said it was a relief to be taken to a cell at that point, because at least she could lie down (on a bare mattress with no blanket). From then on she was kept in the cell. As she had not eaten for four days anyway she decided to protest her treatment by going on a hunger strike. She remembered the prison doctor, called to examine her, saying she should be taken back to her cell and ignored; the hunger strike would be good for her figure. An International Red Cross doctor was less sanguine, apparently concerned about her kidney and liver, and told her she'd die if she refused to eat. She maintained the strike nonetheless but from then until the end of her incarceration a prison doctor examined her

each day. Her cell was so filthy that when her jailers tried to persuade her to end the strike she said she would do so if they would clean it. They refused; she then said she would end her strike if they would give her permission to clean it and would provide a bag in which to put all the filth. Their reply was that the filth had been put in the cell just for her. She was revolted not only by the conditions of the cell but by its toilet arrangements. There was a spigot on the wall with a hole instead of a toilet underneath. A window in the cell door could be opened at any time, and as the spigot and hole were in full view of the window, use of the toilet was inhibited.

She was released after fifteen days, possibly as a result of the international pressure generated in part by her membership in the United Nations–credentialed nongovernment organization for Palestine. Her health problems continued after her release, as did harassment. The family received incessant threatening telephone calls. Her car was shot at when her brother happened to have borrowed it; fortunately, neither he nor his family was hurt. A Molotov cocktail sailed over the car when she was driving it one night, either poorly aimed or designed to frighten rather than hurt her. During a night of much noise around their house the family dog was killed, and in the morning Hani found a notice near the dog's body ordering Maha to report to a certain officer at military headquarters. She did not go.

While the philosophy of Maha's committee, the UPWC, tracks that of the Popular Front for the Liberation of Palestine, the committee insists, as do the other women's committees, that it is not formally allied with any party. The PFLP is the most radical of the four parties and hence a major target of the Shin Bet, although as of this writing it is still an advocate of a two-state solution. While Maha loathes the Israeli government for its treatment of Palestinians, she agrees with the PFLP about the desirability of two states and is determined to see an independent Palestine alongside Israel. Nonetheless she fears that the concessions already made by the PLO have been too many in the face of too little return and may have lengthened rather than shortened the peace process.

We talk about her committee's genesis and plans. Its co-ops, like

the one I visited in Beitello, are part of a conscious attempt to create an alternative economic infrastructure and reflect the committee's recognition that the political, social, and economic oppression of women are connected. Women must become decision makers as well as participants—something Maha believes has occurred during the intifada largely because of the nine years' preparation provided by the women's committees. Her vision of the Palestinian state is one of many small cooperatives, most definitely not industrialized, for she fears the only way Palestine could industrialize would be to borrow so much capital that the result would be economic colonialism. The women's co-ops currently work in concert with agricultural co-ops run by men; for example, the Beitello co-op's pickles are made from cucumbers produced by and purchased from the agricultural co-ops.

Maha is excited about a new school of co-op training that is just beginning. It will meet all day once a week for six months, with participants selected by subcommittees throughout the territories. Students will be taught about politics, economics, sociology, gender-based roles, and the structure of co-ops. Each will then return home and work out plans for the kind of co-op that realistically can be organized locally. After three months of thought and planning, each woman will go back to the school and explain her plan. If the other students agree that it sounds feasible, the presenter will receive a diploma.

Maha asks if I know two New York women who had been invited to stay in her home the year before, commenting that she was startled to learn when they arrived that they were Jewish: she'd never had a Jew in her house before. She's surprised again when I say I'm Jewish too. That leads her to tell me that during the two women's visit she realized that her children had become accustomed to hearing everyone, herself and her husband included, talking about their enemies "the Jews," when the adults knew they meant "the Israelis." She's since made a conscious attempt to change the language used in her home and elsewhere.

9

Men, Women, and Families

"We told the shabab, *stay home and sleep, today we're in charge."*

There are so many phenomena occurring at once during the intifada that realities occasionally seem to conflict. Some of the women who battle with soldiers are ordered by their husbands and fathers not to work in popular committees. Young people of both sexes plan demonstrations and enforce strike hours, but girls of fifteen or even younger are still married off by their fathers. Elite women with professional degrees are knowledgeable about women's liberation around the world, but poorly educated women, who would be shocked by feminist theory, glory in the belief that they and other "real women" are the strong ones of the family. Some women see the intifada as a chance to gain gender equality, while others, like most men, view the participation of women as an emergency measure that will be unnecessary when independence is achieved and the women return to their homes.

On the one hand, the intifada and the women's committees have changed the roles of women. On the other, most people's *perceptions* of women's roles have not been altered. This lack of change is apparent in the public language of the intifada and the private world of the family.

The language of the intifada is found in the *bayanat* (leaflets) issued periodically by the Unified National Leadership of the Uprising. The Leadership's composition is secret, beyond the fact

that it includes representation from all four parties (Fateh, the DFLP, the PFLP, and the Communist party) but not the fundamentalist Hamas group, which is nonetheless sometimes consulted. Its *bayanat* tell the population who is to be congratulated for what deeds, the dates of upcoming strike days, and what new actions are recommended. They are reminiscent of those that appeared during the 1936–1939 uprising, when leaflets issued by the Arab Higher Committee referred to the "youth of Palestine, men, elderly people" and not at all to women. Anyone reading today's *bayanat* might well conclude that the intifada is essentially male, with women occasionally playing a very peripheral role.

The *bayanat* refer to "Brother workers," "Brother businessmen and grocers," "businessmen, professional workers and craftsmen," "Brother doctors and pharmacists," "sons of our people," "brother members of the popular committees and the men of the uprising," "our sons in the fascist jails," and "heroes of the Lofty Intifada." Very infrequently, mention is made of "doctors, pharmacists and nurses," "our people and the youths and girls of Palestine," or "male and female detainees jailed in enemy prisons and detention centers." When women appear in the *bayanat*, they are usually coupled with children and the elderly: "Women and old men will organize protest marches to the Red Cross headquarters" or "the bereaved, children, women, and the elderly who are suffering from the repressive measures of occupation." Even the *bayan* entitled "Call of Celebration of the Independent State" mentions women in only two passages: when the Leadership offers its "congratulations to the mother of the martyr, for she has celebrated only twice: when she gave her son and when the state was declared," thus defining women as baby factories and bystanders, however enthusiastic, in the nationalist effort; and again in its "congratulations to all our women, men, children, and the old," which seemingly desexes the elderly.

One *bayan* deserves to be quoted at length. Among sections entitled "Anniversary of Karameh," "Universities and Higher Institutions, Schools and Students," "Summer Time" (about setting the day on which clocks are to be turned back one hour), "Detention Centers and Prisons," "Green Cards" (identity cards), "Days of

Distinguished Escalation" (calling for specific kinds of actions), and "Days of General Strike," there is a paragraph entitled "International Women's Day":

> Progressive humanity celebrates International Women's Day on March 8. . . . We celebrate this great day and offer our congratulations in the names of the children of our people to the international masses of women, to the masses of the Palestinian women's movement and its vanguard fighters. We send our greetings to every working woman, fighter and housewife and, at their forefront, to women fighters in prison. We praise the developed role of the masses of Palestinian women in the intifada's struggle; praise every woman who is bereaved of a son, daughter, husband or brother and every woman who meets a fighting daughter or heroic son from behind the bars of the zionist enemy's bastilles. The UNL also calls for the organizing of massive women's marches, meetings and sit-ins on that day. The UNL also declares that March 8 is a paid, formal holiday for all women workers in national institutions.

Two paragraphs later, Mother's Day is noted and the Leadership "bows with esteem and high regard to the mothers of our martyrs." One can only conclude that the Unified Leadership's *bayanat* are a joint effort, with different people inserting different words, and that its membership rotates—which would in any event be a logical safety measure—and perhaps infrequently includes a woman or a man more aware of women's changing role.

The *bayanat* might be discounted somewhat as hurried efforts that do not reflect men's altered consciousness. The November 15, 1988, Palestinian Declaration of Independence, however, written with care after extensive debate about its content, portrays women in a traditional, nurturing, but politically passive role: "We render special tribute to the brave Palestinian woman, guardian of sustenance and life, keeper of our people's perennial flame." The declaration also says, "Governance will be based on principles of social justice, equality and nondiscrimination in public rights on grounds

of race, religion, color or sex." But the accompanying PNC "Political Communique" reverts to defining the "Palestinian masses" as "the unions, their vocational organizations, their students, their workers, their farmers, their women, their merchants, their landlords, their artisans, their academics," thereby excluding women from the categories of students, workers, farmers, artisans, and academics, where they can already be found.

It is not only the men whose language denigrates the role of women. The pamphlet issued on October 1, 1988, by the four women's organizations to protest the deportation of nine activists is remarkably similar to the UNLU's pamphlets in being addressed to "the heroic masses of our Palestinian people, the heroes of the great intifada." Women are mentioned only in one sentence, which describes the way the "intifada has reached the whole world . . . and Palestinian women have trilled with joy." The ululation of Palestinian women at moments of great emotion is of course a highly traditional response by passive spectators to the actions of men. As two Birzeit scholars have noted, the traditional role of "mother of the martyr . . . has the qualities of stoical courage but not necessarily of active resistance" and at least "suggests that women's current role has not been adequately assessed and may not be sufficient to improve her status in the future."

In spite of the claim of some women to have been leaders of the popular committees, which were outlawed by the Israelis in August 1988, there is no indication that women participated in the decision making of most popular committees in the camps and villages. Meetings of the camp leadership are usually held in mosques or coffee shops, where women are rarely to be found. Most village popular committees coordinated with women's committees but retained gender segregation, which made joint meetings impossible. Thus, although there were more women than men in most popular committees, it is questionable whether women's participation resulted in long-term political power.

Before the intifada, middle-class women had moved from university-based politics into "middle-management" leadership positions in male-dominated trade unions and political parties. This seems to have been facilitated by two factors. The first was the

experience women gained in mobilizing, public speaking, writing, planning strategies and tactics, and other aspects of organizing at the university and in the women's committees. The second factor was the vacuum created by the increased level of incarceration or deportation of male leaders. During the intifada, women have assumed even more leadership positions because much of the male leadership has been removed from the public sphere by the IDF.

The new visibility of women leaders, combined with the demands of the intifada and the resultant opportunities for female political activity, has led to a radical change in the attitude of some women and perhaps of some men. A young woman organizer of a march of several hundred in the village of Kafr Na'ma on International Women's Day 1988 said, "We told the *shabab*, stay home and sleep, today we're in charge." A twenty-six-year-old woman raised in a traditional home has become a "daughter of the uprising, having risen to the status of a community leader of both men and women just during the past several months." A PFWAC newsletter tells the story of a twenty-seven-year-old laboratory technician who has become a hospital administrator and organizer of a clandestine blood donation network. She has been arrested ten times during the intifada and has been refused a permit to travel out of the West Bank. Her activism appears to be acceptable, for she was married during 1989 and her father is frequently told that his daughter "is worth four men."

Political discussion is no longer a male preserve. Women routinely join in or initiate conversations about politics, demonstrating that the public sphere has become as much theirs as it is men's. But I wonder if Palestinian men, and most women, look at the emergence of Palestinian women as political leaders and entrepreneurs in the same way that American society looked at women in the work force during and after World War II: when American GIs returned, the women were immediately deprived of their wartime jobs and sent home, reflecting both the societal belief that women's place was in the home except in emergencies and the economic reality that their labor in the paid work force was no longer necessary to the men running the economy. Nothing sug-

gests, for example, that the much-extolled laboratory technician's skills are viewed by Palestinian men as indicative of the capabilities of most women.

Whenever Palestinian leaders hold a press conference, the only faces to be seen are male. The occasional exceptions invariably are Zahira Kamal and Hanan Mikhail-Ashrawi and, less frequently, Rana Nashashibi, a family counselor and women's committee leader. The leadership outside the territories consists of such men as Yasir Arafat and Bassam abu Sharif. Women discussing this acknowledge that it is usually Kamal and Mikhail-Ashrawi who are in the public arena but argue that one has to start somewhere and that these women's participation is a sign of progress. They add that many other women take part in peace-oriented conferences abroad, refining their political skills and gaining recognition. They also mention the election of Intissar al-Wazir to the central committee of Fateh and the appointment of Leila Shahid as the Palestinian representative in Ireland, emphasizing not the small number of women in political positions but the changing values that have finally enabled some women to reach them. As Birzeit scholar Nahla al-Assaly has noted, however, there are no women on the Palestine National Council's fifteen-member executive committee, which, since the PNC's 1988 Declaration of Independence, has been the equivalent of a Palestinian government. The implicit message is that there is no room in the government for women.

In addition, since the excitement of the intifada's first year and with the increasing sense that all of its sacrifices have brought peace and statehood no closer, something of a reversion to earlier ideas has occurred. Papers presented by Palestinian scholars at a conference held in Jerusalem in December 1990 suggest both that the nature of women's participation in the intifada has changed and that the alteration in values was short-lived for much of society.

The scholars point out that the popular committees began to decline after they were outlawed by the Israeli administration in August 1988. About that time, party-based "popular armies," in which women have at most a minimal role, came into existence. Many women turned their attention to production projects (other than the women's committees' co-ops) that were extensions of the

home economy. Parents had allowed their children more indepen-
dence and autonomy than ever but by the end of 1988 had turned
back to the traditional ways. The ensuing years have seen the
resurgence of forced early marriages and the old concept of shame.
Marriage and the early arrival of children is viewed by many as a way
of keeping single men and women out of the political activities that
could result in imprisonment, the subsequent unmarriageability of
women, and the permanent wounding or death of men. With the
appalling rate of unemployment, fathers are eager to turn the
burden of supporting their daughters over to potential husbands.
Sara Hanun, the chair of the Red Crescent in Tulkarem, believes
that while the intifada "provides us with the power to be stronger
and more active," fathers still view a daughter as "property to be
married off in exchange for a dowry. After the wedding, she contin-
ues to give part of her salary to her parents." A young woman at the
Nablus Women's Research Center has been studying early marriage
in her village. She has tried to use the study as a way to reach
women and urge them to concentrate on acquiring education. But
even members of the local women's committee, she says, are
oppressed by men, who retain decision-making power over family
as well as political matters. A women's committee leader says that
the tendency toward forced early marriages has moved from the
villages and camps to the cities, citing the marriage of a twelve-
year-old in Ramallah in May 1991.

Families are increasingly forcing women and girls to drop out of
schools and universities, to protect them from political activities
and loss of honor. The culture of the intifada, which downgrades
frivolous or costly activities, including restaurant meals, movies,
parties, and family excursions, has reinforced the tendency of some
elements in Palestinian society to scrutinize women's behavior and
dress. Clothing has become even more of a political statement than
usual with the rise of fundamentalism and its emphasis on "mod-
est" apparel for women.

The new approach to shame has come under attack. Another
young researcher at the Nablus Women's Research Center has
found that it is now difficult for women ex-prisoners to get work or
find a husband, even though the leadership has urged employers to

hire former prisoners. They're treated, she says, as if they have a dangerous disease. There's general agreement that the only women prisoners who can now be certain of societal support once they are released are members of the women's committees.

Some scholars believe that membership in the women's committees had decreased by 1991 because of family and fundamentalist reaction against female political activity, the inability of the committees to articulate a specific program for women beyond participation in production projects and cooperatives, the lack of progress in the peace process and a concomitant general questioning of the utility of political activism, and the demands made on women's time by the combination of household responsibilities, child care, and participation in the drive for economic self-sufficiency through creation of home gardens. Committee leaders disagree, seeing their activities as involving more women than ever, whether or not they are formal members, particularly as the economic decline forces women to seek out the committees' production projects. And the committees' projects are indeed thriving.

Nonetheless, there is a clear disparity between the importance of women in the early intifada and the revival of earlier ideas about their roles, and it appears to be the result at least in part of the lack of systematic thinking by women leaders about the implications of their activities. Leaders of the three socialist committees are well aware that women's equality will be achieved only if it is part of the political agenda, and they have made the abolition of the *shari'a* courts (courts based on Moslem law, with control over family matters such as marriage, divorce, and custody) and the institution of civil marriage part of their nominal agenda. As in most revolutionary situations, however, they have been reluctant to raise potentially divisive issues while the national liberation struggle is taking place. Whether or not to do so has become a major topic of discussion. Some feel that the appropriate time to turn to the women's agenda will be after independence. Others realize that, if a new consciousness about gender equality does not exist by the time the state is created and the revolutionary leadership becomes the leadership of the state, the momentum for change will have been lost. A number of women leaders have read about the role and

status of women during and after the liberation movements in countries such as Cuba, Algeria, Mozambique, the USSR, and China. They recognize that postponement of a women's agenda during the liberation struggle can be followed by a similar argument for delay based on the need for postindependence mobilization of the entire community to create an economic infrastructure.

The ambivalence of the women leaders with whom I have talked is reflected in the activities undertaken by their committees. In spite of the exhausting tension-filled life during the intifada, committees on the lower levels do meet for periodic discussions. Many of the leaders assert that basic matters of roles—household and childrearing responsibilities, employment of women outside the home, the personal choice of a husband, the impact of Islamic and Jordanian law on divorce, custody, and inheritance—are being discussed by those groups. In actuality, such discussions are relatively rare.

When I spoke with the young, largely unmarried women at the 'Eisawiyya frame factory, supposedly one of the groups that were engaging in such discussions, they insisted that marriage would not interfere with their jobs. When I asked how they would manage both, they all agreed with the statement of one woman that "a woman can get up very early in the morning, prepare all the food, clean the house, and then go to her job." There was a clear differentiation between the "job" that provides income and the "nonjob" performed in the home. It was assumed that child care would be handled by a combination of older female relatives and the day care centers, similar to those of the women's committees, that the women expected the Palestinian state to provide. When she returned home the mother would of course serve the family meal and attend to the children. I asked what the husband would do in the home, and while the question seemed to confuse most of the women, one replied rather defensively that the women would try to persuade their husbands to "help out." They would do this during the courtship period, which falls between the signing of the marriage contract and the day the couple actually begins to live together. The courtship frequently lasts for weeks or months, especially if the marriage is arranged when the girl is very young.

Pressed for details, "helping out" was defined as food shopping, traditional for many men in Palestinian society, and playing with the children. I pointed out that during the intifada men work in hospitals, cleaning floors, washing dishes, and so on, and asked whether it would be appropriate for their husbands to do the equivalent at home. They said no but could offer no reason. I observed that before restaurants were shut down by the intifada, most chefs were male and asked whether their husbands would "help" with the cooking. They shrieked with laughter at the idea of men in the home kitchen, crying, "Men don't belong there!" Again, they could not explain why, but they were adamant: perhaps they could not come up with answers to these odd questions, but they knew that the man's role was not in the home.

After we left, I asked for my guide's reactions to the women's willingness to take on such a demanding life. She replied that they clearly hadn't thought the matter through, largely because they were so delighted to have gotten out of their houses that nothing else seemed of great import. She didn't think they would live the lives they anticipate; rather, they probably would find the pressure of so many roles too much, their husbands would be unwilling to have them in the paid work force, and eventually they would leave the workshop.

At the same time, aspects of their domestic lives reflected a new reality. They were absolutely certain they would not be forced to marry men they didn't like. They pointed with pride to one of the workers present, a twenty-one-year-old who had been rejecting offers since she was fourteen. Her older sister, now twenty-nine, well past the age when a working-class woman was expected to be married, had also refused numerous suitors but did not feel harassed by her family. Her parents were unhappy about her refusals but would not use the kind of family or community pressure on her that was typical in the past. Dating still does not exist in Palestinian society. Increasing urbanization and the post-1967 development of coeducational Palestinian universities, along with the intifada, have resulted in the mixing of sexes in public places among students and activists of all classes. But I asked the women how, outside of universities and intifada activities, they can meet suit-

able men, particularly as the women emphasize companionship and compatibility more than was the case in the past. The 'Eisawiyya women said they expected to find acceptable men at demonstrations and in hospitals, and Birzeit sociologist Lisa Taraki predicted that many women will meet their future husbands while engaging in political work—joining political parties or serving on neighborhood and municipal education committees or medical relief committees. She also spoke of marriages that were, in effect, arranged by an informal extended family, the political party. The implication, however, is that as women leave the political arena, the possibility of their meeting and choosing husbands for themselves decreases. And those not participating in political activities are the least likely to be reached by the women's committees' new ideas. But even most politically involved women need the impetus of group discussion if they are to alter traditional values, and that need was not being served because of the ambivalence of some women's committee leaders.

The women in 'Eisawiyya came from urban working-class families. Those in Beitello, from relatively poor rural homes, had told me their husbands were too selfish to help at home. I'd spoken with a group of better-educated middle-class women in a village near Bethlehem, most of them planning to complete at least teacher training programs when the universities were permitted to reopen. They had been readier with the reply that when they got married their husbands would "help." To them, too, the important fact was that they'd gotten out of their homes. When I mentioned the experience of postindependence Algerian women to them, one commented, to the vociferous agreement of the others, "We won't stay home!" But neither, clearly, had they considered the issue of responsibility for labor in the home. When they were pushed to explain the inevitability of the two-job model for women, the participants became thoughtful. All of them asked me to remain in communication with them from abroad because they found the discussion intriguing and wanted it to continue. Their comments were a clear indication that the women's committees were not filling the need to explore these issues at the grassroots level.

The positive effect of intifada-related phenomena on the values

of the average Palestinian is questionable without follow-up discussions but quite apparent when such discussions occur. Zahira Kamal, who has long insisted that the women's committees must begin emphasizing a feminist agenda, spoke to me about an experience during her committee's early days. She had asked members in one area whether they thought men and women doing the same job should receive the same salary. The answer was no. She started asking questions, focusing on a woman she knew was a widow with seven children. What kind of work did she do? What about the men around her? What were her responsibilities on the job and at home? How did her work compare with theirs? At the end of the session the women concluded that salaries should be equal. On March 8, 1989, when part of the International Women's Day celebration consisted of discussions of women's status, committee leaders were happily surprised to find even older women participating.

But in the uproar generated by occupation and the intifada, not enough discussions have taken place either to raise the issues or to give women support for value changes that may be going on, and some leaders remain wary of the possible negative effects if traditional communities become aware of such discussions. Among the almost unmentioned issues in Palestinian society, for example, is that of battered women. Social workers and therapists know it exists, as it probably does in all societies, but it is not an acceptable topic for public consideration, and most women leaders fear that raising it would jeopardize community acceptance of their organizations.

The UNLU has given women little support. The intifada has not generated a program for women beyond their involvement in an expanded home economy that, along with their responsibility for home and children, has reinforced their segregation from the world of men. Israeli journalist Danny Rubenstein reported that in the early stages of the intifada thousands of households in villages, towns, and cities began raising cattle, chickens, sheep, goats, and rabbits, all in backyards and on rooftops. I had learned in Qaddoura camp of small cooperatives started by members of women's committees. Shares sold for 10 or 12 JD ($12.50–$15) and were used to buy cows or chickens or, in some cases, tomatoes that could be

turned into juice. But the importance women gained from the emphasis on home economy has faltered in the face of the boycott of Israeli products: the chickens and cows, the feed for them, and even the pesticides for vegetables and fruit trees come from Israel.

Given the leadership's attitude and the economic situation, it is unsurprising that the committee leaders, some of them less than secure in their feminism, have not been willing to raise feminist issues as such. They are nonetheless proud of and frequently discuss examples of the help they've given individual members. One widely known story concerns a PFWAC member who, after repeated beatings, left her husband and returned to her father's house. Her husband promptly took their newborn son to his own family in Amman. She had no idea that she had the right to contest this abduction. The committee told her she did and encouraged her to begin job training so that she could become economically independent. By the time she had gotten the courage to talk to the committee about her problem, completed job training, and earned enough money for legal proceedings, ten years had passed. She went to Amman to file for divorce and for custody of the child. Her efforts were successful, but because Israel had closed West Bank schools in reaction to the intifada, she decided to leave the boy with the family in Amman to continue his education. She now brings him to the West Bank for school vacations or spends time in Amman visiting him. The court-decreed settlement included the support money her husband should have paid during their ten-year separation but, against the committee's advice, she declined to press for it so as to avoid further problems with her ex-husband and to show the son how willing she was to make sacrifices for him.

I was told of an elderly member of the UPWC who had been beaten by her husband for years. The intifada began, and the woman joined those around her in fighting the soldiers attempting to arrest young men. She realized and told her husband that if she could beat soldiers there was no reason for her to go on being beaten at home. He persisted in his behavior and she left him. The committee has given jobs to two other divorced members and to a number of women separated from their husbands, exactly as it has to women whose husbands are in jail or have been killed.

Committee members, who have the moral support of their peers, are more likely than other women to consider asking for a divorce when a marriage is bad, but it is still not an action taken lightly. At Amal Wahdan's house I met a woman from the 'Aqbet Jabir refugee camp near Jericho who was staying with Amal for a few days. She had worked as a nurse at Maqasad Hospital while training as a laboratory technician. Then she married a teacher, also born in 'Aqbet Jabir, and she was now the mother of the two young children who accompanied her and was about to give birth to a third. She had lived near the hospital in Jerusalem while she worked but eventually moved back to the camp because her husband, disapproving of her activities, declined to join her. When she returned, he refused to permit her to find a new job or even to work with the committee and insisted that she confine her intifada activities to gender-specific ones like visiting the families of the wounded. She reported that his behavior received full approval from the men of the camp. What was worse, she lamented, the women there didn't support her because they thought of her as a leader sufficiently strong to defend her own rights and because they were afraid to do so until she had asserted herself.

She was considering leaving her husband and the committee was encouraging, but he threatened to take the children if she did. Drawing on the committee's advice, she told him she would go to the *shari'a* court and have custody awarded to her. He replied sneeringly that he would refuse to obey such a court order and that during the occupation and intifada she could scarcely complain to the Israeli police. Committee leaders assured her that the court decision would be enforced by members of the local popular committees. She was nonetheless so torn that, with a shamed expression, she admitted that she wished he would be arrested as he had been in the past and returned to prison so that her problem could be solved without any action on her part. The pressure on women not to divorce is evident in this tale of a woman strong enough to get herself an education and professional training and to take her children and leave her husband's home to work but afraid of the societal consequences if she ends a marriage that has become repugnant. Amal, a leader of Zahira Kamal's committee,

commented that some of the other committees make the mistake of thinking that women have achieved equality because they fight with male soldiers but that some Palestinian men still lock "their" women in their homes. And most women are too unsure of themselves to rebel.

The effect of the occupation and intifada on marriage obviously has been complicated. The barriers against leaving the home have been somewhat breached, whether in the relatively minor act of joining demonstrations or in the more difficult ones of doing volunteer work for a women's committee and working on a committee project. It is no longer realistic to assume that a young woman who regularly leaves the sanctity of her home is engaged in sexual activities that would make her unacceptable as a wife. The Unified Leadership has requested that Palestinians limit bride-prices (*muhur*) as an austerity measure. Some women are refusing *muhur* entirely, either out of patriotism or because they have come to view them as offensive (although since Moslem law still requires a *mahr* if a marriage is to be valid, those who reject it often accept one token dinar).

It is far from all women who reject a *mahr*, however, whether because they adhere to the older ideas, they are under pressure from their parents, or they want its security in case the marriage ends. The jewelry stores in Ramallah, Nablus, and Hebron all do a brisk trade in gold, much of it purchased for *muhur*.

Not only are big weddings unacceptable during intifada, but even the sending of printed invitations is frowned upon. Many families consider it rude merely to telephone an invitation and many others have no telephone. I was in a Ramallah home when relatives whose daughter was soon to be married followed the new custom of issuing the invitation in person.

It appears that marriages have increased and the frequency of divorce has dropped during the intifada, possibly out of a felt need to adhere to societally acceptable norms during a period of crisis or because the combination of smaller wedding celebrations and smaller dowries has lowered the cost of weddings and encouraged people to marry at an earlier age. A survey described in the Palestinian newspapers, noting that the marriage rate has gone up

between 20 and 30 percent, suggests in addition that the intifada's street demonstrations have brought people of marriageable age into contact and that siblings of wounded or killed martyrs are also seen as particularly desirable partners.

The emphasis on producing children, especially sons, is reflected in the parents' practice of taking new names after the woman has borne a son. If they name their oldest son Khalil, for example, the parents will be known familiarly as Umm Khalil and Abu Khalil ("mother of Khalil" and "father of Khalil"). The name alterations can go further: if a son becomes a doctor, people may begin calling his mother Umm Edduktor ("doctor's mother"). There is no name change until the mother produces a son (and the "responsibility" for the production of a son rather than a daughter is indeed seen as that of the mother): for this purpose, daughters are of no importance. One of Palestine's leading novelists, Sahar Khalifeh, remembers that her mother, who bore eight daughters but no sons, was known mockingly as Umm Banaat ("mother of daughters"). The average woman is expected to produce a child within the year following her marriage, and it is unlikely that she thinks about the problems of raising a large family until she has at least four children.

Professor Rita Giacaman has found in her longitudinal study of the village of Nahalin that the birthrate has risen 150 percent since the beginning of the intifada. This may, she points out, reflect no more than men's being home more, because of shortened workdays and curfews, than had been the norm. Interviews with women elsewhere, however, suggest that many women have been eager to produce "more children for Palestine" during the national liberation struggle. They reportedly have been encouraged by sermons in the mosques calling for early marriage and a higher birthrate. The childbearing of even some elite women may have been affected by the violent Israeli reaction to the intifada. A number of women told me that they'd heard friends talking about having one more child than they would otherwise because the chances of a child being killed have increased so dramatically: perhaps they should have four to ensure the survival of the desired three.

Labut'ana El-Jamal, a Bethlehem girls' school principal, main-

tains that "the society is essentially conservative, and has not changed its outlook towards women." She and the women scholars who have analyzed the intifada's limited or even negative effects on women are undoubtedly correct. But it is equally notable that many women argue that the traditional woman's role has no relevance for *them*—and that is a major change.

10

Nationalism and Feminism

"Women cannot work in the streets in the intifada and return home as slaves!"

July 21, 1989: The fundamentalist Hamas group has called a strike for tomorrow, Saturday, the day West Bank schools are due to open after having been kept shut for eighteen months. The talk is that parents are so anxious to keep the schools functioning that they'll send their kids anyway. During the last couple of days I've heard everywhere—in villages and refugee camps as well as cities—that the kids will go to school. It's almost unthinkable for people in the villages and camps to ignore a strike called by Hamas (or by the Unified Leadership). Their determination to do so on Saturday is indicative of the high value they place on education. Eventually the Hamas leaders, now jockeying with the Unified Leadership for power, will get the message and announce that the strike is meant to be only for stores; the schools can open. It's an extraordinary example of the people leading the leadership—something that has typified the intifada. The next bulletin of the Unified Leadership will call upon Hamas to coordinate its strike days with the Leadership, which appears to be the Leadership's strategy for gaining leverage in the community, one made easier by Hamas's decision to back down about Saturday.

Talking with neighbors about the reopening of the schools has me thinking about the way their closure exemplifies the problems created by the "people of the book" since they became occupiers.

Closing the schools has had a major impact on the attitude of young Palestinians toward authority and on the leadership of women in the educational sphere. Concern about the closed schools has been a theme I've heard repeated in every setting. The fear that little children are "even forgetting their alphabet" is expressed in tones usually reserved for accounts of imprisonment and beatings. The eighteen-month school closure has driven not only students but entire families out of the West Bank. So many parents have moved abroad that the prestigious Friends (Quaker) Girls and Boys Schools in Ramallah are consolidating into one institution. The same loss of students is to be seen in the local Lutheran school. The people who are leaving, of course, are the members of the skilled professional and monied classes who can afford to do so—precisely the kind of people the society most needs and the Israelis will want as neighbors.

When the government closed the schools, parents and others began study sessions in homes, churches, mosques, and gardens. These were promptly declared illegal, punishable by a prison sentence of ten years and a five-thousand-dollar fine. Some private and UNRWA schools then began preparing and distributing study packets. The packets, too, were outlawed. If classes were discovered, they were broken up and their materials confiscated or destroyed. Pupils with schoolbooks were beaten by the IDF and had their books taken. Nonetheless, the very high premium placed by Palestinians on education has resulted in the meeting of "illegal" classes in homes on a regular schedule in some urban neighborhoods and villages. In refugee camps, poorer urban neighborhoods, and other villages, the more watchful presence of the IDF has made it necessary to hold classes in different locations and at different times each day.

A large part of the West Bank's population has been involved in establishing and participating in the sub rosa classes, and most of them are women. The involvement of women is not surprising, given the existing women's committees, the large number of women teachers, and the relative ease of masking from soldiers the activities of women surrounded by children. In addition, university students, whatever their major academic interest, teach reading or

English or Arabic or math. This direct involvement in the formal educational process by nonprofessional teachers has increased the questioning, begun by educators such as Abdallah Rishmawi, of the relevance of Jordanian education to the West Bank. The Jordanian curriculum used in the West Bank ignores the Palestinian experience and is based on lectures, memorization, and the absolute authority of teachers. Community education and the involvement of students in the intifada, particularly in demonstrations, has resulted in a desire among Palestinians to make the curriculum more relevant, to develop a pedagogy that emphasizes student participation, and to respond to the students' new awareness of their importance to the community and their concomitant unwillingness to grant teachers automatic status as authority figures. The students are returning to their schools after eighteen months not as the docile, authority-accepting subjects they were, but as authority-questioning activists in a revolutionary movement. Many teachers describe the new attitude as respect for the teacher's authority, within the school, in the academic areas about which he or she is knowledgeable, coupled with a sense of equality of students and teachers alike outside its walls. Many women leaders have come to view the new attitudes of youth as part of the societal reassessment necessary for the alteration of women's status.

I take the *service* to Jerusalem and then a bus to reach Beit Sahur, visiting the Rishmawis' pharmacy with its bare shelves. In January I'll discover that Elias managed to restock them but the IDF emptied them once again, warning that he'll be imprisoned if he restocks a second time—so it appears the policy is aimed at economic collapse rather than payment of taxes. When I reach the pharmacy today, I find Elias's mother terribly upset. The army has decided to create an encampment in a vacant lot in the midst of a group of houses, one of them hers, and has told a family living in another house that it will be confiscated for army use as of two o'clock this afternoon. Mrs. Rishmawi is afraid that whenever there's a demonstration the army will behave as it frequently does: rather than giving fruitless chase to demonstrators, it will round up and arrest young men living near an encampment. She has been steadfast as her family members have been beaten and arrested for

nonpayment of taxes, but now she begins to cry at the thought of her family in prison, believing, like most Palestinians, that the young men said by the IDF to have "committed suicide" there actually were murdered. She falls into my arms, sobbing, apologizing between tears for this display of "weakness," clutching the cross that hangs on a chain around her neck and crying, "Where is He? Why has He closed His ears?" I am reminded of the way so many Jews asked the same questions about the Holocaust. There is nothing to be done: the IDF's actions are permitted by the Emergency Defense Regulations. I am so appalled at the army's power simply to order people out of their homes, the lack of recourse, the depth of misery that leads Mrs. Rishmawi to cry on a stranger's shoulder, her impotence in the face of a realistic fear about her children—at so many elements of an inhumane situation—that I can do nothing but hug her and babble meaningless noises meant to be soothing. If I haven't before, I now understand the worst of living under occupation. It isn't fear for oneself; it's fear for the people one loves or even just cares about because they're human. And around us are the men from the home that's being confiscated, no doubt suffering from a fury and a sense of helplessness greater than mine, but all wearing the intifada smile.

July 22: I open my bedroom shutters in the morning. The first thing I see is a shepherd guiding his sheep along a nearby road. The second is a group of three soldiers stationed on the roof of the neighborhood's highest building: they are looking down at me because of the sound of the shutters. Today the schools, including the one in our neighborhood, have been opened. In response to Palestinian assertions that the only way to minimize demonstrations by children is to remove the provocative presence of soldiers, the government has promised that the soldiers will not be around the schools. That seems to mean that the soldiers are to be above the ground rather than on it. The people who live in the building are not only uncomfortable at having soldiers coming and going all day but afraid that the soldiers will urinate in their water tank, something that's been reported in numerous places. The difference among classes and their access to power remains a constant even under occupation: the upper-middle-class residents of the building

complain to the military governor, and by tomorrow morning the soldiers will have been moved to the roof of the nearby post office. Another factor could be the presence in the West Bank of the international press, which has come to monitor the schools' re-opening.

There's intense excitement about the schools. Attendance is reported to be close to 100 percent in the grades that have opened today, and educators believe it would have reached that figure had there not been some continued confusion about the nature of the Hamas strike. The days to come will see no rash of student demonstrations, and the other grades gradually will be permitted to reopen. There will be talk of lengthening the school day (normally 7:00 A.M. to noon) to make up for all the lost months. That would raise the problem of feeding the students lunch, and there's also the heat. Schools usually aren't open during the blistering summer months, so they're not equipped with fans. There's little mention of the extra work teachers would have to perform if the day were lengthened: it's the kind of sacrifice one is expected to make during the intifada.

I'm off to Jerusalem. Rana Nashashibi, a twenty-seven-year-old who runs a Jerusalem counseling center and is a leader of one of the women's committees, has been quoted by *The Jerusalem Post* as saying, "The first priority is the Palestinian national struggle toward the establishment of a state and the fulfillment of the aspirations of a people. . . . But lately we are realizing that if we don't push the agenda of feminism now, it will be too late afterwards. It has not been easy for women to defy their traditional roles and go out in public to participate actively in the national struggle. . . . But it was important, so the obstacles to it were removed. Women have realized their strength and it will be difficult to pull them back."

Today I'm making a point of speaking with Rana, whom I've met only briefly, because of my growing feeling that relatively few women other than several leaders are wrestling with the issue of gender equality, that they know where they want to go but not how to get there, and that they are unaware that some of their troops are falling way behind them and others are looking for more radical answers. Rana seems, from the little I know of her, to have thought

her ideas through more carefully than some, and I want to hear them.

We've arranged to meet in the American Colony Hotel in East Jerusalem. This elegant former stopping place for potentates is one of two Jerusalem hotels that the Unified Leadership has said should keep its restaurants open because, along with the National Palace Hotel, it has become the site where press conferences are held, Israelis meet Palestinians, and foreign journalists and diplomats stay. Other restaurants, catering largely to Palestinians, have been closed in keeping with the intifada's self-denial and with the shuttering of all businesses after noon. During the intifada, the hotel has something of the cinematic atmosphere of *Casablanca*: although some tourists walk in and out, I have the feeling of being watched constantly, and whenever I look up someone else's eyes dart away.

I meet Rana in the lovely blue-tiled courtyard garden. As a counselor, she's particularly concerned about domestic violence. Convinced that it's always been an unacknowledged element of Palestinian life, as of most societies, she's worried about the increase in family battering during the intifada. The men, under tight discipline that forbids the use of weapons other than stones, are frustrated. The shortened workday, limited to prestrike hours, means that they're home more often rather than working and then meeting male friends in coffee houses. The closure of West Bank schools has resulted in children also being home all day. In addition, military curfews force the entire family to stay inside for days at a time, often in very cramped quarters. The battering that follows in some homes is unsurprising. The same thing is occurring in Israel. Many of the men who are repeatedly sent into the territories and told to solve the problems they face there by beating people are unable to return home and behave nonviolently when confronted with domestic dilemmas. The difficulty is compounded by a phenomenon that is otherwise positive: all able-bodied Jewish Israeli men are required to follow their three-year active army service with one month or more a year of active reserve duty until they reach their mid-fifties, making the IDF a true citizens' army. But the reservists are precisely those citizens who lack the training to

deal with a popular uprising and yet must now attempt to do so. I'll talk later with Israeli women leaders, psychologists, and army personnel who confirm the rise in both the number of reservists with psychiatric problems and the level of domestic violence. This was anticipated relatively early in the intifada by the executive board of the Israel Women's Network, twenty-six of whose twenty-seven members issued a statement calling for the end of the occupation because of the domestic violence that would result.

Perhaps because of her comparative youth, Rana sees the glass as half full rather than half empty and emphasizes what the intifada has accomplished for women rather than the length of the road still to be traveled. She says that the intifada has made it easy to mobilize women and orient them politically. They're eager to be involved. The question of how to raise their consciousness, however, remains. She agrees with me that women in the past—I would say in the present as well—have had difficulty making the mental leap from charitable activities to women's issues, in spite of the women's committees' awareness of the need for a women's agenda. To her, the emphasis must be on creating the circumstances for women to support themselves economically, which will pave the way for their assertion of their right to decide what their lives will be like.

She believes that the committees have matured in the last few years. For a while they got caught up in nationalist politics, reacting to the occupation and intifada and pushing women's issues aside (although their discussion of marriage, an issue they decided not to raise, changed their own attitudes toward it). Now they're ready to go back to a women's agenda, but the method for doing so is still somewhat unclear. A lot of ideas are being floated, such as producing draft legislation on women's issues for the eventual state and starting battered women's shelters. Rana acknowledges that the society is unprepared for the latter. What is needed is a real movement for women's liberation—an army of concerned women. But even the Higher Women's Council (sometimes referred to in English as the Supreme Women's Council), the umbrella group that was formed by the four committees in November 1988 at the urging of the PNC, cannot agree on priorities or an agenda.

The national leadership is not responsive to women; as an

example, Rana cites the fundamentalists' attacks on women who don't wear head coverings. She's trying to get attention for the issue in journals and newspapers, encouraging women to fight back. She considers the national leadership's failure to respond to women's issues particularly shortsighted, reflecting the leadership's lack of awareness that the fundamentalists' antisecularism will prove a problem for it too. She says, however, that she can understand the leadership's reluctance to involve itself in a divisive issue during the national liberation struggle. She's prescient: it will take a year before the leadership joins Rana and others in recognizing that growing fundamentalist popularity and demands pose a threat to the entire society.

She's equally aware of other problems. While she blames the occupation authorities for impeding the education of Palestinian women as well as men, she recognizes that most women look for jobs only in their own communities. If a job exists, however, it is most likely to be given to a man. She also knows that the Algerian experience proves that national liberation does not automatically mean gender equality. Now she reiterates her frequently expressed expectation of men's opposition to new gender roles, adding, "If they want us to be active in the national struggle, expect us to be different at home."

She's one of the women leaders who does not rely on an older female relative to provide for her needs at home while she's busy in the public arena. Many of the women whose homes I visit are dependent on their mothers or mothers-in-law for cooking, shopping, and in some instances child care. Rana's mother died some years ago, and her father is quite ill. When I have dinner at Rana's house the following summer, she will just have returned from a long, hot, tiring day escorting a visitor through IDF checkpoints on the way to and around Gaza, but she and her older sister Amal, who was equally busy with a full-time job, will prepare a superb meal for me and some of their friends. They serve it with hilarious tales of Rana and her friends' mistreatment of the nuns who struggled to provide them with a high school education.

July 23: In the early afternoon, returning from a village in the Hebron area, I notice a jeep coming to a stop on a street near my

own. It's picking up the soldiers from their perch on top of the post office: the school day is over. The jeep moves only a few yards before it suddenly halts. One of the soldiers gets out and darts into a shop, returning with a protesting middle-aged man. They stand gesticulating toward the wall of the building next door. Slogans have been scrawled there in red, black, and green. The store owner is obviously being told to clean them off and presumably is denying any involvement in their appearance. The exchange becomes louder and the man returns to his shop, to emerge carrying a bucket and rags. I'm watching this whole scene when I realize that the soldier on the roof of the post office is watching me watch the soldier in the jeep, who's watching his colleague and the man from the shop. The scene would be ludicrous if I didn't find the expression of the rooftop soldier threatening.

In the late afternoon, when the worst of the day's heat is over, Raja, Penny, Mona, and a few other al-Haq people take me for one of the "walks" in the Ramallah hills that Raja has often spoken about. The walk turns out to be only occasionally horizontal: it's three and a half hours of strenuous ups and downs. Penny earns my gratitude by joining me in taking most of the downs on her backside, but I'm the only one who looks as if she's taken a shower by the time the walk is over. All my future telephone calls to the West Bank will include someone chortling, at some point, "And when are you coming back for another walk?" The country around us is lovely. It's all rolling rocky hills made green by the coarse undercover—which, during my unexpectedly horizontal moments, seems to consist entirely of thorns—and terraced rows of olive trees. An abandoned arbor is still producing some fruit and we thirstily down the liquid from the sour green grapes. As the sun starts to set we watch two gazelles that have suddenly leaped into view on the other side of a valley. I'm puzzled when we're deep into the hills by the appearance of an occasional rock painted with stripes. My companions describe with contempt the Israeli settlers who pride themselves on their hikes through land they insist God gave them but who can't find their way home if they don't leave a trail of painted stripes on the rocks. Later we all learn that the stripes are the work of the Israeli Society for the Preservation of Nature.

July 25: As I approach the city center, I notice something
unusual: three soldiers are walking down the center of the street,
guns pointed, while a fourth darts in and out of stores. Apparently
they're looking for someone. Shoppers press themselves against
the walls of shops as the soldiers approach. I'm so busy watching
them that I barely register, out of the corner of my eye, a little boy
running across the street in my direction. He's apparently fright-
ened that the soldiers are coming after him and, running for his
mother with his eyes on the soldiers, he crashes into my ankles. I
fall back down on the sidewalk, and for a moment I'm too stunned
and in too much pain to move. The people along the walls immedi-
ately jump to pick me up, and I become so concerned with trying to
stop the mother from furiously berating her child that I ignore the
pain and hobble to the *service* for Hebron. When I return to Ramallah
I'll hear that the soldiers were seeking someone who threw stones
at a settler's car, although another story has the stoning taking
place after I'd left for Nablus—confusion typical of news traveling
by word of mouth. Apparently there was shooting in Ramallah a bit
later. Mona tells me that the soldiers always stationed on the post
office roof during school hours were shooting in the direction of
Raja's law office, where the desks are right in front of the windows;
if the bullets had gone through the windows Raja or his coworkers
could have been killed.

Two hours later I can barely walk, but fortunately the only
damage seems to be to my muscles rather than to my bones. So I
follow my visit to a women's production committee in a town near
Nablus with an interview of a woman leader in the committee's
Jerusalem office. There I hear loud music from the room next door.
It's coming from a flute player and a tape recorder, both being used
in a class in which teenagers are learning the *dabkeh*, one of the
traditional Palestinian folk dances (found also in other Arab coun-
tries). The dozen or so young people are modern in dress and
outlook, but they don traditional clothing while familiarizing them-
selves with this part of their heritage. One young woman, her bright
orange T-shirt almost covered by the long embroidered black gown
she's pulled tightly around her waist with a modern leather belt,
shows me her version of the little red, black, green, and white

bracelets many girls are making for themselves out of thread woven around a piece of cardboard.

Similar bracelets figure in an incident recounted by one of the members. She was in the committee's East Jerusalem store with another woman member when they saw a jeep pull up to two eight-or nine-year-old girls looking through the window. The soldiers objected to the little girls' bracelets. The women asked the soldiers why they were bothering with the children. One soldier replied that they might be children but they were wearing a flag and the soldiers were at war with that flag—the bracelets had to come off. The women advised the two girls to remove the bracelets lest their wrists be beaten. The girls refused. They said they had a right to wear the colors of their flag, and they weren't afraid of being beaten. The soldier who had spoken took out his cigarette lighter and held it to the bracelet on first one and then the other girl's wrist. Fortunately the bracelets burned very quickly but not so quickly as to prevent the girls from being burned too.

To the Rishmawis' in the evening. The conversation is interrupted by nearby yelling and then the sound of shots. By now I've come to think of the intifada as a gray cloud that constantly hangs overhead: thick enough not to be forgotten, thin enough to be penetrated by the sunlight and some normalcy and merging invisibly and inevitably with the clouds over other heads when people come together. Part of living with the cloud is becoming attuned to the sound of shooting. One hears bullets; one gives only a split second's thought to the time of day and the direction from which the sounds come. If both are "normal"—if, for example, it's 10:30–11:30 A.M. and the gunfire is coming from the shopping district, or it's after dark and the sounds are from the Old City—one goes on with whatever one's been doing, almost without interruption. If, however, as is the case at the moment, the time and place are wrong, one stops and attempts to find out what's happening. But tonight we don't investigate immediately, and I suspect it's because the Rishmawis don't want me to become involved in anything dangerous. Eventually we go outside to find all the neighbors gathered on the sidewalk. Their house is on one of the biggest streets in Ramallah, lined with a shrub-planted divider in an upper-middle-class neighborhood not

known for violence. Apparently the driver of a car racing down the road was ordered to stop by soldiers using their loudspeaker. He stopped, but only after a few moments had gone by, so the soldiers dragged the driver out and beat him. Neighbors who had rushed to the scene had yelled their protests. The soldiers reacted by shooting in the air and arresting the driver. As is common with such incidents, we never find out why the driver was told to stop. The fact that he was driving fast tells us nothing. That has become the norm at night, when all drivers try to avoid both the IDF and the occasional stone thrower. The Rishmawis are concerned that the incident may lead to temporarily increased patrols and don't want me to leave, fearing that I'll be stopped by soldiers. I'm adamant and, as neither Mona nor her mother drives, they insist that they'll both walk me home, and I in turn ask them to call me as soon as they reach home.

July 28: A *bayan* has declared today a day of solidarity with Palestinian women political prisoners.

Al-Haq's office is only a few minutes' walk away but my leg is so painful that I embarrassedly call to ask someone to pick me up by car. Today is my scheduled lecture about women in national liberation movements. About fifty people have packed themselves into the part of a room, walled off by bookcases, that usually serves as al-Haq's library. All the women's committees are represented, and the audience includes many "independent" women as well as a number of al-Haq staffers. I speak about women in the United States, the Soviet Union, Cuba, Algeria, Turkey, and China. When the problems faced by Palestinian women are raised during the question period, I ask the members of the audience to respond and minimize my own participation. The session turns into a highly illuminating discussion of what various members of the audience think the women's committees here should do—a subject I'll hear about in more detail tomorrow.

July 29: When Randa asked me to spend this morning reporting on my conclusions to a small hand-picked group of committee and independent women leaders, I said I'd be glad to give them a few minutes' worth of my observations but suggested spending the remaining time in discussion. So we use the hours for what I'll later

learn is the committees' first joint session about the direction of the women's movement. We have less time than planned because, probably in reaction to some incident, the IDF declares Ramallah to be a closed military zone for an hour, delaying the arrival of some of the women. The time we do have together is fascinating. We move our chairs close together around a table in the tiny conference room. The clothes people are wearing don't correlate with their ideas. The most reluctant feminist in the group is wearing jeans, as are one or two other women, while the most insistently assertive are in skirts or dresses. All that means is that the jeans-clad women probably are staying in Ramallah today and the others are going into villages or camps where jeans wouldn't be appropriate.

The PFWAC and UPWWC, the committees most eager to press a feminist agenda, are represented by Majdolen and Intissar. Hiba is present on behalf of UPWW. Jamila, of al-Haq, is here, as is Randa, who organized the meeting. The leader from the USWC sits quietly and leaves early, indicating her positions only by nodding or shaking her head. She's fluent in English, so presumably her behavior indicates some discomfort with the subject. As the women become more excited and find it harder to get their thoughts out quickly enough in English, I suggest that they switch to Arabic, with someone quietly translating in my ear. We begin slowly and politely, but Randa laughingly has to impose order as ideas begin to fly and people begin interjecting comments.

The theme that emerges from the conversation is summed up by the desire of the women to avoid becoming "heroes on the street, servants in the home." Hiba states the arguments for not raising a feminist agenda, taking the position that the women are constrained by the needs of national liberation. Their men are working at menial jobs in Israel for twelve hours a day and are constantly being humiliated, either at work or by soldiers who beat them in front of their families and throw them into jail. Men here are always in danger of imprisonment or deportation, they have to discipline themselves not to use all available weapons against soldiers who taunt them with their inability to protect their families: how can women possibly choose this moment to demean them and add to the denial of their manhood by demanding that they assume what

has always been viewed as women's work? How, additionally, can the women "Westernize" themselves, raise questions about such matters as divorce and abortion, display their liberation by acts such as smoking cigarettes, if they expect to be accepted by women in the villages? The day after such issues are raised in a village, she declares, the committee members will be asked to leave. Her statement, of course, reflects a problem generic to national liberation movements.

Majdolen is polite but very firm in disagreeing with Hiba's assessment. The women's movement has reached a critical stage, she argues; the groundwork for women's equality has been laid by the participation of women in the intifada. Once a woman was shamed by arrest because of the sexual implications of her being taken out of her home into a mixed-gender setting and handled by men. Now, however, a woman who goes to jail is honored by the community. Husbands and fathers have been arrested or killed, leaving women to assume the responsibilities of sustaining their families. The next step is to raise the consciousness of women about precisely such matters as marriage and divorce if the traditionalist and fundamentalist trends are not to triumph. Tradition must not be permitted to take over. The moment has come to lay the groundwork for exercising public as well as private power, with women supporting other women running for parliament.

Randa's comments indicate that she, too, believes that a feminist agenda is necessary. The committees and the intifada have made many women aware of the "social issues" such as marriage, divorce, and responsibility for childrearing, she says. The real problem is the negative societal reaction when a woman decides to act according to the new values. If the women's movement cannot protect her and support her, she is bound to lose faith in it. The intifada has aided the women's movement because it has increased the movement's numbers and because women have discovered their ability to organize and support one another. This is the time to consolidate the gains, but an agenda is lacking. It is important for the women's committees to put aside their differences of philosophy and their concern about their own importance and work together to empower all women. They must return to the grassroots

for more information about what is needed today. They must look at the childrearing process, for example, beginning with the different attitudes adults have toward girls and boys. It is when they are still young children that girls are imbued with a sense of inferiority.

Hiba notes that the integration of different classes by the women's committees is important in the questioning of traditional concepts such as female inferiority, for the various classes do not necessarily share assumptions and their interaction is bound to lead to a new awareness of their own values. She seems to be arguing that, left to itself, the intifada will make the formal introduction of the feminist agenda unnecessary. Intissar, disagreeing, points out that male superiority is bred into the mind of every Arab and is deeply rooted in the Arab culture. Boys are breast-fed longer than girls, and in every other way they are taught that their needs will be taken more seriously. That is changing, Hiba replies. Just two days ago masked men and women of the popular committees marched together in the Qaddoura refugee camp. When they reached the home of a man who has become known for his brutal wife beating, they went in and beat him. The significance of the committees' rejection of his right to do as he likes to his wife and of women administering justice alongside men is obvious. When Hiba mentions rejection of the husband's right to do what he likes to his wife, Intissar sarcastically presents what she sees as the societal norm: he has no such right beyond the "normal" battering accepted by the culture.

Jamila points out that Palestinian men who enroll in universities usually receive financial support from their families but that women students do not. It is crucial that the PLO develop a program for gender equality. She and Majdolen agree that both developing a program and disseminating explanations about it are necessary. The women's committees must work with other groups such as the popular committees so that the latter become aware of women's issues. Women can argue that an awareness of women's issues is a national duty. A variety of techniques—legal and educational—can be used. Even men who are leftists fail to understand the women's agenda. It is as much the responsibility of women to explain it to them as it is the obligation of the men to support it.

Randa reminds the group that two years ago she offered to visit the local women's committees to discuss legal issues such as divorce and inheritance. The committees had accepted in theory but not in practice, claiming that they were too busy dealing with the occupation to take on new issues. Now, she argues, the time has come.

Hiba, who had been the most reluctant to raise new issues, becomes sufficiently excited at the prospect of empowerment to declare that women must fight for leadership within the various political organizations "so they won't be able to get rid of us after liberation." She notes that the Higher Women's Council, an umbrella group that has been unable to overcome the women's committees' sense of territoriality and that therefore has accomplished little, was organized to speak with an authoritative voice on behalf of all women and to make their demands known to the Unified National Leadership. The Leadership has to be made to accept a women's agenda and to support women's cooperatives as well as it does men's economic institutions. The Palestinian community does not have the financial resources to support divorced women, so women must become economically independent and the Leadership must help. Intissar dissents from the assumption that the answer lies with the existing political organizations. If women are to have real policymaking power, support for the committees' agenda has to come from all women, including the majority unwilling to involve themselves with the parties. That means talking about issues relevant to nonpolitical women and emphasizing the right and ability of women to make their own choices. But choosing effective tactics is crucial: it is not necessary to speak immediately of such issues as divorce; given the general idea of female empowerment, women gradually will apply it in the many areas of life.

Palestinian women are not alone in being affected by external events, Jamila reflects. The demands made by the women of Mozambique during their revolution, for example, are reflected in Mozambique's constitution, but women there are unsure how to mobilize and use the laws to press their demands, given the civil war, attacks by South Africa, and widespread economic dislocation.

Their confusion, even though it comes in the context of a society that has achieved political independence, resembles that of Palestinian women. Majdolen adds that national liberation and the status of women are inextricably interwoven. Palestinian women must interpret the Declaration of Independence in their own terms. They must articulate the policies they want to see in the Palestinian constitution and laws. It must be viewed as unacceptable, from a national perspective, for a husband to stand in the way of his wife if she wants to work outside the home.

The PFWAC has decided to raise one issue from the women's agenda in each edition of its newsletter. There's general agreement that this is a good beginning that members of other committees will report and perhaps emulate.

The meeting ends on an inconclusive note; indeed, it is difficult to imagine anything else occurring. The women have expressed their opinions and perhaps have realized that their differences are less than some had thought. Those affiliated with the women's committees are not official representatives; they can speak and listen and return to their committees to proceed as they think best and as their groups will permit, but they cannot make policy decisions by themselves. When I return six months later, I will discover that some of the ideas have jelled. Perhaps the most significant elements of the meeting have been the emphasis on the immediate need to begin articulation of and education about a women's agenda, the implicit agreement that women must be economically independent, and the unspoken but clear recognition that women have not yet reached the point where they can speak for or as part of the Palestinian leadership rather than to it. Time will show, however, that events rather than discussion will convince the reluctant committees that a feminist agenda has to be introduced immediately.

11

Women and the Economy

"Only when both halves—men and women— work together can the intifada succeed."

January 10, 1990: Israeli friends have driven me to the Notre Dame Hotel, to be picked up by Palestinian friends once again.

There have been a lot of changes. All are relevant to the women's movement, which, constantly caught up in events affecting the entire population, must be understood within its societal context. Yitzhak Mordechai, the new commander of the IDF on the West Bank, has expressed his determination to beat down the intifada. The schools were open from July through October and then forced to take an unwanted break in November and December for exams and a recess. They were not scheduled to reopen until today, the ostensible reason being a fear of violence around the third anniversary of the intifada on December 9 and the Christmas holidays.

In December, al-Haq and B'Tselem shared the annual Carter-Menil human rights award, which was presented to their representatives by former President Jimmy Carter. Al-Haq field worker Sha'wan Jabarin is under administrative detention for a year in Ketziot prison, where he was placed after being dragged from his house, punched, burned with a cigarette butt, handcuffed, and jumped on for ten minutes by a soldier. He was beaten so brutally that a physician called to examine him said, "This one has been hit on the head, he cannot breathe, he must be hospitalized. I'm not ready to bear the responsibility." The IDF had to take him to

Hadassah Hospital for emergency treatment. His wife was in her ninth month of pregnancy when he was arrested in October and he still has not received the letters or the baby's pictures that she's mailed to him. The Israeli government has issued a series of confusing replies to all inquiries, including one from President Carter, on his behalf: Sha'wan received adequate treatment at Hadassah; he was never taken to Hadassah; in any case, no force was used beyond that necessary to arrest him. He was tried once for throwing a Molotov cocktail at a bus. He proved that at the time of the incident he was in jail on another trumped-up charge. He was convicted anyway. It's not just his work for al-Haq that seems to bother the authorities. He witnessed two murders, one by a soldier and another by a settler, and insisted on testifying about them. A life spent half in and half out of jail seems to be his reward for believing in justice.

I learn that ten days before the Greek Orthodox Christmas, eighteen-year-old Fadi Zabakly from Bethlehem was shot by a Border Police officer under the jurisdiction of the IDF and died in Maqasad Hospital. The shooting raised serious questions about the IDF's credibility.

As of September 1989, IDF orders permitted soldiers to shoot at all suspects and defined anyone masked as a suspect. The IDF alleged that Zabakly and his companions were masked and armed with axes and metal bars, that soldiers ordered him to halt and fired a warning shot in the air (the IDF's own requirements before shooting), and that the shot that killed him had been aimed at his legs. A videotape made by an ABC crew that happened to be on the scene contradicted the official report. It showed that Zabakly and the others were masked but armed only with stones and that having thrown their stones they had turned to run when one soldier knelt to aim and shot Zabakly in the head while another simultaneously fired a warning shot into the air. ABC showed the videotape to an IDF adviser, an investigation was ordered, and the two soldiers who fired were suspended pending its completion. The videotape is being shown by television stations throughout the world. The lesson for me, once again, is that accounts of IDF misbehavior

cannot be dismissed out of hand, no matter how vociferously the IDF may deny them.

We take the Jerusalem-Ramallah highway and then, when we reach Ramallah, we travel on side streets. There's a tendency for violence to erupt on the main streets in the early afternoon when the children, who are out of school, display their anger at the extra patrols that are on duty during school hours and have not yet left. I notice the usual group of soldiers on the high rooftop in the shopping district. During the next few days, apparently depending on the whim of whoever is in command, the soldiers will display no flag, fly one of normal size, or drape a huge flag down the side of the building.

January is always a cold, rainy month in Ramallah, but this is the worst one on record. The temperature is hovering in the low thirties, and most homes are not heated. People have almost forgotten the occupation in their quest for warmth. Many homes have small electric heaters and larger but smellier kerosene ones. When you huddle up to either, part of your anatomy is singed while the rest remains frigid. Our electric water heater has to be turned on for two hours to warm enough water for a quick shower in the arctic bathroom. Going on a trip is bliss because cars have heaters. I sleep in tights and a sweater under five quilts and blankets with the electric heater going full blast and am ashamed at my own discomfort when I think of the people in the refugee camps. The people at al-Haq work wearing wool gloves with cut-out fingertips, something I understand when my fingers become too cold for typing. I assume that some clever staffer dreamed up the glove system until I discover similar gloves, made without fingertips, being sold on the streets of Ramallah.

Most of the people around me are sick. I keep going to the pharmacies to stock up on vitamin C and offer packets of it, along with contributions from my supply of aspirin and antihistamines, to anyone sneezing or complaining of a sore throat. Of course, right before I leave for home I will develop the worst cold of all, and when I go back to one of the drugstores to replenish my own supply of vitamin C the pharmacist asks anxiously, "Don't you think you've

been taking too much of it? This is the third box of pills you've bought!" After a few days I've become so used to losing all communication with my toes and to finding—or imagining—my reflection in the mirror to be slightly tinged with blue that when I enter the lobby of the American Colony Hotel to meet someone, I'm amazed to discover that it's warm. I promptly decide to make the lobby my new office, taking the *service* there most mornings and placating the disgruntled manager by ordering occasional pots of coffee.

The only good news is that the Jordanian dinar is being traded for 3 shekels, up from the low of a little above 2 shekels in July. As a regulation still prohibits West Bankers from bringing in more than 200 JD, the difference is significant.

If the weather doesn't get warmer soon, the crops will freeze, further hurting an economy that is already in terrible shape. The curfews, strike days, and strike hours that prevent people from working and shopping are taking a serious toll. Many Palestinians who work in Israel not only are getting to their jobs less frequently but are spending fewer hours per day there, refusing to work for Israelis more than the minimal hours necessary for their families' subsistence. Last year was the off year for the olive crop (it does well only every other year), exacerbating the dire economic situation.

The standard of living in the territories has fallen 30 to 40 percent. Curfews have caused decreases in sales, and many shop owners consequently bounce checks, forcing their suppliers to overdraw their own accounts and pay substantial interest to Israeli banks. Sinokrot Food, one of the largest West Bank companies, says that its employees are working an average of twelve days a month, compared with twenty-six days a month before the intifada began. The Leadership and the trade unions have managed to persuade most Palestinian employers to pay their workers for strike days, but that puts a heavy burden on the employers.

The boycott of Israeli food continues. As a result, Sinokrot's sales of candy-coated chocolates have risen 20 percent and have largely replaced the Israeli-made Elite products. Sinokrot's profits have fallen nonetheless because of the paid strike days during which the factory and all stores are closed. The same is true of other firms that

have expanded during the boycott. Many Palestinians have stopped smoking Israeli Time cigarettes in favor of a brand manufactured in the El-Azaria factory near Jerusalem and have forsworn Coca-Cola for Royal Crown and Club Cola, both franchised in the West Bank. The Club Cola factory in Ramallah has begun producing six hundred cans per minute of orange, cola, and lemon-lime soda. With 120 employees, it is already one of the territories' largest firms, and it is introducing a new line of large containers that will require an additional 80 workers. Ramallah's Royal Crown Cola franchise currently has 187 workers turning out its thirty-three different flavors.

Companies are springing up where they can to replace boycotted foods, but it is extremely difficult to obtain capital locally, the Arab nations do not appear too eager to invest, and the government has refused licenses for some proposed projects such as a chicken hatchery in Ramallah.

The government is making the situation even worse, according to the European Community's ambassador to Israel, by encouraging the damaging of Gazan citrus fruit, which has to go through the Israeli port of Ashdod to be shipped to Europe. Security personnel tear apart the packages, throw fruit on the floor, and impose long, slow security checks. Even though the European Community (EC) has linked EC-Israeli economic relations to Israel's facilitating export of West Bank produce, the German representative to the European parliament has charged that 20 percent of the Palestinian goods destined for the European market have been deliberately damaged. Still, the increasing experience of West Bank farmers in growing vegetables for the European market, the presence of two full-time EC experts, and the monitoring of Israeli cooperation by the EC has resulted in a good 1989–1990 season for agricultural exports: somewhere between 500 and 700 tons of vegetables, compared with 97 tons during the 1988–1989 season.

Municipal services have been affected by the state of the economy. The Israeli administration will soon agree to permit Germany and Italy to fund a sewage system for Bethlehem, Beit Sahur, Beit Jala, and the Deheisha, Eidh, and Aza refugee camps and will even add a token contribution itself. The system will refurbish the towns'

deteriorating systems, which have begun seeping waste water into the water supply, and will replace the open-air sewage disposal systems that still exist in the camps and villages. Following Elias Freij's threat to resign as mayor of Bethlehem because of the city's financial difficulties, the government, fearing that the collapse of municipalities could worsen the uprising, will quietly act to let increased amounts of funds be transferred from abroad to alleviate their financial condition. These improvements are designed to keep economic frustration from becoming explosive.

January 11: The schools opened yesterday and Abdallah Rishmawi tells me how concerned he was to see school-age kids on the streets an hour after school began. Today I see children throwing stones at about 11:00 A.M., although school is not out until noon. All the teachers with whom I speak agree that the children are no longer used to the discipline of school, no longer motivated, and the littlest ones, with only hazy memories of schoolwork, simply don't seem to be able to make the adjustment. An exception is children, primarily in private schools, whose parents insisted on a regimen of study at home or in underground classes. Alternative education programs begun during the school closure, however, have been given up because two educational systems would overburden the students. The universities are still being kept closed for "security" reasons.

I go to Jerusalem for a discussion with Charles Shamas, a member of al-Haq's board of directors, about the economy of the West Bank. I've been wondering whether the economic projects sponsored by the women's committees are too marginal to result in women's acquiring economic power of any magnitude. Charles is a Lebanese-American married to a Palestinian, the father of two delightful trilingual children who attend a French-speaking school, and the holder of a Yale mathematics degree. In keeping with his belief that the Palestinian economy should focus on the export market, the Ramallah lingerie company he created exports almost all of its luxurious silk products. Charles's dynamic wife, Maha Abu-Dayyeh, who runs a legal clinic financed by the Quakers, barely has time to say hello before running off to a meeting. He and I sit in their warm kitchen nibbling nuts and drinking white wine, the

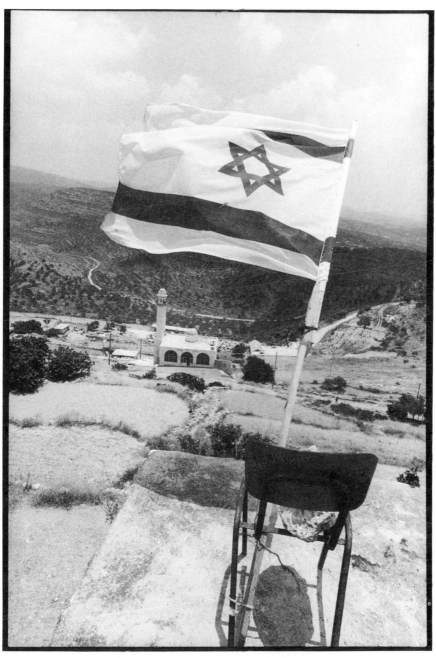

Dir Amir (near Ramallah). Israel claims the area by flying its flag near the local mosque. *Rick Reinhard, Impact Visuals*

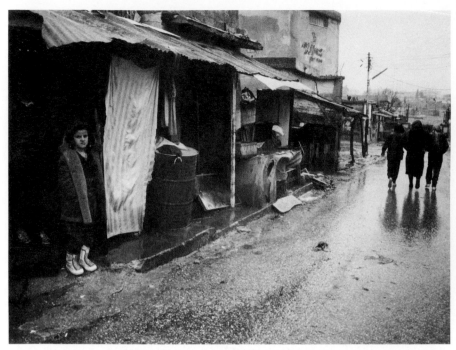

Amari refugee camp, West Bank. *John Tordai, Impact Visuals*

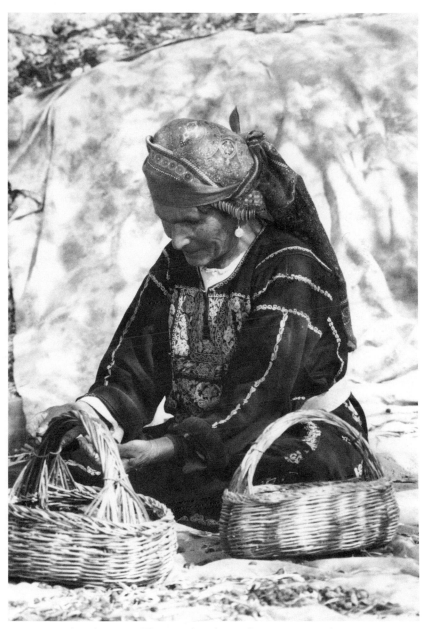

Woman picks olives in West Bank. *John Tordai, Impact Visuals*

Woman wearing and working on traditional Palestinian embroidery. *Azam Abeid*

Palestinian woman whose olive trees were destroyed by Israeli soldiers. *Azam Abeid*

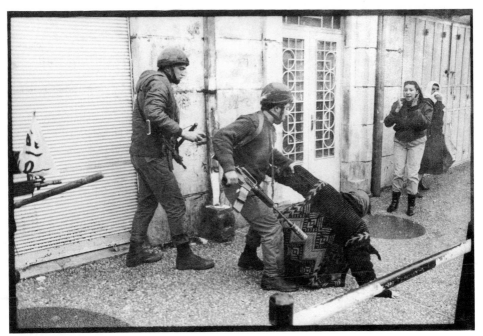

Israeli soldiers attacking Palestinian woman in Ramallah. *Bill Biggart, Impact Visuals*

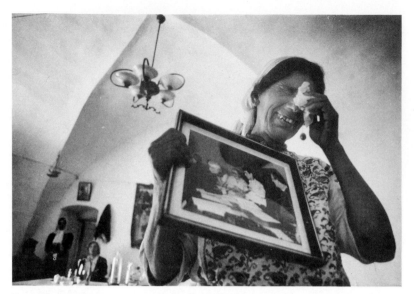

Family members mourn a relative killed by Israeli soldiers.
Nitzan Shorer

Palestinian nurses care for traditionally-dressed intifada
victim at a hospital in East Jerusalem. *Azam Abeid*

Two-year old Nablus child whose eye was shot out of its socket by Israeli soldiers. *Azam Abeid*

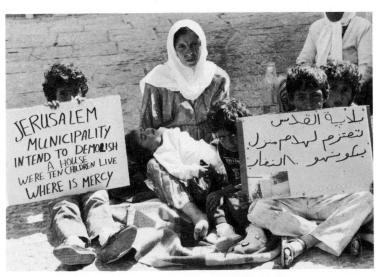

Family protesting the destruction of their home by Israeli officials who alleged that it had been built without permission. *Azam Abeid*

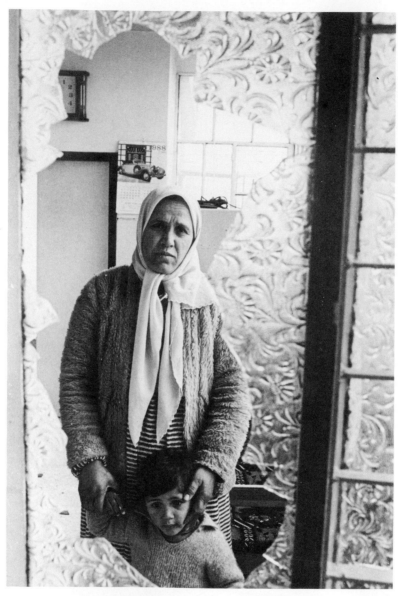

Mother and child after Israeli soldiers supposedly seeking a fugitive vandalized their home. *Nitzan Shorer*

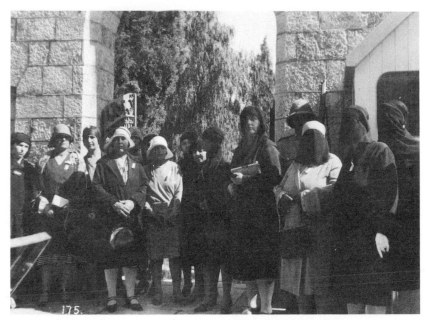

Women demonstrating in Jerusalem, 1929. *Library of Congress*

Left: Zahira Kamal, an early leader of the modern women's movement and head of the Palestinian Federation of Women's Action Committees. *Right*: Randa Siniora in her office at al-Haq. *Philippa Strum*

Mona Rishmawi, former executive director of al-Haq, works for the International Commission of Jurists. She appears here in front of her home in Ramallah. *Philippa Strum*

Professor Rita Giacaman (right) leading a seminar at the Women's Research Center, Nablus. *Philippa Strum*

Seminar at the Women's Research Center, Nablus. *Philippa Strum*

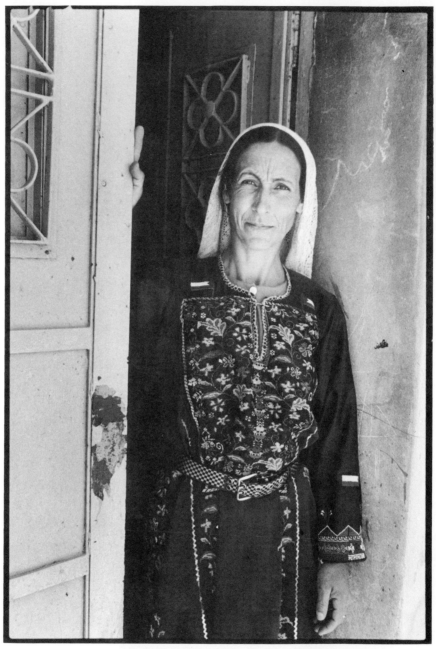

Member of a women's committee cooperative in the village of Sa'ir, West Bank. *Rick Reinhard, Impact Visuals*

Traditional woven straw serving trays,
made by one of the women's committees.
Philippa Strum

Traditional Palestinian embroidered wall
hanging. *Philippa Strum*

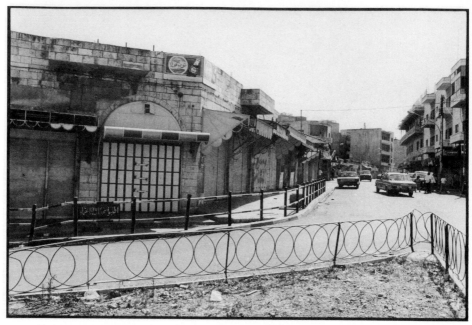
Ramallah during strike hours. *Rick Reinhard, Impact Visuals*

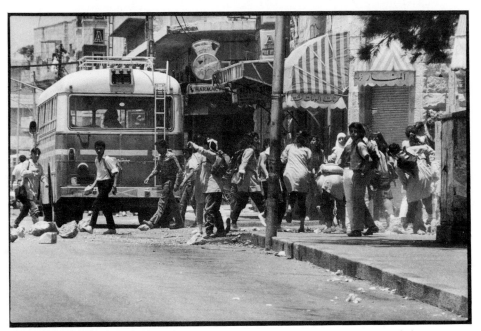

Students construct a barricade in the heart of Ramallah's commercial district.
Rick Reinhard, Impact Visuals

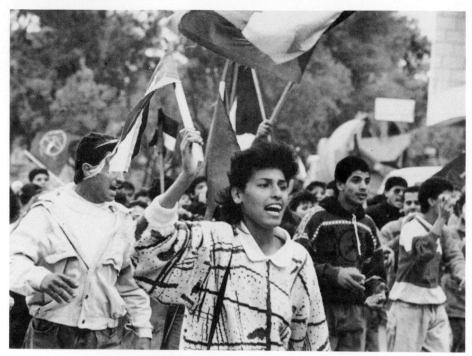

Demonstration in support of the Popular Front for the Liberation of Palestine on the third anniversary of the intifada (Ramallah). *Eric Miller, Impact Visuals*

aroma of his visiting mother's Lebanese-style stuffed cabbage rolls wafting from the stove, his children occasionally popping in from their activities at the piano and the television set.

According to Charles, there are only between fifteen and twenty West Bank companies with more than one hundred employees each, primarily in the fields of garment making, paper products, and confections. Most of the employees are engaged in business and distribution, so some of the firms' goods actually are produced by only fifteen to twenty people and a large number of machines. There are so many small retail outlets in the West Bank that distribution is a major endeavor. The inefficient but politically entrenched mercantile and trading elite is more interested in cash flow than in investment or expansion. It is currently concentrating on producing goods previously imported from Israel. Most of the firms are family-managed and spend their money on buying machines rather than on training personnel who might then move to better-paying jobs in other companies. Charles considers availability of capital to be less a current problem than the negative West Bank cultural attitude toward economic opportunities and the acquisition of skills. He holds partially responsible for that attitude the foreigners who want to purchase traditional Palestinian products such as embroidered gowns and who delight in hosting Palestinians at conferences but do nothing to help them acquire the economic training he considers crucial. The women's committees are more eager than society at large to grasp economic opportunities, Charles comments, but lack the skills with which to recognize and explore them.

His remarks reinforce my own perceptions of the women's ventures, which have struck me as more symbolic and empowering than economically significant. As he says, the product becomes a statement. We agree that the statement is an important one but that it's only the first to be made if the women are to achieve real economic power. He would advise the women's committees to concentrate on embryonic businesses. He'd give a few capable women the power to distribute start-up capital for long-term economic ventures likely to show a profit in three to five years. As I've seen in the UPWC's support for the Beitello cooperative and as I'll

hear in the next few days, the women's committees are willing to underwrite new businesses, but Charles is correct in his perception that they're reluctant to adopt long-term thinking, in part because they feel pressured to demonstrate the ability of women to succeed and in part because the competition among committees makes them unwilling to lose face by undertaking projects that do not become profitable quickly.

I've been assuming that, as more of a premium is put on early childhood care outside the home and additional women enter the paid work force, women will be more willing to use prepared foods. Charles, too, considers food preservation to be an endeavor that could give women economic power. But he sees the hope of the Palestinian economy as lying in medium- and large-scale export-driven enterprises because of the limited market here. The women's committees, however, envision only small projects producing for local consumption. If Charles's view prevails in the larger society, the committees are likely to have little economic clout.

January 12: The *service* drops me off near the PFWAC office where I'm to interview Zahira Kamal. I wait for her in the verandalike room that had been too warm when we spoke last July. It's cold now because of an inadequately covered hole in one of the many windows—a memento of the IDF incursion last summer.

Zahira's family has lived in Jerusalem since the twelfth century. Zahira, the oldest of eight children, benefited from her father's unusual willingness for his daughter to listen to political discussions at home and his insistence, despite family objections, on sending her to college. She wrote her thesis on Egyptian feminism, and her emphasis since then has been on teaching women to be economically independent. She has a degree in physics and works as a teacher's training supervisor at the UNRWA Women's Training Center in Ramallah. Now in her mid-forties, with a few strands of gray in the short black hair that frames her face, she carries herself with an easy air of authority. When she describes a new program for women or one of their recent successes, she smiles with delight and her brown eyes sparkle.

The Israeli press claims that she is a major figure in the Democratic Front for the Liberation of Palestine, which, like all other

political parties, is outlawed. She used to be the sole woman included in official delegations when Palestinians living in the territories met with foreign politicians or held press conferences. At various times during the last few years she has been placed under town arrest and required to report to the police twice each day, and she has also been under administrative detention. Eventually her Israeli attorney cleverly found a loophole in a badly drawn order putting her under town arrest and persuaded a court that the document prohibited her from going into the territories but permitted her to travel everywhere else. So for a while Zahira could go to international conferences, but only by submitting to a thorough search of her possessions and her person, including her body cavities, each time she left the country and each time she returned. She laughed as she recalled that the lengthy search whenever she was on her way out of the country invariably delayed her plane. As a result, she got VIP treatment by being rushed to it in a special car rather than riding the communal bus used by Ben-Gurion airport to shuttle passengers from the terminal to the airplane. She's not traveling much now, as she's been placed under another travel ban, prohibited from going abroad for the last three months in spite of numerous invitations to speak in Europe and the United States.

She appears in boots and a coat with a shawl draped on its shoulders, a uniform I see on dozens of women this month. We sip much-needed tea, made from Palestinian-produced tea bags, while she talks about the PFWAC's economic activities. The committee has decided to survey working women to learn the number of women working in the territories' cash economy, the kind of work they do, their backgrounds, the possibilities their jobs hold for upward mobility, and the problems they encounter. Separate questionnaires for workers and employers are being prepared. Women chosen by branches of the committee throughout the territories are being trained to conduct the first stage of what will be a two-year study. Among the criteria is a high school diploma. While some of the twenty trainees have college degrees, the fact that most do not is a sign of the committees' success in reaching out to non-elite women. They are living at committee headquarters during the ten-day course, taking classes from 8:30 A.M. to 5:00 P.M. and holding

discussions among themselves at night. Their instructors in re-
search techniques and related topics are librarians and professors.
The day I'm there a Birzeit University sociologist lectures about
Palestinian social and class structure. The research will begin in
one geographical area. The women will meet for two or three days a
month to discuss their findings. The results will be published within
a few months, and the lessons they learn while surveying the first
area will be used to refine the questionnaires.

The committee is also buying machinery for a new bakery in
nearby A-Ram. Although Palestinian women routinely bake at
home, bakeries have been considered the province of men. The
committee hopes to turn out products other than traditional Arab
pastries, packaging them with great attention paid to sanitation.
Some days later I'll meet an American woman, married to a Pales-
tinian, who is in charge of the project. She's a potter who started
baking in Boston restaurants with no training, her logic being that
throwing dough around couldn't be all that different from throwing
pots. A kindly coworker in her first restaurant kitchen gave her some
introductory lessons. She moved from restaurant to restaurant and
success to success, and now she's prepared to train two women to
help her turn out Danish pastry, muffins, and croissants, products
she's certain will sell in the sophisticated Ramallah-Jerusalem area.
If the bakery succeeds, it will expand. It's the kind of experimental,
hands-on approach Charles Shamas would approve of. But the
bakery will have far less than the three to five years he considers
necessary to show a profit. It will also lack enough capital for
large-scale operations. Without size, it may not succeed and cer-
tainly won't develop into a major venture.

Another project is the committee's high-protein baby food.
Wanting to market it beyond the child care centers and physicians
who now use it, the committee has sent samples to Britain for
analysis. Israeli law requires that a professional laboratory produce
an exact list of ingredients for inclusion on the package, and there
are no facilities in the West Bank for that kind of testing.

We talk about the economic possibilities of prepared food.
Zahira thinks that freezing food is more hygienic than canning it,
but freezing equipment is too expensive. The PFWAC is sponsoring

a citrus fruit juice project in Jericho. She has advised the committee not to try to sell juice now, when fresh fruit is available, but to buy the fruit, squeeze and can the juice, and sell it during the summer. Education about purchasing and marketing, she feels, must be part of the projects, so the PFWAC is giving project workers a course on accounting and marketing.

Zahira fills me in on her committee's new approaches to consciousness-raising. In November, eighty women attended a course given by the committee. Local subcommittees throughout the territories were asked to nominate potential students, with an emphasis on geographical representation and a balance among rural areas, refugee camps, and cities. The formal sessions lasted into the evenings and the women stayed up most of the night continuing their discussions. Lectures and discussions were run by committee leaders and university professors. Zahira's experience as an educator was reflected in the careful sequence of topics. One series began with social history, from "primitive" through more sophisticated societies, went on to the effect of various economic forms on each level of society, and continued with the development of patriarchy. Another examined the status and role of women in many societies, in the Third World, and finally in Palestine. Emphasis was placed on the relationship between women's movements throughout the world and the achievement and retention of rights.

January 15: I have a short chat with the young woman who, at my request, has arranged much of my schedule and occasionally accompanies me as a translator. Leila is a nineteen-year-old who learned her flawless English in the United States. Her first eleven years were spent there and the last eight here, where her father is a professor. She has finished high school and is waiting for the universities to reopen, refusing to go "outside" to complete her education. She and her parents went to East Jerusalem's al-Hakawati Theatre to see the folk dancing scheduled at the end of the Women's Day for Peace march from West to East Jerusalem on December 29. The day was organized by the Women and Peace Movement, an umbrella organization of Israeli women's protest groups, as part of a three-day peace program held in Jerusalem by Israelis and Palestinians. When the marchers reached the theater,

Leila says, someone raised a Palestinian flag, and she was one of
the people the police immediately attacked. A young Italian man
she'd never seen before tried to help by holding on to her until, she
reports with a laugh, he was bitten by a woman soldier! Another
woman soldier bruised her badly by pinching her arm repeatedly
while clutching it. Her father tried to intervene and Leila had to
watch while he was beaten with a nightstick and then arrested. Her
mother and younger sister were punched but not arrested. One
soldier stepped on her foot so hard that it became swollen and
infected. Taken to the prison at Moscobiyya (the Russian com-
pound in West Jerusalem), she was informed that she was guilty of
pushing a police officer and would remain under arrest for forty-
eight hours. Israeli attorney Lea Tsemel was told by the officer that
Leila had "attacked" him. Lea nonetheless got her out after twenty-
four hours, perhaps because at that point the police arrived with a
load of other people whom they were putting under arrest—
probably some of the thirty thousand Israelis and Palestinians who
linked themselves into a human chain around the Old City of
Jerusalem on December 30 as part of the three-day program. Leila
and her sister were radicalized in seconds by watching their father
beaten. That was much worse, she says, than anything done directly
to her.

Leaving Leila, I take the *service* for Jerusalem. As I walk toward my
next appointment I pass the offices of an organization called
Hotline that I've heard about and decide to stop in. Two tradition-
ally dressed elderly Palestinian men are standing in the small office
speaking with the Israeli who is apparently recording their informa-
tion. The organization was created by an Israeli ex-paratrooper and
is devoted to helping Palestinians report incidents of illegal behav-
ior by law enforcement authorities and find relatives who have been
detained. A volunteer takes me up the steep staircase to a cramped
room where the group's newly acquired computer is being loaded
with data.

Organizations like Hotline and Women for Support of Women
Political Prisoners (WOFPP) have been created by Israelis troubled
by the brutality inherent in the occupation and concerned that the
military has not provided an adequate system for informing Pales-

tinians about family members who have been detained. I can remember Jonathan Kuttab telling a Hebrew University symposium some years before the intifada began that his first problem as an attorney representing a Palestinian prisoner was to find his client. While demonstrations did occur before the intifada, they were not the norm. When a family member disappeared, therefore, it frequently was not as a result of a demonstration, where others would see the person being arrested and could alert the family. A person simply would not come home, and his or her family would not know whether the person had been arrested, harmed, or hospitalized. Even when family members had witnessed or been told of an arrest, they did not know at which prison—out of half a dozen—the person was being held. So Jonathan would start calling wardens. But even if he was told honestly that a client was in a particular prison, the client might just have been moved to another prison or might be in the separate section run by the Shin Bet. Many detainees are taken to the Shin Bet section first for interrogation, and the Shin Bet has no obligation to tell the warden about them.

The problem of families losing track of members who have been detained has increased with the intifada and the large number of people being arrested. The law says that families must be informed of an arrest immediately, but this requirement is honored in the breach, especially by the Shin Bet. The law also permits detainees from the territories to consult with a lawyer, but only after eighteen days, extendable by another eighteen. Frequently, therefore, families do not know the whereabouts or condition of an arrested relative, and some Israelis have organized to help. The Association for Civil Rights in Israel (ACRI) petitioned the High Court on behalf of three Palestinians who were incarcerated for a month and a half before their families were notified. In November 1989, the court awarded costs to the three but dismissed another ACRI petition asking that the IDF be required to comply with the notification requirement because government attorneys assured the court that new notification procedures would be instituted. The key element of the new procedures is providing a detainee with a postcard to send to his or her family. One justice recommended that the authorities try notifying the families by telephone. An indirect

result of the litigation has been that the IDF has given Hotline access to the information in the IDF computer concerning the whereabouts of detainees. Before that the group could only emulate Jonathan Kuttab in calling prisons, a procedure it considered largely ineffective.

To the extent that they can, the fifty Hotline volunteers visit the places where Palestinians say incidents occurred and try to locate witnesses. If there are not enough volunteers, Hotline forwards the basic information from the detainees to the appropriate authorities—another procedure they say usually does not have any effect.

Leaving Hotline, I go to talk with Hagit Shlonsky, one of the leaders of the Jerusalem-based Women for Support of Women Political Prisoners (there are also branches in Tel Aviv and Haifa). WOFPP was first established by Jewish Israelis in Tel Aviv in May 1988; the Jerusalem group was founded in early 1989. It has hired an Arab Israeli woman attorney who goes into the Russian compound, finds out the names of Palestinian women being held there so that their families can be informed, takes affidavits from detainees as soon as they are moved to the main part of the prison after interrogation by the Shin Bet, and represents any detainee who does not have her own lawyer. Members of the group are at the Russian compound every day to deliver parcels with basic items not provided by the prisons: sheets, towels, soap, shampoo, toilet paper, sanitary napkins, writing materials, and newspapers. Many of the parcels fail to reach the prisoners. The women meet outside the compound with detainees' families and relatives in an effort to give them information, boost their morale, and protect them from harassment by officials. WOFPP members also attend the Ramallah military court when women are due to be tried, maintaining a presence there and intervening when families of those on trial are barred from the courtroom. Hagit has not been admitted to the military court lately, the guard at the gate apparently having been instructed to refuse her entry in spite of the law that says the courts are open to all Israeli citizens.

Another member of the group, journalist Michal Schwartz, was herself a prisoner in 1988 when she and three other editors of the left-wing biweekly newspaper *Derech Hanitzotz* were arrested on

suspicion of contacts with the DFLP. She was held in solitary confinement. Her filthy cell was lit by a neon light around the clock but contained no water or toilet. She was not permitted a change of clothing for three days and was given food mixed together in a plate on the floor. Her interrogations usually were at night; when they were not, she was denied sleep. She was not allowed to meet with her attorney. She appealed to the High Court, which took testimony in secret from the Shin Bet, chose not to uphold what it called the "basic and fundamental right of every prisoner" to an attorney, and suggested that she and the state agree on a lawyer. She refused. Eventually the four editors were charged with contact with a foreign agent and membership in an illegal terrorist organization. Whenever Schwartz appeared in court, the corridors were packed with members of the Hebrew University history department, where her father is a well-known professor. After court sessions she would be returned to jail, where the four decided at one point to stage a hunger strike to protest punitive conditions such as solitary confinement and imprisonment in a wing with mentally disturbed patients whose screams echoed throughout the night. Her father told the press that it was impossible for the four to prepare for their defense under such conditions and that their physical and emotional state was deteriorating perceptibly. In the end, they agreed to a plea bargain under which the charge of contacting a foreign agent was dropped and they were found guilty of membership in the DFLP and of supplying services to it.

Next I meet Randa Siniora and we drive to her house in Bethany, near the tomb of Lazarus and next door to the house where he supposedly lived. Randa's husband takes care of their little boy while I sit sipping wine in the kitchen, watching Randa turn out a wonderful dinner of "upside down," kifta,* two different salads, and more. She's just spent an exhausting day working at al-Haq, which is normal for her, and she frequently relies on the laboriously made

*"Upside down" is a uniquely Palestinian dish made with boiled meat or chicken and vegetables that are placed in a pot to which rice and broth are added along with spices such as cinnamon and nutmeg. When the rice is cooked, the pot is uncovered and turned upside down onto a plate. The pot is then removed to display a molded mound of rice topped with vegetables and meat. Kifta is a kind of doughless pie made with chopped lamb and vegetables.

Palestinian dishes that her mother has fully or partly cooked and frozen. She's enthusiastic about the women's projects that produce prepared food and is sorry only that some of them, without retail outlets, depend on members to make informal sales and then discover they don't have enough stock to fill all the orders.

Randa was hurt in Ramallah today. She tells us that she was getting out of her car to do some food shopping when a soldier near the supermarket threw a stone that landed on her knee. It's painful, but she's decided it doesn't require a doctor's attention. She didn't try to report the incident to the authorities, who, as she well knows, probably would refuse to accept her complaint and certainly would do nothing about it.

She's invited me to spend the night, but since she gets up before dawn and leaves the house quite early to deliver her son to a child care center before she drives to al-Haq, I decide I'd rather go home and get a good night's sleep. It's out of the question for her to take me, even if she were willing to make the trip to Ramallah and back, because a woman—or a man—driving at night, especially alone, is very likely to run afoul of a suspicious IDF patrol. She and a friend drive me to downtown Jerusalem's taxi stands but no cab is to be found—there are few requests for them at this hour. Along the way we notice an impromptu but well-lighted checkpoint, which she easily avoids by using other streets. We've nothing to hide, but the possibility of being stopped for a long time, subjected to humiliating questions because we're three women alone in a car at night, or even detained is not an inviting one. The man behind the desk at the National Palace Hotel manages to call a cab. He says he wouldn't drive to Ramallah at this hour because of overzealous stone throwers. Randa clearly would be more comfortable if I weren't going to subject myself to possible IDF patrols, and I spend the whole trip trying to decide whether I'm more frightened of the stone throwers or the IDF. The driver's English-speaking friend accompanies him and insists that the car wait at the house until I get inside, which I do to such loud howling from the neighbors' guard dogs that presumably everyone in the West Bank knows I'm back.

January 16: I pay another visit to Maha Mustaqlem, to hear about her committee's current economic endeavors. The co-op

school she'd spoken of in July has materialized as a school for alternative economic development, with about ten men and twenty women as students. It's been in existence for three months and the basic course will run for an additional three, with classes meeting one day a week. The students have been chosen by subcommittees throughout the territories, including Gaza, where there are many cooperatives. They study subjects such as sociology, the division of labor, basic economic concepts, and Third World experiences, taught by Birzeit University faculty. According to Professor Eileen Kuttab, one of the organizers of the committee's cooperatives, the curriculum was developed largely by representatives from committee cooperatives in Beitello, Sa'ir, and Gaza, emphasizing what experience taught them was most important. The course places a low emphasis on literacy and a high one on group interaction. "The illiterate women have done very well, sometimes better than the literate ones," Kuttab reports, "because they have to prove to themselves that they can participate in the cooperative project."

The committee has also created a new kind of group involving ten village families. The women raise chickens, cows, and rabbits. They share the livestock and cooking chores; two women, for example, make bread while a third sees to the cows. Maha says that the willingness of village women to eat someone else's bread rather than feeling constrained to make their own is nothing short of revolutionary.

January 20: I'm up early to visit a women's committee in Nablus. We pass numerous army encampments, some in tents and others in what are clearly commandeered houses, with soldiers standing on their roofs and balconies. There are signs of transition from a traditional rural society to a more modernized one. A shepherd stands with his flock on a piece of land next to a contemporary house where a woman wearing slacks and a bright red parka is loading a package into the trunk of a new car. A large water pipe runs alongside the road for miles. I ask a woman in the *service* if it's an irrigation pipe for Palestinian fields. She laughs and replies that if it were it would be much narrower and shorter: this pipe carries water to a Jewish settlement right beyond one of the checkpoints. The diversion of water from Palestinian land to that of the settle-

ments (estimated at up to 80 percent of the total underground water supply) is a major complaint.

We're stopped at a checkpoint, where a rather insecure-looking soldier in his early twenties asks everyone in the car for IDs and scans each, checking its picture against the person carrying it. He must feel awkward juggling papers with one hand while he clutches his gun with the other. The atmosphere in the car is a complex mixture of intense resentment and the expectation that, like many other petty humiliations, this one too will end shortly. The young soldier's eyebrows go up when he sees my American passport and he calls over an officer, gun slung casually over his shoulder, who asks what I'm doing here. I decided in July that the safest thing was to tell the truth about the reason for my presence, as I do today. Anyone engaged in research about women, Palestinian or other, is highly unlikely to be taken seriously by most Israeli men, much less viewed as a menace. But when he asks, "What's your religion?" I know it's time to lie.

I've learned that some soldiers start to lose control when they find a Jew voluntarily inside the territories, apparently condemning them as "traitors to the tribe." A soldier at one checkpoint last summer had grabbed my shoulder when I said I was Jewish (but quickly let go when I asked if he really wanted to break into the news as the first member of the IDF to harm an American Jewish woman professor). I'm not particularly afraid for myself, knowing that the worst the checkpoint soldiers are likely to do is detain me long enough to make me late. But I am concerned that they'll take their anger out on the Palestinians in the car by confiscating their papers. So I raise my own eyebrows and reply coolly, "Don't be silly—I'm a Christian Scientist." The Israeli visa card that all Americans have to fill out when they arrive at Ben-Gurion airport, and that I carry tucked into my passport, includes a space for one's father's first name. The officer sees "Joseph" on my visa and queries further, "Isn't that a Jewish name?" "Good heavens," I immediately exclaim, by now having had some experience of this charade, "haven't you people ever heard about Jesus, Joseph, and Mary? May I send you some of our books when I get home?" He returns my papers with a look of disgust and waves the car on.

When I tell Justice Haim Cohn about the incident a week later he is angry: "They have no right to ask you such questions." I reply that I know that, but there isn't any law in the West Bank other than the thoughts in the mind of the man on the other end of the gun and that it's not wise to rely on such niceties as due process when one is in a war zone.

January 25: Today's strike day was called by Hamas "to protest against the Soviet policy of allowing massive Jewish emigration to Israel." Within a month the UNLU will announce another strike day to protest the potential settlement of Soviet Jews in the territories. The collapse of the cold war is viewed as a disaster by the Palestinians. They note that many of the new Eastern European regimes quickly recognized and increased trade relations with Israel. The decline of the pro-Palestinian USSR has left the United States, still perceived as oversympathetic to Israel, as the only superpower. They see the developments in Eastern Europe as drawing world attention away from their plight. Above all, they worry about waking up to find their land filled with Soviet Jews. I'd worked on behalf of Soviet refuseniks after a professional conference took me to the Soviet Union in 1979. Most Palestinians with whom I speak agree that all people have the right of free movement. They argue that the Soviet emigrants should be allowed to go to the United States as they really want instead of being forced to move to Israel, that their right to live where they choose does not negate the Palestinians' right to their land, and that it is hypocritical to proclaim the "right of return" of the Soviet Jews who have never lived in Palestine while denying it to Palestinians whose homes here can still be seen. A letter to that effect from thirty-one prominent Palestinians was sent on January 19 to Western consuls general in Jerusalem. Zahira Kamal and Hanan Mikhail-Ashrawi were among the signers, along with Rana Nashashibi—an amazing ten percent of the signatories were women! The percentage was slightly higher than it would be two months later, when a memorandum reaffirming commitment to the peace process and to the PLO as the sole representative of the Palestinian people would be issued in the name of thirty-four, with the same three women among them. In August 1990, the three will again be the only women in a delegation of twelve Palestinian

leaders that meets with sixteen members of Knesset; in March 1991, Zahira and Hanan are the only women among ten Palestinians meeting with U.S. Secretary of State James Baker. There are still very few women considered by male Palestinians to be "leaders." They are respected as individuals rather than as representatives of women, who apparently are not sufficiently important to merit the carefully calibrated representation given to parties and geographic areas.

The press reports that the PLO has in effect written off the Eastern bloc as a source of potential support for its statehood effort and is turning instead to the West. Prime Minister Shamir's revealing remark about the need for a "big Israel" to absorb the immigrants has exacerbated the Palestinians' fears and has elicited outrage not only from the international community, including the American administration, but from the Israeli peace camp and the Labor party as well. In another example of what frequently seems to be Israel's self-destructive policies toward the Palestinians, the IDF will announce a Shamir-approved order prohibiting publication of any news about the immigration of Soviet Jews, which the administration is forced by the ensuing outcry to "redefine" within a few days.

Today, Mona's sister Mervat, who works at al-Haq, goes to the post office with a friend to pick up al-Haq's mail (many West Bank businesses and institutions find it more efficient to have a post office box than to wait for the mail to be delivered). It's a rainy, uncomfortably cold day, and the strike has emptied the streets. Mervat and her friend notice two soldiers standing on the rooftop gesticulating toward them, one of them smiling—and the next thing she knows there's the sound of a shot and a pain beginning to spread through her leg. Because of the weather she's wearing thick slacks and boots, so the rubber-coated bullet doesn't enter her leg. An Israeli friend has told me that rubber-coated bullet wounds are particularly painful, and indeed Mervat develops both a painful swelling and a sense of bewildered outrage. She may have been hit by the kind of rubber bullet that causes welts and is shot in threes through an extended barrel the soldiers have dubbed a "stromboul." As I well know, there's no demonstration or anything of the

sort going on when this occurs, for, as it happens, I walked nearby on my way to a pharmacy just moments before. Mervat says the soldier was smiling when he shot. Although Mervat is too shocked to remember details, I draw on World War II stories I've read to speculate that the bored, chilled, resentful soldiers said something along the lines of "Let's make the girls dance" and shot at the sidewalk near their feet. The bullet probably hit the street and ricocheted to the area near Mervat's ankle. Mona is as aware as anyone that complaining will do no good but is nonetheless so incensed that she calls military headquarters. She's told that the legal adviser to the local commander is out, no one knows when he'll return, and no one else will accept a complaint.

12

Intifada: The Turning Point

"We don't do that anymore."

June 29, 1990: The American academic year has ended and I'm back in Ramallah. Once again, much has happened. On May 20, an allegedly insane Israeli put on his IDF uniform and murdered seven Gazan Palestinians waiting for work in Rishon Lezion. An eighth died in the hospital. Anticipating violence, the IDF rushed frightened reinforcements into the territories. Nine more Palestinians were killed during the protests of the next few hours and 480 were taken to the three Gazan hospitals. Curfews were imposed on entire cities, towns, and refugee camps in the West Bank, as well as on all of Gaza. The UNLU called a three day strike. Arab Israelis infuriated and frightened Jewish Israelis by holding a one-day sympathy strike that was accompanied by sporadic rioting in Nazareth, where brutal repressive measures were employed. Palestinian leaders went on a hunger strike. The alarm of the world community was reflected in a hastily called UN Security Council meeting, in the course of which the United States vetoed a proposed resolution that would have sent a three-person commission of inquiry to the territories. The secretary-general instead sent his own representative on a fact-finding mission. The UNLU called on all Palestinians as well as Arab nations to end all cooperation with the United States, whether it involved purchase of American products, meetings with American officials, or the sale of oil to the United States. Amnesty International issued a scathing report accusing the Israeli government of

encouraging the killing of unarmed Palestinians during the days following the initial murders. On May 29 a bomb went off in West Jerusalem's Mahane Yehuda market, killing an elderly man and wounding nine other Israelis. Shoppers tried to attack Palestinians who happened to be on the scene, shouting "Death to the Arabs!" Two days later the IDF intercepted armed members of the Palestinian Liberation Front who were attempting to land in boats near Tel Aviv, killing four of the Palestinians and capturing twelve others.

On the day after the Rishon Lezion murders, a Knesset committee voted $17 million to expand settlements in the territories. On June 11, a right-wing government dominated by the Likud's Yitzhak Shamir took power, insisting that no land be turned over to the Palestinians. Defense Minister Moshe Arens declared that it was "no coincidence" that he spent his first full day in office visiting the two largest Jewish settlements in the West Bank.

I have returned to Ramallah to find an embittered, exhausted, impatient, and frustrated population. The combination of a promised $400 million loan for the settlement of Soviet Jews in Israel, in addition to the $3 billion the United States gives Israel annually, and the U.S. veto of the proposed fact-finding mission has resulted in an anti-Americanism so intense that many Palestinians believe the problem isn't the Israelis; it's the Americans. Shopkeepers have been informed by the UNLU that they have until July 2 to get American products off their shelves. Since the massive violence and curfews in May, the IDF has changed its tactics. Arens has persuaded his fellow cabinet members that the intifada can best be handled by permitting Palestinians to lead as normal a life as usual, so the number of troops in the territories has gone down. There are relatively few jeeps patrolling, although there seem to be more lookout points on the roofs of tall buildings. The number of checkpoints on the Jerusalem-Ramallah highway has decreased, and while they still slow cars down, soldiers frequently wave cars through without looking at IDs. Ramallah Hospital is receiving far fewer casualties, and fewer jeeps are to be seen in the nearby refugee camps. The immediate result is a more relaxed atmosphere on the streets, even if the deployment of troops is accompanied by

what seems to be a stepped-up harassment campaign centered on the constant need for official papers.

The intifada clearly is in a state of transition. There's less random violence. Many of the *shabab* are busy in the reopened schools; there are fewer casualties because of a new IDF policy permitting more activities, including short marches, that would have been halted a few months before and because of what appears to be tighter control on the use of gunfire. Workers, particularly those with young children to feed, still "sneak" into Israel on strike days. Interfactional strife and frustration over the dormant peace process have increased. There are more killings of collaborators. This could be the result of any of several factors: increased use of collaborators by Israel (B'Tselem and other sources have reported that Palestinians in need of vital documents such as *laissez-passers* to go to other countries for medical treatment are being told they can be obtained only for the promise of collaboration, and their sole remaining option is to buy the documents from a collaborator); increased information about collaborators; and killings of supposed collaborators in what are actually murders for personal reasons (*bayanat*, in addition to calling repeatedly for the end of collaborator killings, have suggested that a number of collaborators executed were wrongly accused).

Many West Bankers are expressing increased frustration about the paucity of new tactics and the continuation of some that no longer seem as useful as they once were. People are annoyed at the number of strike days, originally used to demonstrate and enhance community coherence but now seen as an impediment to the economy and social life. In fact, the UNLU leadership has already responded by cutting back the number of strike days and by extending shopping hours on nonstrike days. Hamas continues to call its own strike days, but whereas they were scrupulously observed last year, they're not anymore. Cars tear around at terrific speeds on Hamas strike days, their drivers fearful of stones but driving nonetheless. People complain now about the scant activities available for children and teenagers during summer recess. I've heard someone suggest gathering all the people who have to use

wheelchairs as a result of the intifada and parading them down the main street of East Jerusalem in full view of foreign tourists. Let the world see what Israel is willing to do to the Palestinians. Someone else suggested massive marches onto the closed university campuses by faculty and students.

June 30: Beginning my day as usual by going to the newspaper shop, I glance up at the IDF outpost to see the expected group of soldiers and makeshift sunshade of poles and canvas. I'll be amused during the next weeks to see that occasionally a large Israeli flag will serve as the canopy.

What's most noticeable, after the deepened bitterness and the new IDF policy, is that the economic situation is continuing to deteriorate. I stop to chat with a grocery store owner whose large selection of Palestinian wines I've enjoyed and whose five years in California makes communication in English easy. His shelves are almost bare. It's a combination of things, he explains. He's had to remove Israeli goods, and many have no locally made substitutes; now he's taking off American goods; and he's not replenishing his liquor supply because he's certain the fundamentalists will soon make the sale of alcoholic beverages impossible. He tells me that last year his shop was closed for ninety-five days, counting strike days and curfews, and on the other days it was open for only a few hours. The store ran at a loss, requiring his family to use savings to keep it open, and as a young married man with a two-year-old son he's had the embarrassing experience of having to borrow money from his elderly father. His son wants to go to the beach when the weather's hot; he and his wife want to be able to go out to dinner or a movie once in a while. The constant financial drain is demoralizing. He says a lot of middle-class people are leaving. The very poor are being helped by others and the wealthy are of course managing; it's the middle class that's feeling the pinch the most. He's applying for a job, and if he doesn't get it, he may have no choice but to join his siblings in the United States. He's still firmly committed to statehood, but he's not sure he can stay here until it is achieved.

The streets are filled, but, as the merchant has pointed out, people don't seem to be buying much, in spite of the impending celebration of 'Id al-Adha. More women appear to be wearing head

scarves or traditional dresses. I've got to buy an extension cord for my lamp and walk into an otherwise empty store, where a young man cuts the wire to the right length and chats while he's adding the plug and socket. He asks why I'm here and begins an animated discussion of why most Americans know so little about Palestinians, conducted in his fractured English and my very limited and highly impressionistic Arabic. Much to my embarrassment, especially given the economic situation, he absolutely refuses to accept payment, saying it's the least he can do to welcome an understanding American. The result, of course, is that I go in during the next weeks to buy things I don't need.

July 2: It's sad, on the pre-feast days of July 1 and 2, when the stores are permitted to remain open until 9:00 P.M., to see what appears to be a good part of Ramallah's population excitedly flocking to the shopping center in the evenings, not to buy—the stores have few customers—but just to enjoy the unusual sight of street life in the evening. Streets are packed with Palestinians from around the world, spending the summer with relatives, and with Americans and Europeans on fact-finding missions: doctors, lawyers, religious groups, children's welfare specialists. Soldiers still ride jeeps with their guns pointed at pedestrians, jeeps and trucks continue to patrol with their sirens blaring just to remind everyone who's in charge, there are beatings and injuries if not deaths every day, and the late-night raids on houses continue.

In the evening, right before dark, when the breeze has finally ended the miserable heat of the day, my neighbor Rema and I take a brisk walk. Occasionally we're passed by soldiers in jeeps mouthing obscenities at us. In the middle of one street, we see what appears to be the cover of a paper box. We pay no particular attention, but others do. An army jeep zips up, and soldiers jump out to order two teenage boys walking nearby to pick up the box. One does and the soldiers, satisfied that it's not a booby trap, make one boy take the box into the garden of an adjacent house and back into the street a number of times, while the second boy is made to stand next to the jeep. It's petty harassment but there's no telling whether it will extend to arresting the boys, so Rema and I deliberately remain watching, creating the presence of two women who

look older, modern, and well educated. The soldiers glance at us a couple of times and eventually, with rebukes to the kids, zoom off, tires squealing and siren shrieking.

Did our watchfulness make a difference? We don't know. But a few days later a particularly pretty American woman who works at al-Haq tells me that recently she stayed in East Jerusalem later than she had intended and arrived back at the Ramallah *service* station just after dark. She was stopped by an IDF patrol before she managed to walk the few blocks home and, after her passport was checked, one soldier began threatening her in such explicitly obscene language that even with her good Arabic she could get only the sense of what he was saying because some of the words apparently were so vile she'd never heard them. She suddenly realized she was alone with the patrol on a dark, empty street and, New York–toughened though she is, she'd never been as frightened. A family out for a stroll walked by across the street, assessed the situation, and stopped directly opposite the soldiers, watching. She was allowed to leave, and she's sure the family's presence was responsible.

July 3: The IDF announced that yesterday, in honor of 'Id al-Adha, it released more than four hundred West Bank prisoners, most of them first offenders about to complete their terms. It did not add that last night it arrested more than seven hundred, some of them from Ramallah's Old City.

The trial of Colonel Yehuda Meir is concluding. He is charged with ordering the beating of villagers from Beita and Hawara in February 1988. A lieutenant present at the incident described the roundup of male villagers who were suspected by the Shin Bet of "political activity" but not of terrorism, which meant they had organized or participated in demonstrations. They were taken to a field and Meir ordered the lieutenant's unit to "beat them, break their arms and legs, and leave them in the field." The lieutenant picked out soldiers who "would not have a problem with that." The soldiers went a little wild, he commented. Some of them became difficult to control and beat so enthusiastically that they broke their clubs. The lieutenant described the Palestinians lying on the ground, bound and gagged, being beaten until their hands and legs

were broken. "Most of them stopped screaming after fifteen to thirty seconds," he told the court. "Their legs didn't jerk any longer. . . . Then we took the scarves and flannelette out of their mouths." The deputy commander of the company testified that he left the area because he "didn't want to see the condition they were in."

The lieutenant attempted to explain the soldiers' behavior by describing the deep sense of frustration engendered among them by the uncertainty of their orders. Both they and the villagers knew they were not permitted to open fire at stone throwers, he said, but the permissible degree of force was unclear. In 1989, Israeli newspapers headlined the affair and Meir was summoned to appear before the officer responsible for troops in the West Bank, who asked him whether he was aware that the beatings contradicted standing orders. Meir replied that "the regulations at the beginning of the intifada were fluid and changed every other day." At his trial, he has added under cross-examination that while the official policy restricted beatings, oral orders from senior commanders and Defense Minister Rabin had called for beatings as punishment. A lieutenant colonel has confirmed that both the chief of the general staff and Rabin had made it "the acceptable norm" to drag stone throwers out of their homes at night to be beaten. It was prohibited to beat detainees, he went on, but the troops recognized Palestinians as detainees "only after dealing them a few blows and tying them up." Other testimony was given to the effect that a secret IDF unit beat residents of the Ramallah-area village of Kafr al-Deek.

Some soldiers reacted differently. A sergeant testified that he and a medic were ordered by Meir to break an arm or leg of a sixteen-year-old they were guarding and that they couldn't bring themselves to do it, so they kicked him, told him to behave, and released him. It was presumably such soldiers whose reports eventually led to Meir's being prosecuted. As the trial has progressed, some left-wing Knesset members have demanded, with no success, that a commission of inquiry be established to ascertain any involvement of the political echelon.

Reading the story as it unfolds in the newspapers has been awful, particularly as many such incidents have occurred and nothing has

been done about them unless fellow soldiers were so horrified that they forced the IDF to press charges. But soldiers found guilty have received only minimal sentences. And yet the Israeli public continues to regard such incidents as aberrations in violation of orders rather than an integral part of the occupation, which involves futile attempts to destroy a popular revolution with force and engenders inevitable frustrations of reserve soldiers sent without any training to do the impossible.

In April 1991, Meir will be found guilty of ordering the beatings. The military court will reject his claims that Rabin and Amram Mitzna, IDF West Bank commander, bore partial responsibility but will sentence him only to demotion from colonel to private: no imprisonment, no fine. According to IDF lawyers, the demotion is a punishment of such "rare severity," particularly as it means that over the years his retirement benefits will be reduced by hundreds of thousands of shekels, that it will serve as "a clear message and a deterrent." Meir himself, says the IDF, suffered enough from the ordeals of an initial trial by a disciplinary panel, a petition to the High Court, and the eventual year-long trial.

July 4: I interview Lisa Taraki about fundamentalism and, a few hours later, her sister-in-law Rita Giacaman about the women's movement in general. Lisa and Rita are both forty, have both given birth to a first child during the last few months, and are both trying to combine the early stages of a much-wanted but rather bewildering motherhood with their professorial careers. Lisa's husband is also a professor and is able to share child care. Rita's physician husband, Mustafa Barghouti, heads the medical relief committees. He spends long hours trying to keep that part of the overworked medical establishment running, and she's juggling roles madly. The sounds of a howling infant had reverberated through the telephone when I called her to say hello, and she, who normally does more things faster and with greater élan than virtually anyone else I know, was herself wailing: "I'm forty, I'm a professor of public health, and I can't get this child to stop crying! How do twenty-year-olds handle it?"

I hear from Rita about the Women's Research Center that she has established in Nablus with four other independent women: another

professor, a high school teacher, novelist Sahar Khalifeh, and an expert in Arabic. It is teaching marketable skills to and engaging in consciousness-raising with women aged eighteen through thirty, identified by both the women's committees and independent women. Another goal of the program is that more women become knowledgeable about women who live outside the Jerusalem-Ramallah-Bethlehem axis. The young women are learning how to undertake social analysis; how to put together case histories, employing literary as well as analytical skills; and how to manage statistical data, including entering it on computers—something even most West Bank academics can't do. The program has progressed to the point where the three most promising students soon will be assigned to do research about women in the Old City of Nablus. Money for the center comes from the European Community, the Ford Foundation, and church groups.

Rita says the committees continue to be bogged down in factional politics. She deplores that situation because it prevents the committees from using their energies as she thinks they might, but she also recognizes that it pulls more women into the political arena, where the ultimate power lies. Another divisive element is resentment among committees in the areas around Hebron and Nablus at the domination of the movement by the committees in the Jerusalem-Ramallah region, which tend to get perquisites like participation in conferences abroad, the opportunity to interact with visitors to the West Bank, and new equipment. Rita views competition among the groups as particularly harmful because of the low participation rate. She estimates that 10 to 20 percent of the general population and 30 to 50 percent of university students are involved in politics, as are a maximum of 5 percent of all women. Political involvement for the last, according to Rita, means belonging to a women's committee. It's my impression that many publicly active women are members only of a women's committee but that women who first became members of trade unions, student organizations, and parties usually have joined women's organizations as well.

July 8: When I arrive at the stop for the Jerusalem *service* at about 9:00 A.M., a number of shops are closed and my eyes and nose are

assaulted by teargas wafting down the street. Although my lungs advise a faster speed, I walk, not run, to the waiting car; running makes the soldiers suspicious. The driver has rolled up all the windows but he and I start coughing and crying. Hurrying additional passengers into the car, he quickly takes off. There are jeeps racing everywhere and as we make our way through the market area we see a number of them pulled up in a bunch, with soldiers hustling two men into one of them. Apparently someone threw something, probably stones or a petrol bomb, at a jeep or an outpost. Later we learn that the underlying reason for the incident may have been that the night before, an eighteen-year-old was killed at the Ofer detention camp in nearby Beitunia, supposedly during an escape attempt. The boy had served so much of his sentence that his family and friends don't believe he tried to escape. The closed shops are the vanguard of what quickly becomes a full protest strike.

Someone in Ramallah has asked me to look in East Jerusalem for a particular kind of whole wheat bread that's packaged in West Jerusalem. The request has made me uncomfortable because I'm being asked to break the boycott. But one has only to look in the stores to see that the boycott of Israeli products is not uniform, particularly of those goods for which there is no local substitute. What is more interesting is the reaction I elicit when I mention the request to people in Ramallah without divulging the name of the person involved, who made similar requests last year. The reaction of others is much angrier than it was in 1989, and the first Jerusalem storekeeper I speak with tells me, "We don't do that anymore. You may find stores carrying things that can't be replaced by non-Israeli products, but there's enough Palestinian bread available so that we won't carry any from Israel." Curious, I make a point of going into six more stores, all close to the border where Israeli products are most likely to be found. The response in every store is the same as it was in the first.

The women's committees and other organizations have continued to expand their areas of operation, concentrating on infrastructure rather than confrontation. A presentation by three West Bank economists in late June, relying on statistics gathered by Palestinians, reports that 49 percent of Palestinian industries have experi-

enced a rise in demand during the intifada; productivity has in-
creased by 15 percent; fifteen major new investment projects have
been started; and because of the boycott of Israeli goods, Palestin-
ian imports from Israel dropped from $928 million to $650 million
between 1987 and 1988. Palestinians exhibited their products at
this year's Nicosia International Industry Fair, the first time Pales-
tinian products have been shown alongside Western products in an
international setting. A press conference at the National Palace
Hotel has announced the launching of a Business Development
Center, a consulting firm in the territories that will be funded by the
UN Development Program to provide management, administrative,
and technical skills for the local economy. The Jerusalem Post writes
that the Palestinian move toward economic self-sufficiency is pro-
gressing, albeit slowly, and cites the statement of an economist
with the East Jerusalem–based Economic Development Group that
the UNLU's decision to announce strike days well in advance has
permitted rationalization of delivery schedules. It adds that the
stability of the intifada has focused attention on regional markets
and that medium-size plants (rather than the more traditional
small ones) are being established to serve them. The 1989–1990
season of direct agricultural exports to Europe was highly success-
ful. Israeli farmers are complaining bitterly to the Knesset that
while sales of Israeli farm products in the territories have fallen off
sharply during the intifada, Palestinian sales to Israeli dealers have
remained high, even though authorities have confiscated some
illegally shipped goods.

The upturn in the Palestinian economy has occurred in spite of
the reluctance of outside investors to put their capital into a war
zone, the limitations by Israel on outside investment, the ministry
of agriculture's restriction on importing seeds for products that
would compete with those from Israel, continued interference by
Israel with the export of Palestinian goods, and the refusal of Israel
to grant licenses to about seventy proposed factories whose goods
would compete with those of Israeli firms.

Before the intifada began, Palestinian firms were producing food
products, shoes, agricultural equipment, pharmaceuticals, plastics,
metal furniture, and cloth. Existing factories in these areas have

expanded and new ones have been created. But it is interesting that
Palestinian economists noting the growth of self-sufficiency have
singled out the post-intifada establishment of factories producing
items new to the territories: pickles, strawberry marmalade, tomato
paste, ice cream, fruit juice syrups, and jellies. Almost all of these
factories are projects of the women's committees.

 Bayan number 55, issued on April 19, called for intensified efforts
to build alternative Palestinian institutions and added that "dis-
obedience and [institution] building are two sides of the same
coin." *Bayan* number 58, of June 12, encouraged "reinforcing and
deepening the boycott of zionist products" and noted that "the
strike forces are responsible for confronting those who distribute
these products, especially agricultural products." In other words,
self-reliance and creation of an infrastructure are as critical to the
intifada as is direct confrontation with the authorities. Here women
have an opportunity to enhance their importance.

July 9: The ninth of the month is a strike day, which brings the
benefit of lunch under the grapevine with the neighbors. One
mentions that we're talking less politics than we did last year;
everything's been said but nothing's happening.

 In the late afternoon Rema and I are on another brisk walk when
a car stops near us, we hear my name, and out jumps one of the
leaders of the Union of Women's Committees for Social Work. I
haven't called her because she told me in January that she would
spend the summer in the United States. She's still here because the
authorities won't give her a *laissez-passer* or a reason for their refusal.
I learn later that her husband was a political activist killed abroad.
Apparently she's being punished by association; she's not been
arrested or interrogated about any activities of her own. A few
minutes after we leave her we meet other women from our street,
also out for an evening stroll. Rema chats with them briefly before
we resume our earlier speed, leaving them behind, and she reports
that they've expressed their gratitude that at least one American
still cares about Palestinians.

 The time spent in conversation has left us farther away from
home than we normally would be as darkness begins to fall, and as
we pass the Old City we see *shabab* erecting a stone barrier on a

street that we usually follow. We try to detour through the Old City's labyrinthine streets, only to find one after another blocked with barriers. It is almost dark and, clearly, there soon will be stone-throwing and shooting in response. Walking quickly, we finally decide to climb around one barricade, and Rema leads us home by a circuitous route. We hear gunfire from the direction of the barricades about twenty minutes later.

July 10: Maha Mustaqlem picks me up and takes me to her home for another talk. The following day I'll speak with Zahira Kamal and with Suha Hindiyeh, the sociologist who runs the PFWAC's year-old Women's Resource Center in East Jerusalem. The two days' conversations will focus in part on developments in the UPWC and the PFWAC that could have important economic consequences.

Maha, happily pregnant with her third child, tells me that the UPWC has begun the second session of its cooperative training school. The first class graduated, and many of its members are busy attempting to create new co-ops. The second class is drawn from all over the country and this time includes seven women from Gaza, who sleep in the homes of Ramallah women and who not only will carry their training back to Gaza but are enriching the educational experience of the West Bank women by teaching them about the difficulties and possibilities faced by Gazan women. It looks as if the Beitello co-op's problems with the authorities are about to be solved and it is back in full production of pickles and jams, the women working four hours a day and earning more than Palestinian women who work longer hours in Israeli factories. Men from the area who laughed at the project have begun approaching the co-op to ask if they can help, perhaps in marketing, and to observe the phenomenon of women successfully running their own business.

The UPWC now has eight cooperatives and fifty-three kindergartens. The latter employ about 120 people and, in a number of cases, cannot accommodate all the parents who want to enroll their children. The Ramallah kindergarten has sixty children attending and forty on a waiting list, and the committee is considering creating another kindergarten in nearby al-Bireh for the overflow. As the point of the kindergartens is to give mothers a source of

reliable child care that will make only a small dent in the income they now have the time to earn, the schools charge fees well below costs, which means that they have to rely on outside funding. Because they don't like either dependency, which runs counter to their philosophy of self-reliance, or financial uncertainty, they're thinking about transforming one of the cooperatives into a money-making endeavor that will underwrite at least some of the costs of the kindergartens.

The committee also has begun to address one of the main problems of working women, meal preparation. The co-ops' food products have gained enough acceptance to warrant the opening of a small store in Ramallah. When I visit it I see shiny one-liter aluminum foil packages of orange and lemon drink and others of various pickled vegetables: eggplants, hot peppers, cucumbers. On the shelves next to them are jars and bottles of jam, the special Palestinian white cheese made from goat's milk that is in season, balls of yogurt cheese preserved in olive oil, green olives, juice concentrate, and grape leaves ready for stuffing. There are bags of whole almonds, raisins, various spices, and dried mulukhyeh leaves. The last is a vegetable that looks and tastes like spinach when it is cooked with a few pieces of meat and served over mounds of rice. It grows quite differently, however: small individual leaves sprout along stalks three or four feet high. Mulukhyeh is in season now and, a few days earlier, Marie came home looking like a walking forest, hidden behind huge bundles of them. We sat behind the house, meticulously picking off each leaf as quickly as we could and chatting for almost two hours. She laid them out on the dining room table to dry so they could be stored. Given Ramallah's dry heat, they're ready in a few days. The fruits of our labor, she told me, would be enough for four meals. It was my only involvement in the labor-intensive part of Palestinian cuisine, but it was enough to make me understand why some women might be willing to break with tradition and buy some of their food at least partially prepared. Marie said she wouldn't buy the vegetable picked and dried by someone else—she'd be concerned about its cleanliness. It was the same reaction I would get from all but one of the much younger women in the Hebron area village of Idna, who also expressed

unease about ingredients even as they proudly described their committee's bottled yogurt cheese, which I assume they use. Today I join Maha and her family for the midday meal, for which she serves delicious mulukhyeh, using dried leaves from the committee shop.

The committee hopes to raise enough capital to be able to build a kitchen and a small cafeteria near the shop. The kitchen would produce food for the cafeteria and for women to take home to their families after telephoning ahead to place their orders. Maha thinks the popularity of the other prepared foods, coupled with the local reputation of the particular women who have agreed to be the cooks, makes the innovation worth trying. She expects the first customers to be more sophisticated, upper-middle-class women, but as they are the community opinion leaders she hopes that their example will be followed by the working-class women who are the intended clientele. The meals will be kept sufficiently inexpensive to be within a working-class budget.

July 11: I travel to Jerusalem to visit the new Women's Resource Center and interview Zahira Kamal and Suha Hindiyeh.

The PFWAC is undertaking activities different from but complementary to those of the UPWC. The center's major activity is the survey of working women that Zahira described in January. The first part, covering Bethlehem, Hebron, and Jericho, has been completed, and I'd seen Suha when she was in New York to present preliminary results at the Fourth International Interdisciplinary Women's Congress.

The resource center is attempting to locate every woman working in any Palestinian factory of any size. There is so little information available, and some of the factories are so small, with only six or seven employees, that many of the women have to be found by word of mouth. Each employer is asked how many married and unmarried women employees he hires and their names. So far, employers have been persuaded to provide the center with the two lists of numbers if not names. The lists are used to identify random samples of 15 percent each of the married and the unmarried women, who are then interviewed. The women surveyed have been cooperative, possibly because of the novelty of the endeavor.

The survey consists of two sets of questions. The first set is about

marital status, age, level of education achieved, motive for working, skills, and previous work experience. It also includes queries about whether the woman is the sole support of her family; the number of her family members, along with her relationship to them and their levels of education; and the age at which she began to work. If she is a mother, she is asked where she leaves her children during working hours. All the women are also queried about membership and roles in women's committees; if they are not members, they are asked why.

The second group of questions concerns conditions in the workplace: the kind of work (skilled or unskilled) and its level; whether the woman learned the work skills she possesses at the factory; her beginning and current wages; availability of benefits (maternity leave, overtime, health insurance, compensation for injuries, paid day off for International Women's Day and International Workers' Day, annual leave, pay for strike days, pay during the slow season or if the factory shuts down); whether the employer provides transportation; whether wages are equal for women and men; whether women have requested equal pay or why they have not; and whether there is a trade union committee at the factory and whether she is a member of a trade union and why.

The women I saw being trained to conduct the survey have become field workers, recruiting other women to help administer the questionnaires. The results are forwarded to the center. If Suha and her three researchers consider them incomplete, the questionnaires are returned for further information. It is a matter of pride that the computer program that will compile the data is being written by a committee member. Preliminary results have led to plans to seek additional data, such as why women ended their education when they did. If the reason was the closing of the universities, for example, they are asked whether and why they will or will not return once the schools reopen.

A PFWAC newsletter published in December 1989 estimated that fifteen thousand West Bank women, half of the women in the paid labor force, work in the garment industry, whether at home, in West Bank workshops, or in Israeli textile factories. When army checkpoints block the roads, as is frequently the case, the women may

have to walk for hours on dirt tracks to reach their workplace. Those who work in Israel are paid by the day, which means no pay when they do not work on strike days, and numerous absences caused by observance of strike days may lead to their being fired, a problem faced by other Palestinians who work in Israel. In addition, women who work in Israel are stigmatized for doing so, but as the newsletter points out, their families need the income, particularly in cases where other family wage earners have been imprisoned or are unable to work.

The survey will constitute the only complete source of information about a major section of the territories' female work force. Results already indicate that the women questioned belong neither to the women's committees nor to the unions; in fact, some had never heard about the unions. Others had heard of them but reported that their families told them that membership in a union or women's committee means getting involved in party politics and should be avoided. Among the committee's plans is to make recommendations to the unions. It has learned recently that the large Silvana Company, with which women unionists have been holding discussions for more than ten years, finally has agreed to pay women equal wages for equal work. The center thinks this may be the only Palestinian factory to have made such an agreement. Unions recently have persuaded garment factory owners to pay their workers for strike days. In some areas of the country, with Hebron an important exception, they have also achieved a minimum wage for such workers. The data already in suggest that these welcome efforts are insufficient: 86.2 percent of Palestinian women working for wages are unmarried; 6.9 percent are under age fifteen; 39.6 percent are between sixteen and twenty; and 46.5 percent are over twenty. Those in garment factories receive about half the wages paid to men doing equal work: 52 percent of the women interviewed receive the equivalent of $143 per month for workdays of nine or more hours; 44.5 percent receive monthly wages between $143 and $250. UNLU and regional leadership communiqués have called for setting workers' wages, which are paid in Jordanian dinars, at 4.6 shekels to 1 JD, to protect them from the decreasing value of the dinar, and also suggested that factory workers receive

not less than the equivalent of $200 a month. As the market rate in July is 3 shekels to 1 JD, it is unlikely that the suggested rate is being paid, and the survey demonstrates that most women workers are not receiving the recommended minimum wage. Approximately one-third of women in the West Bank's wage labor market receive no wages for days off, whether regular days off or days missed for health reasons; 98 percent of the women have no health insurance.

The kind of continuing economic thinking and experimentation being done by the UPWC, the acquisition of information about the economic status of women by the PFWAC, and the other committees' constant expansion of their economic projects could all prove crucial if women are to be a major economic force. The committees are beginning to talk about sending women abroad for training in business skills. In short, they have begun reexamining and rationalizing their relationship to the economy in a way that is likelier than their earlier efforts to enhance their influence within it. Nonetheless, the women have not made themselves so economically visible that investors—themselves the product of socialization that views large-scale economy as the domain of men—will consider the women's existing and potential projects as appropriate objects of their attention and resources.

Zahira and I turn to other topics. She had been permitted to leave the country briefly (she has since been placed under another travel ban). Following international pressure, the Israeli government is permitting the slow reopening of community and teachers' colleges, although the universities are still closed. She is excited at encountering women who had been married since the closings and who had insisted on adding to their marriage contracts a provision specifying that they could return to their studies once the institutions reopened. The teachers' colleges with which she works are residential, so women's reenrolling means leaving their husbands and, in some cases, small children. A few women returned only two weeks after giving birth; others are pregnant. Some had been in other Arab countries, where their husbands had gone to work, when the reopenings occurred. But they had carefully left their addresses with the school authorities and asked to be kept informed. Many of them immediately came back to the West Bank and their studies, although

others were prevented from doing so by their husbands. Zahira's excitement was understandable: for a woman to be so insistent that her husband felt no option but to agree to her departure for school, even if it meant leaving him in another country or placing her young children in the hands of relatives, was indeed revolutionary. Some women went to the committee for help in persuading their husbands, and the committee had of course responded. One begins to understand the statement of Eileen Kuttab that "development cannot happen if a state neglects half the population. Emancipation is a long process, but everything that has been achieved thus far makes me optimistic about the future of Palestine."

At the same time, Suha tells me that she's made a point of asking women active in the committee about their motivations for joining. Almost all of them, she says, became involved for nationalist rather than feminist reasons, their membership reflecting a desire to help the intifada rather than an awareness of the particular problems of women. This makes it even clearer that the women in the colleges described by Zahira are only one part of an extremely complicated phenomenon. Suha wants to begin courses at the resource center that would take better advantage of the intelligence of the women who participate in the committees in various geographic areas. It is they as well as the elite women, she feels, who should be reading articles about women elsewhere, touring to publicize the status of Palestinian women, reporting on them at conferences. The problem is that many women at the grassroots level do not speak or read English well enough. She's adamant about giving them courses not only in English but also in gathering and analyzing information and in public speaking. The first might bring closer Zahira's goal of producing a summary in English of every paper published by the resource center. Suha is concerned about the constant problem of elitism: the same women always seem to be doing everything. The beginning of an answer, she thinks, might be suggested by something the committee has already done. It held a workshop in which its leaders could address the problem of the gap between the national committee and the grassroots. Now, she says, it's time for a meeting with both middle-class and grassroots women in attendance.

The problem of elitism is also being addressed by the UPWC. Maha Mustaqlem has told me that people on the specialized central committees, such as child care and cooperatives, are being asked to work as well with local women's committees in places such as factories and refugee camps. In addition, the UPWC is encouraging women from the local committees, whose participation has been confined to such activities as demonstrations, to serve on or work with the specialized committees. And the UPWC is reaching out to non–committee members, asking them to use their expertise on advisory committees that will work, for example, with the women supervising the kindergartens.

Zahira and I had been scheduled to speak longer but she apologetically asks for a postponement. A youth was killed in Jerusalem's Shuafat refugee camp last night, a protest strike has been called by merchants in Jerusalem, and Zahira has to drive her mother from Jerusalem to Ramallah during the shopping hours. A few days later I'll meet two women from al-Haq as I take my morning walk to the newspaper store. They've had to leave work to shop for food, and I belatedly realize that all working women have this problem: workplaces and stores are open only during the morning, so women regularly have to take time from work to buy food as well as clothing, other household necessities, and school supplies. They also have to shop in stores near their workplaces, not near their homes, and carry their purchases back to work with them.

13

The Threat of Fundamentalism

"If the Koran is the soul of Islam, then perhaps the institution of the Muslim family might be described as its body."

The clash of fundamentalism and feminism has had and will continue to have a powerful effect on Palestinian women's lives. While the conflict has centered most overtly on women's dress and public behavior, the issues that strike at the heart of the emerging Palestinian feminism and on which a liberated future for women may hinge are reproductive freedom and the effect of Islam on the laws of the Palestinian state.

The fundamentalists believe in the ultimate spread of Islam to the entire world. Harking back to the Ottoman Empire and the years before it, when all of Palestine was Islamic, they teach the legitimacy, desirability, and inevitability of an all-Islamic Palestinian state, including the area within Israel's pre-1967 borders.

A struggle already exists within the larger Palestinian society between fundamentalists and others: nonfundamentalist Moslems, from the extremely orthodox to the rare nonbeliever to those in between, and Christians. Before the intifada, the two key fundamentalist organizations were the Islamic Jihad, or "holy war," and the Moslem Brotherhood, both based primarily in Gaza. The Jihad rejected mass mobilization in favor of forming a secret cadre engaged in armed struggle against Israel. Its activities were cur-

tailed by the arrest of many leaders early in the intifada, but the organization still commands respect in Gaza and among small numbers of West Bankers.

The most important manifestation of fundamentalism in the West Bank today is Harakat al-Muqawama al-Islamiyya, the Islamic Resistance Movement, known by its Arabic acronym, Hamas, which also means "zeal" or "enthusiasm." It was created a month after the intifada started, using the infrastructure that the Moslem Brotherhood had developed to support the strengthening of Islamic values and self-help projects in Gaza. The creation of Hamas was a signal that Palestinian fundamentalism would no longer confine itself to social activism but was becoming a militant grassroots political movement intent on nationalizing its religious beliefs. Its thirty-six-article Mithaq, or covenant, published in August 1988, does not differentiate between Jews and Zionists and accepts the legitimacy of the notorious Protocols of the Elders of Zion. Not surprisingly, therefore, it rejects the peace process and the existence of Israel. The Israeli defense ministry, recognizing Hamas's growing influence, outlawed it in September 1989, in a reversal of the widely rumored Israeli policy of channeling money to fundamentalists before the intifada to nurture a non-PLO political force. The success of the fundamentalists clearly exceeded Israeli expectations.

The extent of West Bank support for the fundamentalists is difficult to gauge but certainly does not equal that in Gaza, where it is now dangerous for a woman to be seen without a head covering. Hamas is not part of the Unified National Leadership and calls its own strikes, which are observed by the population throughout the territories with the same meticulousness as are those of the UNLU. At least in Ramallah, Hamas strike days are observed largely out of fear of Hamas zealots. Some West Bankers nonetheless think that fundamentalism is not a major threat because the overwhelming majority of the population identifies with Fateh, the PFLP, the DFLP, or the Communist party. Others are less sanguine, as is the PLO. Major PLO figures such as Abu Iyad (Salah Khalaf), the leader murdered in 1991, have warned repeatedly that if Israel resists a PLO role in the peace process or if the process appears hopelessly stalled, more and more Palestinians will turn to fundamentalism.

In July 1989, I heard many women leaders express concern about overt manifestations of fundamentalist antipathy toward women, including physical attacks on women who walked outside without *ahjiba* or were otherwise "immodestly" dressed. The attacks increased after July, as did the appearance of slogans scrawled on walls warning such women that they might have acid thrown on their faces. Even the few Christian committee members in Hebron and in the Gaza Strip were finding themselves endangered if they failed to cover their heads, and pressure to do so was beginning to move into the Jerusalem-Ramallah area, where many women had given up head coverings early in the century. Birzeit lecturer Islah Jad compiled a list of incidents and took pictures of the threatening wall slogans. Zahira Kamal and other women called on the UNLU to cover the issue prominently in a *bayan*. The Leadership responded in August 1989 by including what the women felt was an unsatisfactory short statement in *bayan* number 43: "The UNLU condemns attacks by radical groups on Palestinian women in Jerusalem, Hebron and Nablus." The four women's committees, acting as the Higher Women's Council, thereupon published their own *bayan*—a rare joint endeavor—that advised women not to be intimidated and to struggle with men who attacked their behavior and dress, even if the struggle became physical. They also persuaded the Fateh and PFLP leadership in the Nablus area to issue a similar *bayan* and asked various popular committees to put the matter on their agendas. The result was that by January 1990 incidents of harassment had died out in Jerusalem-Ramallah and had diminished considerably in the other areas.

As might have been expected, however, the truce did not last long. Feminism and fundamentalism continue to pull in opposing directions.

Fundamentalist communities have sprung up in the Nablus and Hebron areas and have established their own institutions such as schools. Fundamentalist men organize their own intifada demonstrations, which do not include participation by women. In 1988, restaurants in Ramallah were open during shopping hours throughout the month of Ramadan, when Moslems fast from sunrise to sunset, but in 1989 fundamentalist threats to restaurant owners

resulted in restaurant closures during the last week of Ramadan. In 1990, restaurants were shut for the entire month. But nonfundamentalist women disagreed about whether this show of increasing fundamentalist influence could be translated into a threat to a women's agenda. Some women were concerned that many people, particularly the young, were turning to religion because the peace process was taking so long and the misery engendered by the occupation and intifada was not abating. Others observed an increase in participation in religion but not in fundamentalism, arguing that the newly religious, along with other Palestinians, were increasingly skeptical of Hamas because of its opposition to the Leadership and to a two-state solution, which seems to offer the only hope for Palestinian independence.

Nonetheless, in 1990, a part of the PFLP, the most radical party in the Unified Leadership, attempted to merge with the equally rejectionist fundamentalists. The union did not last long, and after a few weeks the PFLP announced its renewed commitment to a two-state solution and its determination to work within the UNLU to escalate the intifada. Escalation presumably was both the price of the renewed participation of the PFLP in the Unified Leadership and an expression of the general frustration at the stalled peace process.

The Leadership recognized that the fundamentalists still presented a political threat. In an apparent attempt to unify Palestinians and co-opt Hamas, the PLO began negotiations to bring Hamas into the Palestine National Council. No agreement could be reached because of Hamas's insistence that it be given 40 to 50 percent of the seats on the PNC and that the PLO retract its recognition of Israel and its commitment to the peace process. The PLO's anger became apparent in July 1990 when its official organ *Filastin a-Thawra* (roughly, *Palestine: The Revolution*) published an eight-page blast at Hamas, accusing it of being divisive. Ten days earlier, masked Hamas supporters had marched in the Askar refugee camp, chanting, "With Koran and with fire we shall boycott the treasonous American dialogue." Fateh supporters countered with their own march and the chant "With the stone and with fire we shall defeat the treasonous enemy." Hamas replied to the PLO's condemnation in a leaflet declaring, "At a time when our people have decided to

boycott the United States [after its veto of the fact-finding mission the Security Council proposed sending to the territories following the Rishon Lezion murders], supporters of the dialogue with America are preoccupied with finding an outlet which will satisfy the U.S. . . . while ignoring the demands of the masses."

In spite of its differences with the fundamentalists, the UNLU did not curb them, and fundamentalist power continued to increase, to the detriment of women and the feminist cause. Attacks on women seen in Gaza without *hijas*, including women's committee members, continued. Some women scholars suggested that the attacks on committee members were as much on women's participation in the public sphere as on their dress.

By January 1990, even the UPWC, Maha Mustaqlem's committee, was deep into the women's agenda that she had insisted could not be raised if the committee was to retain its credibility with the general population. A triggering event was the suicide of a committee member who had been beaten daily by her father because of her committee work, which he opposed as improper and feared would get her into trouble with the authorities. A meeting of twenty women leaders involved in the committee's work since its inception was called after the funeral to confront the question of whether the committee had adequately supported its members as well as the general national movement. The women leaders decided to begin addressing the women's agenda. Their first step was to face the issue of the *hijab*. The issue already was an expressed concern of other committees as well as of the Unified Women's Council. The UPWC's decision to deal with the *hijab* was a rather conservative and comparatively safe step, but it constituted an important departure for the committee because it implied an overt confrontation with the fundamentalists. The women felt that there was no point in attempting to discuss the issue in Gaza, where fundamentalists had succeeded in making almost all women wear the *hijab*, so they rejected the idea of a march of bareheaded women there. But the UPWC's publications now emphasize the "triple oppression" faced by women in the political, social, and economic spheres.

The four women's committees had become so concerned about fundamentalist power that, focusing on the pressure to wear a *hijab*

as both a real and symbolic threat to feminism, they organized a meeting of all the committees and independent women, bringing to it six women from Gaza who had begun wearing *ahjiba* after receiving physical threats. The next step was supposed to be the drawing up of a position paper and its discussion at a second meeting. The May massacre intervened. In July, the Women's Studies Committee of the Bisan Center for Research and Development, a Ramallah-based institute organized in 1990 by academicians, issued its own position paper against forced wearing of *ahjiba*.

When I spoke with Birzeit sociologist Lisa Taraki, who has studied the fundamentalists, she correctly predicted that the UNLU would not do much about them because the UNLU membership is predominantly associated with Fateh. Fateh's constituency is religious and centrist, and the organization has no incentive for a move against the fundamentalists. At the same time, Taraki did not think public policy would be much affected by fundamentalism, but she added that the shopkeeper was right to fear that he might not be able to sell alcoholic beverages: all it takes is a few young men to decide on their own to intimidate shopkeepers or to harass "improperly" dressed women for fundamentalist extremists to have an impact. Early during the intifada the Ramallah arak* factory was set on fire, presumably by a group of fundamentalists, but it has been repaired and is in full production. Rita Giacaman also thought in mid-1990 that fundamentalism had hit a plateau and pointed to the Ramallah Friends School, whose principal had been told by fundamentalists to force the female students to wear *ahjiba*. He refused and, with the backing of the Leadership, simply ran them out of the school. At the same time, the PLO infuriated Giacaman and other women by issuing a "passport." Patterned on the Jordanian family passport, it has a separate page for information about each of four wives. Rita interpreted its appearance as the foolish act of a bureaucrat but agreed with the women's committees that the PLO has been singularly insensitive to the protests of women.

The Bisan center, convinced that the fundamentalists were using the issue of the *hijab* as the cutting edge in a drive for political power

*Arak is a licorice-flavored alcohol, rather like ouzo or Pernod.

and dismayed by the unresponsiveness of the Leadership, organized a conference in December 1990 entitled "The Intifada and Some Women's Social Issues." Some women allege that the conference originally was meant to be devoted solely to the *hijab*, but the center feared that calling a major conference solely to focus on that issue might alienate some prospective participants. In any event, an astounding 450 women and 50 men from all over the territories went to the day-long conference in Jerusalem. Five papers, all mentioning the threat to women inherent in fundamentalism, were delivered at a morning plenary session; other presentations were given in the afternoon workshops on women and education, women and human rights, women in the media and literature, and the women's committees. A women's committee member from Gaza gave a moving description of the pressure to wear *ahjiba*. All the workshops and the conference itself made recommendations, including revision of the school curriculum and an attempt to end early female dropout, establishment of a committee to draft personal status laws, encouragement of women writers, and the pursuit of research about and solutions to the problems of women. Prominent among the recommendations were references to the *hijab*, objections to its imposition, the desirability of publishing a major document on the issue, and calls on the Leadership to assert itself on the matter of "women's issues," including the *hijab*.

Discussions about the *hijab* continued long after the conference ended. A Hebron woman suggested, "The number of women wearing Muslim dress in Hebron has increased, not because of religious conviction but out of fear after having tomatoes and eggs thrown at them by some conservative *shabab*. This worries us. This means we treat women without democracy. I myself wear long sleeves during the Intifada because I feel with our people's suffering." Zahira Kamal thought that the fundamentalists, sensing a lessening of their power to make new converts, were increasing pressure where they could and that "improperly" dressed women were an easy target. She noted that earlier in the occupation many women were convinced by the fundamentalists that the *hijab* was a symbol of resistance and began wearing one to distance themselves from Israelis and Israeli mores. She also mentioned a relative who

teaches in a community where many women wear a *hijab* and who wears one herself to minimize her social distance from her students. The *hijab* has become the woman's visible indication that she fits into the community. It was hard to agree with Zahira that this doesn't really indicate fundamentalist power. On one of my walks with my neighbor, I had asked why we always seemed to avoid going in a particular direction. She explained that it led to a fundamentalist neighborhood, where, dressed in our baggy slacks and shirts, we might be stoned or pelted with fruit. This is one of the many ironic parallels to life in Israel that seem constantly in evidence in the West Bank. It is equally unsafe to walk around ultra-Orthodox Jewish neighborhoods such as Jerusalem's Mea Shearim wearing shorts or T-shirts. Both Israeli and Palestinian women have found no solution other than to avoid such areas as much as possible. In each case, the fundamentalists' antipathy is reciprocated by the women. In 1991, I was amused to hear committee leader Amal Khreisheh's five-year-old son, who obviously knows what bothers his mother most, threaten that if she didn't let him have something he wanted he'd join Hamas.

The Leadership seems as indifferent to fundamentalism's effect on women as it is to women's issues in general, although it does act when the fundamentalists attack important male institutions. If the fundamentalists are permitted to affect the women's agenda, the women's committees and other forward-thinking people are in trouble. The head of Hamas's Young Women's Moslem Association in Gaza was quoted as saying that women should serve the intifada "by providing the necessities at home for their men to fight the Jihad to liberate Palestine." The nonparticipation of most fundamentalist women in organized West Bank intifada activities reflects the kind of agenda common to Moslem, Christian, and Jewish fundamentalists: use of public policy to enforce religious mores on all members of the society, with particular emphasis on the dichotomy between the public and private worlds and on gender-specific roles.

The on-again, off-again alliances between fundamentalists and various political parties will no doubt continue as factions jockey for power within the PLO and the PNC and among the people of the territories and as the peace process waxes and wanes. The women's

movement has had all the more reason to be concerned about the influence of fundamentalism since mid-1990, when all three socialist committees were finally articulating a feminist agenda. Prominent on the agenda were reproductive freedom and legal equality of the sexes, rights that are both most unacceptable to fundamentalists and crucial to the equality of women.

In the past, only elite West Bank women used birth control, primarily the pill and intrauterine devices. Others didn't even think of using birth control, women leaders told me, until they had at least four children. Most West Bankers assumed that breastfeeding had a contraceptive effect, because women discovered that they usually became pregnant again only after weaning a baby. By July 1990, however, the committees were being urged by some women on the grassroots level to talk about birth control.

The UPWWC subcommittee in Abu Qash, a village near Birzeit, was involved in a variety of projects, including an environmental awareness program organized by educators. Among the topics covered by the program were the relationship between health and pregnancy and the economic implications of producing many children. The committee had noticed that one member, the mother of seven children, had cut back on her participation in committee meetings and activities. The major reason for her slackening involvement clearly was her child care responsibilities. Committee members were concerned that the decision about the number of children she should bear was not being left to her but, as is common, was being made in one way or another by her mother-in-law, her husband, their neighbors, and the community at large. The committee's interest in the subject led to an article entitled "When Can We Have Birth Control?" in the UPWWC's September 1989 newsletter, which summarized the key points made during the local committee's discussion:

1. Establishment of an independent Palestinian state will offer security to individual Palestinians, who now feel pushed to have many children out of fear for the future and because of the harsh economic situation.
2. Movement of women toward work outside the home helps in the progression of birth control use.

3. Movement of women toward increased education would further participation of women in the planning and decision-making about the number of children a family would have.
4. Combating the trend toward early marriages would help to limit the number of children.

The women linked Palestinian independence and birth control: an increasing number of women in schools and in the paid work force will lead to a greater interest in and knowledge about birth control, but only the end of occupation will ease the pressure to produce children as a hedge against economic instability and in favor of the family's survival.

The reaction of other Palestinians to birth control varies. The greatest resistance is in the south, the Hebron region, and the Jordan valley, where families still own and work land. People elsewhere are less opposed, particularly those whose families work inside Israel and earn enough money for necessities but not so much that they are able to afford many children. But most women still feel they cannot make their own decisions about the number of children they will have.

The major form of birth control in the West Bank is the IUD, which requires little attention if it is properly inserted. Birth control pills, which have to be taken each day and then replenished and which are viewed skeptically by a population that regards most pills as dangerous, are far less successful. Condoms are as unpopular a form of birth control here as they are elsewhere. Vaginal cups and creams are not widely used because people are unfamiliar with their own physiology and hesitate to touch the intimate parts of their bodies. Little incidence of infection from IUDs has been found; the Union of Palestinian Medical Relief Committees speculates that the absence of multiple partners means fewer sexually transmitted diseases that could cause problems.

Women's control over the number of children they bear is viewed as inextricably tied to the question of family law. Laws currently limit women's decision-making role, make divorce primarily a male prerogative, allow men to decide whether or not their wives can work, and so on. A woman under such restrictions usually is afraid not to accede to her husband's or mother-in-law's wishes about

childbearing. (This is undoubtedly one of the reasons that abortion is an unthinkable option for Palestinian women.) The women's committees are aware of the connection between law and reproductive freedom. The UPWWC newsletter that addressed birth control included a fifth point:

5. The feminist movement should work on preparing a progressive agenda concerning personal status laws that would go along with women's requirements under the daily changing realities, and on making this feminist agenda a priority by vigourously representing it to the first government of the Palestinian state.

The UPWWC newsletter that discussed family planning also carried an article entitled "The Intifada and the Role of Palestinian Women," which included the questions "What are the safeguards against a recession of the post-intifada role of women? What assurances do women have that they will not be asked to return to their traditional, domestic roles if and when national independence is achieved? . . . Can women become a power able to participate in decision-making in Palestinian life and politics?" The article concluded, "The greatest challenge facing Palestinian women today is how to formulate these questions into a common feminist agenda." Another issue of the newsletter recounted the story of a woman whose husband was killed during the intifada. Her parents insisted that she return to live with them, even though this meant leaving her two-and-a-half-year-old daughter with her husband's family. The article asked, "Why is it not possible for this woman to continue her life, on her own, raising her child? Why can she not decide to work, or get married again, of her own free will?" Calling for an "in-depth analytical review of the civil law and how it relates to women and their rights," the authors urged women to "organize ourselves and our women's unions to protect the human rights of women, our equal rights to life and work." The conclusion was in capital letters: "WE CALL UPON ALL WOMEN AND DEMOCRATIC FORCES IN OUR COUNTRY TO WORK TOWARD FREEING OUR WOMEN FROM THE TRADITIONAL CIRCLE OF RESTRAINT, WHICH THE CIVIL LAWS REINFORCE, PARTICULARLY IN FAMILY AND MARRIAGE-RELATED ISSUES."

The phrase "civil laws" refers to the incorporation of much Islamic law into the Jordanian Law of Personal Status and other statutes. After the PLO issued the Palestinian Declaration of Independence in November 1988, an editorial in the PFWAC's March 1989 newsletter spoke of the "victory of independence . . . a victory for women" and urged:

> Women in this state . . . must also continue fighting for their liberation and for a radical and comprehensive solution to their economic, social and gender problems. . . . Accordingly, it is imperative that Palestinian women continue their struggle after independence, and win key positions in the structures of the state. Particularly, women must participate in developing legislation and a constitution, which will give women equal rights with men, such as the right to work and study, and to liberate women from reactionary laws imposed by the [Jordanian] occupation authorities, whether in personal status, inheritance, work and labor, or others.

As Randa Siniora of al-Haq commented elsewhere, "I notice that women in the refugee camps and villages go out without the permission of their parents, but this means nothing for the future if we do not change the laws which govern personal relationships."

In mid-1990, the UPWWC sponsored a course on women in the law, with Randa using Turkish law as an example of secular law in a state with a largely Moslem population. In addition, the committee organized a subcommittee including independent women such as Mona Rishmawi, Rita Giacaman, and an attorney knowledgeable about the Moslem *shari'a* law. Its charge was to draft nonreligious family laws for the Palestinian state. The committee met only twice before its members were distracted by the Rishon Lezion murders and their aftermath.

The committee did discover during its short life how little the members knew about *shari'a* law and how important such knowledge is if realistic reforms are to be proposed. Randa therefore began working with the four committees to plan a course about women in Jordanian law, including *shari'a* law and the domestic law that governs the various Palestinian Christian denominations. Jor-

danian law would be covered by a *shari'a* court judge; a leading West Bank Christian attorney would discuss family law governing Christians. The course was to begin in the autumn of 1990 and meet twice a week for about two and a half months. Participants would include about thirty women, seven or eight from al-Haq and the remainder chosen by the committees, who would, by the end of the course, be expected to know enough to draft a proposed code. The Gulf crisis intervened, however, and the course was postponed.

The outcome of the struggle between the women and the fundamentalists remains to be seen. A major complicating factor is the uncertainty of the impact on fundamentalism of Iraq's invasion of Kuwait in August 1990, the war that followed in early 1991, and the fundamentalists' initial support for Kuwait and their subsequent reversal to support for Iraq. Some women feel that fundamentalism has suffered. One suggested to me that the fundamentalists' call for Islamic unity was seriously undermined by the split among Moslem countries over support for Iraq as well as by the imprisonment of a large number of fundamentalist leaders by Israel. Another said that Palestinians had considered Iran and Saudi Arabia to be the defenders of Islam, and their alliance with the West against a Moslem Arab country had left many Palestinians feeling shocked at Iran's apparent betrayal of Moslem Arabs and angry at the fundamentalists' assertion that God would see that the right side prevailed. Even anti–Saddam Hussein Palestinians were against Western intervention, believing that the Arab states should have been allowed to deal with Iraq themselves, so few Palestinians felt that the right side did prevail.

Other indications, however, point to fundamentalists gaining adherents. At a time when the Leadership's policies have effectively cut out almost all leisure activities, the fundamentalists have offered opportunities for women, children, and young people. Mosques hold lectures for women, serve generous meals, sponsor gender-segregated swimming trips, and even field sports teams that play against those of other mosques. Some women see fundamentalism as becoming more influential among Palestinians who had lost hope in 1990 because of the breakdown of PLO-U.S. negotiations, the huge wave of Soviet immigration to Israel, the

consequent expansion of settlements and loss of jobs in the territories, and the repression that intensified after the Rishon Lezion killings and during the Gulf war. During the war, I was told, more women were wearing a *hijab*, largely because Saddam Hussein invoked Islam as the tie among Arabs, and some women think that the attitudes developed during the war are still having an impact. There certainly was a higher proportion of women wearing *ahjiba* in Ramallah in May 1991 than I'd ever seen before.

14

Revolution Within the Revolution

"If they want us to work with them in the fields, they can work with us in the house."

July 13, 1990: To get a better sense of what most women are thinking about childbearing, I have scheduled an interview with Dr. Salwa al-Najab, a gynecologist who helped organize the Union of Palestinian Medical Relief Committees (UPMRC).

The perspective of most Palestinian women on reproductive freedom and health issues in general probably derives in large part from the combined activities of the women's committees and the UPMRC, a nonpartisan broad-based organization of 850 volunteer Palestinian health professionals. Organized in 1979 by doctors and other health workers concerned about the poor health care system in the territories, the UPMRC has managed to reach those in need of medical care through local unions, women's committees, *mukhtars* (traditional village leaders), and mosques and churches. The organizers' original goal was to provide enough mobile clinics to serve the entire population. They wanted to create a health infrastructure that would supply primary health care services to those needing them most, particularly mothers and children; to provide preventive medical services; to undertake consciousness-raising and health education; to identify health problems; and to coordinate health institutes. Hoping to create a grassroots organization that would give the population greater access to health professionals' skills, they also wanted to make the population partners in a general health care system.

Villages and refugee camps were encouraged to elect seven to ten people to a local medical relief committee. The committee worked with UPMRC personnel to decide how often its population needed mobile health clinic visits or whether the people needed a permanent clinic. If the committee opted for a clinic, it was asked to choose two local women to take a nine-month course for health workers given by the UPMRC. The women would also become members of the committee.

The need for the UPMRC is all too evident. Almost half of the 489 localities in the West Bank lack any form of modern health care. There is only one pathology laboratory and no burn center. The poorly distributed health care centers are concentrated in the Jerusalem-Ramallah-Bethlehem area. Women whose Pap smears test positive for the presence of cervical cancer are sent to Maqasad Hospital in Jerusalem, which for many means an extended journey away from their families. There is no facility for treating other forms of cancer. Patients have to be referred to Hadassah Hospital in Jerusalem. After the intifada began, the Israeli administration told Israeli hospitals to stop taking patients referred by Palestinian doctors. A year of international pressure led to the reversal of the policy, but at least 70 percent of the territories' population have no health insurance and cannot afford Israeli hospitals.

The UPMRC suffers seriously from the occupation-created problems of not being able to get permission to bring in needed ambulances, equipment, medicine, and other medical supplies. It is usually unable to treat sick or injured people in areas under curfew. Soldiers frequently interfere with ambulances and the cars of medical personnel transporting or attempting to reach people in need of medical treatment. The UPMRC does derive a modicum of protection from its nonpolitical nature. Unlike the trade unions and the women's committees, the UPMRC was organized as a broad nonpartisan coalition of health care workers and has rigorously avoided party politics. Perhaps 3 to 5 percent of its members are affiliated with a party, but their involvement is not permitted to interfere with their work for the UPMRC.

By 1983, the UPMRC had eight organizations providing mobile clinics all over the territories. Some commentators view the

UPMRC as the model for the grassroots organizational structure of the women's committees. Because the two kinds of organizations, as well as the trade unions, came into existence and expanded at roughly the same time, it seems likely that a more correct analysis would be that many university graduates began thinking about grassroots organizing simultaneously and that some of them went into union work, others into the UPMRC, and still others into women's committees. Probably the organizations learned from each other; certainly, when they went into a village or refugee camp that was new to them, they drew upon each other's networks. Whatever the genesis of the grassroots idea, the result for the UPMRC, as of mid-1990, was twenty-six village centers with fifty-three UPMRC-trained workers. An additional sixteen women had just completed training to open six more village centers. Workers in about half the centers hold women's clinics once or twice a week, providing prenatal and postnatal care, gynecological services, and family planning information. The UPMRC plans to teach its workers to be midwives because of the large percentage of home births.

Where women give birth depends on where they live. One study found that 92 percent of women living near cities give birth in a hospital. Hospitalization is rare for those far from cities, and it is precisely because so few West Bank women live in urban areas that the UPMRC scorns Israeli infant mortality statistics, which reflect only deaths in hospitals. The Israeli administration has assessed infant mortality at 11.4 per 1,000 births throughout Israel, including the territories. The UPMRC is certain that the rate in the West Bank and Gaza is 50 to 70 per 1,000 births—a study it did of the West Bank village of Biddu showed a rate of 55—and, in the most deprived rural areas, as high as 80.

A recent United States study found the territories' rate to be 53.5 to 63.5. Infant mortality in the United States in 1986, in contrast, was 10.4 per 1,000 births (18 for black births, 8.9 for white). The rate in Finland was 5.9; Sweden, 5.9; Kuwait, 15.7; Costa Rica, 17.8; Chile, 19.1. The leader in dealing with the problem is Japan, where the rate was 20 percent higher than that of the United States in 1960 but is now 5.1, less than half the U.S. rate. An August 1990 U.S. Department of Health and Human Services report interprets the

Japanese experience as indicating that "with a national commit-
ment and accessible health services it is possible to make substan-
tial improvements in infant health." This is precisely what the
UPMRC has to struggle with: there is no government with a national
commitment to lowering the infant mortality rate in the territories,
and health services are far from accessible. Interestingly, the U.S.
study quotes the Talmud, which says, "If we save but one life, we
save the world." The biggest problems in the territories are dehy-
dration in summer and chest infections in winter. The infant mor-
tality rate in Gaza is lower because the majority of its population
consists of refugee families receiving UNRWA care, but the rate of
infant morbidity, severe illness during the first year of life, is much
higher there because of the appalling living conditions, which
include parasites and contagious diseases.

Most West Bank mothers have lost a child through spontaneous
abortion, stillbirth, or death during early infancy. Many have their
first child at around the age of fifteen, when they know too little
about prenatal care. Mothers also take very young children to the
hospital too late, partly because hospital care is expensive in the
West Bank. Family financial decisions usually are made by men,
who are faster to take sick boys than girls to the hospital. A joint
study by the UPMRC and Birzeit University's Community Health
Unit in an area of the Jordan valley revealed a malnutrition rate of
55 percent among girls and 34 percent among boys. A study of three
villages in the Ramallah area showed a 52 percent malnutrition rate
among girls against 32 percent among boys. It was therefore not
surprising to find that the infant mortality rate in the village of
Biddu was 58 of 1,000 for girls and 41 of 1,000 for boys.

The emphasis on producing boys has led the UPMRC to realize
that it is necessary to emphasize the spacing of children rather than
their number when discussing birth control. The average number of
children per family in the villages is six to seven. Even women who
use birth control will occasionally give it up because only when
they're pregnant do they receive real care from their husbands and
in-laws and can minimize their workload and even spend daytime
hours in bed.

Salwa tells me about the changing attitudes toward birth control.

When she was at a village women's clinic just yesterday, a pregnant thirty-eight-year-old, already the mother of eleven children, came in with her oldest daughter, relatively recently married and now pregnant with her first child. The daughter is resentful of the mother because the large number of children in the family meant that the daughter had to assume responsibility for child care so early that she herself had virtually no childhood. She is determined not to have as many children. The mother says there is nothing she can do about her own situation; her husband insists on more children. Generation gap.

Sometimes that kind of gap can be useful. Another patient, the mother of ten children, wanted desperately to stop giving birth but could not obtain her husband's permission to use birth control. Her first child is now a twenty-year-old man. He objected strenuously to his mother's having to continue bearing children and, last Mother's Day, gave her an IUD and an appointment to have it inserted. Because it was the wish of his oldest son, the father reluctantly consented.

Eight percent of Palestinian doctors are women, specializing, as they do elsewhere, in pediatrics and gynecology. Salwa herself, with two small children, declines to make the middle-of-the-night calls required of an obstetrician. But women health care workers are playing an increasingly important role and are becoming specialists as well. Salwa was long concerned about the lack of facilities in the West Bank for doing Pap smears. She went to England for specialized training and returned to initiate a project and do its first smear just a year ago. The project has since taken and analyzed nineteen hundred smears from sixteen villages and from family planning centers in Jerusalem, Bethlehem, and Hebron. A similar project will begin next year in the north (the Nablus-Jenin area). I'm introduced to a young woman wearing a *hijab* over her long white doctor's outfit. She has just returned from Atlanta, where she completed a six-month course on taking and interpreting Pap smears. The UPMRC provided English lessons before she went. Another village woman, now twenty-one, began working with the UPMRC almost four years ago, when she finished high school and had nothing to do but wait to be married. She managed to get her

family's permission to take the UPMRC's training course and did so well that she was sent to a facility in Belgium similar to the one in Atlanta. Clearly, for some young women, the UPMRC is providing upward mobility in addition to much-needed health care.

Salwa raises another matter that I find disturbing. I had heard of only one case in the West Bank of polygamy, which is allowed by Jordanian law (hence the four-wife passport). It involves Suheila, a women's committee member and employee in one of its kindergartens, who is unable to have children. Because of severe family pressure, she and her husband reluctantly decided that he would take another wife while remaining married to Suheila. The second wife began to bear children and Suheila was surprised to discover that her life began to get better: without the pressure for children, she and her husband are able to maintain what she considers a very good relationship, and she and the second wife get along fairly well. Suheila is fortunate. The only options for a first wife when the husband marries a second one are to stay, putting up with both the implicit rejection and a sometimes tense situation among family members, or to leave her children behind and return in disgrace to her family, where custom will prevent her from remarrying even if her husband agrees to a divorce.

Salwa's clinic days in numerous villages, however, have convinced her that the rate of polygamy is higher than generally known, reaching 5 to 10 percent in some villages. The impetus for taking a second wife (polygamists usually marry no more than two, for economic reasons) can be that the first one does not produce children or that she bears only daughters, that the husband decides he doesn't like the first wife, that he develops a desire for a younger woman, or anything else—the decision is entirely his. Those factors certainly suggest an incentive for women to go on producing children, particularly sons, who will bind the father to his family, possibly object to the idea of his taking another wife, and create by their very numbers a financial situation in which it may simply be impossible for the husband to do so.

After taking up too much of Salwa's precious time, I return to Ramallah. The neighbors on one side bring over a bowl of juicy sour cherries they've picked from their tree; nearby, another neighbor is

up a ladder plucking sweet red plums. It's almost dusk, there's a cool breeze, and the air is redolent of fruit trees and flowers. We sit and pop fruit into our mouths as we chat, barely pausing as the nightly sounds of shots begin to be heard from the Old City.

July 17: Usually the passengers in any *service* are of both sexes, a variety of ages, and a mixture of traditional and modern dress. All the passengers today happen to be middle-aged women in blouses and skirts. The only man is the driver, with whom I'm sharing the front seat, and I can't imagine a less threatening-looking group. I note this in passing but have reason to focus on it within moments. The car starts toward the street leading to Jerusalem. There's a small barrel in the middle of the street, however, and an IDF jeep is blocking the road. Presumably the soldiers fear that it may be a booby trap. We're right near the crowded fruit and vegetable market, a large space jammed with produce-laden carts and hastily assembled stalls made out of stacks of cartons with the merchandise displayed on top. There's really no room for a car but we have no other option. The driver rolls down his window and starts shouting at the cart owners to pull over so we can get through. Suddenly, a young soldier appears directly in front of the car. He's pointing his gun, fitted with a teargas grenade thrower, right at our windshield. The driver and I instantaneously and foolishly react by rolling up our windows, each of us obviously thinking about keeping the teargas out while ignoring the threat of its being shot through the windshield. I've placed a shopping bag full of books, a present for one of the women's committees, next to my feet, and I quickly consider ways to move it so that I can get myself down under the dashboard. The soldier is young and looks literally frantic with fear. It's the first time I've ever been close enough to see someone's finger on the trigger of a gun. Why he's pointing it at a cab full of middle-aged women is beyond me, unless he's so frightened he simply doesn't know what he's doing. Apparently there's a sound behind him (we don't hear it because of the closed windows) and he whirls around, now aiming the gun at someone or something we can't see. Seize the moment: the driver quickly maneuvers the car, no longer careful of the produce piled up around us, scraping past tomatoes and overturning cucumbers. We

reach the end of the market and, after detouring through much of Ramallah, take another route to Jerusalem. As we roll along in comparative safety, I think of the policies that have put that terrified youngster in the midst of a mass of civilians, at least one of whom is likely to be wounded or killed simply because the frightened man has a gun.

I'm on my way to the UPWWC office in Jerusalem and will go from there to visit a committee in the Hebron area. All my meetings with village women and with elite women who have worked extensively in the villages have convinced me that any shred of reluctance to raise a women's agenda with the villagers is misplaced and that village women, who work alongside their male relatives outside the home and who are therefore well aware they have an economic role, may be readier for new ideas than their urban counterparts or women in refugee camps.

Today's visit, which supports that hypothesis, is to a committee in Idna, a village in the highly traditional and economically under-developed south. When people talk about the impact of fundamen-talism on the West Bank, they refer to the Hebron area. The UPWC had a lesson in Hebron traditionalism when it started organizing its grape molasses factory in nearby Sa'ir. The men initially refused to rent space to the women because they were certain it would be used to produce alcoholic beverages. (Eventually they relented and are now supportive of the successful cooperative.) Idna is also a particularly politicized area. On July 3, three young men were killed by a grenade thrown during a clash among what was reportedly hundreds of villagers. The Israeli press described it as occurring during a factional dispute that might have been related to a family feud. Palestinians in the area, however, as well as the Sanabel Press Services in Jerusalem, are certain that the grenade thrower was a collaborator and point to such evidence as the highly unusual absence of the IDF in the town both before and immediately after the event.

Our young male driver bears a marked resemblance to his American counterparts as he casually steers an overly fast car along the Jerusalem-Hebron highway, occasionally deigning to drag his eyes to the window and away from the very pretty women's commit-

tee member seated next to him. I think I'm getting a firsthand look at the way potential spouses meet during the intifada, but it's rather a relief when we finally near Idna and slow down. The main road to Idna has been semibarricaded with huge boulders arranged in an S-shape that requires careful, slow navigation. Alongside the boulders is an IDF post.

The committee's meeting place is also the site of its kindergarten. It is a boxlike room, with two windows cut into one side facing a door. The walls are painted in two colors and decorated with drawings done by the teacher and the children. Loops of brightly colored crepe paper are draped from wall to wall, high enough to escape little hands. The room is bare except for stacks of gaily hued tot-sized plastic chairs in one corner, a table with a pile of toys in another, and a long bench in between. When we arrive, the chairs are placed in a circle, someone brings two big flat circular loaves of peasant bread that are passed around so we can tear off pieces, and the meeting begins. Later someone gets a glass pitcher of water and, after some talk, one glass that is offered to me. The other women wait to drink from the glass or directly from the pitcher. Karima, my Jerusalem guide, confuses me by looking embarrassed when I ask to use a bathroom, murmuring, "We usually do that before we come here." Apparently most people use holes behind their homes, and she doesn't consider that appropriate for the American guest. She holds a quick conference with two of the women and I'm ushered to a nearby house, amusedly apologizing to the donkey tethered inside the gate as I squeeze by. I'm handed a ceramic pitcher of water and shown to a closetlike enclosure of boards attached to the house, with a hole in the floor and a box containing a supply of cut-up newspaper. As I emerge from it, one of the committee members comes rushing up with a belated box of tissues, undoubtedly found at Karima's insistence.

The radicalism of the committee women can be appreciated only by recognizing the severe material deprivation they experience daily as well as their role working the fields alongside the men of their families. UPWWC leader Amal Khreisheh has told me that some of the women are now working the fields by themselves, either because many Idna men are on the IDF wanted list and hide

in the hills during the day or because their husbands or fathers have already been arrested. Of course, their agricultural work is in addition to their homemaking functions. Shortly after the UPWWC organized the Idna committee, its representatives from Jerusalem were surprised to find no one at a scheduled meeting. The women eventually arrived, explaining they were late because they had been covered with the sweat and dirt of the fields and had taken time to shower.

About a dozen women aged sixteen to twenty-eight are present today, as are their children, who have no other place to be. (The committee's membership numbers about forty, and twenty-five others participate in some activities.) The children range from a year or so to about eight or nine. Throughout the meeting we can see and hear them playing outside the open door when they're not racing into the room, crying, chasing one another, demanding to be fed, or climbing onto their mothers' laps. The noise level is quite high but must be usual because the women are unfazed by it. All of them had been wearing head scarves, which they removed when they arrived, and modern clothes—dresses, skirts and blouses, slacks and blouses. Legs are modestly encased in stockings in spite of the ninety-degree weather.

One of the women was married when she was fourteen. She's now seventeen and has two children. Her home is about two kilometers away and she walks to committee meetings with the two children after a morning's work in the fields. Another, twenty-five, has six. A third is twenty, has two children, and is pregnant. The twenty-two-year-old kindergarten teacher cheerfully reports that she is still unmarried. A high-spirited nineteen-year-old who interrupts with impassioned but good-natured political speeches and laughter is unmarried and clearly will marry only whom she pleases. And one of the first subjects of conversation is children.

Most of the women insist on reproductive freedom. They are determined to limit the number of children they bear, although they tell me that decisions about how many children their mothers had was made by their fathers, even if the result was death in childbirth. I ask why they want a minimal number of children, both to hear what they have to say and to assess whether their ideas are

their own or those of my guide, who organized the committee. Their answers indicate that whatever the genesis of their opinions, the women are speaking out of strongly held beliefs that bearing too many children is bad for a woman's health, that the family will be able to afford a better education for the children if there are fewer of them, and that an overworked mother will be deprived of time for her own interests, whether visiting her friends or improving her mind or doing public work. They all say that while these attitudes were unthinkable a generation ago, they will talk with their husbands about the number of children they want. They recognize that they may have to compromise, since husbands like to have many children to prove their manhood, to help in the fields, and to provide for their old age, but their compromise will extend only to the number and not to the principle: if pushed, they will agree to have four rather than three. After that, they announce firmly, they will go to the UPMRC clinic and be fitted with IUDs. I begin to realize how crucial to the women's movement the UPMRC is.

The women formed their village committee during the early months of the intifada, they say, because their education and the role of women in the intifada made them aware that the situation of women in their community is very bad. In their words, women are deprived of their human rights (their language) by their family—fathers, husbands, and mothers-in-law—and by their community. Asked to elaborate, they add that when women want to go to the market or to visit friends, they have to ask permission of the men in the family, and permission frequently is denied. This, they say, is oppression. Not being able to sit and talk with men whenever anything serious is discussed also constitutes oppression. They want to be able to speak up about important matters. They also recognize the economic contribution they make to the family by working in the fields, and they demand equality as compensation: "If they want us to work with them in the fields," proclaims the nineteen-year-old, "they can work with us in the house."

They view their mothers as equally oppressed and frustrated but overcome by the combined forces of religion, tradition, and illiteracy. They attribute their own awareness to their education and the intifada. All the women finished primary school, and they empha-

size the importance of what they learned about themselves and their society from lessons and schoolbooks. They also mention ideas acquired by reading the newsletters and other materials provided by the committee. (Rita Giacaman had told me she thought the newsletters did little for women outside the elite because female Palestinians are not readers. She is right, if one considers that the majority of women are not in the women's committees, but for those who are, the newsletters appear to have an effect.) The West Bank educational system consists of kindergarten (ages four to five), elementary (six to eleven), preparatory (twelve to fourteen), and secondary (fifteen to seventeen). All these women stopped formal education after elementary school because there is no preparatory school in Idna and their families would not permit them to go to the next village for school. There were forty girls in the kindergarten teacher's class when she graduated from elementary; only one went on to preparatory school. The women organized themselves last year, however, and asked the bus company to arrange for a special bus to transport only girls to and from the next town's preparatory school. As a result, of the thirty girls who graduated from elementary in the summer of 1989, fifteen are going to preparatory.

The women believe their work to be as important to society as to themselves and actively solicit new members, largely by going in pairs on the traditional women-to-women social visits and inviting friends to participate. If a woman's family objects to her involvement, a group of members will visit the family and try to explain the importance of what they're doing. They're enlightening themselves, they say, as a first step before they can raise the awareness of others.

The intifada has made a deep impression on this group. Every single one of the women has been wounded by gunfire, whether by rubber-coated or plastic-coated bullets or bullet fragments. During one demonstration soldiers confiscated a Palestinian flag being carried by men. The nineteen-year-old woman ducked around the soldiers and rescued the flag. She and the others mock the men who stay behind when the women go out to confront the soldiers. The committee had organized a demonstration for March 8, Inter-

national Women's Day. That morning, however, they were told by the male leaders of the various parties that they could not hold it: the time was not politically right for a demonstration and the women had not asked the men for their permission. The men's position had sparked a furious discussion among the women, many of whom agreed that the touchy political situation in the village made it the wrong time for a demonstration. Others disagreed but were afraid to defy the men. The demonstration finally was held by about twenty committee women, who not only marched but placed Women's Day stickers on most of the shops in the village. The men's opposition had an effect—the women had thought that three or four hundred women might have joined them otherwise—but so, clearly, did the experience of the women in ignoring it.

Queried about the future, they reply, "We are not going to waste the achievements of the intifada and we will be equal with men!" They expect women not only to serve in the government but to compete with men for leadership positions. They also recognize that they may not achieve full equality. We have to work hard, they affirm repeatedly. If we don't get equality, our daughters will. When asked whether the men share their new opinions, one woman replies that perhaps a third of the men accept some notions of some female equality. The other women consider this figure much too high. That in no way impairs their enthusiasm. Change comes step by step, they say. It was a major step forward for their generation to be able to go to elementary school, they point out; now others are going to preparatory.

The hands of these young women are hard and calloused from work in the fields and at home. Their handshake is not the gentle thing of urban West Bank women, nor are their voices or laughter as soft. They may not manage as many alterations in the traditional lifestyle as they would like, but their strength is apparent in their articulation of ideas alien to their immediate culture and in many of their actions. They have made themselves familiar with the medical relief committee; they have learned about the health needs of women and children and about family planning. One woman, bottle-feeding her child—that alone is unusual—carefully measures a powdered protein supplement. Others talk about their new

practice of sitting with the men of their families when politics are discussed. They won't yet demand that "privilege" elsewhere, but they've begun in their own homes and say that they have the courage to speak when men are present because of the speaking experience they've had in committee discussions. Their Jerusalem mentor was present at a conversation between one woman and her husband, who, because he is wanted by the IDF, spends much of his time hiding in the hills. He complained about his life: always on the run, constantly worried not only about himself but about his wife and children, lonely for his family. He felt that when he did manage to get home it was his wife's duty to pamper him. And what about her? his wife demanded. He ought to understand the difficulties of her life: she is always worried about him, not knowing from one day to the next if he is dead or wounded or in prison; she is left with the responsibilities of home and children and crops; she is constantly concerned about her own safety and that of the children. Far from expecting to be pampered, he ought to return home with an awareness of the problems that she, too, suffers.

The seemingly unremarkable colloquy between two adults was extraordinary precisely because it was a colloquy. It was not a man demanding special attention and a woman according it to him as a right. It was two people talking as equals. That is the revolution within the revolution.

The Idna committee was put together largely through the efforts of Karima, a college graduate who approached the younger women of Idna, with backgrounds so different from hers, with trepidation. She reports having gained enormous poise as a result of her success. The poise is much in evidence as she varies leading the meeting with letting it move undirected, sometimes sitting quietly while women interject comments and occasionally interrupting to ask specific women for their opinions. It's nice to see her enjoying her newfound talent for leadership. But she considers her success incomplete because the women have not yet shaken their dependency on her. She is pleased to hear them speak well elsewhere after months of experience in committee discussions, but she won't be content until they not only can call and run their own meetings but are able to branch out to organize additional committees. This

really is grassroots organizing, bringing together women from different geographical areas and classes.

July 21: I'm interviewing UPWWC leader Amal Khreisheh. She's pregnant with her third child. Maternity clothes would be an unaffordable luxury for many of the women here. Like Amal, they wear their blouses outside their skirts for as long as they can and then borrow a larger woman's clothing.

Amal is not particularly upbeat about the attitude of Palestinian men toward women in the home and outside. She offers an example. The UPWWC supposedly agrees with the Communist party ideology, but Amal considers the party irrelevant for women because it does not practice gender equality. The women have waged a major battle within the party to get women onto committees, but their success has been limited. One example is the party's media committee. The members and leaders were male, but women were doing all the committee's work. After a struggle, some women finally have been named to it. She considers male party members hypocrites who don't treat their wives and daughters as equals. She has little patience with the gender attitude of other major organizations. There is only one woman on the thirteen-member General Committee of Trade Unions. The PLO has not even responded to a letter the women sent about its Jordanian-style passport. "Women cannot work in the streets in the intifada and return home as slaves!" Amal exclaims, saying that the slogan of the marches sponsored by the UPWWC on International Women's Day was that there must be struggle to increase the representation of women in politics.

She has put her concerns on paper, publishing a local magazine article asking women to think about the division of labor at home. The UPWWC is now discussing how to raise these issues on the grassroots level. She has suggested to Randa Siniora that after al-Haq's course on women in local law, a consultants' council should be created to work with women wanting to deal with issues of equality at home. She also wants to start a battered women's shelter so that women who are beaten by their husbands will have an option other than returning to their fathers' homes, but most other women on the committee consider this move far too radical.

As I leave Amal's office, I reflect that a clearly discernible bond connects her, Selwa al-Najab, and the young women of Idna. It is the rejection of many traditions: men's control over women's bodies, female illiteracy, exclusively patriarchal politics. The bond does not yet extend to all West Bank women. Nevertheless, its strength can be seen in the insistence of many on taking control of their lives and restructuring their society.

15

After the Gulf War

"This area is becoming a jungle."

"Democracy is not a choice for us; it is a necessity."

On August 2, 1990, Iraq invaded Kuwait. The United States and the United Nations promptly placed an embargo on Iraq and began mustering troops in Saudi Arabia. Virtually no Western media carried the text of the statement issued by West Bank and Gaza leaders condemning the invasion but calling on the West to permit the Arab countries to deal with the situation themselves; instead, the world was told that Yasir Arafat's embrace of Iraq's Saddam Hussein and the PLO leader's futile attempts to serve as a mediator reflected unequivocal Palestinian support for the invasion. Hundreds of thousands of foreign workers from many nations, including Palestinians, began pouring out of Kuwait. Of the nearly four hundred thousand Palestinians who had been employed in Kuwait, more than half fled, leaving behind their possessions, ending their remittances to dependent relatives in the territories, and seeking refuge anywhere. The infusion of Arab money into the territories virtually stopped. The Kuwaitis were no longer in a position to give it, and other Arab nations, allied with the United States, were embarrassed and angry at Arafat's refusal to separate condemnation of Iraq from the question of the Israeli occupation of the territories.

Then, in October 1990, Border Police killed seventeen to twenty-one Palestinians in a violent clash at the Temple Mount/al-Aqsa,

the site of both the Jewish Western Wall and the Moslem Dome of the Rock mosque. The killings were condemned by much of the world and, ultimately, by an Israeli lower court. The IDF's immediate response to the violence was to pour raw troops into the territories, with the unsurprising result that many more Palestinians were killed and wounded in the ensuing demonstrations, particularly in Gaza. The administration sealed off the territories and forbade all Palestinians from entering Israel. A hastily convened government commission declared that the Border Police had failed to anticipate events and called for administrative changes but did not recommend dismissal of the officers involved. Israeli employees were encouraged to replace Palestinian workers with new Soviet immigrants, increasing the Palestinian unemployment rate. The government issued regulations banning from Israel any Palestinian worker who had ever been placed under administrative detention or identified as an "activist" in the intifada. Initial estimates were that seven thousand workers, mostly from the West Bank, would be affected.

The defense ministry quarreled with the economic ministry about the increased permit limitations, roadblocks, and curfews designed to keep Palestinians out of Israel, arguing that unemployed people would only make the IDF's task inside the territories more difficult. Defense Minister Moshe Arens reacted to the violence in Gaza by banning the Islamic Jihad movement. The IDF began deploying hidden snipers along West Bank highways with orders to shoot Palestinians who threw stones at Israeli cars, whether or not the situation was life-threatening.

The secretary-general of the United Nations issued a report calling for a monitoring team to protect Palestinians in the territories. This was rejected by Israel, which agreed under American pressure to permit the secretary-general's personal envoy to make a fact-finding trip. Israel then deported four Gazans. There was a spate of attacks on Israeli civilians in Jerusalem and Tel Aviv, some resulting in death, by individual Palestinians. Tensions increased almost unbearably.

On January 13, 1991, *The New York Times* quoted Palestinian journalist Hanna Siniora as saying, "From the point of view of the

Palestinian man in the street, he has not much of a future and no stability. He sees Israeli annexation creeping steadily all around him.... We are becoming a Soweto. We spend our time playing cards and waiting." Prominent Palestinians appeared "traumatized" by the collapsing economy and the strained relationship between the PLO and the Gulf countries, the *Times* said, and privately condemned Arafat's handling of the situation. Mayor Elias Freij of Bethlehem spoke of "a deepening rift between Arabs and Jews that has become unbridgeable." About ten thousand Palestinians were given green cards, the IDs that barred them from working in Israel; curfews became more frequent; more checkpoints were set up in the territories and on the invisible line separating Jerusalem from the West Bank. Violence on both sides escalated. "This area is becoming a jungle for sure," Palestinian leader Faisal al-Husseini was quoted as saying in Jerusalem. "Increasingly we are hearing not only about killings but about massacres." As the U.S. deadline of January 15 for Iraqi withdrawal from Kuwait neared, Israel distributed gas mask kits to its citizens along with directions for creating sealed rooms in homes and obeying sirens, all in anticipation of possible chemical warfare. Palestinians in the territories were given no gas masks; no sirens were installed. When the government began to distribute gas masks to Jewish settlers in the territories, a Palestinian sued in the Israeli High Court for equal treatment under the Geneva Convention. The government argued that gas masks were unnecessary because the territories were an unlikely target. Justice Aharon Barak asked why, in that case, Jewish residents had been supplied with them. The answer was that the government decided to distribute them following political pressure by Jewish residents. "In my opinion, this arrangement is unacceptable," Barak replied. "This is blatant discrimination.... It's a scandal." The court ordered the IDF to distribute whatever gas masks it had on hand. The IDF said privately that it was afraid to do so because the masks could be used during demonstrations after the war was over.

In any event, it was too late, given the IDF's small stock of masks. Two days after the court's decision, massive American forces and some European and Arab troops attacked Iraqi forces in Kuwait and

bombed Iraq under the banner of the United Nations. The entire
Palestinian population of the territories was immediately put under
a twenty-four-hour curfew, which amounted to house arrest of more
than one and a half million people, lasting for a month and a half.
Military patrols prevented sick people and women about to give
birth from reaching hospitals, although the staffs of most hospitals
were home because they were denied permits allowing them out
during curfew. Crops rotted in the fields and on trees, and farm
animals died because farmers were not permitted to leave their
homes. Factories were nearly bankrupt because they could not
operate; the pharmaceutical factories clustered in the Ramallah/al-
Bireh area were unable to produce needed medication. When the
curfew was lifted occasionally and unexpectedly for a few hours to
permit shopping, there was little food to be bought, as farmers had
not been able to harvest it or get it to market. In many places few
people could afford food, as workers had not been able to get to
their jobs for weeks. An American journalist described the curfew as
"a terrible thing, scarcely imaginable to comfortable Westerners.
Homes were turned into prisons where large families of a dozen or
more persons were confined to three or four small rooms. . . . In
villages, sanitary facilities were often inaccessible, being located
outside the houses."

I sat up every night watching the progress of the war on CNN; I
called Tel Aviv whenever a SCUD missile landed to make sure Israeli
friends were safe and then called the West Bank to try to find out
what was going unreported by the American media. CNN showed
Palestinians up on their roofs cheering the missiles on. I spoke with
Palestinian friends huddled in sealed rooms, many denied gas
masks for themselves and all denied gas masks for their children.
The IDF said it had no children's masks but waited until late January
to place an order for them. At Ketziot, the Negev detention camp,
Israeli guards put on their gas masks whenever the missile alert
sounded and told the seven thousand maskless prisoners living in
tents to put down the flaps and cover their faces. Most Palestinians
were dependent on Israeli radio for word of missile attacks because
there were no sirens. I could call Mona Rishmawi and her sister
Mervat when it was night in the West Bank because they, like many

others, slept during the day, staying up all night to listen to the radio so they could alert their parents in case of attack. Their mother saw families without money standing hopelessly in front of food stores during curfew liftings.

The Association of Israeli-Palestinian Physicians for Human Rights, led by Ruchama Marton, defied the curfew and took back roads to Nablus to distribute half a ton of baby food to needy families in Nablus's Old City and the Balata refugee camp. Activists from Peace Now, the Committee of Heads of [Israeli] Arab Local Councils, and the Jerusalem-based Committee Against Starvation were prevented by the IDF from taking food to refugee camps and turned it over to UNRWA in the hope that the international agency would have better luck. Hungry people in the camps watched bitterly as some UNRWA trucks were turned away. Economist Samir Halailech estimated that six percent of the families in West Bank hill towns were at starvation level. UNRWA's commissioner general said that the food situation in the territories was becoming critical and appealed for international donations so that the agency could distribute foodstuffs such as flour and oil, amounting to a thousand calories a day, to needy refugee and nonrefugee families. B'Tselem, Hotline, and the Association for Civil Rights in Israel called on the government to permit Palestinians workers to return to their jobs in Israel or provide alternative employment in the territories, saying that many people were "verging on hunger." Nonetheless, Israeli tax collectors were going from home to home demanding immediate payment of advance taxes on 1991 income.

After the war, as many as a third of the Palestinians who had worked in Israel continued to be denied entry. The New York–based Catholic Near East Welfare Association distributed a report by Palestinian nongovernment organizations estimating that approximately 35 percent of the territories' work force was unemployed (at least 60 percent in West Bank refugee camps, where malnutrition rose by 700 percent), with 80 percent of West Bankers living below the poverty line and half of all Palestinian children suffering from anemia.

Getting through checkpoints from Ramallah to Jerusalem was so difficult that both Israeli and Palestinian friends wondered if I

should postpone my scheduled visit. I was warned about anti-American feeling—on Israel's part because the Bush administration was exerting mild pressure for the convening of a Middle East peace conference and among Palestinians because of the glaring disparity in treatment by the United States of the occupations of Kuwait and of the territories. But I was concerned about the people I had come to know, and in early May I returned to Ramallah.

May 3, 1991: Mona picks me up at the American Colony Hotel. As our car starts off, she points out construction. The road into Jerusalem is being moved so that settlers will be able to go from the West Bank directly into West Jerusalem without driving through East Jerusalem. A large tract of land in the middle of the road is to be used by the police. There are numerous military checkpoints on the side of the road heading for Jerusalem, with long rows of cars backed up behind them.

In the afternoon I go to the shopping district in Ramallah. It's Friday, and one of the UNLU's responses to the economic crisis has been to allow stores to remain open until 6:00 P.M. on alternate Fridays and Sundays. Nobody seems to be buying very much. Some stores have half-filled shelves. Others are closed, and I assume it's because of the lack of customers this late in the afternoon; I'll find out that they're closed permanently because the Gulf war curfew ended their already precarious existence.

People's faces don't look the same. They aren't exactly drawn, but somehow thinner, as if they've been stripped of all flesh that isn't absolutely necessary. Israeli friends had told me about Israelis overeating during the tension of the war. Some people here say the Israelis got fat during the war but the Palestinians got thin; others tell me that compulsive eating was a syndrome here, too, for people who had the money to stock up on food. I puzzle over the difference in friends' faces and finally realize that their facial expressions remind me of pictures of disaster victims. Their eyes seem wary, as if they reflect a knowledge of horrors that won't quite permit them to trust the world.

The telephones aren't working today; it's impossible to make appointments. I walk over to the Rishmawis' and sit chatting until

long after dark, pleased about the important position Mona has gotten with the Geneva-based International Commission of Jurists. Traces of tape, the result of the attempt to create a sealed room, can still be seen on the walls of one room, as is true of most homes here. Suddenly, loudspeakers start to blare commands that all young men are to go to the police station. This happens in the evenings whenever there's been an "incident." At once there are sounds of running feet outside, as young men head away from their homes and the soldiers. Sometimes elderly men respond to such calls just so the soldiers won't get furious at being ignored, knowing that the old are far less likely to be slapped into jail. Then, at about 10:30 P.M., soldiers appear at the house next door. Its owner, once a leading doctor, has been ill and hasn't worked for two years. He had unsuccessful open heart surgery a few months ago and has been in the hospital ever since, a tube in his throat alleviating his difficult breathing. The soldiers have arrived to demand an advance payment of 3,000 shekels (more than $1,500) a month on his 1991 earnings. The family is awakened; his bewildered wife signs a paper written in Hebrew, which she can't read, that the soldiers say acknowledges receipt of the demand, and they leave. While we're outside finding out what happened, we smell teargas, which is probably the remains of whatever incident provoked the call for young men to turn themselves in.

I've been introduced to two of the most striking phenomena I'll find this month. One is the Palestinians' bitterness at the world's concern about the invasion of "democratic" Kuwait, which is an oil-rich feudalistic autocracy tightly controlled by one extended family and dependent on the labor of foreigners. The second is the staggering taxes and fines which have become a part of Israeli policy, and seem to be designed to drive out the middle class. An article in the English-language edition of the Palestinian newspaper *al-Fajr* describes the sorry state of Palestinian industry and notes that the typical factory, with a dozen or fewer workers, cannot withstand the kinds of losses brought by the Gulf war and the curfew. Business had already been cut back some 40 percent by the intifada's strike hours and strike days, by military curfews, and by the general lack of consumer money. Now many businesses are

finding that they've been cut another 40 percent by the war and its aftermath. Local merchants whose special Israeli permits are supposed to guarantee them entry to East Jerusalem and Israel are often stopped by soldiers, and all the roads to Jerusalem are closed to Palestinians whenever a foreign dignitary visits or Israel has a holiday. The long lines at checkpoints cost merchants valuable time, and all of these problems are exacerbated by arbitrary tax assessments. The manager of a Bethlehem weaving firm, for example, has been assessed income tax of 128,000 shekels ($64,000) for the month of January 1991, during half of which he was under the Gulf war curfew, and 138,000 shekels ($69,000) for February, during which he was under curfew and didn't work at all.

May 4: I visit al-Haq for general greetings and to meet the new chief administrative officer, Said Zeedani, a Birzeit philosophy professor, and then a women's committee project near Jericho.

Driving back to Ramallah, we pass a settlement. It materializes suddenly like a huge whitewashed fortress squatting in the desert. Israeli flags are draped from the windows. There's a lot of excavating equipment and new mobile homes. The settlement is clearly being expanded, something the media haven't yet reported. All we've learned is that another settlement is created every time Secretary of State Baker arrives in Jerusalem to talk about beginning the peace process. In a few days Birzeit professor Hanan Mikhail-Ashrawi will comment dryly during a speech in Washington that the Palestinians can't afford Baker's visits: every one costs them a new settlement. It will be a month before Prime Minister Shamir makes explicit his refusal to freeze settlements and Housing Minister Sharon announces what we've already begun to see: five thousand new homes, designed to hold twenty to twenty-five thousand settlers, are under construction in the West Bank. Other officials say that housing now being built is meant to double the number of settlers in the West Bank and Gaza.

May 7: The first thing I hear from Suha Hindiyeh, director of the Women's Resource Center, is that the women's movement is suffering from the Palestinian community's intense concentration on the peace process, with many people wondering whether the Palestinians should accept autonomy as an interim measure (as leader

Faisal al-Husseini soon tells Baker they might) or hold out for a state. Suha's analysis will be repeated by Amal Khreisheh of the UPWWC a few days later.

All the data for the survey of women working in garment factories are in, although the results are more limited than Suha had hoped. The survey covers 254 factories employing 3,223 women, and Suha thinks this probably constitutes only a third of the factories and their work force. One problem was timing. Because of the war and its economic aftermath, a number of factories have closed, but their employees are continuing to work at home. These people are impossible to locate. In other cases the small size of factories means that few people know about them. Out of the 3,223 women, 504 were interviewed intensively, and the findings are similar to those I'd heard about for the Ramallah-Bethlehem-Jerusalem area: they are mostly unmarried workers paid on a daily basis, working as many as ten to twelve hours a day, with no paid days off and no pay for days they miss because of strikes or curfews, in spite of the UNLU's asking employers to pay workers for strike days. And these women, too, proved not to be members of unions or women's committees.

The center's projects are multiplying. It has finished a survey of women street vendors, to be issued as a Birzeit occasional paper; it has published two analyses of the treatment of women by Palestinian newspapers and magazines and has completed a third. Now it's investigating the effect of the Gulf war on the role of women. In addition, it has a Ph.D. candidate conducting a study about divorce. After using *shari'a* court records to identify women requesting a divorce, she's interviewing the women, finding that physical abuse is a major factor. The center also is working with a weekly Arabic magazine that will devote one issue a month to women. The issue—or magazine, if the center's attempts to get a government permit to publish its own are successful—will be devoted to social issues like marriage, divorce, custody, and inheritance and will approach them as the PFWAC's newsletters did, by using the examples of specific women rather than theoretical essays.

The center is trying to build up its research library, which at the moment houses dozens of periodicals. There are few books, how-

ever, in part because there's so little in Arabic about women and other languages aren't easy for most people here to read.

That is one reason for Suha's continuing concern about the chasm between the grassroots and the elite. She keeps seeing the same faces at meeting after meeting. This, she says, reflects the inability of the women's committees to build on the initial rush of women out into the streets. And the grassroots-elite divide has had serious consequences. Last winter, the PFWAC's Beit Hanina building was taken over by grassroots insurgents who accused Zahira and the other officers of not running the committee democratically and of allowing fiscal irregularities. As best I can tell after speaking with women on both sides and many who were not directly involved, one group felt shut out and the leaders of all the committees, as my own work had indicated, were not as much in touch with grassroots members as they believed. Of at least equal importance to the takeover, however, is an ideological split within the DFLP, which is also reflected in other DFLP-related organizations such as trade unions. Zahira and her supporters back a two-state solution faction led by Yasser Abed-Rabbo, chief PLO negotiator in the talks that the United States held with the PLO in Tunis and former deputy to DFLP head Nayef Hawatmeh. The other group, including new PFWAC head Nada T'weil, supports Hawatmeh and rejects a current endorsement of a two-state solution, saying that Israel and Palestine will have to recognize each other's legitimacy simultaneously in the course of an international peace conference. In addition, Nada's group appears to place less importance on the feminist agenda than it does on the national movement. Complicating the issue is the role of Samihah Khalil of In'ash al-Usra, who once viewed Zahira as a protégé but, becoming far more anti-American in recent years, now deplores Zahira's willingness to meet with American officials and denigrates the attempt by Zahira and other women's committee leaders to press the women's agenda. There were violent encounters, both in Beit Hanina and at various PFWAC-run projects, by men and women on the two sides. Nada's group has physical control of the Beit Hanina building, many of the day care centers, the West Bank part of the baby food project, and a number of other projects, including the 'Eisawiyya workshop.

Zahira and most of the former leaders have opened headquarters in Shuafat. Both groups claim title to the PFWAC name.

While the center was begun by the PFWAC, the committee hoped from the beginning that it would attract women with other or no party affiliations. It has now become all the more important for the center, formally part of an independent charitable organization registered under Israeli law, to be perceived as a nonpartisan research-oriented entity. Its new council, charged with writing its platform, setting its policy toward employees, and establishing and monitoring a financial system, includes both independent women and others identified with Zahira's group.

May 8: Back to al-Haq for an interview with Randa Siniora. She thinks many women are now working for the committees because they provide jobs rather than out of any commitment to the women's agenda. As examples, she cites the UPWC's nursery in a-Ram, where all the women wear *ahjiba*, and the current teaching of the Koran by similarly dressed women at the PFWAC nursery in Beit Hanina. Randa doesn't see any relationship between a *hijab*-wearing group that considers the Koran's somewhat negative view of women as a vital element in preschool education and the socialist feminist agenda expressed by both committees. She adds that while women used to work for the committees as volunteers or at minimal wage, they are now responding to family pressure to demand competitive salaries.

She turns to the subject of families. Professional women, she says, automatically have two or three children without thinking through the number compatible with their careers. She's arguing not against motherhood but for the kind of reasoned examination of its positive and negative sides that she believes real feminists would undertake. In a few days Rana Nashashibi will tell me that non-elite women are having fewer children, but for economic rather than feminist reasons. It's difficult to support many children and, given the paucity of jobs, they're no longer viewed as potential earners. Rana hypothesizes that one reason most women have not attempted to get their husbands to share child care is that they still perceive childbearing as an achievement and want to attach their children to themselves. Like Randa, she sees no change in women's

attitude toward men and their roles; or, if a few have altered their values, they've been unable to translate those changes into action. Her committee's newsletter recently carried an interview with a mother of five who is administrator of one of its nurseries and active in its cooperative committee. Asked if she thought the intifada had changed women's situation, the mother replied, "Unfortunately, women's role in the street has not been reflected in their social situation in general, as they are still under a great deal of social pressure; even women who are educated and economically independent or nationally and socially active still experience this pressure. Our journey is still a long one."

Randa adds that friendships between the sexes still are not understood and that while her husband has no objection to her continued friendship with a man she's known since they played together as toddlers, her neighbors are scandalized. "It's like a tax you pay" for having values that are different from those of the majority, she says sadly. The one encouraging phenomenon she mentions is the December Bisan conference and its recommendation that committee members and independent women alike should push ahead with the discussion of women's issues and develop a real women's movement.

Next, a talk with Rita Giacaman. As Rita rocks her feverish daughter, who is reacting to a measles vaccination, she talks about the split in the PFWAC and the close relationship that she's always deplored between the women's committees and the parties. She wonders whether pressure from political leaders outside the territories to begin grassroots work may have been a factor in the genesis of the committees and whether it therefore was inevitable that they would be hurt by factionalism. Their inability to build on the outpouring of women into intifada activities, she says, is attributable largely to factionalism. But she has praise for the committees' accomplishments. She can tell which young women among those involved with her Nablus Women's Research Center are committee members by their political skills and their willingness and ability to deal with problems outside the home.

In the cab going home from Rita's, the driver asks where I'm from. I know that anti-American feeling is high but I don't like lying unless

I have to, so I answer somewhat tentatively that I'm from New York. "I have a cousin in New York!" the driver exclaims in delight. "I was in San Francisco two years ago." I promptly abandon my fallback plan, which was to claim Canadian citizenship. I will find in the days ahead that my being American subjects me to a lot of anti-American diatribes but not, as far as I know, any danger.

When I arrive home I find our neighbor Adnan jumping so hurriedly to move his car that he doesn't have time to explain until the maneuver is over. A passing driver had called out, "The army's taking cars," which means that soldiers in the neighborhood are commandeering cars with Palestinian license plates for use in raids on villages. Such cars usually are returned eventually, but not necessarily in very good shape, and the owner is without recourse both while the car is gone and after it's been used. So Adnan rapidly pulls the car as far into the driveway as it will go, as proximity to an upper-middle-class home and people who will protest its seizure is considered sufficient inducement for the army to look elsewhere for transportation.

Adnan's been spending much of his time at military headquarters trying to get permits. He needs one so his son, who's been in the United States for his first year of college, can come home for the summer and another so he can leave again. He has to get one for himself, because he's been asked to give a paper at a scholarly conference abroad. He has to renew the permit for his car, and he's trying to get a permit so he and his wife can pick up their son at the airport. Each permit requires repeated visits to a number of offices, and he's been permit hunting every day except Saturdays, when the offices are closed. If he's lucky, he'll still have to pay about 200 shekels ($100) for each license; if not, as everyone around us predicts will be the case for the permit to go to the airport, his request will be denied without explanation.

May 9: A strike day, as the ninth of the month always is. There appear to be more private cars on the roads than there were last summer and they're not moving as quickly. Apparently people, at least in this area, feel less threatened about "cheating" on UNLU strike days than they do when the strike is called by the fundamentalists. And the driving seems to be another sign of weariness at some of the intifada's strictures and the lack of any signs of peace.

May 10: Back to Jerusalem to talk with Zahira Kamal. The checkpoints are stiffer than usual because it's Friday and the IDF is trying to prevent young men from going into Jerusalem to pray at al-Aqsa and then possibly demonstrate. All the passengers in the *service* are women, perhaps because the men know they're likely to be stopped today, and we're waved through without being checked. The buildings that have been commandeered by soldiers along the road all have Israeli flags flying above them or draped from the roof. As the number of troops on the ground decrease, the number of flags seems to increase.

I've told Zahira that I'll never be able to find her office in the Shuafat neighborhood so she meets me at the Women's Resource Center. Someone suggests lunch. Everyone goes into the kitchen to make sandwiches of pita, finely diced cucumbers and tomatoes, and thick yogurt, liberally sprinkled with zatar, and then Zahira and I take our sandwiches and cups of tea out to the little balcony overlooking Jerusalem.

It's my impression that the split in the PFWAC, however traumatic, has had two important positive results, both of which Zahira alludes to in describing her committee's new projects. She says the conflict has made her and other PFWAC leaders stop and reevaluate their activities. They used to demonstrate their solidarity with families whose homes had been demolished by visiting them and sitting with them on the rubble, for example; now they're organizing a study about the effect on women of such demolitions as well as of administrative detention and deportation of male relatives. The committee plans to join with the Family Planning and Protection of the Family organization in a project about women and work. There will be two study days in Gaza, hammering out ideas for a conference to be held in 1992. In addition, a kind of think tank has been established in Nablus. Its first goal will be to identify and study women's concerns that have been inadequately addressed. One involves single women aged thirty-five to forty who haven't married because of the poor male-female ratio resulting from the large numbers of men working outside the country, incarcerated in jail, and so on. What problems do these women face? How can the movement help them?

Zahira's PFWAC controls the baby food project in Gaza. It has moved the West Bank sewing project to an unidentified location because, she says, men from the Hawatmeh faction have physically ousted teachers hired by her from some of the kindergartens and have removed all the furniture and equipment from others. The sewing project and a new embroidery project will concentrate on items like shawls that can be used rather than hung on the walls. The committee's Hebron solar heat project will turn out the traditional rocklike dried Bedouin yogurt as well as raisins and maftool (a mixture of wheat and semolina, similar to couscous); a project in Gaza's Jabalya camp, coordinated with a Swedish organization, has trained thirteen women to work with thirty-two retarded children and is sending workers into the children's homes to train their mothers; and a second Gaza project is teaching retarded men and women aged fifteen to thirty marketable skills such as carpentry. The long-planned bakery is being set up in Ramallah, as Nada T'weil's faction of the PFWAC group has taken over the premises in a-Ram. A number of women who used to work in a Jerusalem bakery but are no longer permitted to go into Israel because they've been in prison for political activities will be employed by it and will train others as well.

Up to now, the committees have been working hard to increase their production projects and child care centers. But there hasn't been any real sounding of the grassroots that I can discern since the original WWC's door-to-door survey in 1978, nor has there been any systematic examination of women's problems or of the way to make an originally Western women's agenda directly relevant to Palestinian women. The pause for reevaluation generated by the PFWAC split apparently has shown women leaders that they need a lot more information and has focused their attention on various small-scale surveys and projects. It's this kind of thinking and information gathering that was lost in the excited rush of the early intifada. It not only has to be done now if the movement is to succeed; it has to become a process that is permanently built into the movement.

The second positive effect of the split is the downgrading of factional ties. Zahira doesn't mention it but many women leaders say that they were shocked into the realization that party ties had

nothing to do with them as women and were weakening the committees. I'll learn from UPWWC leaders that women who were allied with the Communist party but were not active as women with the committee are no longer granted membership unless they are willing to work on women's projects. Zahira's faction of the PFWAC and the UPWWC are planning a counseling center for women in Nablus, initially open one day a week and drawing on the skills of social workers and lawyers. If it works well, other committees will be asked to join. The two groups also intend to open a center in Ramallah, doing first social and then psychological counseling, with training courses already in progress for the women who will staff it. The Nablus think tank is the first project of the new Democratic Women's Coalition. While *Democratic* in the name suggests DFLP, Zahira emphasizes that everyone is welcome, with the understanding that women from other committees will go on working with their committees while they're participating in the coalition and that the coalition will be equally open to independent women. An independent woman will tell me that some local groups affiliated with the two factions of the PFWAC are cooperating. The ability of what were firmly party-based entities to free themselves and coalesce without regard to party lines is, in this highly politicized society, astonishing. The only broad-based organization I'm aware of that's done anything like it up to now is the Union of Palestinian Medical Relief Committees, which had decided at the outset not to be partisan and therefore had no divisive background to overcome.

The work and turmoil have taken their toll. Zahira, who found that all the problems she faced were making her impatient in the classroom, has given up her teaching job with UNRWA, after twenty-two years. She hopes to go back after a couple of years.

I return to Ramallah and, bumping into two al-Haq staffers on their way to get ice cream at the Ramallah ice cream factory, add my money to what they've already collected. I sit in the library trying not to drip vanilla and chocolate onto today's *Jerusalem Post*, which has a story about land the government is confiscating from a farmer in Deir Dibwan. It's particularly fertile land, now covered with his crop of onions and lentils, and he's been told by a military officer

based in Ramallah that it's so fertile because it's secluded and its seclusion makes it perfect for use as a garbage dump. It's being confiscated as a matter of "state necessity": the necessity to get rid of garbage. How strange to be sitting in an office full of lawyers, knowing there's nothing they can do about this.

May 11: I visit Maha Mustaqlem, whose five-month-old daughter gurgles and smiles from her mother's lap as we talk. Maha tells me that during the Gulf war the army refused to give gas masks to anyone with the green IDs that indicate they've been in prison, and her husband was denied one. The masks others got were stamped with the date they were made, 1968, and a warning that they were not to be used after seventeen years. The government demanded their return after the war but added that a fine of 50 shekels ($25) would be assessed for any kit that had been opened. Since the first thing one does is open the kit to try on the mask, people simply didn't turn them in. Talking about people who had cheered the SCUDs from their rooftops, Maha says she knows it's not nice to rejoice in other people's misfortunes, but after more than twenty years of being forced to live under Israeli occupation, she can understand the Palestinians who applauded Israeli vulnerability. She was living without a telephone during the war because hers had stopped working right after she agreed to a telephone interview with a German radio station.

Her committee's co-op school stopped functioning during the war and is still closed. The kitchen in Ramallah is almost complete, however, and will produce frozen cakes as well as ready-made meals. The committee is working on eight new cooperatives, including one in a nearby refugee camp and another that will make simple, inexpensive clothing. The committee leadership is trying to meet every two weeks, but the increased number of curfews and temporary designation of places as closed military zones make travel difficult, and there are always absentees.

After lunch with Maha and her family, it's back to the *service* for Jerusalem. As we approach the first checkpoint near a-Ram, people in the car check their IDs. A soldier asks if we all have Jerusalem IDs and when the people answer that they do, he waves the car through without checking. I'm rather surprised until I discover that he wasn't

really being generous. There's another checkpoint just down the road and there we're told that the car has to go back to Ramallah. Jerusalem is a closed military zone today and tomorrow because of Jerusalem Day, the Israeli celebration of the city's 1967 "reunification." This really is throwing it in the Palestinians' faces. Not only does Israel deny their claim to East Jerusalem; it also denies them the right to get to it for work or prayer. The driver complains bitterly, but waving his permit proves futile and he makes a U-turn. Passengers can walk a few yards across the invisible border and wait for a bus or *service* with Jerusalem license plates. Checkpoints on this road have two lines: one for cars with yellow Israeli license plates, which the settlers in the territories also have; the other for Palestinians. Two young men in the *service* ask a soldier if they'll be able to get to Jerusalem. They have permits but they don't have Jerusalem IDs. He says they can try but he doubts they'll be permitted in, which is a euphemistic way of saying that when the bus arrives at the station in central Jerusalem they'll be turned back at best and possibly arrested. Assuming they avoid arrest, they will have paid 2 shekels for the *service*, 1 shekel for the bus, and a fourth shekel for the bus back (or two more for a returning *service*), which makes a total of two to two and a half dollars on a day they won't be able to work for their regular daily wage of ten to fifteen dollars. They decide to try it anyway. I get off the bus before it reaches the center of the city, so I don't know what happens to them.

Administrators of schools and colleges in Jerusalem recently appealed to the Israeli authorities to permit students from Ramallah into the city. Ibrahimiya College and the Abu Dis College of Science and Technology are almost paralyzed because a majority of their students can't get past checkpoints to the campuses. No decision has been made.

May 12: I have an appointment with some of the new leaders of the PFWAC in Beit Hanina, which is now considered part of Jerusalem, so I set out early for what I know will be the time-consuming routine of taking the *service* to the checkpoint, waiting in line for the car to be turned around, and walking to the bus. Two buses come along and I get on the first. As we head down the highway I think I hear shooting from behind us, but the bus is noisy, I can't see out

the back window, and I think I must be mistaken. Tomorrow I'll discover I wasn't. Men from the nearby settlement of Shiloh apparently fired at the next bus, wounding a four-year-old and a five-year-old. Three settlers were arrested.

At Beit Hanina I talk with some of the leaders, including Haifa Asad and Zahira Abed, of the new PFWAC group. Later I'll interview Nada T'weil, its head. Their attitude toward women is not markedly different from that of Zahira and the other women they've ousted. Women have done much in the streets, they say, demonstrating their strength outside the home, and now they must demonstrate it inside as well. Men now are forced by economic necessity to permit women to work but have not changed their basic attitude toward women's place. The women's movement therefore must continue after independence. The women leaders mention the Algerian model.

While Nada and the women around her are concerned about getting women out of the house and into jobs, they tend to denigrate the rest of the feminist agenda. It appears to me that the split was generated by a division between leadership and grassroots, both in process and in substance. Zahira Kamal's group is less radical politically and more radical in its feminism. But the two groups are not greatly different in their ultimate goal of gender equality, and it seems to be the kind of chasm that might have been bridged had party politics not intervened.

May 14: I visit the Bisan Center for Research and Development in Ramallah to speak with its director, Izzat Abdul Hadi, and Eileen Kuttab, the Birzeit sociologist who is coordinator of Bisan's Women's Studies Committee.

Bisan was established to study issues of development and to develop strategies for popular development. Development must be democratic, Izzat emphasizes, as "democracy is not a choice for us; it is a necessity." Without real participation by the grassroots and by people who prefer not to be involved in party politics, a Palestinian state will not come into existence. The center is seeking to put together elected higher councils of groups such as doctors and economists, all to be chosen in a nonpartisan manner. Members of its three committees—on development issues, women, and oral

history—are chosen without regard to political background. The oral history project is designed to rectify the fact that existing Palestinian history is written by the elite about the elite; the project will concentrate on Palestinians who are not from the few famous families.

No examination of development is complete without discussion of the status of women, Izzat tells me. One phenomenon the researchers have already noted is that working women are asking for "unofficial" raises because the men at home insist on their turning over their official wages. Eileen and two colleagues are completing a questionnaire that will survey six hundred women from all sectors of the population in an attempt to define their problems, categorize pressing issues, and create priorities for action. Bisan is also opening a consulting center for women in the Jalazon camp, offering the services of a psychologist, a social worker, a lawyer, and a gynecologist. Stories of the women who use the Jalazon facility will be considered as another source of information, and its success as a resource for women and a place to accumulate data will be evaluated after six months.

The development committee has completed a study of popular cooperatives and wants to provide systematic training so that the co-ops will succeed economically and provide training in the process of collectivity, teaching democracy, and the work ethic. We talk about the perception that the co-ops are female entities. The reason, Izzat believes, is that most co-ops produce food by hand— "women's work." If they become high tech, he expects men to get involved.

Eileen discusses the changes that have and have not been wrought by the intifada. She thinks it legitimized the word *feminism* and turned many professional women like herself into feminists because it was the first time they realized that other women didn't have access to equal opportunity. When I speak to Islah Jad in a few days, she will add that the intifada enabled women to recognize the different pressures entailed in playing multiple roles. Both Eileen and Islah therefore view the intifada as a crucial element in the women's movement, but one that was inadequately exploited. Eileen thinks its first year virtually pushed women into liberation,

while Rita Giacaman has begun to wonder whether scholars like themselves are urging change too rapidly on women who may be hurt by it in the absence of a support system.

May 17: I chat with my friend the grocery store owner, whom I notice as I walk by his shop. He tells me that he's gotten the job he was seeking last summer and his customers are now waited on by an elderly male relative. Most of the shelves in the store are bare, but I notice that he has replenished his stock of Palestinian wines, in spite of his fear of the fundamentalists. He says the Israelis are making money from the intifada. The paint used to spray slogans on the walls comes from Israel, the cleaning product used to wipe the slogans off comes from Israel, and the owners of the walls are fined as well.

May 18: I travel to the Women's Research Center in Nablus with Rita Giacaman and two other Birzeit women working with her on a study of women's health in Nablus's Old City. As we drive along, Rita describes some of the survival tactics she's already encountered in the Old City. Soldiers there break windows and throw teargas canisters into the houses, so the residents have learned to put bedsprings up against their windows to make the canisters boomerang. Rita is an M.D. as well as a professor of public health and her windshield carries a red cross and a red crescent. In the midst of our laughter, a *service* coming the other way honks madly and then pulls over to the side of the road. Rita quickly stops, backs up the car, and runs across the road, thinking someone may be ill. But the *service* driver simply wants to warn her that there's a long, slow checkpoint ahead and tells her how to take back roads to circumnavigate it. Eventually we're stopped at another checkpoint, but it's off the main road so the line is short and the soldiers wave us through.

Waiting for us in the apartment used as an office by the research center are ten of the thirty-three women doing research. All have completed high school; some have gone to junior college and a few have attended university. They've each selected topics for research, with the center's goals being to learn about women, teach the researchers (all trained by the center in conducting surveys and using computers) marketable skills, and raise their consciousness.

Among the topics the women have chosen are early marriage, women prisoners, and domestic workers. They meet periodically as a seminar to present their work in progress. When each part of the work is completed, the group, augmented by volunteer academics, decides whether it's good enough to be published in the center's scholarly magazine, the first seventy-page issue of which has just come out. Rita generously turns half an hour of their seminar time over for my interviews of the women, and it is precious time: Nablus is so frequently under curfew that the women never know, leaving their homes elsewhere, whether they'll make it to class or not. They become so caught up in discussing their projects and the importance of the center to them that we talk for an hour and a half, after which they ask me for a half hour's impromptu lecture about the American women's movement.

They agree that the women's committees spend too much time on politics and too little on the needs of women, which is one reason they're here. They say that the center gives them the opportunity to talk with each other, to develop their consciousness, and to hone their skills, mentioning, for example, that they have realized that they've chosen insufficient or unrepresentative samples. They view their work as helping to give their society a picture of itself. They can't change it overnight, they say, but unlike the women's committees, they're giving those who are interested the information they need before they can address women's problems. They talk about how difficult it is to effect change in the absence of a representative government and adequate funding. They become animated when one woman suggests that the committees are ineffective because men have all the real power and are the ones who know how to solve problems. Others argue that this is the fault of women. I ask what they'd do if they were setting up their own research centers. One replies that she'd employ men to do the research so they could see and understand women's problems. Another promptly objects: that would be turning the problems over to men to solve, and anyway, all they have to do to see what women suffer is look at their own families. They object to men who don't choose to see, but, clearly, not to all men, for the job of selecting the center's administrator was given to them, and the person they

chose is a twenty-five-year-old man who participates animatedly in our discussion.

Rita comments as we drive home that the women at the center are so used to thinking of men as problem solvers that they still don't see what they're doing as linked to problem solving. She muses about what it is that makes people different, using herself as a model and describing her family as outsiders. It's outsiders, she decides, who rebel. I comment that perhaps women need to realize that in a man's world, we're all outsiders.

May 19: There's a spontaneous commercial strike because four more Gazans were deported yesterday, the day after Secretary of State Baker left Jerusalem.

May 20: To Amal Khreisheh's house for dinner. Her husband, whom she met doing union work, does a lot of the household chores and is frequently teased by the people in the neighborhood, who ask him things like "What's the price of Pampers today?" She shows me her eleven-year-old's homework. He was supposed to draw a picture of a child helping out at home and began a sketch of a boy with a vacuum cleaner. He interrupted himself, however, to become much more intent on drawing a Palestinian flag on the other side of the paper.

May 21: I receive a telephone call from Ruchama Marton, the Israeli doctor who heads the Association of Israeli-Palestinian Physicians for Human Rights. She tells me she's about to take half a ton of rice and powdered milk to the village of Qifeen. About 95 percent (2,500) of the village's work force was employed in Israel before the war. Now only 150 are permitted in. All the village's land has been confiscated, so the people can't grow their own produce. As a result, the residents have been eating nothing but flour, olive oil, and eggs (they keep chickens). Ruchama says some of the kids have skin ulcers from the diet; infants, given unpasteurized milk when none other was available, have serious cases of diarrhea; many of the villagers' faces have turned yellow. Since there's no money for the village council, the council can afford only enough fuel to pump water from the well at the edge of the village for a few hours twice a week. On other days, residents have to drink water that has been standing in open buckets. Open sewers run along the

dirt roads. Ruchama works around the clock and is in despair at the near-starvation.

May 22: It's unusually cold today, so I put on the one long-sleeved dress I've brought, which is navy. I add my only scarf for color, not realizing until later that, along with my red belt, its red-white-blue-black design makes me look like a walking American flag. That's the way I arrive at one of the buildings that's been used by Birzeit University for its classes since the authorities shut down its campus in January 1988.

I've been here before and have seen how crowded and noisy the inadequate space is. Somehow, I didn't expect classes to be that way. The room in which I'm to lecture about the similarities and differences of the American and Palestinian women's movements is the only free one that could be found. It's tiny, right off the building's porch, and the noise made by the students coming and going and just milling around is loud—not at all an optimum learning environment. About twenty students and faculty crowd in, dragging chairs from another room. The chairs, in short supply, are always being moved. Half the audience is male, something I tell them wouldn't be the case in the United States, given the topic. The overcrowding means that no one can take more than two courses a semester, even though far from the normal number of students are enrolled, and everyone is simply thirsty for knowledge. Their campus library is locked up, so they all take turns with the few books available, while books and laboratory equipment deteriorate, unused and uncared for, on the campus that's forbidden to them. They giggle when I draw a parallel between the false femininity that has manifested itself in the United States, largely in books detailing twenty-seven or so ways to keep one's man, and the similar phenomenon in the West Bank where, I've learned, local merchants stock the sexy black or red underwear that fundamentalist women have begun to demand. I've also noticed fundamentalist women this month wearing cosmetics and bright lipstick. Izzat Abdul Hadi had mentioned, when we were speaking at Bisan, the white headbands some fundamentalist women here are wearing around their *ahjiba* to make them more attractive and the similar phenomenon of

tighter, brightly colored robes he's seen on fundamentalist women in Egypt. I've noticed women students at Birzeit in *ahjiba*; none has come to this lecture. The group is thoughtful and lively, asking intelligent questions and interpreting for each other and for me when English becomes a problem. I'll be in Ramallah for a few more days but this is my last formal activity, and it's a good way to end.

Conclusion: And When the March Is Over?

"Our journey is still a long one."

"Heroes on the street, servants in the home."

The questions of how the women's committees and the intifada have changed women's status and whether such changes will last beyond independence remain. The West Bank is a society in transition, with the multiplicity of attitudes that such a state implies. A few men can discuss and speculate about the altered roles engendered by the intifada. Most, however, think of the new roles as temporary, assuming that unmarried women will give them up when they're married and that they'll be unnecessary once the occupation is over. Men accept women's new activities on the condition that women will continue to fulfill all their traditional home responsibilities. Some men still demand that their daughters marry young or that their wives leave their homes only for those intifada activities the men consider appropriate.

The conversation I had with Baheeja, my guide to Qarawat Bani Zeid, was typical. She is in her early twenties and was studying for a B.A. in economics at Birzeit before the universities were closed. She expects to work in a bank or research institution after she receives her degree. When I mentioned the two-job trap, she commented that Palestinian women really have three jobs: their paying job,

political work, and their tasks at home. As an unmarried woman she
lives with her parents. She had asked her father why he doesn't
assume some of the household responsibilities when her mother is
so busy with political work. He replied that he will help if he
chooses but that housework is the woman's responsibility. More
depressing to Baheeja is her mother's belief that household chores
are not his job. The majority of Palestinian men would agree with
her father and mother, and it appears that the efforts of most
independently minded young women are focused on the revolu-
tionary and liberating act of leaving home—even if it entails taking
on additional responsibilities rather than trading the old ones for
others. Put differently, there is no indication that most people,
male or female, see the alteration of gender roles as involving men
as well as women.

Nawal El-Saadawi has written, "Arab society still considers that
women have been created to play the role of mothers and wives,
whose function in life is to serve at home and bring up the children.
Women have only been permitted to seek jobs outside the home as
a response to economic necessities in society or within the family.
A woman is permitted to leave her home every day and go to an
office, a school, a hospital or a factory on condition that she returns
after her day of work to shoulder the responsibilities related to her
husband and children, which are considered more important than
anything else she may have done." A key question is to what extent
the hoped for Palestinian government will recognize women's new
roles. El-Saadawi comments that even in those Arab countries that
claim to follow socialist policies, no "real steps have been taken to
solve the problems of working women, and above all to provide
facilities that could reduce the burdens of cooking, cleaning, serv-
ing in the home, and bringing up the children. The provision of
appropriate institutions or facilities does not seem to be a matter
of importance to the rulers of these countries." Some of the
Palestinian women who now rely on their mothers or mothers-in-
law to perform household and child care functions argue that this
will change once their own state creates such institutions. The
future availability of child care, however, even if it is sufficient for all
the parents seeking it, will not end the need to tend the children

when they're home or when they're sick or to decide who does the kitchen and laundry chores.

Still, the phenomenon of women becoming active outside their homes constitutes a revolution that has occurred in a remarkably short time. Although some families are taking their daughters out of school early, the idea that women should receive a substantial amount of formal education has spread, its popularity ironically perhaps encouraged by anger at the government's long-term closing of schools and the belief that the closures are designed to render the Palestinians illiterate and ignorant. No less radical, if not as popular, is the idea that women who do not absolutely need to earn money may choose to do so without losing their respectability or femininity.

The change in the relationship between the women's committees and the community during the past year is notable. In July 1989 and January 1990, I could not help feeling that the committee leaders were living in a world of their own. What Islah Jad referred to as the "women's vanguard" had altered some of the activities and economic dependence of the women reached by the committees but not necessarily their ideas about appropriate gender roles. The women leaders who were talking feminism seemed better at communicating among themselves than with the mass of women—and they were not even attempting to reach the men. They emphasized, as signs of progress, what appeared to an outsider to be no more than tokenism in the political sphere and, in the economic arena, efforts that were of greater symbolic than monetary import. Although they could and did point with legitimate pride to their production projects and to women such as Leila Shahid, Zahira Kamal, and Hanan Ashrawi, they spoke in a defensive tone that suggested awareness that women had not really achieved meaningful economic or political power and uncertainty about what kinds of additional efforts they should make.

That had changed in subtle but important ways by May 1991. By then, three of the committees had begun to articulate the limits of their knowledge and to do something about them. This was reflected in their determination to learn more about domestic law before proposing reforms, their return to the information-gathering

process on the grassroots level, and their recognition that they had to go outside their own society to learn basic economic organizational skills that they could adapt to their own purposes. They had committed themselves to a women's agenda and had begun to communicate it to women outside the inner circle. While most West Bank women do not read the committees' newsletters, those who do are finding provocative ideas in them. The general societal emphasis on turning from demonstrations and symbolic acts to more intensive creation of a social and economic infrastructure has helped the committees' new ventures and will continue to do so, with the committees' participation in building infrastructure possibly enhancing their importance in the eyes of the community at large and the national leadership. Both the continued involvement of women in confrontations with the IDF and the work of such organizations as the medical relief committees are having an impact on the thinking of many women and, thereby, are creating a potentially larger popular base with which the "vanguard"— independent women as well as the committees—can work. It is notable that women in their twenties chose a man their age as administrator of the Nablus Women's Research Center. He and the male director of the Bisan center are thoroughly committed to women's rights. And Bisan has the potential for opening communication between the women and male opinion makers.

The new willingness of the women's committees to ignore party preferences is important. Equally so is the creation of organizations such as the Nablus research center and the Bisan center, for they not only transcend partisan lines, giving independent women an organizational base, but also address the crucial need for information about the problems and values of non-elite women and those outside the Ramallah-Jerusalem-Bethlehem axis. A necessary core of aware women and organizations now exists.

All this means, however, is that there are new phenomena to consider in assessing the possible future status of women. It does not mean that the nature of that status is clear; indeed, it is still in the process of being determined. While it seems safe to predict that the status of women will never again be precisely what it was before the intifada, the impact of women's role in the intifada on their

status cannot be assessed with any finality until the occupation and the intifada have ended. Clearly, the groundwork for gender equality has to be laid now. What kind of edifice will follow remains to be seen.

Many factors will influence the outcome. How long will the occupation last? The longer the occupation lasts, the more time and energy will be spent by everyone, including feminists, on reacting to events and on desperately attempting to eke out a living. What will be the role and influence of the fundamentalists in writing laws and in directing the politics of the state? As the intifada continues, the new roles of women will become more entrenched, but the power of the fundamentalists may also increase. What kind of economy will evolve in the state, and how central will be the provision of the kinds of functions with which the committees are experimenting? If the committees' production projects remain peripheral to the economy, their power will be minimized. To what extent will women participate in the creation of the laws and policies of the new state? A partial answer perhaps can be found in women's efforts to write new educational guidelines and draft legislation concerning marriage and divorce. While laws are not self-implementing, the inclusion of the women's agenda in the new state's constitution and statutes would be an important weapon in the struggle. Which diaspora Palestinians will move to the new state, and what skills and attitudes will they bring with them? Palestinians outside the territories, particularly those in Eastern and Western Europe and the United States, have been exposed to, and in some cases have become, highly educated and skilled women involved in the public as well as the private sector.

The intifada has been referred to as the revolution of the young. It is easier to make revolutions than to create political systems, but the importance of the *shabab* and of young women in intifada activities promises a cadre of new leaders somewhat unfettered by traditional values. Although the Unified National Leadership appears to include few if any women, the leadership of the political parties and trade union movements have an increasing number of women. There appears to be less resistance to a grassroots public role for women among the people of the West Bank than there is

within the PLO leadership outside the territories. The women who have been "talking politics" are unlikely to be satisfied with a purely private persona. Their interest and experience may well be translated into support for women in a national legislature.

One phenomenon is more central to the success or failure of the women's movement than any other. It is the occupation. While it lasts, women will not be equal except in the extent of their oppression by an outsider, for, like the Palestinian economy, the women's movement cannot succeed until independence is achieved. Only then will it have the time, the energy, the freedom, the unimpeded flow of ideas, and the financial resources to develop additional basic institutions. Until the occupation is ended, the march of the women must be one of protest rather than celebration.

Glossary

ACRI: Association for Civil Rights in Israel, an organization similar to but smaller than the ACLU.

ahjiba: See *hijab.*

bayan **(plural** *bayanat*): leaflet issued by the Unified National Leadership inside the occupied territories.

B'Tselem: the Israel Information Center for Human Rights in the Occupied Territories, an Israeli data-gathering group.

DFLP: Democratic Front for the Liberation of Palestine, one of the four Palestinian political parties.

Fateh: one of the four Palestinian political parties, started by Yasir Arafat.

Giacaman, Rita: professor of health at Birzeit University, a leader of the women's movement and scholar of it.

Hamas: Harakat al-Muqawama al-Islamiyya, the Islamic fundamentalist resistance movement. Its name means "zeal" or "enthusiasm."

hijab **(plural** *ahjiba*): head covering worn by traditional and religious Palestinian Moslem women.

IDF: Israel Defense Force, the Israeli armed forces.

kuffiyeh: checkered head covering worn by Palestinian men.

mahr **(plural** *muhur*): bride price.

Nashashibi, Rana: one of the leaders of the UPWWC; sometimes included in delegations of Palestinians meeting with foreign dignitaries.

PFLP: Popular Front for the Liberation of Palestine, one of the four Palestinian political parties.

PFWAC: Palestinian Federation of Women's Action Committees, successor to the first women's committee and originally headed by Zahira Kamal. As of late 1990, the name has been used by two factions of the original committee.

PLO: Palestine Liberation Organization, umbrella organization of Palestinian parties.

PNC: Palestine National Council, the legislative arm of the PLO.

Rishmawi, Mona: former executive director of al-Haq, currently an official of the International Commission of Jurists.

shabab: literally, "young men" or "the guys," young male activists in the intifada.

shari'a: the Moslem code of law and religious courts.

Shin Bet: General Security Service, undercover Israeli domestic police and intelligence force, responsible directly to the prime minister.

Siniora, Randa: staff person at al-Haq; former head of its women's project.

UNLU: Unified National Leadership of the Uprising, a secret group composed of representatives of the four Palestinian political parties that sets strike days and other intifada activities and communicates with the population through leaflets.

UNRWA: United Nations Relief and Works Administration, UN organization charged with aiding Palestinian refugees since 1950.

UPMRC: Union of Palestinian Medical Relief Committees, a nonpartisan organization of volunteer health care professionals that provides primary health care and health education in clinics throughout the occupied territories.

UPWC: Union of Palestinian Women's Committees in the West Bank and Gaza, one of the women's committees.

UPWWC: Union of Palestinian Working Women's Committees, one of the women's committees.

UWCSW: Union of Women's Committees for Social Work, one of the women's committees.

WOFPP: Women for Women Political Prisoners, a group of Israeli women who help Palestinian political prisoners. Founded in Tel Aviv, the organization has branches in Jerusalem and Haifa.

WWC: Working Women's Committee, the first women's committee, created in 1978.

Notes

Introduction

1 "The women of Palestine": Zahira Kamal, interview with author.

2 Both have been altered: Central Palestine was annexed by the British-installed Hashemite family in 1948. The arrangement became part of the armistice agreement signed by Israel and Trans-Jordan in April 1949. See Pamela Ann Smith, *Palestine and the Palestinians, 1876–1983* (London: Croom Helm, 1984), pp. 87–88.

5 Statistics about refugee population in camps: Odil Yahya, "The Role of the Refugee Camps," in Jamal R. Nassar and Roger Heacock, *Intifada: Palestine at the Crossroads* (Ramallah and New York: Birzeit University and Praeger Press, 1991), pp. 91–92, citing UNRWA *Quarterly Report, October 1–December 31, 1988* (Vienna: United Nations Relief and Works Administration, 1988).

5 Statistics about refugee population in villages and cities: Husein Jameel Bargouti, "Jeep versus Bare Feet: The Villages in the Intifada," in Nassar and Heacock, *Intifada*, p. 108.

14 "participant observation": Elizabeth Warnock Fernea and Robert A. Fernea, *The Arab World: Personal Encounters* (Garden City, N.Y.: Anchor Books, 1987), p. 313. Pari Baumman discusses the irrelevance of the scientific objectivity paradigm and the interviewer's need to gain the trust of women by demonstrating her interest and concern. See "Some Notes on Doing Development Research on Palestinian Women," in Pari Baumman and Rema Hammami, *Annotated Bibliography on Palestinian Women* (Jerusalem: Arab Thought Forum, 1989), pp. 11–12.

17 Iron Fist policy: See Geoffrey Aronson, *Creating Facts: Israel, Palestinians, and the West Bank* (Washington, D.C.: Institute for Policy Studies, 1987), pp. 225–26; Naseer H. Aruri, "Dialectics of Dispossession," in Naseer H. Aruri, *Occupation: Israel over Palestine*, 2nd ed. (Belmont, Mass.: Association of Arab-American University Graduates, 1989), pp. 26–36.

17–18 The intifada: See Zachary Lockman and Joel Beinen, *Intifada* (Boston: South End Press/Middle East Research and Information Project, 1989), particularly Penny Johnson and Lee O'Brien with Joost Hiltermann, "The West Bank Rises Up," and Anita Vitullo, "Uprising in Gaza"; *Middle East Report* 164/165 (May–June/July–August 1990); Nassar and Heacock, *Intifada*; Ze'ev Schiff and Ehud Ya'ari, *Intifada: The Palestinian Uprising, Israel's*

Third Front (New York: Simon and Schuster, 1989); Rita Gia-
caman, "Political Women in the Uprising: From Followers to
Leaders?" (Unpublished paper, September 1988), pp. 1–2; Gail
Pressburg, "The Uprising: Causes and Consequences," *Journal of
Palestine Studies* 17 (1988), and "An Interview with Gail
Pressburg," *Newsletter* (American-Israeli Civil Liberties Coali-
tion), March 1988, pp. 5–6; Jerusalem Media and Communica-
tion Centre, *The Intifada: An Overview* (Jerusalem, December
1989).

18 spontaneous commercial protest strikes erupted: Salim
 Tamari, "Revolt of the Petite Bourgeoisie: Urban Merchants
 and the Palestinian Uprising," in Michael C. Hudson, ed., *The
 Palestinians: New Directions* (Washington: Georgetown University
 Center for Contemporary Arab Studies, 1990).

19 "beatings, might, force": Amnesty International, *Excessive Force:
 Beatings to Maintain Law and Order* (London, 1988).

20 At the end of March 1991: Palestine Human Rights Information
 Center, *Human Rights Update: May 1991* (Jerusalem and Chicago,
 1991).

20 The figures issued by B'Tselem: *New Outlook Newservice* (Tel Aviv:
 New Outlook, June 3, 1991), p. 5.

20 The IDF's judge-advocate general stated: Bradley Burston,
 "75,000 Arrested, 45,000 Put on Trial since Beginning of Inti-
 fada, IDF Says," *Jerusalem Post*, February 22, 1991, p. 18. *Al-Fajr*,
 the East Jerusalem English-language weekly, counted 955 dead
 as of May 20, 1991. "Intifada Update," May 20, 1991, p. 1.

20–21 administrative detention: Amnesty International, *Israel and the
 Occupied Territories: Administrative Detention during the Palestinian
 Intifada* (London, June 1989); Amnesty International, *Israel and
 the Occupied Territories* (New York, 1989); Allegra A. Pacheco,
 "Occupying an Uprising: The Geneva Law and Israeli Adminis-
 trative Detention Policy," *Columbia Human Rights Law Review* 21
 (Spring 1990), pp. 515–63; Mona Rishmawi, "Administrative
 Detention in International Law: The Case of the Israeli Occu-
 pied West Bank and Gaza," *Palestine Yearbook of International Law* 5,
 no. 83–128 (1990).

20 sentence of up to twelve months: In December 1991, the initial
 maximum sentence was reduced to six months, apparently
 because of pressure from the Israeli Supreme Court. Jon Im-
 manuel, "Administrative Detention Reduced," *Jerusalem Post*,
 December 27, 1991, p. 2.

20 This is a violation of the Fourth Geneva Convention: Article 42
 states, "The internment or placing in assigned residence of

protected persons may be ordered only if the security of the Detaining Power makes it absolutely necessary." Article 49 states, "Individual or mass forcible transfers, as well as deportations of protected persons from occupied territory to the territory of the Occupying Power . . . are prohibited, regardless of their motive." The only exception is evacuation of an area for safety or military reasons. International Committee of the Red Cross, *The Geneva Conventions of August 12, 1949* (Geneva, 1986), pp. 169, 172. The British Defense Emergency Regulations of 1945, which permitted administrative detention, were promulgated over the fierce objections of the Jewish inhabitants of what was then Palestine but were incorporated into Israeli law. They were reaffirmed in 1979 (Emergency Powers [Detention] Law, March 1979) and specifically extended to the occupied territories by military orders 815 and 876 (for the West Bank) and 628 and 667 (for the Gaza Strip). See Martha Roadstrum Moffett, *Perpetual Emergency: A Legal Analysis of Israel's Use of the British Defence (Emergency) Regulations, 1945, in the Occupied Territories* (Ramallah: al-Haq, 1989). Military orders 119 (West Bank) and 941 (Gaza)—Order concerning Administrative Detainees (Interim Provisions)—permitted officers of the rank of colonel and above to issue six-month detention orders. The orders also suspended prompt, automatic review of such orders as well as the right of detainees to appeal to a military court. Instead, detainees could appeal to an Advisory Appeals Committee, which could make recommendations to the military commander of the area. Criticism within Israel led to these orders being replaced on June 13, 1988, with military order 1236, which abolished the committee and replaced it with a single military judge able to make binding decisions.

20 Conditions at the prison: Ketziot, or Ansar 3, opened in March 1988. In 1989, the "civil administration" announced regulations, denying the International Red Cross its usual right to arrange visits. Family members could visit only if they were not considered security risks and they owed no taxes. They would have to pay $70, and the administration could keep out anyone it chose. The regulations were condemned by Israeli, Palestinian, and other human rights groups, and no visits took place. On October 28, 1991, new rules went into effect. A detainee could give the jail administration a list of family members, which would be censored by the "civil administration;" the Red Cross would then arrange visits; only one family member acceptable to the administration could visit at a time. It takes

several hours to reach Ansar 3, located in the Negev. Gaza Center for Rights and Law, press release, "Family Visits to Ansar III Begin Under Miserable Conditions After Three and a Half Years," October 28, 1991.

20–21 The Israeli High Court has upheld: HC 698/80, Qawasme v. Minister of Defence, 36 P.D. (1) 666; HC 513/85, Nazzal et al. v. the IDF Commander; HC 514/84, Jayousi v. the IDF Commander; Rabbi Kahane et al. v. Minister of Defence, 33 P.D. (1) 257; HC 785/87, Afu et al. v. the IDF Commander in the West Bank. Also see, on deportations, HC 814/88, Nasrallah and Hamdallah v. IDF Commander in the West Bank, June 21, 1989; HC 765/88, Shakhshir v. the IDF Commander in the West Bank, June 28, 1989; and HC 792/88, Mtour, Ma'ali, 'Arouri and al-Labadi v. the IDF Commander in the West Bank, August 24, 1989.

21 Other techniques used by Israel: Middle East Watch, The Israeli Army and the Intifada: Policies That Contribute to the Killings (New York: Human Rights Watch, 1990); al-Haq, Punishing a Nation: Human Rights Violations during the Palestinian Uprising, December 1987–December 1988 (Ramallah, 1989), also available in an edition published by South End Press (Boston) in 1990; al-Haq, A Nation under Siege: Annual Report on Human Rights in the Occupied Palestinian Territories (Ramallah, 1990); Joost R. Hiltermann, Israel's Deportation Policy in the Occupied West Bank and Gaza, 2nd ed. (Ramallah: al-Haq, 1988); Ronny Talmor, Demolition and Sealing of Houses as a Punitive Measure in the West Bank and the Gaza Strip during the Intifada (Jerusalem: B'Tselem, September 1989); B'Tselem, The Military Judicial System in the West Bank (November 1989); B'Tselem, Soldiers' Trials and Restrictions on Foreign Travel (November 1989); B'Tselem, Annual Report 1989 (December 1989); B'Tselem, Annual Report 1990: Human Rights Abuses in the Occupied Territories (1990); B'Tselem, Cases of Death and Injury of Children (January 1990); B'Tselem, The System of Taxation in the West Bank and the Gaza Strip as an Instrument for the Enforcement of Authority during the Uprising (February 1990); B'Tselem, The Use of Firearms by the Security Forces in the Occupied Territories (July 1990); B'Tselem, Limitations on Building of Residences on the West Bank (August 1990); B'Tselem, Collective Punishment in the West Bank and the Gaza Strip (November 1990); B'Tselem, House Demolition and Sealing as a Form of Punishment in the West Bank and Gaza Strip: Follow-up Report (November 1990); Stanley Cohen and Daphna Golan, The Interrogation of Palestinians during the Intifada: Ill-Treatment, "Moderate Physical Pressure," or Torture? (March 1991); Jordan J. Paust, Gerhard von Glahn, and Gunter Woratsch,

Inquiry into the Israeli Military Court System in the Occupied West Bank and Gaza (Geneva: International Commission of Jurists, 1989); West Bank Data Base Project, *The Price of Insurgency: Civil Rights in the Occupied Territories* (Jerusalem, 1988); Government of Israel, Landau Commission, *Report of the Commission of Inquiry of the General Security Service regarding Hostile Terrorist Activities* (Jerusalem: Government Printing Office, 1987) (on the use of torture by the Shin Bet during interrogations).

21 Figures for curfews, demolitions and sealings, and trees uprooted: Palestinian Human Rights Information Center, Human Rights Update (Jerusalem, April 1991). The figure for demolitions and sealings in B'Tselem's May 1991 press release was 662. The disparity exists in part because the Palestinian Human Rights Information Center includes "Houses and other Structures" in its count and also differentiates structures demolished and sealed "For Security Reasons" from "Indirect Demolitions" (buildings that collapse when others next to them are demolished), "Unlicensed/Demolished" (demolished by the IDF, purportedly because no license to build had been granted by Israeli officials), and "Demolished by Settlers." It should be noted that many of the tactics used by the Israelis during the intifada, including those described in the text, were introduced much earlier in the occupation. It is their intensity that has increased. See, for example, al-Haq, *Punishing a Nation*, pp. 3–7; al-Haq, *Briefing Papers on Twenty Years of Israeli Occupation of the West Bank and Gaza* (Ramallah, 1987); Raja Shehadeh, *Occupier's Law: Israel and the West Bank*, 2nd ed. (Washington, D.C.: Institute for Palestine Studies, 1988); Aruri, *Occupation*; Mona Rishmawi, *Planning in Whose Interest? Land Use Planning as a Strategy for Judaization* (Ramallah: al-Haq, 1986); Meron Benvenisti, *The West Bank Data Base Project: A Survey of Israel's Policies* (Washington, D.C.: American Enterprise Institute, 1984), and *The West Bank Data Base Project Report* (Boulder: Westview Press, 1986); Israeli Ministry of Defense, Coordinator of Government Operations in Judea and Samaria, Gaza District, Sinai, Golan Heights, *A Thirteen-Year Survey (1967–1980)* (Jerusalem: State of Israel, 1981); Geoffrey Aronson, *Creating Facts*; Amnesty International, *Report on the Treatment of Certain Prisoners under Interrogation in Israel* (Geneva, 1970), and *Reports* (Geneva, 1977–1980, 1982–1986); International Center for Peace in the Middle East, *Research on Human Rights in the Occupied Territories, 1979–1983: Interim Report* (Tel Aviv, 1983). An excellent and complete bibliography can be found in Diana Vincent-Daviss, "The Occupied Territories and

International Law: A Research Guide," *New York University Journal of International Law and Politics* 21 (1989), pp. 583–93, 601–20.

21	The intifada inevitably affected the movement: Jamal R. Nassar and Roger Heacock, "The Revolutionary Transformation of the Palestinians under Occupation," in Nassar and Heacock, *Intifada.* See, in the same volume, Joost R. Hiltermann, "Work and Action: The Role of the Working Class in the Uprising," and Tamari, "Revolt of the Petite Bourgeoisie."

Chapter 1

25	"My woman never left our home": Quoted by Nawal El-Saadawi, *The Hidden Face of Eve: Women in the Arab World* (Boston: Beacon Press, 1980), p. 146. Also see Magida Salman, "The Arab Woman: A Threatening Body, a Captive Being," in Khamsin Collective, *Women in the Middle East* (London: Zed Books, 1987), pp. 6–11; Amal Rassam, "Introduction: Arab Women: The Status of Research of Social Scientists and the Status of Women," in UNESCO, *Social Science Research: Women in the Arab World* (New York, 1984), pp. 2–4; Fatima Mernissi, *Beyond the Veil* (London: Al Saqui Books, 1985); El-Saadawi, *Hidden Face of Eve*, pp. 135–38, 143–45; Fatna A. Sabbah, *Women in the Muslim Unconscious* (New York: Pergamon, 1984), especially Chapter 5, "The Omnisexual Woman," and Chapter 6, "The Omnisexual Woman in Action: Subversion of the Social Order"; Analiese Moors, "Gender Hierarchy in a Palestinian Village: The Case of Al-Balad," in Kathy and Pandeli Glavanis, eds., *The Rural Middle East* (Ramallah and London: Birzeit University and Zed Books, 1990), p. 201.

26	their being confined to spaces controllable by the men: Salman, "Arab Woman," p. 7; El-Saadawi, *Hidden Face of Eve*, pp. 143, 145.

26	The genders did not normally mix: Salman, "Arab Woman," p. 8. Islamic law forbids mixed gender parties. B. Aisha Lemu, "Woman in Islam," in B. Aisha Lemu and Fatima Heeren, *Woman in Islam* (London: Islamic Council of Europe, 1978), p. 25.

26	men . . . did much of the purchasing: Ibrahim Wade Ata, *The West Bank Palestinian Family* (London: KPI, 1986), p. 43; Joseph Ginat, *Women in Muslim Rural Society* (New Brunswick, N.J.: Transaction Books, 1982), p. 15.

26	It was men who went into the paid work force . . . socializing outside the home: Ata, *West Bank Palestinian Family*, pp. 115–17.

26	The Arab and Moslem ideals of female seclusion: Moors, "Gender Hierarchy"; Sarah Graham-Brown, "The Political Economy

of the Jabul Nablus, 1920–1948," in Roger Owen, ed., *Studies in the Economic and Social History of Palestine in the Nineteenth and Twentieth Centuries* (London: Macmillan, 1982). Also see Hilma Granqvist, *Marriage Conditions in a Palestinian Village* (Helsingfors: Akademische Buchhandlung, 1935), who refers to peasant women being buried in face veils.

26–27 Rural women . . . frequently had to work: Joseph Ginat, *Women in Muslim Rural Society*, p. 19.

27 the adoption of a veil was a middle-class symbol: Margot Badran, Introduction, in Huda Shaarawi, *Harem Years* (New York: Feminist Press, 1987), p. 8. Badran claims that wearing a veil has to do with economic standing, not Islam. Women are enjoined by the Koran to dress modestly. That traditionally has been taken to mean fully covered with at least their heads (if not their faces) hidden. Lemu, "Woman in Islam," pp. 25–26.

27 Palestinian society is almost overwhelmingly family-oriented: Moors, "Gender Hierarchy," pp. 197–98, 200–201; Halim Baraket, "The Arab Family and the Challenge of Social Transformation," in Elizabeth Warnock Fernea, ed., *Women and the Family in the Middle East* (Austin: University of Texas, 1985); Ata, *West Bank Palestinian Family*, pp. 58, 60–61, 66, 119, 122.

27 "If the Koran is the soul of Islam": Baraket, "Arab Family," p. 28; Elizabeth Warnock Fernea, Introduction to Part 2, "The Family," in Fernea, *Women and the Family*, p. 25.

28 The Palestinian Women's Union was organized . . . the first Arab Women's Congress: Hamida Kazi, "Palestinian Women and the National Liberation Movement: A Social Perspective," in Khamsin Collective, *Women in the Middle East*, pp. 27–28; Ghada Talhami, "Women in the Movement: Their Long, Uncelebrated History," *al-Fajr Weekly*, May 30, 1986; Ghada Talhami, "Women of the Intifada," *Chicago Tribune*, December 15, 1989, p. 26; Noha S. Ismail, "The Palestinian Women's Struggle for Independence: A Historical Perspective" (Unpublished paper, October 17, 1989), p. 2; Rita Giacaman and Muna Odeh, "Palestinian Women's Movement in the Israeli-Occupied West Bank and Gaza Strip," in Nahid Toubia, ed., *Women of the Arab World* (London: Zed Books, 1988), pp. 57–58; Joost Hiltermann, *Before the Uprising: The Organization and Mobilization of Palestinian Workers and Women in the Israeli-Occupied West Bank and Gaza Strip* (Ph.D. dissertation, University of California at Santa Cruz, June 1988), p. 409; Islah Abdul Jawwad, "The Evolution of the Political Role of the Palestinian Women's Movement in the Uprising," in Michael C. Hudson, ed., *The Palestinians: New Directions* (Washing-

ton, D.C.: Georgetown University Center for Contemporary Arab Studies, 1990), p. 63; Islah Jad, "From Salons to the Popular Committees: Palestinian Women, 1919–1989," in Jamal R. Nassar and Roger Heacock, *Intifada: Palestine at the Crossroads* (Ramallah and New York: Birzeit University and Praeger Press, 1991), p. 127. Kazi refers to what appears to be the Palestinian Women's Union as the Arab Women's Society. Both Giacaman and Ismail refer to the Palestinian Women's Union; Islah Abdul Jawwad calls it the Arab Ladies Committees (Hudson, *The Palestinians*, p. 63); Talhami uses the title Arab Women's Union. (Islah Jad's name is given in various publications as Islah Abdul Jawad or Islah Abdul Jawwad. The form of her name used in the notes is as it appears in the publication being cited; because she prefers Islah Jad, she is referred to that way in the text.)

29 The Palestinian women's movement always has been inextricably intertwined: Rita Giacaman, "Palestinian Women and Development in the Occupied West Bank" (Unpublished monograph, Birzeit University, undated), p. 2; Talhami, "Women in the Movement"; Jad, "From Salons to the Popular Committees," p. 138.

29 The work of the Arab Women's Congress in the 1920s and 1930s: Islah Jad, interview with author; Julie Peteet, "Women and the Palestinian Movement: No Going Back?" *Middle East Report* 16, no. 138 (January–February 1986), p. 20.

29 Women's groups from the late 1920s: Giacaman, "Palestinian Women," pp. 2, 26 nn. 2–3; Jad, "From Salons to the Popular Committees," p. 126.

29–30 Women in rural areas played an important role: Kazi, "Palestinian Women," p. 28; Talhami, "Women in the Movement"; Stephen J. Sosebee, "The Palestinian Women's Movement," *American-Arab Affairs* 32 (Spring 1990), p. 83. Sosebee says that six women's organizations were founded during the 1936–39 revolt to train nurses and conduct literacy classes.

30 One woman recalled that she had hidden fighters: Peteet, "Women and the Palestinian Movement," p. 21.

30 One woman picked up.... Another, a schoolteacher: Kazi, "Palestinian Women," p. 28; Tom Segev, *1949: The First Israelis* (New York: Free Press, 1986), p. 25.

30 One writer even views the flood of refugees: Ata, *West Bank Palestinian Family*, citing P. Dodd and H. Baraket, *River without Bridges* (Beirut: Institute for Palestine Studies, 1968).

30 Whether the Palestinians were forced from their homes: See, for example, Simha Flapan, *The Birth of Israel: Myths and Realities*

(New York: Pantheon, 1987); Benny Morris, *The Birth of the Palestinian Refugee Problem, 1947–1949* (New York: Cambridge University Press, 1987), and *1948 and After: Israel and the Palestinians* (Oxford: Clarendon Press, 1990); Nafez Nazzal, *The Palestinian Exodus from Galilee, 1948* (Beirut: Institute for Palestine Studies, 1978); Segev, *1949: The First Israelis*; Shabtai Teveth, *Ben-Gurion and the Palestinian Arabs* (Oxford: Oxford University Press, 1985); Erskine Childers, "The Other Exodus," in Walid Khalidi, ed., *From Haven to Conquest* (Washington, D.C.: Institute for Palestine Studies, 1987).

30 West Bank women responded: Giacaman, "Palestinian Women," p. 3; Giacaman and Odeh, "Palestinian Women's Movement," p. 58; Jad, "From Salons to the Popular Committees," pp. 127–28; Rita Giacaman, "Reflections on the Palestinian Women's Movement in the Israeli-Occupied Territories" (Unpublished monograph, Birzeit University, May 1987), p. 4; Ata, *West Bank Palestinian Family*, p. 13. Pamela Ann Smith reports that a program of food rations organized in January 1949 registered one million refugees, most peasants with non-transferable skills. *Palestine and the Palestinians, 1876–1983* (London: Croom Helm, 1984), pp. 144, 145, 239 n. 2.

31 Although the absence of men reinforced: Ata, *West Bank Palestinian Family*, pp. 115, 63; Ismail, "Palestinian Women's Struggle," pp. 3–5.

31 Refugee families tended to arrange marriages: Ata, *West Bank Palestinian Family*, p. 64.

31 Contact between refugee women and members: Giacaman, "Reflections," p. 11; Kazi, "Palestinian Women," p. 31.

31 educating girls became a high priority: Jad, "From Salons to the Popular Committees," p. 127; Sosebee, "Palestinian Women's Movement," p. 83. Kazi points out that the need for women's labor led to greater freedom of movement for them in addition to education. "Palestinian Women," pp. 28–29.

31–32 women's organizations during the 1947–1950 period: Giacaman, "Palestinian Women," p. 3, and "Reflections," pp. 3–4; Jad, "From Salons to the Popular Committees," pp. 127–28; Ismail, "Palestinian Women's Struggle," p. 4. Kazi describes the 1948–1967 period as one of women's retreating from direct involvement in the struggle and of turning to social and charitable activities, with their minimal participation in superficial political activities shaped by the ideology of the male leadership. Kazi, "Palestinian Women," pp. 28–29; also see Ismail, "Palestinian Women's Struggle," p. 4.

32 Thirty-eight societies: Giacaman, "Palestinian Women," p. 7,
 Table 1, and pp. 4–6, citing General Union of Charitable Societ-
 ies in Jordan, *Guide to Charitable Societies in the East and West Banks*
 (Amman, 1980), pp. 234–346 (in Arabic). Giacaman notes that
 the list is not entirely accurate. She reports the existence of at
 least four more organizations and has established the differ-
 ence between the date of actual operation and that listed in the
 register for numerous organizations as ranging from six to
 thirty-six years (pp. 7–8). One society, unusual only because it
 was founded in Nablus in the north rather than in the central
 area, was the Arab Women's Union, organized by such women
 as journalist Raymonda Tawil and novelist Sahar Khalifeh, who
 were able to get the Israeli authorities to open up the UNRWA
 warehouse after the 1967 invasion. The union emerged as the
 charitable response of urban middle-class women to the needs
 of displaced villagers. Suha Sabbagh, "Palestinian Women and
 the Intifada," *Social Text* (Spring 1989), pp. 63, 76, 77. Sabbagh
 sees the role of women as extending from the traditional
 maternal one to that of protector in the political context and
 cites Tawil as viewing the alteration as a possible protection
 against traditional norms (p. 77). See Randa George Siniora,
 *Palestinian Labor in a Dependent Economy: Women Workers in the West
 Bank Clothing Industry*, Cairo Papers in Social Science, vol. 12,
 monograph 3 (Cairo: American University in Cairo Press, Fall
 1989), pp. 61–63.

32–33 Arab Women's Union of Bethlehem: Giacaman, "Palestinian
 Women," pp. 13–14.

33 The Jordanian Law of Personal Status: The current law, enacted
 in 1976 in place of the 1951 Law of Family Rights, is officially
 called Jordanian Law of Personal Status, Temporary Law No.
 61/1976, Official Gazette No. 2668 of 1/12/76. For internal politi-
 cal reasons, all Jordanian laws passed between 1976 and 1984
 were labeled temporary. See Lynn Welchman, "Family Law
 under Occupation: Islamic Law and the Shari'a Courts in the
 West Bank" (Unpublished monograph, 1988), p. 23 n. 17. A new
 substitute law, drafted in 1987, has not yet been enacted.

33 It permits a woman to specify: Lynn Welchman, "The Develop-
 ment of Islamic Family Law in the Legal System of Jordan,"
 International and Comparative Law Review 37 (1988), pp. 873–74, and
 "The Jordanian Law of Personal Status: A Comparative Analy-
 sis" (Unpublished monograph, London, undated), p. 4.

33 But most West Bank marriage contracts: Welchman, "Jordanian
 Law," p. 19 n. 16, and "Development of Islamic Family Law," p.

874 n. 10; Articles 12, 19, 68, 102–12, 181. Also see Aharon Layish, *Women and Islamic Law in a Non-Muslim State* (New York: Wiley, 1975). Under the law, the husband's right to divorce (*talaq*), which includes three declarations that the marriage is ended, cannot be exercised all at once and must either take place in court at three different sessions or be registered with the court within fifteen days. But the wife forfeits her *mahr* if the divorce is by mutual consent rather than the sole decision of the husband. A divorced wife has custody of children only until puberty, and the amount the husband must pay toward their support until then is minimal. A wife inherits a very small portion of her husband's estate, with preference given to their children and the husband's relatives. Polygamy is implicitly allowed.

33–34 Palestinian Women's Association . . . General Union of Palestinian Women: Hiltermann, *Before the Uprising*, pp. 412–13; Mai Sayeh, "Choosing the Revolution," in Monique Gadant, ed., *Women of the Mediterranean* (London: Zed Books, 1986), p. 86.

34 Men decided which women: Fawzia Fawzia, "Palestine: Women and the Revolution," in Robin Morgan, ed., *Sisterhood Is Global* (New York: Penguin, 1985), p. 542; Abdul Jawwad, "Evolution of the Political Role," p. 66.

34 It was not until 1989: "Fatah Expands Leadership Committee," *Jerusalem Post*, September 10, 1989, p. 2. The woman is Intissar al-Wazir.

34 Israeli policies confiscating Palestinian land: Hiltermann, *Before the Uprising*, p. 124.

34–35 Others either became blue-collar workers or emigrated: *The New York Times* estimated in 1990 that more than 30,000 Palestinians held jobs in Kuwait alone (although the *Times* did not say so, many of those in Kuwait were professionals: doctors, engineers, and so on). It quoted a Palestinian economist as saying that the Palestinian workers sent or brought home about $140 million a year and that 100,000 Palestinians were dependent on that income. Joel Brinkley, "Israel Says It Will Block Exports Bound for Iraq at Jordan's Border," *New York Times*, August 27, 1990, p. A8.

35 the increased need for women to enter the paid work force: Hiltermann, *Before the Uprising*, pp. 129–30, citing Susan Rockwell, "Palestinian Women Workers in the Israeli-Occupied Gaza Strip," *Journal of Palestine Studies* (Winter 1985), pp. 119–21; Women's Work Committee, *First Social Field Study: The Conditions of Palestinian Working Women* (Ramallah/al-Bira, 1979), pp. 12–13; Siniora, *Palestinian Labor*, p. 85; Kazi, "Palestinian Women," pp.

32–33. Also see Amal Samed, "The Proletarianization of Palestinian Women in Israel," MERIP *Reports* 50 (August 1976), p. 12, and Suha Hindiyeh and the Women's Resource and Research Center, "Socio-Economic Conditions of Female Wage Labour in the West Bank" (Paper presented at the Fourth International Interdisciplinary Congress on Women, Hunter College, New York, June 1989), p. 2.

35 A 1984 United Nations report: Kazi, "Palestinian Women," p. 32. Although Ramallah is unrepresentative of the West Bank because the women are largely Christian and highly educated and because many women of the elite work because they choose to, the Women's Work Committee, surveying Ramallah working women, nevertheless found that between 45 and 75 percent of those polled worked out of economic necessity (*First Social Field Study*, pp. 12–13).

35 Women began entering universities: Giacaman, "Palestinian Women," p. 22; Penny Johnson, "Uprising of a Novelist," *Women's Review of Books* (July 1990), p. 24. There are differing estimates of the number of women university students. Terry Boulatta, a student at the time, thinks that 25–30 percent of Birzeit University's student body immediately before the intifada was female (records are on the Birzeit University campus, which was closed by the IDF at the time of my writing). Terry Boulatta, interview with author. Kazi says that as of 1981–1982, women constituted 40 percent of West Bank students in institutions of higher education. Kazi, "Palestinian Women," p. 33. In 1981, Rosemary Sayigh estimated that women made up 40 percent of the Birzeit student body and a slightly lower percentage of the population at other West Bank universities. "Encounters with Palestinian Women under Occupation," *Journal of Palestine Studies* (Summer 1981), reprinted in Naseer H. Aruri, *Occupation: Israel over Palestine*, 2nd ed. (Belmont, Mass.: Association of Arab-American University Graduates, 1989), and Fernea, *Women and the Family*. Jad estimates the percentage in the late 1970s as 35–55 percent. Jad, "From Salons to the Popular Committees," p. 130.

36 A study of education in 1982: Ata, *West Bank Palestinian Family*, pp. 46, 48, 132. Israel's Central Bureau of Statistics estimates that in 1987, 55.2 percent of women aged fifteen to seventeen had nine to twelve years of formal education; 39.6 percent of those aged eighteen to twenty-four; 24.3 percent of those aged twenty-five to thirty-four. The estimates for those with nine to twelve years of schooling in the age categories forty-five to

fifty-four, fifty-five to sixty-four, and sixty-five and over are 5, 0.9, and 1.2 percent, respectively. Similarly, 93.8 percent of women sixty-five years and older are reported as having no schooling while only 2.4 percent of fifteen-to-seventeen-year-olds had none. Central Bureau of Statistics, *Statistical Abstract of Israel 1988* (Jerusalem, 1988), p. 752. The statistics are not entirely reliable because they are based on a small sample and the political situation obviously makes acquisition of this kind of information difficult, but the growth in the proportion of West Bank women receiving formal education is clear.

36 UNRWA figures show: Cited by Sosebee, "Palestinian Women's Movement," p. 84. It should be noted that the figures are for schools in both the West Bank and Gaza and that UNRWA runs only elementary schools.

37 they demonstrated in Jerusalem in February 1968: Rita Giacaman and Penny Johnson, "Building Barricades and Breaking Barriers: Palestinian Women in the Intifada," in Zachary Lockman and Joel Beinen, *Intifada* (Boston: South End Press/Middle East Research and Information Project, 1989), p. 158. A very few women became active in the armed struggle during the period 1967–1972, delivering food and weapons to the *fedayeen* and helping plan and carry out armed operations.

37 Israeli domestic law is the domain: Philippa Strum, "Women and the Politics of Religion in Israel," *Human Rights Quarterly* 11 (November 1989), pp. 491–96.

37–38 Becoming aware of these disparities ... caused some Palestinian women to regard Islamic law: Ata, *West Bank Palestinian Family*, p. 23.

38 The Islamic religious hierarchy realized: Ibid., pp. 21, 24.

38 With the exception of East Jerusalem women: Ibid., p. 18.

38 The elections produced a leadership: Jad, "From Salons to the Popular Committees," p. 130.

38 Volunteers spent their days working: Giacaman and Johnson, "Building Barricades," p. 159; Kazi, "Palestinian Women," p. 19; Lisa Taraki, "Mass Organizations in the West Bank," in Aruri, *Occupation*, pp. 451–53. Israeli policies are thoroughly documented in al-Haq, *Punishing a Nation: Human Rights Violations during the Palestinian Uprising, December 1987–December 1988* (Ramallah, 1989), also available in an edition published by South End Press (Boston) in 1990; al-Haq, *A Nation under Siege: Annual Report on Human Rights in the Occupied Palestinian Territories* (Ramallah, 1990); and Raja Shehadeh, *Occupier's Law: Israel and the West Bank*, 2nd ed. (1985; Washington, D.C.: Institute for

Palestine Studies, 1988). Also see Geoffrey Aronson, *Creating Facts: Israel, Palestinians, and the West Bank* (Washington, D.C.: Institute for Policy Studies, 1987), pp. 23–24, 225–26.

38–39 Women in the work committees also discussed the tension: Giacaman, "Palestinian Women," pp. 10, 22; also interviews with author.

39 Social Youth Movement: Don Peretz, *Intifada: The Palestinian Uprising* (Boulder: Westview Press, 1990), p. 87.

39–40 Many factors converged: Jad, "Political Role of Palestinian Women," and "From Salons to the Popular Committees," p. 130; Giacaman, "Palestinian Women," pp. 9–10; Siniora, *Palestinian Labor*, pp. 109–11; Barbara Debus and Maria Spieker, "We Do Not Only Want a Liberated Land: Palestinian Women's Movements in the West Bank," trans. Patricia Toun (Unpublished paper, 1984), p. 3; Hiltermann, *Before the Uprising*, pp. 422–32; Talhami, "Women in the Movement."

39 The dependence of Palestinians on the Israeli economy: Meron Benvenisti, *1986 Report: Demographic, Economic, Legal, Social and Political Developments in the West Bank* (Jerusalem: West Bank Data Base Project, 1986), p. 5.

39 The organizations that emerged in the West Bank: See Taraki, "Mass Organizations," and Peretz, *Intifada*, pp. 87–88, 95–96.

40 At least 682 women had been imprisoned: Maisoun Alouhaidi, *Palestinian Women and the Israeli Occupation* (Jerusalem: Arab Studies Association, 1986). About a third of the women arrested were charged and convicted. A total of 257 Palestinian women, between 157 and 172 of them from the West Bank, were convicted and sentenced to four or more years between 1967 and 1984. Of the total, 198 were sentenced to four years; 22 to five to nine years; 14 to ten to twenty years; and 12 to more than twenty years. The number of West Bank women is inexact because it is unclear whether 13 of them came from the West Bank, Gaza, or inside the Green Line. Between 1968 and 1983, 62 women, including 42 from the West Bank, were deported after serving from one to sixteen years in prison. An additional 49, 16 of them West Bank women, were killed between 1967 and 1985. Of the 49, 23 were killed when their villages were demolished in 1967. Alouhaidi says that the numbers may be low because of incomplete information. Her data include the name and age of each women and, where available, the place she lived.

40 According to one scholar, by 1981: Giacaman, "Palestinian Women," citing Soraya Antonius.

Chapter 2

41 "The women are marching!": al-Haq staffers.

42 nighttime incursions by Jewish settlers: Government of Israel, Ministry of Justice, *Investigation of Suspicions against Israelis in Judea and Samaria: Report of the Inquiry Team*, reprinted as *The Karp Report: An Israeli Government Inquiry into Settler Violence against Palestinians on the West Bank* (Washington, D.C.: Institute for Palestine Studies, 1984); Palestine Human Rights Campaign, *Israeli Settler Violence in the Occupied Territories 1980–1984* (Chicago, 1985); al-Haq, *Punishing a Nation: Human Rights Violations during the Palestinian Uprising, December 1987–December 1988* (Ramallah, 1989), Chapter 3 (also available in an edition published by South End Press, Boston); al-Haq, *A Nation under Siege: Annual Report on Human Rights in the Occupied Palestinian Territories* (Ramallah, 1990), Chapter 3.

43 Marie is Christian: The 5 percent figure that I was given for Christians in July 1989 may be too high, largely because the extent of Christian outmigration was not generally known then. Jiryis Khouri, head of the Ecumenical Institute for Theological Research in Bethlehem (al-Liqa), and Bernard Sabella, a sociologist at Bethlehem University, extrapolated from research on 550 Christian families in Jerusalem, Ramallah, Bethlehem, Beit Sahur, and Beit Jala to estimate that more than 2,000 West Bank Christian Palestinians, out of a Christian population they put at 45,000, emigrated annually between 1987 and 1989. This was almost twice the pre-intifada departure rate. Sabella found 3,000 Christian families—including 541 of Ramallah's 2,990 Christian families, 816 out of 4,595 in Bethlehem, 316 out of 1,430 in Jerusalem's Christian Quarter, and 355 out of 1,190 other East Jerusalem families—planning to emigrate. The findings were presented at a seminar held at Jerusalem's Notre Dame Hotel on July 5–7, 1990. See Hisham Abdallah, "Exodus of Palestinian Christians Worries Demographers," *al-Fajr Weekly*, July 16, 1990, p. 9; Joel Greenberg, "Alarmed by Arab Emigration," *Jerusalem Post*, July 13, 1990, p. 7.

43 The IDF has been known to enter homes: B'Tselem, *Banned Books and Authors* (October 1989); Article 19, *Violations of Freedom of Expression and Information in the Occupied Territories of the West Bank and Gaza Strip* (London: The International Campaign against Censorship, December 1989), p. 7.

47–50 But most of our conversation is about In'ash al-Usra: Samihah Khalil, interview with author, July 1989. Also see Sameeha Khalil, "Personal Status" (Unpublished document, undated);

"The Society of In'ash El-Usra" (el-Bireh, 1985); Rita Giacaman, "Palestinian Women and Development in the Occupied West Bank" (Unpublished monograph, Birzeit University, undated), pp. 11–13; Joost Hiltermann, *Before the Uprising: The Organization and Mobilization of Palestinian Workers and Women in the Israeli-Occupied West Bank and Gaza Strip* (Ph.D. dissertation, University of California at Santa Cruz, June 1988) pp. 414–17.

50–51 On June 8, 1988: In'ash El-Usrah, "A Statement" (al-Bireh, June 14, 1988), and "Response" (al-Bireh, June 25, 1988); Palestine Human Rights Information Center, "Initial Report regarding the Illegal Search, Seizure and Closure of the In'ash El-Usra Society in el-Bireh" (Unpublished manuscript, undated); Orayb Najjar, "Palestinian Self-Reliance on Trial," *Christian Century*, November 23, 1988, pp. 1070–72; Joel Greenberg, "Acid Thrown at Soldiers in Hebron," *Jerusalem Post*, October 12, 1989, p. 12. The court decision, In'ash al-Usrah and Samiha Khalil v. Commander of the IDF in Judea and Samaria, HC 660/88, handed down on October 11, 1989, by Justices Moshe Bejski, Gavriel Bach, and Abraham Halima and written by Justice Bach, is summarized in English in Asher Felix Landau, "Law Report: A Question of Closure," *Jerusalem Post*, October 25, 1989, p. 5. The high court has been reluctant to interfere with any measures taken by the IDF in the territories, and its cutting down of the closure period was unprecedented. The court described the two-year period as an unreasonably long punishment rather than a deterrent measure.

53 about a month and a half after my visit to Beit Hanina: PFWAC leaders, interviews with author; also see Palestine Federation of Women's Action Committees, *Newsletter*, December 1989, p. 7.

56 The exceptions are private schools run by religious denominations: Educational Network, *Education during the Intifada* (Ramallah, June 1990), p. 7. By comparison, UNRWA runs 51 percent of all Gaza schools. The network's count of West Bank schools (including East Jerusalem) for 1988–1989 was 862 government schools with 251,554 students, 100 UNRWA schools with 40,678 students, and 317 private schools with 57,741 students, or a total of 349,973 students in 1,279 schools (p. 8).

56 The first non-church-affiliated school: Islah Jad, interview with author.

Chapter 3

59 "The struggle for our rights": Amal Wahdan, quoted in Libby Fillmore and Sharry Renn, "Palestinian Woman Unionist Finds Organizing Tough Going," *al-Fajr Weekly*, March 7, 1980.

59 Women's Work Committee: Rita Giacaman, "Palestinian Women and Development in the Occupied West Bank" (Unpublished monograph, Birzeit University, undated), pp. 16–17; Islah Abdul Jawwad, "The Evolution of the Political Role of the Palestinian Women's Movement in the Uprising," in Michael C. Hudson, ed., *The Palestinians: New Directions* (Washington, D.C.: Georgetown University Center for Contemporary Arab Studies, 1990), pp. 67–68.

59–60 The leaders of the WCC began by creating cadres: Joost Hiltermann, *Before the Uprising: The Organization and Mobilization of Palestinian Workers and Women in the Israeli-Occupied West Bank and Gaza Strip* (Ph.D. dissertation, University of California at Santa Cruz, June 1988), pp. 424, 429–430; Giacaman, "Palestinian Women," p. 26.

60 Perhaps 5 percent of the roughly thirty-three thousand Palestinian women workers: Amal Wahdan, interview with author. Wahdan was talking about workers in 1984–1985. Also see Didar Fawry, "Palestinian Women in Palestine," in Monique Gadant, ed., *Women of the Mediterranean* (London: Zed Books, 1986), p. 73, who estimates that there were 30,300 women in the paid work force in 1978. In a 1991 interview, I was told by the Labor Study Center in Ramallah that approximately 10 percent of working women were unionized then, compared with 0.02 percent a decade earlier, and that women were prominent in the administration of unions in garment factories and medical factories, where most workers are female.

60 To find out, they undertook two surveys: Hiltermann, *Before the Uprising*, p. 425. Rosemary Sayigh states that these were the first research studies ever done by a Palestinian women's group. "Encounters with Palestinian Women under Occupation," *Journal of Palestine Studies* (Summer 1981), reprinted in Naseer H. Aruri, *Occupation: Israel over Palestine*, 2nd ed. (Belmont, Mass.: Association of Arab-American University Graduates, 1989), p. 18.

60 Clothing became a major subcontracting industry: Randa George Siniora, *Palestinian Labor in a Dependent Economy: Women Workers in the West Bank Clothing Industry*, Cairo Papers in Social Science, vol. 12, monograph 3 (Cairo: American University in Cairo Press, Fall 1989), pp. 1–3, 46, 49, 52.

60–61 The primary initial objection to women's working outside the home: Siniora, *Palestinian Labor*, pp. 42–55; Amal Samed, "The Proletarianization of Palestinian Women in Israel," MERIP Reports 50 (August 1976), pp. 10–15; Siniora, *Palestinian Labor*, p.

68; Hiltermann, *Before the Uprising,* pp. 507–17; Amal Wahdan, interview with author. This section draws heavily on the work of Siniora as well as conversations with her, for all of which I am extremely grateful.

61 Palestinian subcontractors take work directly to them: Charles Shamas, interview with author.

61 they frequently work without knowing how much they will be paid: In the PFWAC survey, 3 percent of the women said they had begun working only recently and did not yet know what their wages or work demands would be. Suha Hindiyeh and the Women's Resource and Research Center, "Socio-Economic Conditions of Female Wage Labour in the West Bank" (Paper presented at the Fourth International Interdisciplinary Congress on Women, Hunter College, New York, June 1989), p. 6.

61 Women were also forced by economic necessity: Suha Sabbagh, "Palestinian Women and the Intifada," *Social Text* (Spring 1989), p. 75. Sabbagh says that in 1980, 24.8 percent of West Bank women were in the paid work force, an increase from 8.4 percent in 1967, and that those who worked in the West Bank were paid half the salaries received by their Palestinian counterparts working in Israel.

62 So the thousand members of the WWC fanned out: Zahira Kamal, interview with author; Giacaman, "Palestinian Women," pp. 20–21.

62 numerous organizers had come to the same realization: Rita Giacaman and Muna Odeh, "Palestinian Women's Movement in the Israeli-Occupied West Bank and Gaza Strip," in Nahid Toubia, ed., *Women of the Arab World* (London: Zed Books, 1988), p. 60.

62 The efforts included writing material: Giacaman, "Palestinian Women," p. 21.

62 Nursery schools were established: Rita Giacaman, "Political Women in the Uprising: From Followers to Leaders?" (Unpublished paper, September 1988), p. 3 n. 4.

63 "The popular movement is extremely important": "Women, Resistance, and the Popular Movement" (Interview with Rita Giacaman), *Palestine Focus* 24 (July–August 1987), p. 3.

63 the concepts of national liberation and women's liberation: "Women, Resistance, and the Popular Movement." There were other important organizing efforts on the grassroots level at the same time. As noted in the text, medical relief committees, designed to provide services for the sick and wounded who had limited access to medical facilities because of geography or because of IDF curfews, were created throughout the country. A

more limited effort was made to spread knowledge and help in the agricultural sphere. Unlike the unions and women's committees, however, these groups were designed to provide services rather than to alter status. The university students' groups, which became important to the raising of a national consciousness and the acquisition of political skills, were of course not a grassroots phenomenon.

63–64 What had been one committee was transformed into four: Hiltermann, *Before the Uprising*, pp. 17–18; Islah Jad, "From Salons to the Popular Committees: Palestinian Women, 1919–1989," in Jamal R. Nassar and Roger Heacock, *Intifada: Palestine at the Crossroads* (Ramallah and New York: Birzeit University and Praeger Press, 1991), p. 131 (giving the date of the UPWC as 1981 and that of the UWCSW as 1982); Siniora, *Palestinian Labor*, p. 100. On the ideological differences of the parties, see Pamela Ann Smith, *Palestine and the Palestinians, 1876–1983* (London: Croom Helm, 1984), pp. 195–201.

64 In addition, a number of professional upper-middle-class women work closely: Giacaman, "Political Women," p. 4.

65 Women were brought into the committees: Hiltermann, *Before the Uprising*, p. 459; Siniora, *Palestinian Labor*, pp. 120–21.

65 women had internalized the restrictions: Hiltermann, *Before the Uprising*, pp. 535–40.

65–66 The committees' structure reflected: Union of Palestinian Working Women's Committee in the West Bank and Gaza Strip, untitled pamphlet (Jerusalem, 1988); Palestinian Federation of Women's Action Committees in the Occupied Territories, "Program and Internal Platform" (Jerusalem, 1988); Hiltermann, *Before the Uprising*, pp. 460–68; Giacaman, "Women, Resistance, and the Popular Movement"; Giacaman, "Palestinian Women," p. 24.

66 promulgation of a 1982 military order: Military order 998, "Use of Enemy Money," discussed in Hiltermann, *Before the Uprising*, pp. 93, 532–35.

66 In addition, the committees have faced the same treatment: Geoffrey Aronson, *Creating Facts: Israel, Palestinians, and the West Bank* (Washington, D.C.: Institute for Policy Studies, 1987), pp. 23–24.

66 It is difficult to know exactly how many women: The estimate of 3 percent membership is in Jad, "From Salons to the Popular Committees," p. 132; that of 2–3 percent, Rita Giacaman, interview with author.

66 "level of political consciousness": Jad, "From Salons to the Popular Committees," pp. 132.

67 "the struggle for our rights as workers": Wahdan quoted in Fillmore and Renn, "Palestinian Woman Unionist."

67 "The danger in the present strategy": Rita Giacaman, "Reflections on the Palestinian Women's Movement in the Israeli-Occupied Territories" (Unpublished monograph, Birzeit University, May 1987), p. 14; compare p. 11 of the latter document and Giacaman, "Palestinian Women," pp. 4–5. Also see Ghada Talhami, "Women of the Intifada," *Chicago Tribune*, December 15, 1989, p. 26, and Noha S. Ismail, "The Palestinian Women's Struggle for Independence: A Historical Perspective" (Unpublished paper, October 17, 1989).

67 Acceptance by society required them: Siniora, *Palestinian Labor*, p. 112.

67 The committees therefore concentrated: Giacaman, "Reflections," p. 11.

67–68 Their pre-intifada successes: Rita Giacaman and Penny Johnson, "Building Barricades and Breaking Barriers: Palestinian Women in the Intifada," in Zachary Lockman and Joel Beinen, *Intifada* (Boston: South End Press/Middle East Research and Information Project, 1989), p. 158; Hiltermann, *Before the Uprising*, p. 446.

68 empowering poor women: Giacaman, "Women, Resistance, and the Popular Movement."

68 "of renunciation, of captivity": Magida Salman, "The Arab Woman: A Threatening Body, a Captive Being," in Khamsin Collective, *Women in the Middle East* (London: Zed Books, 1987), p. 6.

Chapter 4

69 "If they want us to be active": Rana Nashashibi quoted in Randi Jo Land, "A Separate Peace?" *Jerusalem Post*, June 29, 1989, p. 7.

70 prices here zoomed . . . even now that inflation has been brought under control: Meron Benvenisti, 1986 *Report: Demographic, Economic, Legal, Social and Political Developments in the West Bank* (Jerusalem: West Bank Data Base Project, 1986), p. 7.

71 all the telephone lines in the territories were tapped: In late 1990, an Israeli district court would allude to the wiretapping, ruling that non-intifada-related convictions based on evidence gathered over bugged telephones in Gaza were legal because the Jerusalem district court had acceded to a police request to tap any calls from Gaza to Israel. "Judge: Police May Bug Gaza Phones," *Jerusalem Post*, December 17, 1990, p. 8.

72 Five of al-Haq's field workers . . . have been arrested: al-Haq, A

Nation under Siege: Annual Report on Human Rights in the Occupied Palestinian Territories (Ramallah, 1990), Chapter 18; Article 19, *Violations of Freedom of Expression and Information in the Occupied Territories of the West Bank and Gaza Strip* (London: The International Campaign against Censorship, December 1989), p. 10.

72 Ketziot . . . has been strongly criticized: Lawyers Committee for Human Rights, *An Examination of the Detention of Human Rights Workers and Lawyers in the West Bank and Gaza and Conditions of Detention at Ketziot* (New York, 1988), Chapters 3 and 4; al-Haq, *Ansar 3: A Case for Closure* (1988); al-Haq, *Nation under Siege*, pp. 285–95; Article 19, *Violations*, pp. 7–8; Middle East Watch, *Prison Conditions in Israel and the Occupied Territories* (New York: Human Rights Watch, 1991), pp. 17–18, 49–80. The 5,000 figure was confirmed by the IDF in August 1989.

74 Production Is Our Pride: Additional information can be found in the brochure "Our Production Is Our Pride" by Kathy Glavanis and Eileen Kuttab (undated, probably 1989), much of which is reproduced as "Women's Cooperative Organization in Palestine," *Jerusalem* 65 (October 1990), pp. 28–29. Also see Saida Hamad, "Intifada Transforms Palestinian Society, Especially the Role of Women," *al-Fajr Weekly*, March 13, 1989.

Chapter 5

79 "He is my son!": Rita Giacaman and Penny Johnson, "Building Barricades and Breaking Barriers: Palestinian Women in the Intifada," in Zachary Lockman and Joel Beinen, *Intifada* (Boston: South End Press/Middle East Research and Information Project, 1989), p. 161.

79 "It's my struggle too": Overheard by author.

79 The physical involvement of women in the intifada: Islah Jad, "From Salons to the Popular Committees: Palestinian Women, 1919–1989," in Jamal R. Nassar and Roger Heacock, *Intifada: Palestine at the Crossroads* (Ramallah and New York: Birzeit University and Praeger Press, 1991), p. 140.

79 a cross section of the population: Rita Giacaman, "Political Women in the Uprising: From Followers to Leaders?" (Unpublished paper, September 1988), pp. 1, 2 n. 1; Michael C. Hudson, Introduction, in Michael C. Hudson, ed., *The Palestinians: New Directions* (Washington, D.C.: Georgetown University Center for Contemporary Arab Studies, 1990), p. xvi; Salim Tamari, "Revolt of the Petite Bourgeoisie: Urban Merchants and the Palestinian Uprising," and Joost Hiltermann, "Mass Mobilization and the Uprising: The Labor Movement," both in Hudson,

The Palestinians; Odil Yahya, "The Role of the Refugee Camps," and Husein Jameel Bargouti, "Jeep versus Bare Feet," both in Nassar and Heacock, *Intifada: Palestine at the Crossroads* (1991).

79 The bulk of the violent casualties: Yahya, "Role of the Refugee Camps," p. 95.

80 Some urban women claim: Interviews with author; also see Joost R. Hiltermann, "Sustaining Movement, Creating Space: Trade Unions and Women's Committees," *Middle East Report* (May–August 1990), p. 34.

80 Women from all areas rushed out: Giacaman, "Political Women," p. 5; Islah Jad, "The Political Role of Palestinian Women in the Intifada" (Lecture at the Jerusalem offices of the Union of Palestinian Working Women in the West Bank and Gaza, July 7, 1989); see also Palestinian Union of Women's Work Committees, *Newsletter* (Special Issue, "Women in the Uprising"), March 8, 1988, p. 2.

80 the modern-looking mother of a young man being arrested: Interviews with author. The story is also told in Giacaman and Johnson, "Building Barricades," p. 161, and in Palestinian Union of Women's Work Committees, "Women in the Uprising," p. 8, which adds that the young man's mother managed to get into the jeep taking him to the police station, where he was released to seek medical care, and that both the mother and her daughters returned to the mosque every Friday thereafter in case another youth needed the aid of women.

80 On another occasion a man in his early twenties: The incident was witnessed by Professor Munir Fasheh of Birzeit University, who recounts it in "Community Education: To Reclaim and Transform What Has Been Made Invisible," *Harvard Educational Review* 60, no. 1 (February 1990), p. 30. I am grateful to Dr. Linda Levine for bringing the article to my attention.

80 "it has become dangerous for men": Jad, "From Salons to the Popular Committees," p. 140.

81 The misuse of teargas in confined spaces: al-Haq, *Punishing a Nation: Human Rights Violations during the Palestinian Uprising, December 1987–December 1988* (Ramallah, 1989), Chapter 3 (also available in an edition published by South End Press, Boston), pp. 35–40; al-Haq, *A Nation under Siege: Annual Report on Human Rights in the Occupied Palestinian Territories* (Ramallah, 1990), pp. 409–511.

81 A report issued on May 5, 1988: The report was issued after a demand in the Knesset by member Dedi Zucker. See al-Haq, *Punishing a Nation*, p. 39.

81 In Beit Fajjar: Ibid., p. 37.

81 On January 16, 1988: Ibid., pp. 37–38. Also see Amnesty Interna-
 tional, *The Misuse of Teargas by Israeli Army Personnel in the Israeli
 Occupied Territories* (London, June 1988); H. Jack Geiger, Jennifer
 Leaning, Leon A. Shapiro, and Bennett Simon, *The Casualties of
 Conflict: Medical Care and Human Rights in the West Bank and Gaza
 Strip* (Somerville, Mass.: Physicians for Human Rights, 1988),
 pp. 17–19.

81 a weekly average of 115 women's marches: Jad, "From Salons to
 the Popular Committees," p. 133.

81 "When I got up I begged": al-Haq, *Nation under Siege*, p. 509.

82 Al-Haq has noted that most women: Ibid., pp. 506–7, quoting
 from affidavits.

82 On January 19, 1988: Ibid., p. 508

82 A woman in the Balata refugee camp: Ibid., p. 507.

82 In January 1988 a mother of eight children: Ibid., p. 508.

82 A mother who returned to her home in the Jenin refugee camp:
 Ibid., p. 508.

82–83 The fifty-two-year-old mother of a wanted man in Beit Furik:
 Joel Greenberg, "Soldier Hurt in Hebron," *Jerusalem Post*, Febru-
 ary 21, 1990, p. 10. On soldiers going into Palestinian towns
 disguised as women, see Joel Brinkley, "Israel in Uproar over TV
 Report Confirming Existence of Secret Army Unit," *New York
 Times*, June 24, 1991, p. A3.

83 A few days later five Nablus women: Joel Greenberg, "British
 Tourist Stabbed in Hebron," *Jerusalem Post*, March 1, 1990, p. 10.

83 the forty-five-year-old Bethlehem housewife . . . the fifteen-
 year-old killed in Rafidiya the eleven-year-old shot: al-
 Haq, *Nation under Siege*, p. 506.

83 the seventeen-year-old on her way home from school: Joel
 Greenberg, "Nablus Schoolgirl Slain in Intifada Violence,"
 Jerusalem Post, February 19, 1990, p. 1; Greenberg, "Soldier Hurt
 in Hebron," February 21, 1990, p. 10.

83 A five-month-old girl died: "Weekend Clashes," *Jerusalem* 57
 (February 1990), p. 12.

83 In June 1990, a number of *shabab*: Joel Greenberg, "Tulkarem Girl
 Dies of Wounds," *Jerusalem Post*, June 26, 1990, p. 1.

83 Soldiers who saw burning tires: Michal Sela, "14-Year-Old Shot
 Dead near Jenin," *Jerusalem Post*, September 8, 1989, p. 16.

83 A sixteen-year-old studying on the roof of her house: The
 sergeant who killed the student was charged with manslaugh-
 ter. Joel Greenberg and Michal Sela, "IDF Lieutenant Faces
 Homicide Charge for Shooting Beita Boy," *Jerusalem Post*, Octo-
 ber 25, 1989, p. 2.

83–84 a fifteen-year-old in the village of Jeba': Joel Greenberg, "MK
 Queries Fatal Shooting in IDF Arrest of Fugitive," *Jerusalem Post*,
 February 16, 1990, p. 2; Greenberg, "Nablus Schoolgirl." Also
 see "Sanabel Special Report: The Detention of Asmahan and
 Mohammed Alawneh" (Jerusalem: Sanabel Press Services, Feb-
 ruary 9, 1990), which contains affidavits taken by the Associa-
 tion for Civil Rights in Israel (ACRI) concerning the incident, the
 charge sheet filed against the wanted man and his eighteen-
 year-old sister, a summary of the report made to Women for
 Women Political Prisoners—Jerusalem by its attorney, and a
 complaint submitted by ACRI to the chief military prosecutor
 for the West Bank.

84 In November 1989, women held a pre–independence day
 march: Joel Greenberg and Michal Sela, "Masked Men Kill Two
 Amid Widespread Arrests by IDF," *Jerusalem Post*, November 13,
 1989, p. 3.

84–85 Women marching in downtown Ramallah: Joel Greenberg and
 Michal Sela, " 'Stone-Throwing' Leads to Two Killings in Ar-
 eas," *Jerusalem Post*, December 11, 1989, pp. 1, 8.

85 There were numerous marches and sit-ins: Joel Greenberg, "IDF
 Demolishes Home of West Bank Fugitive," *Jerusalem Post*, March
 8, 1990, p. 10; Joel Greenberg, "4 Settlers Released from Cus-
 tody," *Jerusalem Post*, March 6, 1990, p. 10; "Israelis Break Up
 Women's Demonstration," *New York Times*, March 9, 1990, p. A8
 (caption accompanying photo); Robert Rees and Joel Green-
 berg, "Rubber Bullets Used to Stop Women's Day Marches in
 J'lem," *Jerusalem Post*, March 9, 1990, p. 1.

85 By the end of 1989, sixty-seven women had been killed: al-Haq,
 Nation under Siege, p. 504. Al-Haq believes that the remaining
 twenty-three women were killed by the IDF or by Jewish settlers
 but will not list them as such without sufficient documentation.

85 a ten-year-old who died: "10-Year-Old Dies of Wounds, 'Collab-
 orator' Hacked to Death," *Jerusalem Post*, March 1, 1990, p. 10.

86 On the 1989 anniversary: Joel Greenberg, "Masked Bir Zeit
 Teenagers Mark PFLP's Anniversary with Paramilitary March,"
 Jerusalem Post, December 12, 1989, p. 12.

86 A twenty-two-year-old woman and a twenty-six-year-old man
 were killed: Joel Greenberg and Michal Sela, "Two Killed on
 Second Anniversary of Intifada," *Jerusalem Post*, December 10,
 1989, p. 1.

86 Some of those in the women's demonstration: Michal Sela,
 "Palestinians Report 25 Wounded in Scattered Clashes in Terri-
 tories," *Jerusalem Post*, December 25, 1989, p. 8.

86 Two days later two young women: Joel Greenberg, "Hamas Calls General Strike to Protest Immigration Wave," *Jerusalem Post*, January 25, 1990, p. 10.

86 A sixteen-year-old girl was shot in the leg: Joel Greenberg, "Three Killers of 'Collaborators' Caught, Army Says," *Jerusalem Post*, February 23, 1990, p. 18.

86 Al-Haq has documented numerous cases of soldiers using obscene language: al-Haq, *Nation under Siege*, pp. 511, 517, 519–20.

86 There have also been cases of soldiers exposing themselves: Ibid., p. 512. The photographs, of soldiers parading naked on a rooftop lookout post in the Jerusalem-area village of Abu Dis and exposing themselves to women, were distributed to the media by M. K. Mohammed Miari. Joel Greenberg, "IDF Punishes Soldier for Parading Nude," *Jerusalem Post*, June 28, 1990, p. 10.

87 Women probably have shocked soldiers: Jad, "From Salons to the Popular Committees," p. 138.

87 Palestinian women face sexual threats: al-Haq, *Nation under Siege*, pp. 513–20; Women for Women Political Prisoners—Jerusalem, *Report* (1989), pp. 7, 19, 21, 24, and *Semi-Annual Report* (January–June 1990), pp. 5, 7, 13, 17. An Israeli journalist has described "the daily infliction of injury to the bodies and to the dignity of these women" as having become "an acceptable work method." Yossi Dahan, "Let the Minister of Police and the Prime Minister Step Forward to Deny," *Hadashot*, February 18, 1990, quoted in Women for Women Political Prisoners—Jerusalem, *Semi-Annual Report*, p. 5.

87 Women who were prisoners during the first year: Palestinian Union of Women's Work Committees, *Newsletter*, Special Issue, March 8, 1988, and June 30, 1988, October 1988.

87 "the honor of the women has more political": Sharon Rose, "Women and the Intifada: Interview with Eileen Kuttab," *Palestine Focus* (November–December 1989), p. 8.

87–88 "The whole system of taboos": Harriet Lewis, "It Is Possible to Agree on Principles: An Interview with Hanan Mikhail-Ashrawi," *New Outlook* (June/July 1989), p. 8.

88 A new kind of committee: Daoud Kuttab, "The Struggle to Build a Nation," *Nation*, October 17, 1988, pp. 336–40; author's interviews.

88 Women in some towns and villages even claim: Hiltermann, "Sustaining Movement," p. 34. Islah Jad suggests that women were more active than men primarily in education and first aid

committees, although they were active in other urban popular committees. Jad, "From Salons to the Popular Committees," pp. 134–35.

89 The women's committees were a model: Islah Abdul Jawwad, "The Evolution of the Political Role of the Palestinian Women's Movement in the Uprising," in Hudson, The Palestinians, p. 71.

89 "the grass-root women's committees": Quoted in Stephen J. Sosebee, "The Palestinian Women's Movement," American-Arab Affairs 32 (Spring 1990), p. 88.

89 There was also a dramatic rise in the variety: Saida Hamad, "Intifada Transforms Palestinian Society, Especially the Role of Women," al-Fajr Weekly, March 13, 1989. All the women quoted are between fourteen and twenty-two years old.

89–90 "Not at all, although my community": "Neighborhood Committees: Organizing for Self-Reliance," Newsletter (Palestinian Union of Women's Work Committees), June 30, 1988, p. 8.

90 "Really, the shebab's respect for us" . . . "When we went to demonstrations": "In Their Own Words . . . ," Voice of Women (UPWWC newsletter), undated (probably early 1990), pp. 2–3.

90–91 Women, especially in the rural areas: Rita Giacaman and Penny Johnson, "Mother, Sister, Self: The Women of Nahalin" (Unpublished manuscript, Birzeit University, 1989), p. 8.

91 "The authority of the father and mother": Quoted in Alex Fishman, "The Palestinian Woman and the Intifada," originally printed in Hadashot, republished in New Outlook (June/July 1989), p. 11. The leading role played in the intifada by young people, particularly young men, has been widely noted. See, for example, Hirsh Goodman, "Army Meets a New Palestinian," Jerusalem Post, January 15, 1988, p. 5; David Grossman, "The Masked Country: An Israeli's Observations on the Intifada," Yediot Aharonot, December 8, 1989, reprinted in Israeli-Palestinian Digest (March 1990), p. 4; Nizar Qabbani, "Children Bearing Rocks," in Lockman and Beinen, Intifada, p. 100.

91 One scholar reports: Hiltermann, "Sustaining Movement," p. 34.

92 nonmembers are now welcome: Union of Palestinian Working Women Committees in the West Bank and Gaza Strip, untitled pamphlet (1988), p. 1; Union of Palestinian Women's Committees in the Occupied Land, Newsletter 1 (July 1988), p. 2; Palestine Federation of Women's Action Committees, Newsletter, December 1989, pp. 4–5.

93 the military administration closed the universities: Beginning in June 1990, a number of colleges and universities, the latter

including al-Quds, Bethlehem, Hebron, al-Najah, and Islamic, gradually were permitted to open, some of them in stages involving limited numbers of students and all of them conditionally. As of early 1992, Birzeit University, the territories's most prestigious institution, was still under military closure.

93 The charge sheet submitted: Sanabel Press Services, *Bulletin* (Jerusalem, July 9, 1990), p. 2–4. The charge sheet is dated May 7, 1990.

Chapter 6

95 "We are not going to waste": Author's interview with women in Idna

98 Sixty-three-year-old Husna Shibab: al-Haq, *Punishing a Nation: Human Rights Violations during the Palestinian Uprising, December 1987–December 1988* (Ramallah, 1989), Chapter 3 (also available in an edition published by South End Press, Boston), p. 17.

100–101 Yaser Abu-Ghosh: al-Haq, *A Nation under Siege: Annual Report on Human Rights in the Occupied Palestinian Territories* (Ramallah, 1990), pp. 62–64, 115–16.

101 The Shin Bet is Israel's internal security force: *The New York Times* has referred to the Shin Bet as "Israel's secret police, which has no public accountability and no one to answer allegations." Sabra Chartrand, "Palestinian Indicted, Mainly for Work as Reporter," *New York Times*, March 17, 1991, p. 19.

101 *Samed . . . Occupier's Law*: Raja Shehadeh, *Samed: Journal of a West Bank Palestinian* (New York: Adama Books, 1984); Raja Shehadeh, *Occupier's Law: Israel and the West Bank*, 2nd ed (Washington, D.C.: Institute for Palestine Studies, 1988).

102 the Israeli authorities have kept it and the other universities . . . closed: Naseer Aruri, "Universities under Occupation," in Naseer H. Aruri, ed., *Occupation: Israel over Palestine*, 2nd ed. (Belmont, Mass.: Association of Arab-American University Graduates, 1989), pp. 507–10; and Munir Fasheh, "Al-Intifada and a New Education," in Aruri, *Occupation*, pp. 537–60; B'Tselem, *Closure of Schools and Other Setbacks to the Education System in the Occupied Territories* (September–October 1990); al-Haq, *Israel's War against Education in the Occupied West Bank: A Penalty for the Future* (Ramallah, 1988); al-Haq, *Punishing a Nation*, Chapter 8; al-Haq, *Nation under Siege*, Chapter 13; Jerusalem Media and Communication Center, *Palestinian Education: A Threat to Israel's Security?* (Jerusalem, 1989); Birzeit University, Public Relations Office, *The Criminalization of Education* (Ramallah: Birzeit University, 1989); Article 19, *Violations of Freedom of Expres-*

sion and Information in the Occupied Territories of the West Bank and Gaza Strip (London: The International Campaign against Censorship, December 1989), pp. 5–6.

103 "Summary Execution in Ramallah": There were more such killings. See al-Haq, *Human Rights Focus: The Illegal Use of Lethal Force Against "Fleeing Suspects"* (Ramallah, May 1, 1991); B'Tselem, *The Use of Firearms by the Security Forces in the Occupied Territories* (July 1990), pp. 29–30; Middle East Watch, *The Israeli Army and the Intifada: Policies That Contribute to the Killings* (New York: Human Rights Watch, 1990).

104 four members of the IDF's Givati Brigade have been found guilty: Middle East Watch, *Israeli Army*, pp. 149–59.

106–7 Beit Sahur . . . is now under curfew: Philippa Strum, "Beit Sahur: 'This Is Our Peaceful Protest against the Occupation,'" *Newsletter* (American-Israeli Civil Liberties Coalition), Winter 1990, pp. 1–2; Norman Finkelstein, "Bayt Sahur in Year II of the Intifada: A Personal Account," *Journal of Palestine Studies* (Winter 1990), pp. 62–74. Also see articles by Joel Greenberg in *The Jerusalem Post* in 1989 on July 12, July 15, October 3, October 4, October 6, October 12, October 30, October 31, November 1, November 2, and December 1; Michal Sela, "Elias Rishmawi's 'Tea Party,'" *Jerusalem Post*, September 29, 1989, p. 9; Alan Cowell, "In a Tax War, Even the Olivewood Dove Is Seized," *New York Times*, October 11, 1989, p. A4; Joel Brinkley, "West Bank Town Gleeful as Israel Calls Off Its Six-Week Tax Siege," *New York Times*, p. A1. The Lawyers Committee for Human Rights estimates that 82 percent of the Civil Administration's budget is financed by taxes and fees paid by residents of the territories. Lawyers Committee for Human Rights, *An Examination of the Detention of Human Rights Workers and Lawyers in the West Bank and Gaza and Conditions of Detention at Ketziot* (New York, 1988), p. 4 n. 11, citing Dan Sagir, "Territories Provide 'Nice Income' for Treasury," *Ha'aretz*, April 28, 1988.

Chapter 7

109 "You've got to try and be strong": Ramallah woman to author.

112–15 On the military courts: See International Commission of Jurists, al-Haq, and Gaza Center for Law and Rights, *Justice? The Military Court System in the Israeli-Occupied Territories* (Ramallah, 1987); al-Haq, *A Nation under Siege: Annual Report on Human Rights in the Occupied Palestinian Territories* (Ramallah, 1990), Chapter 6; B'Tselem, *The Military Judicial System in the West Bank* (November 1989); B'Tselem, *The Military Judicial System in the West Bank*,

Followup Report (May 1990); Jordan J. Paust, Gerhard von Glahn, and Gunter Woratch, *Inquiry into the Israeli Military Court System* (Geneva: International Commission of Jurists, 1989). The two major military courts in the West Bank are in Ramallah and Nablus. Two subsidiary courts in Jenin and Hebron began to operate daily in December 1989; the one in Tulkarem operates on an "as-needed" basis. Al-Haq, *Nation under Siege*, p. 237.

119–20 If it reflects the overall statistical picture: Odil Yahya, "The Role of the Refugee Camps," in Jamal R. Nassar and Roger Heacock, *Intifada: Palestine at the Crossroads* (Ramallah and New York: Birzeit University and Praeger Press, 1991), pp. 91–93.

124 The intifada has strained its facilities: See al-Haq, *Punishing a Nation: Human Rights Violations during the Palestinian Uprising, December 1987–December 1988* (Ramallah, 1989), Chapter 3 (also available in an edition published by South End Press, Boston), Chapter 2; al-Haq, *Nation under Siege*, Chapter 2; Association of Israeli and Palestinian Physicians for Human Rights, *Report on the Condition of Health Services in the Gaza Strip* (Jerusalem, 1989); Mustafa Barghouti and the Union of Palestinian Medical Relief Committees, "Health and Health Services," in Naseer H. Aruri, ed., *Occupation: Israel over Palestine*, 2nd ed. (Belmont, Mass.: Association of Arab-American University Graduates, 1989); Chairman of the Special Committee of Experts, "Health Conditions of the Arab Population in the Occupied Arab Territories, including Palestine," Document A44/34 (New York: World Health Organization), May 6, 1991; World Health Assembly, "Resolution concerning Health Conditions of the Arab Population in the Occupied Arab Territories, including Palestine," Resolution WHA 44.31 (Geneva: World Health Assembly), May 15, 1991.

124 Money supposedly designated as premiums for health coverage: Meron Benvenisti, *1986 Report: Demographic, Economic, Legal, Social and Political Developments in the West Bank* (Jerusalem: West Bank Data Base Project, 1986), p. 12.

Chapter 8

125 "In prison, you are not allowed to sing": Amal Wahdan, interview with author.

125ff. On prison conditions: See Government of Israel, *Report of the Comptroller-General of Israel* (Jerusalem: Government Printing Office, 1990); Government of Israel, Landau Commission, *Report of the Commission of Inquiry of the General Security Service regarding Hostile Terrorist Activities* (Jerusalem: Government Printing Office,

1987); Stanley Cohen and Daphna Golan, *The Interrogation of Palestinians during the Intifada: Ill-Treatment, "Moderate Physical Pressure," or Torture?* (March 1991); B'Tselem, *Information Sheet: Violence against Minors in Police Detention* (June–July 1990); Physicians for Human Rights, *Health Care in Detention: A Study of Israel's Treatment of Palestinians* (Boston, 1990); Middle East Watch, *Prison Conditions in Israel and the Occupied Territories* (New York: Human Rights Watch, 1991), pp. 16–19, 49–80; al-Haq, *A Nation under Siege: Annual Report on Human Rights in the Occupied Palestinian Territories* (Ramallah, 1990), Chapters 5, 7, pp. 512–22; Laila al-Hamdani, "A Palestinian Woman in an Israeli Prison: Personal Notes," in Khamsin Collective, *Women in the Middle East* (London: Zed Books, 1987), pp. 40–59; Women for Women Political Prisoners—Jerusalem, *Report* (1989), and *Semi-Annual Report* (January–June 1990); "Palestinian Journalist Freed from Israeli Jail," *New York Times*, March 8, 1991, p. A7; Sabra Chartrand, "Palestinian Indicted, Mainly for Work as Reporter," *New York Times*, March 17, 1991, p. 19.

125 "refrigerator" . . . "coffin": Chartrand, "Palestinian Indicted." Chartrand describes the "refrigerators" used by the Shin Bet as sixty-by-thirty-inch cells kept very cold with air conditioning. The same *Times* article reported that the Shin Bet also places some Palestinian prisoners in a long, narrow lobby with interrogation rooms on either side; this space is called the "bus" because prisoners are forced to sit on child-sized chairs a few inches high, with their hands tied behind their backs, filthy hoods on their heads, and all facing the same direction.

128 On deportation: Between the beginning of the intifada and the end of 1991, Israel deported sixty-seven people. See al-Haq, *Punishing a Nation: Human Rights Violations during the Palestinian Uprising, December 1987–December 1988* (Ramallah, 1989), Chapter 9 (also available in an edition published by South End Press, Boston); al-Haq, *Nation under Siege*, Chapter 8; al-Haq, *Human Rights Focus: Deportation* (Ramallah, March 7, 1991); Joost R. Hiltermann, "Israel's Deportation Policy in the Occupied West Bank and Gaza," *Palestine Year Book of International Law* 3 (1988). A third Labadi brother was deported in August 1989. See HC 792/88, Muhammed Mtour, 'Oda Ma'ali, Taysir 'Arouri, and Majed al-Labadi v. IDF, August 24, 1989.

132 On deaths in prison: al-Haq, *Punishing a Nation*, pp. 351–57; al-Haq, *Nation under Siege*, Chapter 5.

134 Itmar Luria: Ron Kampeas, "New Worries for Soldiers' Parents," *Jerusalem Post*, May 29, 1990, p. 6, reporting on a presentation by

Luria to a meeting of Parents against Erosion. The group of several hundred Israeli parents is concerned about the effect on their sons of the moral dilemmas faced by the young men when they serve in the territories. The parents attempt to cope with the dilemma and advocate a political rather than a military solution.

Chapter 9

137 "We told the *shabab*": Rita Giacaman and Penny Johnson, "Building Barricades and Breaking Barriers: Palestinian Women in the Intifada," in Zachary Lockman and Joel Beinen, *Intifada* (Boston: South End Press/Middle East Research and Information Project, 1989), p. 159.

138 They are reminiscent of those that appeared: Islah Jad, "From Salons to the Popular Committees: Palestinian Women, 1919–1989," in Jamal R. Nassar and Roger Heacock, *Intifada: Palestine at the Crossroads* (Ramallah and New York: Birzeit University and Praeger Press, 1991), p. 133.

138–39 *bayanat*: Translations of most of the *bayanat* issued between January 8 and November 22, 1988 (through number 29), can be found in Lockman and Beinin, *Intifada*, pp. 327–94. *Bayanat* are also reprinted in *Jerusalem* (published in Tunis by the Palestine Committee for NGOs), which is issued monthly, and in the press bulletins released by Sanabel Press Services in Jerusalem through 1990. Jamal R. Nassar and Roger Heacock, "The Revolutionary Transformation of the Palestinians under Occupation," in Nassar and Heacock, *Intifada*, includes some information about the composition of the UNLU (p. 197).

138 "Anniversary of Karameh": Karameh is a Jordanian valley village in which Palestinian guerrillas battled with the IDF in March 1968. *Bayan* number 53, about International Women's Day, quoted in Sanabel Press Services, "Daily Press Bulletin: March 6, 1990," p. 3.

139–40 The November 15, 1988, Palestinian Declaration of Independence: The PNC's discussion of the Declaration of Independence and its accompanying communiqué are discussed in Edward Said, "Intifada and Independence," in Lockman and Beinin, *Intifada*, pp. 14–16. Also see "Proclamation of the Independent Palestinian State" (Algiers, November 15, 1988), in Lockman and Beinin, *Intifada*, pp. 397–98, 399; Palestine National Council, "Political Communique" (Algiers, November 15, 1988), in Lockman and Beinin, *Intifada*, p. 402.

140 The pamphlet issued on October 1, 1988: Jad, "From Salons to the Popular Committees," p. 134.

140 "mother of the martyr": Giacaman and Johnson, "Building
 Barricades," p. 165.
140 there is no indication that women participated: Islah Abdul
 Jawwad, "The Evolution of the Political Role of the Palestinian
 Women's Movement in the Uprising," in Michael C. Hudson,
 ed., The Palestinians: New Directions (Washington, D.C.: George-
 town University Center for Contemporary Arab Studies, 1990),
 p. 71; Jad, "From Salons to the Popular Committees," p. 135.
 The UPWC says that its members participated in at least seven
 of the Ramallah/al-Bireh neighborhood guarding committees.
 Newsletter, July 1988, p. 4.
140 Before the intifada, middle-class women had moved: Rita Gia-
 caman, "Political Women in the Uprising: From Followers to
 Leaders?" (Unpublished paper, September 1988), p. 9.
141 "We told the shabab" . . . "daughter of the uprising": Giacaman
 and Johnson, "Building Barricades," pp. 159, 157.
141 A PFWAC newsletter tells the story: Newsletter (Palestine Fed-
 eration of Women's Action Committees), December 1989, pp.
 2–3.
141 Political discussion is no longer a male preserve: Giacaman
 and Johnson, "Building Barricades," p. 160.
142 the appointment of Leila Shahid as the Palestinian representa-
 tive: Shahid never assumed her duties in Ireland, the Irish
 government having decided not to change the status of the
 PLO entity there from information office to mission or delega-
 tion with diplomatic privileges. See Maher Abukhater, "Leila
 Shahid: Breaking the Stereotype," al-Fajr Weekly, July 23, 1990, p.
 11. Shahid currently represents the PLO in the Netherlands.
 See Nahla Al-Assaly: "The Palestinian National Movement and
 Its Perception of the Women's Role," in Women's Studies
 Committee, The Intifada and Some Women's Social Issues: A Confer-
 ence Held in Al-Quds Al-Sharif/Jerusalem on December 14, 1990
 (Ramallah: Women's Studies Committee/Bisan Center, 1991),
 pp. 12–13.
142–43 Papers presented by Palestinian scholars: Women's Studies
 Committee, The Intifada and Some Women's Social Issues includes
 the papers presented and the conference's recommendations,
 in Arabic, as well as English abstracts of the papers and
 recommendations. Among the papers collected, see Eileen
 Kuttab, "The Intifada and Some Women's Social Issues," pp.
 10–11; Islah Abdul Jawad, "Trends in the Social Relations
 within the Palestinian Family during the Intifada," pp. 14–15;
 Rema Hammami, "Women's Political Participation in the Inti-

fada: A Critical Overview," pp. 75–78, 81–82 (the full text of Hammami's paper is presented in the collection).

143 "provides us with the power": "In Their Own Words . . . ," *Voice of Women* (UPWWC newsletter), undated (probably early 1990).

143 "property to be married off": Quoted in Alex Fishman, "The Palestinian Woman and the Intifada," originally printed in *Hadashot*, republished in *New Outlook* (June/July 1989), p. 10.

143 Clothing has become even more of a political statement: See Hammami, "Women's Political Participation."

143–44 Another young researcher at the Nablus Women's Research Center: Interview with author.

144 Some scholars believe: Interviews with author.

144 they have made the abolition of the *shari'a* courts: Giacaman and Johnson, "Building Barricades," p. 24.

148 Israeli journalist Danny Rubenstein reported: Danny Rubenstein, "The Fruits of the Intifada," *Davar*, August 11, 1989, translated in *Israel Press Briefs* (International Center for Peace in the Middle East, Tel Aviv), September 1989, pp. 21–22.

151 It appears that marriages have increased: Ya'acov Lamdan, "Love, Marriage and the Intifada," *Jerusalem Post*, May 18, 1989, p. 7.

151 the combination of smaller wedding celebrations: Rita Giacaman, interview with author.

151–52 a survey described: Lamdan.

152 One of Palestine's leading novelists: Penny Johnson, "Uprising of a Novelist," *Women's Review of Books* (July 1990).

152 the birthrate has risen 150 percent: Rita Giacaman, interview with author, discussing results reported in Rita Giacaman and Penny Johnson, "Mother, Sister, Self: The Women of Nahalin" (Unpublished manuscript, Birzeit University, 1989); Lamdan, "Love, Marriage and the Intifada."

152 the chances of a child being killed have increased: B'Tselem, *Cases of Death and Injury of Children* (January 1990); Anne Elizabeth Nixon, *The Status of Palestinian Children during the Uprising in the Occupied Territories* (Swedish Save the Children and the Ford Foundation, 1990).

153 "the society is essentially conservative": Quoted in Fishman, "The Palestinian Woman and the Intifada," p. 10.

Chapter 10

155 "Women cannot work in the streets": Amal Khreisheh, interview with author.

156 These were promptly declared illegal: Educational Network,

Education during the Intifada (Ramallah, June 1990), p. 1; al-Haq,
*Punishing a Nation: Human Rights Violations during the Palestinian
Uprising, December 1987–December 1988* (Ramallah, 1989), pp.
420–23 (also available in an edition published by South
End Press, Boston); al-Haq, *A Nation under Siege: Annual Report on
Human Rights in the Occupied Palestinian Territories* (Ramallah,
1990), pp. 456–57; B'Tselem, *Closure of Schools and Other Setbacks
to the Education System in the Occupied Territories* (September–
October 1990), pp. 9–13.

159 "The first priority is the Palestinian national struggle": Rana
Nashashibi quoted in Randi Jo Land, "A Separate Peace?"
Jerusalem Post, June 29, 1989, p. 7. Also see Greer Fay Cashman,
"Defiant Palestinian Women," *Jerusalem Post,* April 6, 1990, p. 10.

165 Similar bracelets figure in an incident: A similar incident is told
by Gezina Schultz, a German volunteer in a Jerusalem orphan-
age, in Women for Women Political Prisoners—Jerusalem, *Re-
port* (1989), p. 25.

Chapter 11

173 "Only when both halves—men and women—work together":
Nablus man whose wife spent six months in prison on the
charge of working with a popular committee. Quoted in
Stephen J. Sosebee, "The Palestinian Women's Movement,"
American-Arab Affairs 32 (Spring 1990), p. 89.

173 In December, al-Haq and B'Tselem shared: See al-Haq, *A Nation
under Siege: Annual Report on Human Rights in the Occupied Palestin-
ian Territories* (Ramallah, 1990), pp. 669–72, for a discussion of
the al-Haq acceptance speech and of Jabarin.

173–74 Al-Haq field worker Sha'wan Jabarin: Affidavit of Jabarin, taken
by Israeli attorney Lea Tsemel. Al-Haq, *Nation under Siege,* pp.
625–27. Also see al-Haq, "Alert," October 12, 1989, and
"Update on Alert," October 13, 1989; Anthony Lewis, " 'You Are
a Dog,'" *New York Times,* October 22, 1989, "Self-Inflicted
Wound," *New York Times,* November 19, 1989, and "One Step for
Justice," *New York Times,* February 27, 1990, all on the OpEd
page. Jabarin's case is summarized in al-Haq, *Nation under Siege,*
pp. 617–18. Also see Joel Greenberg, "Letters Rarely Reach
Detainees, Say Families," *Jerusalem Post,* March 6, 1990, p. 10.

174 The Israeli government has issued a series of confusing replies:
Defense Minister Rabin's reply to President Carter's letter of
inquiry is discussed in al-Haq, *Nation under Siege,* pp. 628–29; a
discussion of the resolution of the European parliament on the
same subject, adopted on November 23, 1989, is on pp. 630–31.

President Carter persisted in his inquiries. As a result, in March 1990 the Ministry of Justice and the IDF court-martialed the sergeant in command of the soldiers who arrested Sha'wan. He was found guilty of brutality and conduct unbecoming a soldier, demoted to private, and given three months in prison and a suspended sentence of four months. Joel Greenberg, "Soldiers Faces [sic] Charges in Beating of Rights Activists," *Jerusalem Post*, January 29, 1990, p. 2; Lewis, "One Step"; Tamar Gaulan, advocate director, Human Rights and International Relations Department, Ministry of Justice, letter to author, March 15, 1990; Joel Greenberg, "Soldier Sentenced for Beating Palestinian Human Rights Worker," *Jerusalem Post*, June 19, 1990, p. 12.

174 ten days before the Greek Orthodox Christmas: Ben Lynfield, "Orthodox Christmas Becomes Funeral in Bethlehem," *Jerusalem Post*, January 8, 1990, p. 1; Ben Lynfield, "ABC Videotape Contradicts IDF Account of Bethlehem Shooting," *Jerusalem Post*, January 9, 1990, p. 1; Ben Lynfield, "Two Border Police Suspended in Bethlehem Killing Cover-up," *Jerusalem Post*, January 15, 1990, p. 8.

176–77 The standard of living in the territories has fallen. . . . The boycott of Israeli food continues: Reuters feature, April 15, 1989, reprinted as "Buy Palestinian" in AJME (Americans for Justice in the Middle East) *News* (May 1989), pp. 6–7. Also see Stanley Maron, "Could a Palestine [sic] State Survive Economically?" *Jerusalem Post*, December 24, 1989, p. 4; Jeff Black, "The Palestinians' Part-time Solution," *Jerusalem Post*, October 13, 1989, p. 14. In addition to the Royal Crown Cola and Club Cola factories in the West Bank there is a 7-Up franchise in Gaza.

177 it is extremely difficult to obtain capital: Joel Bainerman, "Palestinian Firms' Business Plans Are Being Shaped by the Intifada," *Jerusalem Post*, February 13, 1990, p. 10.

177 The government is making the situation even worse: Michal Sela, "Gazan Citrus Exporters Complain of 'Sabotage' at Ashdod Port," *Jerusalem Post*, November 23, 1989, p. 2; "EEC: Transportation Problems for Palestinian Agricultural Produce," *Jerusalem* 55 (December 1989), p. 51. The figure of 500 tons is in Ben Lynfield, "Bounty of Exports for West Bank," *Jerusalem Post*, February 6, 1990, p. 2, that of "over 600" in Peter Gubser, *Report to the ANERA Board of Directors: Peter Gubser's Middle East Trip, March 16–23, 1990* (Washington, D.C.: American Near East Refugee Aid, April 1990), p. 2. On Israeli interference with the Palestinian economy generally, see Joel Bainerman, "Palestin-

ian Right to Economic Freedom," *Jerusalem Post*, August 27, 1990, p. 4, in which Bainerman asks, "Has Israel turned the administered areas into a captive economic colony?" and answers that it has. He cites the problems deliberately created by the civil administration in the areas of arranging letters of credit, securing import permits, and issuing licenses to create or expand production lines and open new plants as well as the government's refusal to let Palestinian firms compete freely with Israeli companies in the Israeli marketplace and to let Israeli institutions buy West Bank produce. He concludes, "When the violence is used against Israeli troops, the army has the right to take any measures needed to quell those violent acts. Yet in the economic arena when we take equal measures without provocation we are doing it not for security reasons, but so our own inefficient enterprises can hide behind the security claim." Compare Meron Benvenisti, 1986 *Report: Demographic, Economic, Legal, Social and Political Developments in the West Bank* (Jerusalem: West Bank Data Base Project, 1986), pp. 8–10. Also see al-Haq, *Punishing a Nation: Human Rights Violations during the Palestinian Uprising, December 1987–December 1988* (Ramallah, 1989), Chapter 7 (also available in an edition published by South End Press, Boston); al-Haq, *Nation under Siege*, Chapter 12. A good short introduction to the economic situation can be found in Kate Rouhana, "The Crucial Economic War Heats Up," *Nation*, January 1, 1990, pp. 1, 18–20.

177 The Israeli administration will soon agree to permit Germany and Italy: Ben Lynfield, "Germany, Italy Fund Sewerage System for 100,000 West Bank Palestinians," *Jerusalem Post*, January 15, 1990, p. 1–3.

178 Following Elias Freij's threat: Joel Greenberg, "Transfer of Funds to Areas Eased," *Jerusalem Post*, March 7, 1990, p. 1.

178 To Jerusalem for a discussion with Charles Shamas: The view of the Palestinian state as high tech and export-driven is shared by at least one key PLO leader. See Milton Viorst, *Reaching for the Olive Branch* (Washington, D.C.: Middle East Institute, 1989), p. 116, quoting Nabil Sha'ath.

181 The Israeli press claims that she is a major figure: Ori Nir, "Zahira Kamal's Double Battle," *Ha'aretz*, January 26, 1990, p. 3; Jon Immanuel, "Changes in DFLP Reflect Growing Radicalization," *Jerusalem Post*, November 28, 1990, p. 1; Joel Greenberg, "Husseini and Others Barred from Foreign Travel," *Jerusalem Post*, January 7, 1990, p. 1. Zahira is described in Greenberg's

article as the head of the PFWAC "and a leading supporter of the Democratic Front for the Liberation of Palestine."

183–84 She and her parents went to East Jerusalem's al-Hakawati Theatre: Leila, interview with author. Also see Vivian Eden and Michal Sela, "Women's Groups March for Peace," *Jerusalem Post*, December 31, 1989, p. 2; "Officers Break Up a March in Israel," *New York Times*, December 30, 1989, p. 2.

185 The law also permits detainees from the territories: Military order 378, which also permits a prisoner to be held for eighteen days without being taken before a judge. HC 670/89, Audeh et al. v. Commanders of the Military Forces, published November 12, 1989. Also see Joel Greenberg, "High Court Backs Up Palestinians on IDF Failure to Notify of Arrests," *Jerusalem Post*, November 23, 1989, p. 2. An English summary and partial translation can be found in Asher Felix Landau, "Rights of Detainees," *Jerusalem Post*, December 6, 1989, p. 5; "Statement from the Office of the State Attorney to the Israeli High Court of Justice concerning the Notification of Families after an Arrest," HC 670/89, reprinted in al-Haq, *Nation under Siege*, pp. 281–84.

186–87 Another member of the group, journalist Michal Schwartz: Andy Court, "High Court Delays Ruling on Leftist Editor," *Jerusalem Post*, May 3, 1988, p. 2; Devorah Getzler, "Leftist Editors Facing up to 40 Years in Jail," *Jerusalem Post*, May 24, 1988, p. 1; Devorah Getzler, " 'Derech Hanitzotz' Leftists Hear Security Charges," *Jerusalem Post*, May 26, 1988, p. 4; "Prison Hunger Strike," *Jerusalem Post*, July 18, 1988, p. 10; Devorah Getzler, "Jailed Journalists' Parents Protest 'Punitive Isolation,'" *Jerusalem Post*, July 19, 1988, p. 2; Oscar Franklin, " 'Derech Hanitzotz' Editors Admit Charges and Get Short Jail Terms," *Jerusalem Post*, January 26, 1989, p. 1.

189 "The illiterate women have done very well": Eileen Kuttab quoted in Sharon Rose, "Women and the Intifada: Interview with Eileen Kuttab," *Palestine Focus* (November–December 1989), p. 8.

189 We pass numerous army encampments: B'Tselem, *Information Sheet, Update April 1990: IDF Posts on Private Homes*.

189–90 The diversion of water from Palestinian land: Rouhana, "Crucial Economic War," p. 18; Benvenisti, 1986 *Report*, p. 10; "Water: the Approaching Thirst," *Tanmiya* 22 (March 1991), pp. 1–4 (published in Geneva by the Welfare Association). The *Tanmiya* article states that Jewish West Bank settlers use 965 cubic meters of water per capita per year; Israelis within the Green

Line, 537; Palestinians in the West Bank, 160. This means that Palestinians are permitted to use only 20 percent of the water in the West Bank. See the chart on p. 3 of the article.

191 A letter to that effect: The January 19 letter can be found in *Israeli-Palestinian Digest* (March 1990), p. 9. The March memorandum is reprinted in Sanabel Press Services, "Daily Press Bulletin: March 6, 1990," pp. 5–6.

191–92 In August 1990, the three will again be the only women: Jon Immanuel, "16 MKs Meet with Palestinians to Discuss Guidelines for Peace," *Jerusalem Post*, August 6, 1990, p. 8.

192 The press reports that the PLO has in effect written off: "Shamir: We Need the Areas to Settle Soviet Immigrants," *Jerusalem Post*, January 15, p. 1; "PLO Writes Off East Bloc, Turns to West," *Jerusalem Post*, January 21, p. 2; Joel Greenberg, "Hamas Calls General Strike to Protest Immigration Wave," *Jerusalem Post*, January 25, p. 10; Joel Greenberg, "Intifada Call for Force to Halt Aliya," *Jerusalem Post*, February 16, p. 1; Jerry Lewis, "Don't Settle Soviet Jews in Areas, Thatcher Warns," *Jerusalem Post*, February 20, p. 2.

192 the IDF will announce a Shamir-approved order: David Makovsky and Herb Keinon, "Uproar over Censorship on Soviet Aliya Leads Jerusalem to a Redefinition," *Jerusalem Post*, March 5, 1990, p. 1.

Chapter 12

195 "We don't do that anymore": East Jerusalem merchant to author, speaking about the sale of Israeli products.

195–96 On May 20, an allegedly insane Israeli: Matthew Seriphs, "Massacre Refuels the Intifada," *Jerusalem Post*, May 21, 1990, p. 1; Yoram Bar, "Murder Suspect Went on Rampage because 'Girlfriend Left Him,'" *Jerusalem Post*, May 21, 1990, p. 1; David Rudge, " 'Relative Quiet' Returns to Arab Towns in North," *Jerusalem Post*, May 23, 1990, p. 1; Ron Kampeas and Asher Wallfish, "Hunger Strike Called in Wake of Massacre," *Jerusalem Post*, May 22, 1990, p. 1; Matthew Seriphs, "Three Gazans Collapse during Hunger Strike," *Jerusalem Post*, May 29, 1990, p. 14; "Amnesty Raps Israel for Arabs' Deaths," *Jerusalem Post*, May 23, 1990, p. 1; Youssef M. Ibrahim, "Bombing in Jerusalem Kills Jewish Man," *New York Times*, May 29, 1990, p. A3; Ron Kampeas, "One Dead, Nine Injured in Jerusalem Bombing," *Jerusalem Post*, May 29, 1990, p. 1; Bill Hutman, "Crowd Vents Anger on Arabs after Blast," *Jerusalem Post*, May 29, 1990, p. 1; Joshua Brilliant, "IDF Thwarts Attack by Terrorists by Libya," *Jerusalem Post*, May 31,

1990, p. 1; Joel Brinkley, "Shamir Toughens Line on Negotiations," New York Times, June 14, 1990, p. A3. The killer eventually was sentenced to life imprisonment.

196 On the day after the Rishon Lezion murders: David Rudge, " 'Relative Quiet' Returns to Arab Towns in North," Jerusalem Post, May 23, 1990, p. 1.

196–97 Since the massive violence and curfews in May: Matthew Seriphs, "New Open-Fire Regulation Reduces Casualties in Gaza," Jerusalem Post, May 29, 1990, p. 2; Joel Greenberg, "Intifada Toll Hits New Low," Jerusalem Post, July 2, 1990, p. 1; Jon Immanuel and Matthew Seriphs, "Downward Trend in Palestinian Deaths in Territories Reported," Jerusalem Post, August 2, 1990, p. 10; Hisham Abdallah, "New Army Policy Changes Nothing, Say Palestinians," al-Fajr Weekly, July 23, 1990, p. 3.

197 There are more killings of collaborators: B'Tselem, Information Sheet, Update November 1, 1989, English version, p. 21; al-Haq, A Nation under Siege: Annual Report on Human Rights in the Occupied Palestinian Territories (Ramallah, 1990), Chapter 4.

200–202 The trial of Colonel Yehuda Meir is concluding: Joshua Brilliant, " 'Not Guilty' Plea at 'Break Bones' Trial," Jerusalem Post, Mar. 30, 1990, p. 18; "Officer: 'I Looked the Other Way,' " Jerusalem Post, April 2, 1990, p. 10; " 'Meir Said Break Arms and Legs,' Lieutenant Testifies," Jerusalem Post, April 13, 1990, p. 2; Joshua Brilliant, "Meir Insists Military Had Two Policies on Beatings," Jerusalem Post, June 28, 1990, p. 1; Joshua Brilliant, "Meir Says Beatings Authorized," Jerusalem Post, June 29, 1990, p. 18; Joshua Brilliant, "Officer: Rabin and Shomron Ordered Beatings," Jerusalem Post, July 1, 1990, p. 8.

201 A sergeant testified that he and a medic: "Officer: 'I Looked the Other Way,' " Jerusalem Post, April 2, 1990, p. 10; Middle East Watch, The Israeli Army and the Intifada: Policies That Contribute to the Killings (New York: Human Rights Watch, 1990), pp. 180–86; Asher Wallfish, "MKs Want to Know Who's Responsible for Beatings," Jerusalem Post, July 3, 1990, p. 1; Asher Wallfish, "Calls for Beatings Inquiry Continues to Gather Steam," Jerusalem Post, July 4, 1990, p. 2.

201–202 many such incidents have occurred and nothing has been done about them: Middle East Watch, Israeli Army, Chapter 2; Amnesty International, Killings by Israeli Forces (London, January 2, 1990); B'Tselem, The Use of Firearms by the Security Forces in the Occupied Territories (July 1990); al-Haq, Nation under Siege, Chapters 1, 5.

202 In April 1991, Meir will be found guilty: Bradley Burston, "Col.

Meir Found Guilty of Ordering Beatings," *Jerusalem Post*, Apr. 9, 1991, p. 1; "IDF Lawyers to Let Meir's Sentence Stand Unchallenged," *Jerusalem Post*, May 9, 1991, p. 10. Following Meir's conviction, the IDF's chief education officer produced a publication for soldiers entitled "The Black Flag Has Been Hoisted," dealing with the implications of the case and the obligation to refuse illegal orders. Asher Wallfish, "IDF Seeks to Hoist the 'Black Flag,'" *Jerusalem Post*, May 21, 1991, p. 1. In June, ACRI reported that IDF police were questioning members of the secret unit about the Kafr al-Deek beating. "Trial of Former Army Colonel Reveals Other Army Atrocities," *al-Fajr Weekly*, July 1, 1991, p. 3.

204–205 A presentation by three West Bank economists: Hisham Abdallah, "Palestinians Work to Develop Local Economy," *al-Fajr Weekly*, July 23, 1990, p. 8, reporting on an al-Najah University seminar entitled "Industrialization in the West Bank" as well as on the Nicosia fair and the press conference. Joel Bainerman, "Palestinians Progress Slowly to Industrial Self-Sufficiency," *Jerusalem Post*, July 23, 1990, p. 11.

205 The 1989–1990 season of direct agricultural exports to Europe: Ben Lynfield, "Bounty of Exports for West Bank," *Jerusalem Post*, February 6, 1990, p. 2.

205 Israeli farmers are complaining bitterly: Asher Wallfish, "Produce and Intifada," *Jerusalem Post*, July 12, 1990, p. 2; Asher Wallfish, "Farmers See Red Ink over the Green Line," *Jerusalem Post*, July 18, 1990, p. 8. Israeli officials said that as of the summer of 1990, forty trucks a day carrying Palestinian fruit, vegetables, and olive oil regularly crossed the Allenby Bridge into Jordan, their loads destined for Jordan and other Arab states, and that commerce with Arab states brought the Palestinian economy an estimated tens of millions of dollars per year. Joel Brinkley, "Israel Says It Will Block Exports Bound for Iraq at Jordan's Border," *New York Times*, August 27, 1990, p. A8.

205 the ministry of agriculture's restriction on importing seeds: Wallfish, "Farmers See Red Ink."

205 the refusal of Israel to grant licenses: Bainerman, "Palestinians Progress Slowly." The lists of products are found in Bainerman.

206 She's still here because the authorities won't give her a *laizzez-passer*: B'Tselem, "Restrictions on Foreign Travel," *Information Sheet, Update November 1989*.

210 A PFWAC newsletter . . . estimated that fifteen thousand West Bank women: "Women Factory Workers," *Newsletter* (Palestine Federation of Women's Action Committees), December 1989, p.

4. The Israeli estimate of the size of the textile industry in the West Bank is more than four thousand workers. The differential presumably is explained by the lack of a major attempt by Israeli officials to collect such statistics and by the limiting inquiries they do make to better-known factories, thereby excluding women in the smaller workshops and those who do piecework at home. Joel Bainerman, "Ramallah Firm Finds Niche in European Textile Trade," *Jerusalem Post*, August 14, 1990, p. 9.

211 the large Silvana Company: Suha Hindiyeh, interview with author.

211 Unions recently have persuaded garment factory owners: Randa Siniora, interview with author.

211–12 The data already in suggest: Suha Hindiyeh and the Women's Resource and Research Center, "Socio-Economic Conditions of Female Wage Labour in the West Bank" (Paper presented at the Fourth International Interdisciplinary Congress on Women, Hunter College, New York, June 1989), pp. 4–7.

212 She had been permitted to leave the country briefly: Jon Immanuel and Matthew Seriphs, "Hussaini, 2 Others, Barred from Leaving the Country," *Jerusalem Post*, August 21, 1990, p. 10; Jon Immanuel, "Eight Injured in Clashes," *Jerusalem Post*, January 8, 1991, p. 12.

213 "development cannot happen": Eileen Kuttab quoted in Sharon Rose, "Women and the Intifada: Interview with Eileen Kuttab," *Palestine Focus* (November–December 1989).

Chapter 13

215 "If the Koran is the soul of Islam": Halim Baraket, "The Arab Family and the Challenge of Social Transformation," in Elizabeth Warnock Fernea, ed., *Women and the Family in the Middle East* (Austin: University of Texas, 1985), p. 28.

215–16 Islamic Jihad: Jean-François Legrain, "The Islamic Movement and the Intifada," in Jamal R. Nassar and Roger Heacock, *Intifada: Palestine at the Crossroads* (Ramallah and New York: Birzeit University and Praeger Press, 1991), pp. 178–87; Lisa Taraki, interview with author; Lisa Taraki, "The Islamic Resistance Movement in the Palestinian Uprising," in Zachary Lockman and Joel Beinen, *Intifada* (Boston: South End Press/Middle East Research and Information Project, 1989), p. 176.

216 Its thirty-six-article Mithaq: Don Peretz, *Intifada: The Palestinian Uprising* (Boulder: Westview Press, 1990), pp. 104–6; Taraki, "Islamic Resistance Movement," pp. 174–75. Also see Joel

Greenberg, "An Encounter with Hamas," *Jerusalem Post*, March 30, 1990, p. 6.

216 The Israeli defense ministry, recognizing Hamas's growing influence: Michal Sela, "Defence Ministry Outlaws Islamic Movement Hamas," *Jerusalem Post*, September 29, 1989, p. 1; Ben Lynfield, "More than 100 Arrested as IDF Raids Hebron Area," *Jerusalem Post*, January 21, 1990, p. 8 (about election by Gaza's twelve hundred physicians of representatives to the Gaza Medical Association); "Gaza Professionals Prefer Nationalists," *Jerusalem* 57 (February 1990), p. 17; Ben Lynfield, " 'Peace Steps Could Spark Gaza War between PLO and Hamas Backers,' " *Jerusalem Post*, February 15, 1990, p. 2.

216 the widely rumored Israeli policy of channeling money: See Yehuda Litani, *Jerusalem Post*, September 8, 1988, cited in Taraki, "Islamic Resistance Movement," p. 413 n. 2. A study by the Gaza Community Mental Health Program in March 1991 and another by the Jerusalem-based Arab Center for Research Studies in January and April gauged fundamentalist support in the territories at about 20–25 percent. Jon Immanuel, "Surveys Show Support for Moslem Hardliners Weaker than Believed," *Jerusalem Post*, May 7, 1991, p. 1. These numbers seem unrealistically low to me. In June 1991, representatives to the Hebron Chamber of Commerce were elected in the first West Bank election since 1976. Fundamentalists won six seats; PLO supporters, 4; independents, 1. Joel Brinkley, "A West Bank Business Chamber Votes for Islamic Fundamentalists," *New York Times*, June 20, 1991, p. A10. Hebron is the West Bank's most heavily fundamentalist city. It was nonetheless pro-Fateh candidates who won almost all the seats in the July 1991 elections to the Hebron Red Crescent. Secularists won all the seats on the Jericho Chamber of Commerce during the same month as well as all positions on the Arab Journalists Association's administrative board the following month. PLO supporters won 13 out of 16 seats in the November 5, 1991 election to the Gaza Chamber of Commerce. It should be noted, however, that the votes were cast by members of the relatively conservative professional and business classes, who probably are not representative of the political sympathies of most Palestinians. Even so, the percentage of the vote received by PLO supporters in the Gaza election was 53, that of Hamas 40, and that of four independent candidates, 7. "Weekly Review," *al-Fajr Weekly*, August 5, 1991, p. 12; "National block wins AJA administration elections," *al-Fajr Weekly*, August 5, 1991, p. 13; Clyde Haber-

man, "Gaza Voting Favors Arab Moderates," *New York Times*, November 6, 1991, p. A17.

216 Hamas is not part of the Unified National Leadership: Joel Greenberg, "Rubber Bullet Kills Arab Passerby," *Jerusalem Post*, March 19, 1990, p. 10; Joel Greenberg, "Call for Escalated Clashes on Land Day," *Jerusalem Post*, March 27, 1990, p. 12; "Abu Iyad Warns of Radicalization," *Jerusalem Post*, November 24, 1989, p. 18.

217 Zahira Kamal and other women called on the UNLU to cover the issue prominently: Rema Hammami, "Women's Political Participation in the Intifada: A Critical Overview," in Women's Studies Committee, *The Intifada and Some Women's Social Issues: A Conference Held in Al-Quds Al-Sharif/Jerusalem on December* 14, 1990 (Ramallah: Women's Studies Committee/Bisan Center, 1991), p. 80. An appendix to *bayan* 43 was distributed in Gaza, where the problem is much more serious. It said, in part, "1) We are against excessive vanity in personal dress and use of cosmetics during these times. . . . 3) We should value highly the role women have played in our society during these times. . . . 4) The phenomenon of harassing women contradicts the traditions and norms of our society as well as our accepted attitudes about women. At the same time it denigrates the patriotism and humanity of each female citizen. 5) Nobody has the right to accost women and girls in the street on the basis of their dress or the absence of a headscarf. 6) The Unified National Leadership will chase these hooligans and will stop such immature and unpatriotic actions." It is unclear why these points were put into an appendix rather than the body of the *bayan* or why the appendix was distributed only in Gaza. It can be speculated that the Leadership simply did not believe the problem to be serious enough in general and in the West Bank in particular to merit its full attention.

218 In an apparent attempt to unify Palestinians and co-opt Hamas: Joel Greenberg, "Hamas's Militant Stand on Joining the PNC," *Jerusalem Post*, April 13, 1990, p. 16. Hamas had informed Sheikh Abdul Hamid As-Sayih, chairman of the PNC, that one of its demands was issuance of a PLO statement declaring, " 'the land of Palestine, from the sea to the river and from the Negev to Ras el-Naqura [Rosh Hanikra, in the north of Israel], is one indivisible unit and belongs to the Palestinian people.' " "Hamas: 'From the Sea to the River,' " *Jerusalem Post*, December 19, 1990, p. 8.

218 The PLO's anger became apparent: Ben Lynfield, "PLO Warns Hamas to Stay in Line," *Jerusalem Post*, July 7, 1990, p. 1.

218 Ten days earlier, masked Hamas supporters . . . Fateh support-
 ers countered: Joel Greenberg and Matthew Seriphs, "Id al-
 Adha Marked by Nationalist Protests," *Jerusalem Post*, July 3,
 1990, p. 10.

218–19 Hamas replied to the PLO's condemnation: Joel Greenberg,
 "Hamas Scores Attempts to Renew U.S.-PLO Talks," *Jerusalem
 Post*, July 10, 1990, p. 10; also see Matthew Seriphs and Jon
 Immanuel, "Shots Fired at IDF Patrol near Hebron," *Jerusalem
 Post*, August 19, 1990, p. 8. Fateh and Hamas followers clashed
 sporadically throughout 1990 and 1991 while leaders of the two
 entities tried to make peace between them. See, for example,
 Matthew Seriphs and Jon Immanuel, "Hamas, Fatah Attempt-
 ing to Make Peace," *Jerusalem Post*, September 19, 1990, p. 16;
 Jon Immanuel, "Strike in Nablus over Attack on Hamas Man,"
 Jerusalem Post, September 24, 1990, p. 10; Jon Immanuel, "Masked
 Youth Wounded; New Leaflet Is Issued," *Jerusalem Post*, October
 2, 1990, p. 10. UNLU leaflet 70, issued in May 1991, said that
 people were to obey only strikes called by the UNLU or Hamas,
 thereby expressing both the Leadership's disapproval of a
 strike called by the Jihad for May 6 and implicitly endorsing
 Hamas strikes.

220–21 The Bisan center, convinced that the fundamentalists:
 Women's Studies Committee, *The Intifada*; Basem Tawfeeq,
 "Openness and Frankness Dominate Discussion on Women's
 Role," *al-Fajr Weekly*, December 24, 1990, p. 8.

221 "The number of women wearing Muslim dress": "In Their Own
 Words . . . ," *Voice of Women* (UPWWC newsletter), undated (prob-
 ably early 1990), p. 2.

222 "by providing the necessities at home": Quoted in Stephen J.
 Sosebee, "The Palestinian Women's Movement," *American-Arab
 Affairs* 32 (Spring 1990), p. 82.

223–24 "1. The establishment of an independent Palestinian state":
 "When Can We Have Birth Control?," *Voice of Women* (UPWWC
 newsletter), September 1989.

224 The major form of birth control in the West Bank: Salwa
 al-Najab, interview with author.

225 "5. The feminist movement should work": "When Can We Have
 Birth Control?"

225 "What are the safeguards": "The Intifada and the Role of
 Palestinian Women," *Voice of Women* (UPWWC newsletter), Sep-
 tember 1989, pp. 1, 10; "The Occupation Robbed Me of My
 Husband and Backward Tradition Took My Child," *Voice of
 Women* (UPWWC newsletter), September 1989, pp. 5–6.

225 Calling for an "in-depth analytical review": *Voice of Women* (UPWWC newsletter), September 1989, p. 4.

226 "Women in this state ... must also continue fighting": Editorial, "The Victory of Independence Is a Victory for Women," *Newsletter* (Palestinian Federation of Women's Action Committees), March 1989, p. 2.

226 "I notice that women in the refugee camps": Randa Siniora, "In Their Own Words . . . ," p. 3.

Chapter 14

229 "If they want us to work with them": Idna women's committee member, interview with author.

229 The perspective of most Palestinian women on reproductive freedom: Salwa al-Najab, interview with author; UPMRC, *Objectives, Organization, and Activities, 1979–1990* (Jerusalem, 1990), pp. 1–2.

230 Almost half of the 489 localities in the West Bank: UPMRC, *An Overview of Health Conditions and Services in the Israeli Occupied Territories* (Jerusalem, August 1987), p. 13, citing Union of Physicians, West Bank, *Primary Health Care in the West Bank* (Jerusalem, 1986), p. 4.

230 There is only one pathology laboratory ... patients referred by Palestinian doctors: Salwa al-Najab, interview with author.

230 at least 70 percent of the territories' population have no health insurance: UPMRC, *Overview*, p. 3. In early 1991, over the objections of Hadassah Hospital's director-general, the government removed his power to decide which territories' residents should be admitted because they could not be treated adequately elsewhere. The new policy was that the civil administration would no longer pay for treatment of uninsured Palestinians, no matter what the condition of the potential patient. The immediate result was that when a child from the territories who had suffered burns over 75 percent of his body in a household accident arrived at Hadassah's emergency room, the civil administration dispatched an ambulance to transfer him to a Hebron hospital after ascertaining that he had no health insurance. The child died. Judy Siegel and Jon Immanuel, "Change Enacted in Hospital Care Policy at Hadassah for Uninsured Area Arabs," *Jerusalem Post*, June 5, 1991, p. 10.

230 Soldiers frequently interfere with ambulances: In May 1991, a woman from Ya'abad in a taxi on her way to Jenin Hospital to give birth was stopped by soldiers for an hour at a roadblock, although there was no curfew in Jenin at the time and both the

husband and the midwife explained to the soldiers that the woman had potentially dangerous high blood pressure. The midwife had to deliver the child in the taxi. B'Tselem joined a Palestinian gynecologist in asking the IDF to take action against the soldiers at the roadblock, apparently without success. Jon Immanuel, " 'Arab Woman Gives Birth in Car at IDF Roadblock,' " *Jerusalem Post*, June 5, 1991, p. 10.

230–31 Some commentators view the UPMRC as the model: See, for example, Don Peretz, *Intifada: The Palestinian Uprising* (Boulder: Westview Press, 1990), p. 88.

231 Whatever the genesis of the grassroots idea: Salwa al-Najab, interview with author.

231 a study it did of the West Bank village of Biddu: UPMRC and Community Health Unit, Birzeit University, "Profile of Life and Health in Biddu: Interim Report" (Unpublished, 1987).

231–32 A recent United States study: White House Task Force on Infant Mortality, cited in Robert Pear, "Study Says U.S. Needs to Attack Infant Mortality," *New York Times*, p. A1.

232 "with a national commitment and accessible health services": Quoted in ibid.

232 A joint study . . . revealed a malnutrition rate: UPMRC, *Overview*, p. 10, citing UPMRC and Community Health Unit, Birzeit University, "A Survey of Health Conditions in Ain al-Dyouk" (Unpublished, 1987).

232 A study of three villages in the Ramallah area: Ibid., p. 22.

232 It was therefore not surprising: UPMRC, *Overview*, p. 23, citing UPMRC and Community Health Unit, "Profile of Life and Health in Biddu."

234 It involves Suheila: Interviews with PFWAC leaders; *Newsletter* (Palestinian Federation of Women's Action Committees), March 1990, pp. 7–8.

236 The UPWC had a lesson in Hebron traditionalism: Sharon Rose, "Women and the Intifada: Interview with Eileen Kuttab," *Palestine Focus* (November–December 1989), p. 8.

236 On July 3, three young men were killed: Beth Goldring, editor of Sanabel Press, interview with author.

Chapter 15

245 "This area is becoming a jungle": Faisal al-Husseini quoted in Youssef M. Ibrahim, "Palestinians Find Life More Bitter Than Ever," *New York Times*, January 13, 1991, p. 1

245 "Democracy is not a choice for us": Izzat Abdul-Hadi, interview with author.

245 Of the nearly four hundred thousand Palestinians: John H. Cushman, Jr., "Under Harassment, Many Palestinians in Kuwait See No Choice but to Leave," *New York Times*, June 9, 1991, p. 3.

245 The infusion of Arab money into the territories: Joel Brinkley, "Israel Says It Will Block Exports Bound for Iraq at Jordan's Border," *New York Times*, August 27, 1990, p. A8; Jacob Wirtschafter, "Arab Investors Making Plans to Fill Bank-Service Vacuum in Territories," *Jerusalem Post*, August 30, 1990, p. 6; Jon Immanuel, "Palestinian Plight Worsens as Gulf State Expulsions Rise," *Jerusalem Post*, September 11, 1990, p. 1; " 'PLO Income Halved since Iraq Invasion,' " *Jerusalem Post*, December 5, 1990, p. 8; Jon Immanuel, "Refugee Camps' Residents Appeal for More UNRWA Help," *Jerusalem Post*, January 4, 1991, p. 18; "Gulf States Suspend Aid to PLO and Jordan," *Jerusalem Post*, March 31, 1991, p. 1.

245–46 Then, in October 1990, Border Police killed: B'Tselem, *Loss of Control: The Temple Mount Events* (October 1990); Association of Israeli-Palestinian Physicians for Human Rights, "The Temple Mount Report," in *Annual Report 1990* (Tel Aviv, 1991), pp. 38–40; "Death in Jerusalem: Passions and Violence Led to Tragedy," *New York Times*, Oct. 14, 1990, p. A1; Middle East Watch, "Middle East Watch Deplores Excessive Use of Force by Israeli Police," October 9, 1990; "Judge Finds Zamir Commission Report Not Fair to Aqsa Events," *al-Fajr Weekly*, May 20, 1991, p. 2, citing *Hadashot*, May 14, 1991; Bradley Burston, Michael Rotem, and Asher Wallfish, "IDF Pours into Areas, Seals Off Population," *Jerusalem Post*, October 25, 1990, p. 1; David Makovsky, "Zamir Panel Justified Firing on Temple Mt.," *Jerusalem Post*, October 28, 1990, p. 1; Larry Derfner et al., "Thousands of Palestinian Workers Exit; Some Israelis Ebullient over Ban," *Jerusalem Post*, October 25, 1990, p. 1; Larry Derfner et al., "Employers Seize the Opportunity to Replace Work Force from Areas," *Jerusalem Post*, October 29, 1990, p. 1; Alisa Odenheimer and David Makovsky, "Plan to Limit Arab Labor Meets Arens's Roadblock," *Jerusalem Post*, November 19, 1990, p. 8; Joel Brinkley, "Israel Sends Snipers to Stop Car Stonings," *New York Times*, December 13, 1990, p. A3; David Makovsky et al., "Israel Won't Assist UN Probe of Temple Mt. Riot," *Jerusalem Post*, October 15, 1990, p. 1; "Report by U.N. on Arabs," *New York Times*, November 2, 1990, p. A10; David Makovsky, "Damage Control behind Decision to Accept Envoy," *Jerusalem Post*, November 14, 1990, p. 1; David Makovsky et al., "4 Intifada Leaders Ordered Expelled," *Jerusalem Post*, December 16, 1990, p. 1; Bradley Burston, "Expulsion

of Four Hamas Leaders May Be Harbinger of More to Come," *Jerusalem Post*, December 17, 1990, p. 1; "Tighter Security Jams Tel Aviv Roads," *Jerusalem Post*, December 5, 1990, p. 1; Michael Rotem, "Hamas Members Rounded Up in Mass Arrests in Territories" (following murder of three Israelis in Jaffa), *Jerusalem Post*, December 16, 1990, p. 1.

246 There was a spate of attacks on Israeli civilians: At the end of April, 1991, the IDF said that thirty-one Israeli civilians, eight soldiers, and four tourists were killed by Palestinians during the intifada. B'Tselem's figures were thirteen civilians, twelve soldiers, and one tourist. B'Tselem press release, May 2, 1991.

246–47 "From the point of view of the Palestinian man" . . . "a deepening rift between Arabs and Jews" . . . "This area is becoming a jungle": Hanna Siniora, Elias Freij, and Faisal al-Husseini, respectively, quoted in Ibrahim, "Palestinians Find Life More Bitter."

247 Israel distributed gas mask kits to its citizens: Jon Immanuel and Bradley Burston, "High Court Orders IDF to Give Masks to Arabs in Territories," *Jerusalem Post*, January 15, 1991, p. 1; Asher Felix Landau, "Defense Kits and Discrimination," *Jerusalem Post*, January 30, p. 5, translating and summarizing HC 168/91, Marcos v. Minister of Defense et al. January 14, 1991.

248–49 The entire Palestinian population of the territories: Jon Immanuel, "Curfews to Prevent Deadline Day Disorders," *Jerusalem Post*, January 17, 1991, p. 10; Jon Immanuel, "Judea/Samaria Curfew Lifted for 3 Hours," *Jerusalem Post*, January 21, 1991, p. 10 c. 6; Jon Immanuel, "Areas' curfews lifted temporarily," *Jerusalem Post*, January 22, 1991, p. 10; Jon Immanuel, "Palestinians Fear Month-long Curfew," *Jerusalem Post*, January 25, 1991, p. 18; Jon Immanuel, "Palestinians Are Short of Money, Food," *Jerusalem Post*, January 31, 1991, p. 10; UNRWA press release, January 31; Jon Immanuel, "Curfew Eased, but Economy Suffering," *Jerusalem Post*, February 1, 1991, p. 18; Jon Immanuel, "UNRWA Begins Distribution of Food in Territories," *Jerusalem Post*, February 3, 1991, p. 2; Jon Immanuel, "Curfew in Areas to Last as Long as Missile Raids," *Jerusalem Post*, February 4, 1991, p. 10; Jon Immanuel, "Economy in Territories on Verge of Collapse," *Jerusalem Post*, February 8, 1991, p. 15; al-Haq, press release, January 29; Association of Israeli-Palestinian Physicians for Human Rights, press release, February 20; Association of Israeli-Palestinian Physicians for Human Rights, *Activities Report* (January–February 1991), pp. 19–29; Penny Johnson, "Letter from the Curfew Zone," *Middle East Report* (May–June 1991), pp. 38–39; Jon

Immanuel, "UNRWA Head: Food Situation in Territories near Critical," *Jerusalem Post*, March 13, 1991, p. 12; Jonathan Schacter, "UN Report Slams Israel," *Jerusalem Post*, April 1, 1991, p. 2; Frank Collins, "The Rescue of the Palestinian Economy," *al-Fajr Weekly*, June 3, 1991, p. 5.

248 The IDF said it had no children's masks. . . . At Ketziot, . . . Israeli guards put on their gas masks: Jon Immanuel, "Unrwa Asks Several Countries for Gas Masks for Palestinians," *Jerusalem Post*, January 24, 1991, p. 10; Jon Immanuel, "High Court Turns Down Request for Gas Mask Distribution in Ketziot," *Jerusalem Post*, January 29, 1991, p. 10; Jon Immanuel, "Kalkilya's Regular Missile Spotters Get Their First Close View of a SCUD," *Jerusalem Post*, January 30, 1991, p. 10; Jon Immanuel, "More Masks for West Bank," *Jerusalem Post*, February 15, 1991, p. 18, which said, "Distribution of masks for children is to begin next week."

249 The Association of Israeli-Palestinian Physicians for Human Rights . . . defied the curfew: Harriet Lewis and Anat Reisman-Levy, "Peace Activity," *New Outlook Newservice*, February 21, 1991, p. 3; Dorit Abramovich, "A Blatant Disregard for Human Life," *Challenge*, 2, no. 2, p. 24.

249 Economist Samir Halailech estimated: Jon Immanuel, "Quota on Area Workers Lifted," *Jerusalem Post*, February 2, 1991, p. 10.

249 UNRWA's commissioner general said that the food situation: Immanuel, "UNRWA Head: Food Situation in Territories."

249 After the war, as many as a third: al-Haq, *Human Rights Focus: Restriction of Access to and Through East Jerusalem* (Ramallah, April 4, 1991); Jon Immanuel, "75,000 Permits Granted to Areas' Workers," *Jerusalem Post*, April 2, 1991, p. 1; also see Jon Immanuel, "Shots Fired at Second Car as Ramallah Crime Probed," *Jerusalem Post*, March 28, 1991, p. 10.

249 The New York–based Catholic Near East Welfare Association: Jerusalem Press Service (Washington, D.C.), daily report, June 18, 1991, p. 5. See Co-ordinating Committee of International NGOs, "Update," February 28, March 26, May 24, and June 17, 1991, and its "Press Statement," May 8, 1991, all available from Catholic Near East Welfare Association.

252 The manager of a Bethlehem weaving firm: Sami Abu Ghazaleh, "Palestinian Industry Waiting for Relief but Getting Nothing," *al-Fajr Weekly*, May 6, 1991, p. 9.

252 It will be a month before Prime Minister Shamir makes explicit: Bill Hutman, "Home for Immigrants from Addis inside Year," *Jerusalem Post*, June 3, 1991, p. 1; Joel Brinkley, "Israel Sets New Condition for Joining Peace Talks," *New York Times*, June 11,

1991, p. A10. Two Knesset members, relying on housing ministry figures, reported that the ministry had built or was planning to build twelve thousand housing units for fifty thousand settlers in the territories in 1991–1993. Dedi Zucker and Chaim Oron, "Report on the Construction of Jewish Settlements in the Occupied Territories," *Journal of Palestine Studies* 20 (Spring 1991), pp. 151–53.

256 "Unfortunately, women's role in the street": "An Experience," *Voice of Women* (UPWWC newsletter) 1, no. 5 (1990), p. 3.

257 Each permit requires repeated visits: "Exit Permits Resumed," *al-Fajr Weekly*, May 10, 1991, p. 13, announcing that as of May 14 West Bankers have been able to apply for exit permits (the first time they've been allowed to do so since the beginning of the Gulf war), good for one month, and for permits for visiting relatives, good only in the summer months. "Take One Down, Put Another Up" on the same page notes that police have been stopping Bethlehem motorists and ticketing them for not having renewed their licenses. The only place to renew the licenses is Ramallah, to which Bethlehem residents were not able to go from the beginning of the war until May 13.

261 It's being confiscated as a matter of "state necessity": Jon Immanuel, "An Arab Village Ponders the Loss of Its Lands," *Jerusalem Post*, May 10, 1991, p. 8.

262 Adminstrators of schools and colleges in Jerusalem: "Ramallah Students Not Allowed to Travel to Schools," *al-Fajr Weekly*, May 20, 1991, p. 12; Jon Immanuel, "3 Held for Shooting at Arab Bus," *Jerusalem Post*, May 13, 1991, p. 1.

267 About 95 percent (2,500) of the village's work force: See Palestine Human Rights Information Center, *From the Field: April 1991* (Jerusalem).

Conclusion

271 "Our journey is still a long one": "An Experience," *Voice of Women* (UPWWC newsletter) 1, no. 5 (1990), p. 3.

271 "Heroes on the street": Women activists, interviews with author.

272 "Arab society still considers that women": Nawal El-Saadawi, *The Hidden Face of Eve: Women in the Arab World* (Boston: Beacon Press, 1980), p. 188.

273 "women's vanguard": Islah Jad, "From Salons to the Popular Committees: Palestinian Women, 1919–1989," in Jamal R. Nassar and Roger Heacock, *Intifada: Palestine at the Crossroads* (Ramallah and New York: Birzeit University and Praeger Press, 1991), p. 140.

275 Palestinians outside the territories, particularly those in
 ... the United States: Research by Louise Cainkar suggests
 that while Palestinian parents in the United States retain
 gender-specific values, some of their daughters are in the
 white-collar labor force and are highly politicized. Cainkar,
 "Palestinian Women in the U.S.: Who Are They and What Kind
 of Lives Do They Lead?," in Suha Sabbagh and Ghada Talhami,
 eds., *Images and Reality: Palestinian Women under Occupation and in
 the Diaspora* (Washington, D.C.: Institute for Arab Women's Stud-
 ies), pp. 59–61.

Useful Background Reading

The following is a selection of relevant books in English available outside the West Bank.

Abu Lughod, Ibrihim, ed. *The Transformation of Palestine.* 2nd ed. Evanston: Northwestern University Press, 1987.

Al-Haq (Law in the Service of Man). *Punishing a Nation: Human Rights Violations during the Palestinian Uprising, December 1987–December 1988.* Boston: South End Press, 1990.

Aronson, Geoffrey. *Creating Facts: Israel, Palestinians, and the West Bank.* Washington, D.C.: Institute for Policy Studies, 1987.

Aruri, Naseer H., ed. *Occupation: Israel over Palestine.* 2nd ed. Belmont, Mass.: Association of Arab-American University Graduates, 1989.

Bendt, Ingela, and Downing, James. *We Shall Return: Women of Palestine.* London: Zed Press, 1982.

Bennis, Phyllis, and Neal Cassidy. *From Stones to Statehood: The Palestinian Uprising.* New York: Interlink, 1989.

Benvenisti, Meron. *The West Bank Data Project: A Survey of Israel's Policies.* Washington, D.C.: American Enterprise Institute, 1984.

————. *The West Bank Database Project Report.* Boulder: Westview Press, 1986.

Fernea, Elizabeth Warnock, ed. *Women and the Family in the Middle East.* Austin: University of Texas, 1985.

Geiger, H. Jack, Jennifer Leaning, Leon A. Shapiro, and Bennett Simon. *The Casualties of Conflict: Medical Care and Human Rights in the West Bank and Gaza Strip.* Somerville, Mass.: Physicians for Human Rights, 1988.

Government of Israel, Ministry of Justice. *Investigation of Suspicions against Israelis in Judea and Samaria: Report of the Inquiry Team.* Reprinted as *The Karp Report: An Israeli Government Inquiry into Settler Violence against Palestinians on the West Bank.* Washington, D.C.: Institute for Palestine Studies, 1984.

Hudson, Michael C., ed. *The Palestinians: New Directions.* Washington, D.C.: Georgetown University Center for Contemporary Arab Studies, 1990.

Lockman, Zachary, and Joel Beinen. *Intifada.* Boston: South End Press/ Middle East Research and Information Project, 1989.

Middle East Watch. *The Israeli Army and the Intifada: Policies That Contribute to the Killings.* New York: Human Rights Watch, 1990.

Nassar, Jamal R., and Roger Heacock. *Intifada: Palestine at the Crossroads.* Ramallah and New York: Birzeit University and Praeger Press, 1991.

Nixon, Anne Elizabeth. *The Status of Palestinian Children during the Uprising in the Occupied Territories.* Swedish Save the Children and the Ford Foundation, 1990.

Peretz, Don. *Intifada: The Palestinian Uprising.* Boulder: Westview Press, 1990.

Physicians for Human Rights. *Health Care in Detention: A Study of Israel's Treatment of Palestinians.* Boston: Physicians for Human Rights, 1990.

Sabbagh, Suha, and Ghada Talhami, eds. *Images and Reality: Palestinian Women under Occupation and in the Diaspora.* Washington, D.C.: Institute for Arab Women's Studies, 1990.

Schiff, Ze'ev, and Ehud Ya'ari. *Intifada: The Palestinian Uprising, Israel's Third Front.* New York: Simon and Schuster, 1989.

Segev, Tom. *1949: The First Israelis.* New York: Free Press, 1986.

Shehadeh, Raja. *Occupier's Law: Israel and the West Bank.* 2nd ed. Washington, D.C.: Institute for Palestine Studies, 1988.

————. *Samed: Journal of a West Bank Palestinian.* New York: Adama Books, 1984.

Toubia, Nahid, ed. *Women of the Arab World: The Coming Challenge.* London: Zed Books, 1988.

Warnock, Kitty. *Land before Honour: Palestinian Women in the Occupied Territories.* New York: Monthly Review Press, 1990.

Winternitz, Helen. *A Season of Stones: Living in a Palestinian Village.* New York: Atlantic Monthly Press, 1991.

Index